THE POLITICS OF
MUSICAL TIME

THE POLITICS OF
MUSICAL TIME

Expanding Songs and Shrinking Markets in Bengali Devotional Performance

Eben Graves

INDIANA UNIVERSITY PRESS

This book is a publication of

Indiana University Press
Office of Scholarly Publishing
Herman B Wells Library 350
1320 East 10th Street
Bloomington, Indiana 47405 USA

iupress.org

Manufactured in the United States of America

First printing 2022

Library of Congress Cataloging-in-Publication Data

Names: Graves, Eben, author.
Title: The politics of musical time : expanding songs and shrinking markets
 in Bengali devotional performance / Eben Graves.
Description: Bloomington : Indiana University Press, 2022. | Includes
 bibliographical references and index.
Identifiers: LCCN 2022023402 (print) | LCCN 2022023403 (ebook) | ISBN
 9780253064370 (hardback) | ISBN 9780253064387 (paperback) | ISBN
 9780253064394 (ebook)
Subjects: LCSH: Kirtana (Hinduism)—India—West Bengal—History and
 criticism. | Hinduism—Prayers and devotions—History and criticism. |
 Devotional literature, Indic—History and criticism. | Popular
 music—India—West Bengal—Religious aspects.
Classification: LCC ML3748 .G73 2022 (print) | LCC ML3748 (ebook) | DDC
 782.00954/14—dc23/eng/20220711
LC record available at https://lccn.loc.gov/2022023402
LC ebook record available at https://lccn.loc.gov/2022023403

For Pandit Nimai Mitra

CONTENTS

Accessing Audiovisual Materials

AUDIOVISUAL MATERIALS FOR THIS VOLUME can be viewed online at https://purl.dlib.indiana.edu/iudl/media/643999tp3p. Information and links for each individual entry follow.

Audio Example 0.1: "*āre mora āre mora gaurāṅga rāya*," Som Tāl ṭhekā, Dyuti Chakraborty, https://purl.dlib.indiana.edu/iudl/media/366613sp14.

Audio Example 0.2: "*suradhunī mājhe yāñā nabīna nābika hoiñā sahacara miliyā khelāya*," Lophā Tāl ṭhekā and ākhar, Dyuti Chakraborty, https://purl.dlib.indiana.edu/iudl/media/811k52193q.

Audio Example 1.1: "*brindabaner līlā gorār manete paṛila*," Som Tāl ṭhekā, Nimai Mitra, https://purl.dlib.indiana.edu/iudl/media/x11x41sj10.

Audio Example 6.1: "*brindabaner līlā gorār manete paṛila*," Som Tāl ṭhekā, Nimai Mitra, https://purl.dlib.indiana.edu/iudl/media/425k32755p.

Audio Example 6.2: "*brindabaner līlā gorār manete paṛila*," Som Tāl kāṭān, Nimai Mitra, https://purl.dlib.indiana.edu/iudl/media/851564983q

Audio Example 6.3: "*yamunāra bhāba suradhunīre karila*," Birām Daśkośī Tāl ṭhekā, Nimai Mitra, https://purl.dlib.indiana.edu/iudl/media/w72b29h31x.

Audio Example 6.4: "*yamunāra bhāba suradhunīre karila*," Birām Daśkośī Tāl kāṭān, Nimai Mitra, https://purl.dlib.indiana.edu/iudl/media/g74q57ts58.

Audio Example 6.5: "*khol karatāl gorā sumela kariyā*,"Jhānti Tāl ṭhekā, Nimai Mitra, https://purl.dlib.indiana.edu/iudl/media/8418617p06.

Audio Example 6.6: "*dān deho dān deho bali gorā ḍāke*," Jhānti Tāl ṭhekā, Dyuti Chakraborty, https://purl.dlib.indiana.edu/iudl/media/188158hj9w.

Audio Example 7.1: *nām kīrtan*, Alpana Naskar, https://purl.dlib.indiana.edu/iudl/media/217q67qm7f

Audio Example 7.2: *hātuṭi*, Rahul Das, https://purl.dlib.indiana.edu/iudl/media/f85n305w2n.

Audio Example 7.3: *maṅgalācaraṇ*, Dyuti Chakraborty, https://purl.dlib.indiana.edu/iudl/media/n89d17jm8q.

Audio Example 7.4: "*bhaja gaur pada paṅkaja yugalām*," Gaura-bandanā, Dyuti Chakraborty, https://purl.dlib.indiana.edu/iudl/media/k12831jk5s.

Audio Example 7.5: "*gaurāṅga cāndera mane ki bhāba uṭhila*," Som Tāl ṭhekā, Dyuti Chakraborty, https://purl.dlib.indiana.edu/iudl/media/029p09c155.

Audio Example 7.6: "*jaya rādhā-mādhaba kuñja-bihārī*," Radha-Krishna bandanā, Dyuti Chakraborty, https://purl.dlib.indiana.edu/iudl/media/n89d17jm7d.

Audio Example 8.1: "*āre mora āre mora gaurāṅga rāya*," Som Tāl ṭhekā and kāṭān, Dyuti Chakraborty, https://purl.dlib.indiana.edu/iudl/media/k61r46ws3m.

Audio Example 8.2: *"suradhunī mājhe yāñā nabīna nābika hoiñā sahacara miliyā khelāya,"* Lophā Tāl ṭhekā and ākhar, Dyuti Chakraborty, https://purl.dlib.indiana.edu/iudl/media/z20s75kh2c.

Audio Example 8.3: *"prabhu kā nām japo man mere,"* Hindi devotional song, Dyuti Chakraborty, https://purl.dlib.indiana.edu/iudl/media/g15b39d24h.

Video Example 6.1: *khol pranām,* Nimai Mitra, https://purl.dlib.indiana.edu/iudl/media/z01069f58z.

Video Example 7.1: *dhvani,* Dyuti Chakraborty, https://purl.dlib.indiana.edu/iudl/media/r171886j1w.

Video Example 7.2: *"gaurāṅga cāndera mane ki bhāba uṭhila,"* Som Tāl ṭhekā, Dyuti Chakraborty, https://purl.dlib.indiana.edu/iudl/media/g94h63ztom.

Video Example 7.3: *"gaurāṅga cāndera mane ki bhāba uṭhila,"* Som Tāl kāṭān, Dyuti Chakraborty, https://purl.dlib.indiana.edu/iudl/media/g94h63zs8t.

Video Example 7.4: *"dān deho deho dān,"* ākhar and kathā section, Dyuti Chakraborty, https://purl.dlib.indiana.edu/iudl/media/r56n00gx8n.

Video Example 7.5: *"tomrā dekho āmāder rādhār uḍani pareche"* from *"lalitā biśākhā sāthe,"* Dyuti Chakraborty, https://purl.dlib.indiana.edu/iudl/media/118r370s8r.

Video Example 9.1: Radha and Krishna awake in the morning, from *Muralī-bṛṣṭi* VCD, Shampa Mishra, https://purl.dlib.indiana.edu/iudl/media/831c585q6g.

Video Example 9.2: *"hari nija āncare rāi mukha mochai,"* from *Muralī-bṛṣṭi* VCD, Shampa Mishra, https://purl.dlib.indiana.edu/iudl/media/h246735v89.

ACKNOWLEDGMENTS

THE POINT WHERE THE PEN hits the paper—or where the fingers meet the keyboard—suggests the presence of a singular writer assembling words, images, and thoughts into a book's final form. In reality, of course, there are dozens if not hundreds of people who have been involved in offering knowledge, advice, and support throughout a long process. This point surely holds true with this book as well. And, in addition to the usual types of interaction and assistance that mark the work of writing, there is another level of dependence involved in this book. Throughout my research, I have been keenly aware of the ways that studying *padābalī kīrtan*—a musical genre that mostly depends on face-to-face acts of musical transmission—is especially reliant on the goodwill of others sharing their knowledge with me. It is here that my gratitude starts—with the dozens if not hundreds of kīrtan musicians in Bengal with whom I studied, performed, traveled, drank tea, and more. At the top of this list is one of my main kīrtan gurus and interlocutors, Pandit Nimai Mitra. While studying with him during extended periods of fieldwork, follow-up visits, and correspondence over the course of a decade, he proved to be a bottomless ocean of knowledge about kīrtan. Even more amazing was his eagerness to share all of this with me

at a moment's notice. With sadness, I note that he passed away in September 2021, as this book was in its final stages of writing. Nevertheless, I hope that the spirit with which he eagerly shared his love of kīrtan is communicated in the pages that follow.

There is a long list of other musicians with whom I studied and discussed kīrtan, all of whom were ready to answer my many questions as they arose. Dr. Kankana Mitra met with me regularly to study padābalī kīrtan, share her research, and connect me with musicians and colleagues at Rabindra Bharati University. Rahul Das (Krishna Bharadwaj) and Dyuti Chakrabarty have been incredibly generous with their time and artistry, allowing me to travel with them throughout West Bengal and answering my unending questions about kīrtan theory and performance. Many other kīrtan musicians were instrumental in my research, including: Adhyapak Manoranjan Bhattacharya, Suman Bhattacharya, Rabin Sanfui, Ananta Nitai Das, Koumen Mondal, Shampa Mishra, Shrabani Mondal Mukherjee, Gobinda, Pratyasha De, Shampa Mishra, Shib Prosad Paul, Archana Das, Koumen Mondol, Vikas Nashkar, and Murari Hari Das.

Many others in Kolkata and across West Bengal and India were crucial guides during my research. Hena Basu connected me with key research contacts and sources in Kolkata and West Bengal; her knowledge of kīrtan was also an invaluable resource as she assisted with many transcription projects and translation queries. I also owe her a special thanks for granting permission to use the beautiful painting of Chaitanya by Dipen Bose in chapter 1. My longtime friend Bharati Roy offered invaluable assistance when tracking down sources and with Bangla translation work. The staff at the Bhaktivedanta Research Centre in Kolkata offered me use of their library facilities and the chance to access many rare texts housed in their collection. Amlan Das Gupta at Jadavpur University helped me locate recordings in the musical archives there. The staff at ARCE in Gurgaon helped me find valuable archival recordings during a short visit in 2012. In Kolkata, Debtosh

Guha kindly took time to meet and offer a detailed perspective on the musician Rathin Ghosh that was key to my analysis. Sweta Gupta, formerly at Raga Music, met with me to discuss media production and distribution in West Bengal. And Pandit Samir Chatterjee was kind enough to put me in touch with Kankana Mitra during an early research trip to Kolkata.

The early research for this book began as a dissertation project at The University of Texas at Austin. As my research supervisor, Stephen Slawek offered wonderful guidance throughout my time there. His vast knowledge of Hindustani and devotional music in South Asia gave me a firm foundation to begin and advance my work. Several other faculty members at The University of Texas at Austin steered my learning and project in crucial ways, including Kaushik Ghosh, Kathryn Hansen, Shanti Kumar, and Robin Moore. I offer a special thank you to Veit Erlmann, who urged me to take seriously the temporal links that connected various topics studied in this book. A Junior Research Fellowship from the American Institute of Indian Studies and a Graduate Dean's Prestigious Fellowship Supplement from the Graduate School at The University of Texas at Austin were two key pieces of funding that allowed this research to begin. And a FLAS Fellowship for Dissertation Writing offered by the South Asia Institute at The University of Texas at Austin was another key part of the early research trajectory for this project.

The book's initial formation and final editing took place at the Yale Institute of Sacred Music. First as an ISM Fellow in 2015–16 and later as a member of the ISM staff, I have been buoyed by the rich interdisciplinary environment of the Institute and its study of sacred music and the related arts. None of this would have been possible without the support of ISM Director Professor Martin Jean and his commitment to the ISM Fellows program. I am grateful for the cohort of ISM Fellows who read drafts of chapters during our year together, including Claire Pamment, Andrew Albin, John Graham, Meredith Gamer,

Tala Jarjour, Hugo Mendez, and Michael Dodds. I also thank Professor Phyllis Granoff for many rich discussions and connecting me with the South Asian Studies Council and faculty at Yale.

Another source of intellectual inspiration for the writing of this book was the time I spent as a Mellon Postdoctoral Fellow in the Department of Music at Columbia University (2016–18). I am grateful to Professor Susan Boynton and the faculty and staff in the department for the immense support offered throughout my time at Columbia. I owe a special thank you to the faculty and students at the Center for Ethnomusicology at Columbia, which served as an inspirational node for discussion and research during my time in New York. Among my colleagues during my time at Columbia, I am especially appreciative to Alessandra Ciucci, Aaron Fox, Kevin Fellezs, Ana Maria Ochoa Gautier, and Chris Washburne for feedback and support as I worked through my ideas for this book. Of course, many of the graduate students at Columbia offered wonderful feedback and friendship during my time there as well, including Nandini Banerjee-Datta, Kyle DeCoste, and Jesse Abel Chevan, among others.

I am thankful for the advice, suggestions, and encouragement offered by co-panelists, discussants, and other engaged listeners as I presented various parts of this research over the past several years at conferences and other fora. I thus offer my thanks to Francesca Cassio, Richard Widdess, Meilu Ho, John Stratton Hawley, Christian Novetzke, David Haberman, Ben Krakauer, Richard Wolf, Ritwik Sanyal, Abhishek Bose, Annu Jalais, Kiyokazu Okita, Shrivatsa Goswami, Peter Manuel, Carola Erika Lorea, Ferdinando Sardella, Swapna Sharma, and Santanu Dey, among others, for the valuable comments and ideas given in response to my talks. David Buchta provided incredibly helpful suggestions after reading a chapter of the manuscript and further clarified many points regarding translation, and Aleksandar Uskokov helped with a Sanskrit verse translation in the final hours, for which I am extremely grateful. I offer thanks to my

close friend Matthew Dasti, who read several chapter drafts and offered a great deal of advice that shaped my ideas about the book. Thank you to Suvarna Goswami and Moushumi Bhowmik, who kindly gave me permission to use photos they took in Braj and Kolkata, respectively.

I am grateful to the *Journal of Hindu Studies* and *Ethnomusicology* for granting me permission to include portions of previously published material in this book. Chapter 3 includes material from my article "'Kīrtan's Downfall': The Sādhaka-Kīrtanīyā, Cultural Nationalism and Gender in Early Twentieth-Century Bengal" from the *Journal of Hindu Studies* (2017a), and sections of chapter 8 are drawn from my publication "The Marketplace of Devotional Song: Cultural Economies of Exchange in Bengali Padāvalī-Kīrtan" (2017b), published in *Ethnomusicology*. I am also indebted to several people at Indiana University Press who have guided this project along from the start. Allison Chaplin, my editor at the press, has offered keen advice at every stage of the process while expressing enthusiasm in the project from the start. I also thank Janice Frisch and Sophia Hebert for their support in guiding my book through the editorial process. Three anonymous readers offered detailed and eye-opening comments that have greatly contributed to the arguments presented in this book and its overall organization. I offer a thank you to these readers for their thoughtful suggestions that have improved the writing on nearly every page of this book.

The most sustained forms of support throughout the work of research and writing have come from my many family members who offered encouragement. My mother, Cynthia Graves, and sister, Rebecca Graves-Bayazitoglu, who are both writers, could well understand the challenges of keeping focused on the work and were always there with enthusiastic words of inspiration. My uncle, Theodore Fraser, yet another writer and academic, remains an inspiration for many reasons, not least of which is his enthusiasm to continue to uncover new areas of scholarship

and his seemingly unending zeal to write and publish. No one deserves a bigger thank you for supporting me through travel, research, and writing than my wife, Mariana Torrens Arias. It was her question at a pivotal moment in the life of this book that, in many ways, led to its current state. For that, and for her keen attention to detail in the production of many images in this book, I am eternally grateful. My daughter, Valentina, is an everyday source of wonder and encouragement for me as a writer as I watch her read with abandon; she has also learned to play a few patterns on the khol drum—what could be better for an enthusiast of Bengali drumming?

<div style="text-align: right">

Eben Graves
Madison, Connecticut
October 29, 2020

</div>

Notes on Spelling and Transliteration

THOUGH THIS BOOK PRESENTS TRANSLITERATIONS of several different South Asian languages, including Sanskrit, Hindi, and a few examples of Maithili or Brajabuli, the most common language transliterated and translated throughout is Bangla. There are many ways to transliterate Bangla. The two most common techniques have been a form of Sanskrit transliteration that uses the diacritical system to differentiate between the long (ā) and short (a) vowels and different consonants as well (e.g., ś, ṣ, s). This system is referred to as the International Alphabet of Sanskrit Transliteration. A second method is a phonetic approach where vowels and consonants are approximated in their Roman alphabet counterparts. For example, the various sibilants in Bangla (such as শ and স) are commonly transliterated as "sh" in the second approach.

I use a combination of these two systems in this book, though most of the Bangla-language transliteration follows the International Alphabet of Sanskrit Transliteration. An important reason why I privilege this form of Sanskrit transliteration is that it underscores the many links that exist between the vocabulary of Sanskrit aesthetics and the song repertoire of padābalī kīrtan.

The International Alphabet is also applied to transliterations of Sanskrit, Hindi, and Maithili/Brajabuli terms. One reason for augmenting the system of Sanskrit transliteration is to underscore the phonetic features of Bangla that reflect key features of the genre in performance. Here, I present notable modifications to the International Alphabet that reflect important phonetic features of Bangla and other modifications for more commonly known words:

- The proper nouns Krishna, Radha, and Chaitanya are used throughout.
- As a general rule, the final *a* is removed at the end of Bangla words as it is not pronounced (e.g., *kīrtan* and *bhadralok*). Exceptions to this include transliterations of Sanskrit words and examples when final vowels are used in Bangla-language songs for performance reasons.
- The Bangla letter ব is transliterated as *b* throughout the book, not the Sanskritic *v*, to reflect Bangla pronunciation. Exceptions to this rule are the words *Vaiṣṇava, dhvani, Gosvāmī, Viṣṇu, Advaita,* and *svabhāba* and terms that are primarily from the Sanskrit lexicon, such as *pūrva-rāga*.
- The Bangla letter য is transliterated as *j* and the letter য় as *y*.
- The Bangla word বড় is transliterated as *boṛo* throughout.
- The proper names of figures described in the book from the hagiographical and early modern period are written in the Sanskritized form with final vowels (e.g., Narottama Dāsa) while contemporary examples are spelled phonetically and without diacritics (e.g., Advaita Das Babaji). The exception to this is the spelling of Chaitanya (i.e., not Caitanya).
- All place names have been spelled according to the official Indian government versions, such as Kolkata (not Calcutta). One

exception to this is the name of the north Indian city Brinda-
ban, which reflects features of Bangla phonetics.

- Bangla terms using the nasalized character known as *candrabi-
 ndhu,* "ঁ," are transliterated using an extra *n* for the nasalized
 symbol for ease of reading. For example, the term ফাঁক is trans-
 literated as *phānk,* and the tāl name ঝানতি is represented as
 jhānti.

Unless otherwise noted, all translations of non-English languages
are mine.

Notes on Representing
Musical Sound

THERE ARE THREE VISUAL WAYS that musical sound is represented in this book. I stress at the outset that these techniques are not meant to be stand-alone forms of representation; rather, they are meant to work in tandem with the numerous audio and video examples of performance that accompany the book. As such, I consider these representations to function as analytic listening guides that can serve as a type of visual complement to the audio and video examples. Furthermore, these forms of visual representation are not meant to be (1) exhaustively descriptive or (2) comprehensible prescriptive forms of sonic representation, as some methods of transcription in ethnomusicology have been defined (See Marian-Bălaşa 2005). Most of the visual representations in this book thus have an accompanying multimedia example that can be accessed on the accompanying website.

The first and most common form of representation is a graphic table system where each cell in the graph corresponds with a single time unit (*mātrā*) in performance. This form is often referred to as TUBS (Time Unit Box System). This graph form is used to both communicate the abstract theoretical structure of an individual tāl as well as to demonstrate the relationship between sung text and the tāl structure. This method of representing the

temporal structure of a tāl is also common in padābalī kīrtan instruction, where a musician will mark out the form of a tāl with a graphic representation that moves from the upper left portion of a sheet of paper toward the right side, then descending down the page in rows. This is the same order in which one can read the table systems in this book. Each cell in the tables used here is labeled to identify which mātrā in the larger tāl cycle it corresponds with, and the cell is sometimes further populated with the sung syllables that occur during that time unit. There is no pitch information given in this form of transcription, as the melody is determined by the tāl being used in performance (see chap. 6), a method that is also followed in padābalī kīrtan instruction.

The second type of visual representation found primarily in chapter 6 is a form of staff notation used to illustrate the basic melodic structures that are used with each tāl. These staff notation examples are based on my own lessons and transcriptions of vocal performance; I have never seen this method of representation used by kīrtan musicians during my research. These examples of staff notation are meant to communicate the basic melodic template used in performance and are thus skeletal outlines of how a melody unfolds during a song. These notations might be best used as analytic listening guides that outline the melodic structure used to accompany each song text. The pitch of C in the staff notation has been given as the *sa* or tonic pitch throughout these transcriptions for ease of reference.

The third form of transcription used is a short example that presents the spoken syllables (*bols*) and rhythm for a khol composition in chapter 7. This example is also presented in the TUBS form but includes small notes that identify the rhythm of the pattern and is a modified version of a system of notation used for the khol (Graves 2014) and adapted from Kippen's system used for the tabla (Kippen 2006).

Notes on Dating Systems

THIS BOOK CITES TEXTS THAT use two different dating systems. In addition to the common Western system (CE), the other dating system is called *bāṅgālā śaka* (BS) and is calculated by subtracting 593 or 594 years from the Western date, depending on the month of publication. I list the Western date in brackets to orient the reader. A sample citation using these two dating systems is as follows: (Mitra 1333 BS [1926], 380).

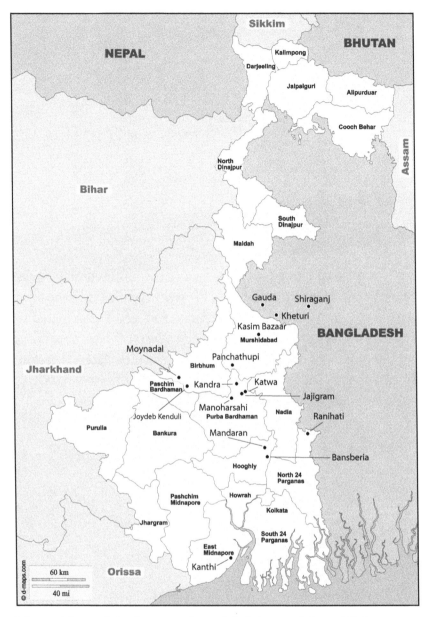

Map 0.1 Map with key locations for padābalī kīrtan. © Daniel Dalet, https://d-maps.com/carte.php?num_car=9210&lang=en

THE POLITICS OF
MUSICAL TIME

INTRODUCTION

KĪRTAN'S INFLUENCE DERIVES FROM TIME

"KĪRTAN'S INFLUENCE DERIVES FROM TĀL."[1] It was this short aphorism about the relationship between devotional song in Bengal (kīrtan) and conceptions of meter (tāl) that emerged and resurfaced in discussions, performances, and writings as I studied a genre of Hindu devotional song known as *padābalī kīrtan*.[2] In one sense, this statement can be traced to a discrete location. The first time I heard it was in a 2012 meeting with the kīrtan guru Pandit Nimai Mitra in Kolkata (Calcutta). But it was more than a one-time discursive marker. This idea was repeatedly voiced when musicians and music scholars emphasized relationships between metric theory in Bengal and an affective sphere of musical performance and storytelling.[3] If the songs of padābalī kīrtan tell of the "divine play" (*līlā*) of Hindu deities and saints, these texts are influenced by the numerically vast and theoretically dense repertoire of meter specific to this musical style and the Bengal region. Often, this musical style is called *boṛo-tāl kīrtan* (large-meter kīrtan), a reference to the large meters and slow tempos that define its parameters of performance.

In the present, however, the ability to perform this musical style is not taken for granted. Rather, performing kīrtan songs that depend on long-duration tāls has increasingly become

1

constrained by shrinking time allowances found in professional performance contexts in contemporary West Bengal. To understand the temporal challenges involved in performance, it is useful to start with an ethnographic example. In 2012, during my fieldwork in the Indian state of West Bengal, the annual religious and musical festival (*melā*) in the town of Joydeb Kenduli attracted a swelling crowd of pilgrims. On the busiest day of this three-day event, hundreds of thousands of attendees vied for space in the overflowing tents that dotted the festival grounds. A stage occupied the center of each tent, equipped with an amplification system that projected the sounds of musical performance throughout the huge tents and beyond into the night air. The crowds on this day converged at the festival grounds from throughout West Bengal in response to the rhythms of lunar time: devotees follow a calendar that marks this day as a moment when an extra dose of religious merit can be accrued by bathing in the local Ajay River. The Jaydeb Melā, as this festival is called, is the most popular in an established circuit of similar music melās throughout West Bengal.[4]

One of the largest and most crowded tents on this evening was situated between the bank of the river and the village center. Attendees like myself who had found a seat on the cold January ground under the tent had waded through congested crowds that had temporarily massed in this usually quiet village. Deep in the rural Birbhum district of West Bengal, we sat in these tents for hours on end. What drew pilgrims from throughout the Bengal region was the chance to enjoy a rotation of kīrtan ensembles that performed in a twenty-four-hour schedule. Each group mixed song and storytelling to enact the divine plays of the young cowherd Krishna and his paramour, Radha. The presentation of these līlās was prefaced with songs and prayers dedicated to Chaitanya Mahāprabhu (1486–1533), a fifteenth-century mystic from Bengal. Chaitanya, as he is commonly known, was a figure who spread the worship of Radha and Krishna in the Bengal region

and whose life and teachings formed the template for the devotional practice that has become known as Gauḍīya Vaiṣṇavism.

On this evening, a young female singer, Dyuti Chakraborty, took the stage with her ensemble. She began with a song in praise of Chaitanya, fulfilling a formal characteristic of the genre that dates to its founding in the sixteenth century. This prefatory song featured the large-meter style, marked by slow tempos and large metric cycles (Audio Example 0.1). The divine play that followed this song depicted the mythical time of a secret, amorous meeting on a boat between Radha and Krishna. In her performance, fragments of text emerged from a slow-moving tempo, as various syllables were formed, elongated, and joined to complete the first phrase: *āre mora āre mora gaurāṅga rāya* (oh, my Gaurāṅga Rāya [Chaitanya]). This vocative phrase was shadowed by an electronic keyboard and accompanied by a sparse time-keeping pattern in the *khol* (double-headed drum), as two drummers sketched out the barest of musical signposts in this thin sonic texture. After her melismatic rendition of this line of text, Dyuti Chakraborty signaled for an increase in the tempo. With this, a series of textual and percussive elaborations were introduced, increasing the rhythmic density of the song before arriving at a short pause. These elaborations were seedlike in that they expanded from the form and lyrical content of the song's first line.

At this point, Dyuti Chakraborty would usually return to the slow and ponderous large-meter style to accompany the next line of song text. However, on that night her performance took an unexpected turn. Following her lead, the kīrtan group launched into a quick-tempo interpretation of the song's second line: *suradhunī mājhe yāñā nabīna nābika hoiñā sahacara miliyā khelāya* (going in the midst of the Suradhunī [Ganges] River, he [Chaitanya] began to play with his companions) (Audio Example 0.2). As the two drummers gracefully danced in time with a short-duration tāl, the theme of riverine play foreshadowed the story of Radha and Krishna that would dominate the rest of the performance and

synchronized this prefatory song about Chaitanya with the up-coming story. While the first line of song text in the large-meter style had taken several minutes to complete, this line of the song was completed in a matter of seconds. At its conclusion, Dyuti Chakraborty began to dance in time with the quicker tempo, gracefully raising her arms above her head in an embodied sign of devotion for Chaitanya (fig. 0.1).

Dyuti Chakraborty's slow-tempo rendition of the first line of this song about Chaitanya is one example of how kīrtan derives its influence from tāl. If song texts in padābalī kīrtan describe the divine plays of the past and immerse listeners in the sacred stories of gods and saints, the large-meter musical style in kīrtan *directs* this process through its musical aesthetic. Features of musical time, such as the song's durational features and tempo, represent aspects of devotional ideology and practice. Song texts are referred to as *word-pictures* in discourse, and throughout history one key to unlocking the images they contain has been found in the slow tempos and large meters used in performance, two features of musical time that illustrate the genre's relationship with devotional visualization.[5] Musical style is fundamentally *expansive* in the way that short song texts become longer forms in performance, and kīrtan musicians (*kīrtanīyās*) commonly refer to this process of elaboration with the Bangla term "*bistār*" (ex-pansion).[6] The work of defining the musical process of expansion and its link with meditation emerged in premodern Bengal yet were revitalized during the colonial period when Bengali intel-lectuals and musicians connected these musical processes with the emergent sphere of regional politics.

If the opening section of Dyuti Chakraborty's performance underscored these relationships between musical style and devotional practice, a shift in musical style and tempo was intro-duced as the song progressed. Instead of returning to the large-meter style normally used for the second line of the song, she used a quicker tempo and shorter tāl that allowed her to quickly

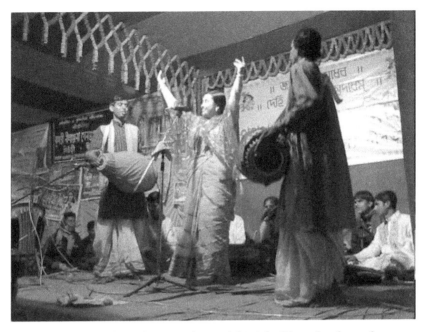

Figure 0.1 Dyuti Chakraborty at the Jaydeb Melā. Photo by the author, 2012.

progress through the compulsory song about Chaitanya. This transformation of musical form was a response to the shortened time allowances found at this festival, which were determined by institutional imperatives and the growing number of musicians who compete for stage time to promote their kīrtan ensembles. Because only one hour of stage time was offered, the usual three-hour duration of a kīrtan performance required significant modification. The local and global influences affecting these truncated time spans are numerous, and several can be traced to transformations in India's political economy and neoliberal economic reforms of the past two decades. These shifts have fostered a symbiotic growth of surplus wealth and entrepreneurial marketing strategies that have influenced kīrtan performance, swelling the ranks of professional kīrtan performers over the past decade. Therefore, at promotional musical events such as the Jaydeb Melā,

there is an inherent conflict between how long a musical performance *should* be and how long it *can* be. Long-standing practices of musical style thus meet with everyday economic and political time practices that seep into the lives of performers. To formulate a response to the friction found between musical style and temporal limitations, we might rework the short aphorism that opened this chapter. The statement that kīrtan's influence derives from tāl implies another consideration—namely, that kīrtan's influence also derives from *time*. If the emphasis on practices of devotional religion in Bengal represent one way that music's social values are constructed, these relationships are challenged as musicians seek to find spaces that allow for the performance of a specific musical style and its connections to devotional practice.

—⚬—

For centuries, performances of devotional song in Bengal have used temporal features of musical style to express ideas about religious affect and political belonging. *The Politics of Musical Time* focuses on history, ethnography, and performance analysis to examine how musicians reinforce these links while also studying how these connections become strained in the performance contexts of contemporary India. While the genre's slow-moving and expansive style is linked with facets of devotional meditation and conceptions of ritual time, the book tells the story of the inherent temporal conflicts found in present-day performance. With the rise of various forms of professionalization, musicians are required to navigate features of modern time organization to promote their careers, as renditions of the genre's expansive musical aesthetic become shortened in commercial contexts. The conflicts found between musical imperatives and temporal limitations represent one strand in a larger *politics of musical time* surrounding the genre, which includes practices and debates where the meanings and contours of musical sound are negotiated. Combining ethnographic, historical, and analytic work,

this book traces this politics of musical time in Bengal by study-
ing connections between temporal aspects of performance and
devotional thought and practice; links between regional politics,
gender, and normative definitions of musical style; musical tech-
niques that adapt long-duration forms to shortened time allow-
ances; and debates about devotional performance and economic
exchange. If the performative and discursive spheres of padābalī
kīrtan express ideas about the values that lead to the organiza-
tion of musical time, then the politics that surround this work
continues to challenge musicians who engage new contexts and
new temporal terrain.

Musical time is a frame of analysis that examines how the
temporal aspects of performance, historical consciousness, and
contemporary social life intersect and interact in this volume.
Studying a lineage of padābalī kīrtan musicians from premod-
ern to contemporary periods, my focus considers how historical
and social contexts have shaped temporal aspects of perform-
ance. From premodern religious contexts to the emergence of
professionalization and the live-music markets in the present,
the book's analysis forms two interrelated perspectives that are
briefly introduced here and further elaborated on in the following
chapter. The first studies how musicians act *on* time by tracing
how time-related aspects of musical performance such as form,
tempo, and meter are linked to ritual practice in Bengali devo-
tional practice. Two overarching forms of temporality that focus
this discussion are *sequence* and *durational time spans*. A focus
on temporal sequence in padābalī kīrtan underscores the ways
that theological and political thought has influenced the sequen-
tial order of events in a performance while another branch of
inquiry, temporal duration, studies the connections between the
genre's slow-moving style and processes of devotional medita-
tion that depend on prolonged time frames. The ritual meanings
of padābalī kīrtan's musical style took on new meanings during
the colonial period, when the large-meter musical style became

defined as representative of a nation's past and a chronotope that stood in contrast to an urban present of colonial subjugation.[7] The conceptual frame of *synchronies of musical sound* presented in this book thus calls attention to similarities in temporal organization found between musical sound and social practice.[8]

The second set of inquiries analyzes how musicians act *within* time by focusing on how aspects of modern social time—including economic policies, media forms, and social ideologies—influence the shortened durations that dominate present-day performance contexts. It is through these negotiations, I argue, that the politics of musical time becomes intensified. Central to the professional lives of contemporary kīrtan musicians are the shortened durations of music festivals and media production, two contexts where the musicians are required to adapt features of the expansive musical aesthetic and the large-meter style. This book thus focuses on how musical labor produces both social and economic value in various contexts, a process that sparks debates about the relationship between musical change and financial recompense across informal discussions, media coverage, and university education in contemporary West Bengal. The links that have been formed between musical style and social value, and the manner in which they are challenged in the present, thus underscore a politics of musical time that animates the performative and discursive sphere of padābalī kīrtan in contemporary West Bengal.

By examining the political economy of devotional music in Bengal, this book joins discussions about contemporary South Asia that see performance and social life as interlocked spheres of action. I begin from the premise that performance can be analyzed as a space that both reinforces and transforms the values expressed in the textual repertoires of religious practice. In South Asia, recent ethnographic work has begun to examine the complex ways that expressive culture and religious practice interact with issues of nationalism, gender, caste identity, and economic

exchange, among other topics.[9] Running parallel to this perspective is work in the frame of cultural history that has examined how the meanings of religious texts work to shape modern and secular identities in addition to those of the religious domain.[10] These two developments have augmented a long-standing emphasis on the study of religious texts that has significantly shaped research in South Asia in general and Bengal in particular but have offered only scattered glimpses of how these texts interact with everyday life. A focus on the expansive mode of song performance in padābalī kīrtan demonstrates how sound is central to social life in present-day West Bengal, where musicians travel from village to village, night after night, telling the stories of gods and saints.

Another discussion this book engages in considers how musicians navigate the shifting social contexts that have fundamentally refigured how performers earn a livelihood. While the elite-supported classical musics of north and south India have managed to shift from earlier systems of court patronage to contemporary circuits of instruction and concert performance (Wade 1992), the case of nonclassical performance traditions in South Asia reveals a diverse set of approaches that musicians employ to create aesthetically and economically valuable musical lives. Though some of this nonclassical music has remained connected with caste-based services and identities (Mason 2013), the case is more complicated for performance styles associated with nonclassical and nonhereditary social structures such as padābalī kīrtan. An emerging research focus in South Asia has considered how nonclassical music has begun to adopt methods of production and distribution from the sphere of popular music.[11] While significant, one issue not directly approached in this research is how the techniques and contexts of popular music production and distribution introduce musicians to new temporal conditions of performance. How do musicians adapt cultural forms created in past social contexts to present-day performance settings? How

do the negative critiques of such transformations overlook the limited opportunities and difficult decisions that confront musicians in the frame of musical time? The challenges that padābalī kīrtan musicians face in adapting cultural forms to shrinking durations and features of social time are not isolated instances. Indeed, disparate cases such as Western classical opera, art music in Egypt, and central Himalayan folk music underscore how musicians and producers face a series of contradictions that exist between aesthetic forms and the shrinking time slots of musical performance in the present.[12] This remains an understudied phenomenon that has been mentioned in passing but not been a central focus of ethnomusicological research.

The frame of musical time in this book addresses these issues and questions by studying temporal aspects of musical sound from two perspectives. The first approach considers how performers produce *temporal imaginaries* and joins discussions in studies of musical time that seek to study the interrelationships between musical sound and temporal features of social life.[13] In the case of padābalī kīrtan, this focus studies how the conceptual spheres of devotional and political belonging are linked to temporal aspects of performance through the synchronies of sequence and duration. In this strand of inquiry I stress how, by acting on time, musicians reinforce and transform a web of social values that derive from time-related ideas about devotional practice and regional politics in Bengal. If this approach shares an emphasis on musical analysis found in earlier work on musical time (Kramer 1988), it further draws from more recent work that considers the time frame of the musical event as actively engaged in the production of temporal meanings and experience (Born 2015). Based on the idea that there is a bidirectional exchange between musical time and temporal thought and practice, this work sees "social processes immanent in time and time as immanent in social processes" (363). The focus on synchronies of musical sound that I present in chapter 1

emphasizes this bidirectional exchange between musical time and social practice.

The production of temporal imaginaries further involves a focus on historical consciousness. To consider how kīrtan derives its influence from time is a way of paying attention to the continued power that conceptions of the past have on the present. Time and history are "separate but linked concepts" (Murphy 2011, 1) that reveal the importance of "temporal imaginaries" in forming the complex ground of the religious and national in South Asia (2). The past, from this perspective, is not simply a source that inspires cultural production; as Saba Mahmood suggests, "It is the very ground through which the subjectivity and self-understanding of a tradition's adherents are constituted" (2005, 115). The analysis of historical consciousness in this book thus considers how temporal aspects of musical style and form are suffused with a range of social values that gain their potency through an attention to the past. To study musical time, then, considers how performance evokes the past while retaining its presence in the present, forming genealogies encapsulated in sound.

A counterbalance to the production of temporal imaginaries in this book sees musical time from what I consider a *materialist* viewpoint to underscore how musicians act within the confines of time. This overarching conceptual frame focuses on theories of social time that stress time's materiality and how it exists as a finite resource influenced by different social ideologies and practices (Adam 2004). The frames of sequence and duration emerge from this stance, and I take each as an instance of organizing time's material boundaries. Duration, in this reading, is thought of as a finite time span and not analyzed from a phenomenological perspective as found in the sphere of time studies more generally.[14] The terms *duration* and *time span* refer to finite and quantitative periods of time—the minute, the hour, or the day, among others. From this viewpoint, musical

time is not only a creative space where social values can be expressed in performance and discourse; it further becomes a site of contestation where musicians encounter the materiality of finite time durations determined by social practices and technologies. Drawing from earlier work on the anthropology of time (Gell 1992), recent anthropological work on "modern social time" (Bear 2014a) informs this approach as it uses ethnography to provide a frame for analyzing the conflicts that arise when the effects of disparate methods of temporal thought and practice converge. This work considers how a variety of divergent temporal effects intersect in the present, including the global time practices of capitalism and their abstract processes of time reckoning, features of social time organization, various forms of bureaucratic and institutional time practices that affect everyday life, and the continuing imprint of historical consciousness (7). The focus on modern social time in this book further attempts to avoid the ethnographic trap that would deny interlocutors a temporal "coevalness" with the present (Fabian 2014, 31). Studying the interaction between temporality and performance further suggests that musical acts are not frozen in a premodern and timeless past. The temporal imaginaries that shape and influence acts of musical sound, moreover, are not immune from the time-related vicissitudes that make up the fabric of the twenty-first century, as features of local and global temporal influence are felt equally across frames of experience. Though focusing on visual media, Rebecca Brown's study of the archive of the 1980s *Festival of India* offers an insightful way to think about how events display a series of "intersecting temporalities" (2017, 27). Her study suggests how these intersecting temporalities—from the impulse of Reagan-era neoliberalism to the spinning of a potter's wheel—"embody . . . a range of temporalities" that "participat[e] . . . in and [are] produced by the historical, political, economic, and cultural flows that constitute the larger social formation" (27). To ap-

ply this approach to studying temporality thus differs from the view that sees "musical time as differ[ing] pointedly from the time of daily existence" (Kramer 1988, 3), and the frame of musical time in this book widens the lens of analysis to consider how the seemingly mundane tasks of daily existence cannot be separated from acts of performance. In short, this view seeks to inject considerations of the ordinary or unexceptional into a study of musical time, a stance that argues for considering a range of activities that surround the production of musical sound as "musical" in their own right (Beaster-Jones 2014, 339).

The units of historical, ethnographic, and performance-based analysis in this book are defined as *time-spaces*. This focus analyzes the links between temporal and spatial parameters in moments of musical and ethnographic analysis. The compound nature of the term not only illustrates the interdependence of temporal and spatial facets of performance but further suggests that their ontologies are fundamentally linked (May and Thrift 2003). As Nancy Munn writes, "In a lived world, spatial and temporal dimensions cannot be disentangled, and the two commingle in various ways" (1992, 94). Drawing from Richard Wolf's use of the term *spacetime* in the case of Kota performance in South India, the time-spaces I analyze in the case of padābali kīrtan present an analytic frame where "some definable pattern with respect to both time and space within which a set of related events is performed or . . . perceived to occur" (2005, 3). The final point about perception is key to the temporal imaginaries of padābali kīrtan, as the time-spaces that are activated move between present, historical, and mythical time frames, and thus point to the virtual work that time-spaces activate as "events which are remembered, evoked, described or metaphysically accomplished through ritual" (3). As will become evident, focusing on the interrelationship between time and space is relevant to the meditative processes found in Bengali devotional practice, as imagining the divine plays of Radha and Krishna further seeks to construct

sacred place through listening to and remembering songs and stories (Sarbadhikary 2015).

Throughout the past century, the time-spaces of kīrtan performance have undergone significant transformation, as musicians have adapted from the settings of rural temples to urban educational settings and into the competitive markets of musical labor that define the present. The book's organization illustrates these shifting social locations in part I by combining historical and ethnographic perspectives to situate a genealogy of kīrtan musicians in their social and economic contexts and lay the groundwork for the following sections. Tracing this lineage of musicians through hagiographic writings, oral histories, and ethnography presents a series of moments that musicians suture into narratives about how the past informs the present through devotional and musical forms of transmission. Part II is comprised of three chapters that explore how the historically situated values examined in Part I are linked to the expansive musical aesthetic of padābalī kīrtan. Chapters on the genre's repertoire of devotional sung poetry, theories of tāl, and a full-length performance constitute this section. Part III turns to an ethnographic study of the shrinking time frames of promotional music festivals and media production that define performance in the present, which explores the shifts of local and global influence that construct these durations and their implications for professional musicians.

Chapter 1 outlines the book's theoretical concerns through describing the perspectives of how musicians act on and within time. The methods of acting on time are considered through the theoretical concept of sonic synchronies to call attention to similarities in the organization of time found between musical sound and time-related thought and practice. Acting within time is a second focus introduced in this chapter to study how the convergences and disjunctures of modern social time can be applied to the frame of music research. The earliest historical descriptions of padābalī kīrtan performance are presented

in chapter 2, as I analyze how the image of a newly sprouted seed and its expansive process of unfolding became key to describing features of musical sound. Chapter 3 shifts from the hagiographic record to historical sources to examine how the genre was supported by a class of landed wealth in Bengal during the early modern and colonial periods. The second part of the chapter then turns to how musicians and scholars initiated a project to redefine padābalī kīrtan in the early decades of the twentieth century when male musicians from rural networks began to relocate to the urban center of Kolkata. A process of classicization discursively worked to define these musicians according to the rubrics of musical skill and devotion while also differentiating their performances from contemporaneous and popular female devotional singers. Chapter 4 studies the social contexts of kīrtan performance in the present, as I continue to trace the lineage of musicians from chapter 3 to contemporary musicians in West Bengal. This chapter thus examines the underlying bifurcation of instructional and professional performance contexts found in present-day West Bengal and how the temporal and subjective conditions of neoliberalism define these various settings. The musicians introduced in this chapter constitute three generations of performers in West Bengal; I begin with a description of my studies with the octogenarian Pandit Nimai Mitra before recounting discussions and instruction with the Rabindra Bharati University professor Kankana Mitra and a younger generation of musicians that includes the musicians Dyuti Chakraborty and Rahul Das (Krishna Bharadwaj).[15]

Part II comprises three chapters that focus directly on the processes of temporal expansion that constitute padābalī kīrtan's musical aesthetic. Chapter 5 analyzes the role of song texts in the construction of padābalī kīrtan's temporally expansive musical aesthetic through two techniques. The first involves how the stories of the Hindu deities Radha and Krishna described in songs expand from an underlying set of devotional moods from the

domains of Sanskrit theater and aesthetics. The second expansive process takes place during performance, as the original lines of song text are augmented with a series of additional lyrical sections that elongate short texts into long-duration forms. Chapter 6 describes the system of tāl theory that underpins processes of temporal expansion and musical structure in padābalī kīrtan. At the center of this chapter are the interlocked domains of metric theory and the performance techniques of the genre's main percussion instrument, the khol, as I introduce the terminology and practical function of padābalī kīrtan's theory of meter. Rounding out part II, chapter 7 pulls together the discussions of lyrical and musical expansion to illustrate how they are combined and organized in an ethnographic description of a multi-hour performance titled the Dān Līlā, which studies Krishna's adoption of the role of a road-tax collector to approach Radha and her friends. A particular focus in this chapter is the role of temporal sequence in constructing a theological hierarchy through a series of genres that constitute a multi-hour līlā kīrtan performance.

Obtaining opportunities to perform full-length līlā kīrtan performances such as the one described in chapter 7 requires participation in a competitive market of musical labor and its shrinking durations. Part III offers two ethnographically focused chapters that study how musicians act within time as they adapt the large-meter, expansive musical style to these newer performance contexts. Chapter 8 examines how professional musicians navigate the all-important domain of promotional music festivals, where the links between kīrtan's long form and devotional practice are strained through the influence of modern social time and the shrinking time durations that musicians encounter. A particular focus in this discussion is the largest music festival in rural West Bengal, the Jaydeb Melā, a three-day event that features a growing number of professional musicians seeking to promote their groups. Chapter 9 examines the possibilities and limitations that media production offers in the present-day markets

of professional kīrtan performance. The primary medium that professional musicians used during my fieldwork, video compact discs, introduces temporal limits that require musicians to omit the expansive forms of the large-meter style discussed in part II. Conversely, the ability to combine synchronized audio and video material in this media presents possibilities for the storytelling mode of performance and the genre's connections with theater and visualization, as musicians use video technology to record actors who play out the devotional stories told in song. The conclusion brings together the main theoretical points that have animated the perspectives of how musicians act on and within time discussed throughout the book while further examining new ways that professional kīrtan musicians are using the internet for musical promotion and distribution, as the use of physical media forms begins to recede in current practice.

NOTES

1. "*kīrtane tāler prabhāb.*" Personal communication, September 11, 2012, Kolkata.

2. I consider tāl in padābalī kīrtan to be a form of meter and use the two terms interchangeably in this book. Of course, not all features of meter—such as time signature—are relevant to the ways in which I see the concepts of tāl and meter overlapping. In an article discussing the similarities and differences between meter and tāl in Hindustani music, Clayton suggests several ways that tāls function as metrical forms, including the psychological perception of meter as a "background against which the rhythmic surface is perceived" (2011, 4) and a system that features the "interaction of two or more concurrent levels of pulsation" (4). He also notes features of tāl in Hindustani music that are required above and beyond the features of what is typically defined as meter (14–15). Of course, padābalī kīrtan tāl differs in significant ways from Hindustani tāl, though both systems share a common theoretical framework (see chap. 6).

3. Mentioning the affective sphere of song and storytelling in padābalī kīrtan is not a direct reference to the field of affect theory in contemporary scholarship. Using this term throughout the book is a way to augment a primary focus on the relationship between the song and storytelling of the

genre and the domain of Sanskrit aesthetics with attention to the ways that musical sound and other aspects of performance contribute to this field, which, as Sarbadhikary notes (2015), is often considered a field of emotionality that is, in many ways, discursive.

4. Another example of a similar music festival is the annual Ramkeli Melā in Ramkeli, West Bengal, though this festival is significantly smaller and takes place in the Bengali month of Joishtho (usually June).

5. See Brajabashi and Mitra for use of the term word-picture (1317 BS [1910], vii).

6. This term is obviously related to the Hindi/Sanskrit term vistār commonly used in Hindustani musical discourse. See Slawek (1987) and Ruckert (2004), for example.

7. Mikhail Bakhtin (1981) discusses the concept of the chronotope in literature to address the "intrinsic connectedness of temporal and spatial relationships" (84). For its use in music scholarship, see Engelhardt (2009).

8. My study of synchronies in this book differs from recent work in ethnomusicological scholarship focusing on the temporal links between musical time and bodily movement, which also commonly uses the term *synchrony*. See, for example, Turino (2008, 41), Fairfield (2019), and Herrera (2018). Though embodiment is certainly a part of my study on music and temporality, I extend the idea of synchronies beyond aspects of bodily movement to consider temporality and social life more broadly.

9. For example, see Schultz (2013), Beaster-Jones (2016), Fiol (2011; 2017), DeNapoli (2014), Hess (2015), and Hansen (1992).

10. For example, see Bhatia (2017), Novetzke (2008b), Chatterjee (1993), and Talbot (2016).

11. See Fiol (2011), Ayyagari (2014), and Manuel (1993; 2012).

12. For opera, see Michael Cooper, "Could You Shorten That Aria? Opera Weighs Cuts in the Classics," *New York Times*, last modified July 6, 2016, https://www.nytimes.com/2016/07/07/arts/music/could-you -shorten-that-aria-opera-weighs-cuts-in-the-classics.html?_r=0; for art music in Egypt, see Marcus (2007, 116); and for the case of central Himalayan music, see Fiol (2011).

13. Murphy (2011) presents a formulation of temporal imaginaries that influences the general perspective I adopt here.

14. See Massey (2015).

15. Recently, Rahul Das has decided to use the name Rahul Krishna Bharadwaj as a stage name when performing kīrtan and other devotional genres.

PART I

GENEALOGIES OF KĪRTAN

ONE

—◊—

TEMPORALITY AND DEVOTIONAL
PERFORMANCE IN BENGAL

ON A FULL-MOON NIGHT IN November 2012, our taxi twisted and turned through the crowded streets of north Kolkata. After a short drive, we arrived at the home of the Basak family, where the octogenarian singer Pandit Nimai Mitra, his kīrtan group, and I disembarked. We climbed five stories to the rooftop of the building, which was enclosed on all sides by tent walls; a small stage flanked by a large sound system sat in one corner. The persistent background noise of car horns offered a constant reminder that this home was in the busy Hatibagan neighborhood in north Kolkata, in a building that had hosted Nimai Mitra on this full-moon night for the past forty-five years. Gauḍīya Vaiṣṇava calendars mark this particular evening as the anniversary of Radha and Krishna's well-known circle dance, known as the Rās Līlā, and performances of this story regularly coincide with this day on the lunar calendar. However, the long-standing invitation to perform at this house in urban Kolkata underscores another history of padābalī kīrtan in the city. Beginning in the early twentieth century, prominent elite, English-educated Bengalis began to promote padābalī kīrtan as a cultural form that articulated a Bengali regional identity. Though this support was most intense in the first half of the twentieth century, a small number of families have maintained an interest in kīrtan in the intervening years.

On the rooftop, the musicians took the stage and accepted fresh flower garlands from members of the family organizing the event, and then the kīrtan began. Following a series of invocatory verses and songs, Nimai Mitra began a prescribed prefatory song that depicted the activities of Chaitanya. Performed in the large-meter style, the song's text was slowly voiced, one syllable at a time (audio example 1.1):

> *brindabaner līlā gorār manete parila*
> "Gaura [Chaitanya] remembered the līlā of Brindaban."

The central image in the song was Chaitanya's entrance into a trancelike state of contemplation. As the song progressed, the text described how his meditation was so intense that it caused him to forget his own identity as Chaitanya. Song texts such as this have inspired descriptions of Chaitanya as a "lavishly absorptive" mystic (Hawley 2015, 142). The slow tempo of the musical accompaniment added an additional dynamic to the song, a sonic aid to the meditative process described in the text. By using the word *remembered*, the song further articulated a point about Chaitanya's identity—namely, that he was Krishna appearing again on earth. As the song progressed, this point was confirmed through lyrics that described how Chaitanya had indeed forgotten his own identity, and, in a type of devotional fervor, began to adopt the role of Krishna. Further images of Chaitanya enacting the various aspects of Radha and Krishna's Rās Līlā circle dance unfolded in each of the song's verses. The performance continued to describe how Chaitanya, in his state of contemplation, saw a flower garden that suddenly led him to believe that he was in the past time-space of Krishna's Brindaban. Then, glancing at his male companions, he mistook them for the young women of Brindaban, friends of Krishna's beloved Radha.[1]

I begin by analyzing this short moment of Nimai Mitra's performance to illustrate the process of synchronization that lies at the heart of padābalī kīrtan's expansive musical aesthetic. The first part of this chapter offers an analysis of the way that musicians

such as Nimai Mitra shape musical time and form temporal imaginaries to express and reinforce values of devotional thought and practice, an idea presented through the concept of synchronies of musical sound. While the lyrics of the devotional song mentioned here focus on Chaitanya's meditative state, the musical style of padābalī kīrtan, with its slow tempos and large meters, directs the process of meditation as a way of acting on time. The way that song texts seek to synchronize Chaitanya's identity with the mythical Krishna involves the merging of temporal frames in performance. Another act of historical synchrony and alignment alluded to in the opening vignette derives from the genre's social history in Kolkata, where the relationship between regional politics and this musical genre was articulated when musical style became associated with a past imaginary of the Bengali nation.

The ample duration that defined the kīrtan performance described here is not the only temporal feature of the contemporary musical landscape in West Bengal. In contrast to Nimai Mitra's multi-hour performance, contemporary professional kīrtan musicians encounter shorter durations that do not easily allow for renditions of the large-meter style. In fact, occasions for unabbreviated kīrtan performances rarely take place in urban Kolkata, and ones that do often rely on older social networks, such as the performance mentioned above. Therefore, the second part of this chapter turns to an examination of the implications of modern social time (Bear 2014a) and the various methods that musicians use to act within the temporal limitations of performance in the present. The chapter now turns to an overview of the various repertoires of Gauḍīya Vaiṣṇava kīrtan in Bengal and relationships between devotional song and social background.

SITUATING PADĀBALĪ KĪRTAN: A REPERTOIRE AND ITS SOCIAL CONTEXT

The sphere of knowledge and practice that informs and surrounds kīrtan performance is known as Gauḍīya Vaiṣṇavism.[2] A collection

of devotional texts and practices that constitute Gauḍīya Vaiṣṇava praxis can be traced back through a lineage of devotees to Chaitanya and his followers in the Bengal region in the fifteenth century.[3] The various forms and practices of Gauḍīya Vaiṣṇavism are concentrated in the highly populous region of the Indo-Gangetic plain in South Asia known as Bengal (or greater Bengal), an area spread across the Indian state of West Bengal and the nation-state of Bangladesh. Gauḍīya Vaiṣṇava practice rests on the development of devotion (*bhakti*) toward the Hindu deities Radha and Krishna. One practice among many under the umbrella of bhakti is the act of devotional visualization, which emphasizes meditating on the images and activities of these two divine personalities. Theoretical writings on Gauḍīya Vaiṣṇava practice describe this process as *līlā-smaraṇa*, a "contemplative technique" where the devotee attempts to visualize or remember (*smaraṇa*) a divine play (*līlā*) of Radha and Krishna (Haberman 1988, 64). One way this technique is extended is when a devotee further imagines herself in that same līlā with Radha and Krishna, similar to how an actor might assume a role in a drama. A historical imprint of this meditative practice is found in the repeated use of the term *smaraṇa* in līlā kīrtan performances, where it is common for the singer to implore the audience to remember or visualize (*smaraṇa kari*) a particular moment in the divine play of Radha and Krishna that is unfolding through song and storytelling.[4] Though musical performance has been central to this aspect of devotional practice since its inception, it is relatively uncommon to see audience members engaged in rigorous acts of devotional visualization in the midst of a performance, suggesting that the links between musical sound and the practice of līlā-smaraṇa might represent a past fascination with the genre that has receded in recent decades.

The repertoire central to this meditative process is padābalī kīrtan, a performance mode where Gauḍīya Vaiṣṇava poems are set to music as a form of devotional sung poetry. The poem-songs

in this genre, referred to as *padas* (or *pad*, sing.), describe the images and emotions central to the mythical līlās of Radha and Krishna and the historical līlās of Chaitanya. The term *padābalī* refers to a series (*ābalī*) of verses (*padas*); and padābalī kīrtan thus denotes the performance mode when these verses are set to music. The most common term used to refer to the written repertoire of poem-songs is *Vaiṣṇava padābalī*. When this song repertoire is organized in performance to describe one specific līlā, and songs are interspersed with theatric storytelling, the form is called *līlā kīrtan* or *pālā kīrtan*. There are three terms used to discuss this shared repertoire throughout this book: 1) padābalī kīrtan refers to a musical performance that features the repertoire of Vaiṣṇava padābalī but does not necessarily group songs according to a single līlā; 2) a līlā kīrtan is a multi-hour performance of song and storytelling that arranges the repertoire of Vaiṣṇava padābalī to depict one specific līlā of Radha, Krishna, or Chaitanya; 3) the more general term kīrtan is a discursive category that includes both of these settings and further refers to other forms of devotional song, such as *nām kīrtan* (singing the names of deities). The large-meter musical style mentioned earlier is linked most closely with a specific repertoire of padābalī kīrtan songs that focus on the life and activities of Chaitanya. This repertoire, briefly described in this chapter's opening, is named *Gaura-candrikā*, a title based on the common epithet for Chaitanya found in numerous song texts: "Golden Moon" (*Gaura* = golden, *candra* = moon). The Gaura-candrikā repertoire has been central to a lineage of kīrtan musicians that have straddled the genre's geographic and ideological shifts of the past century and has also been instrumental in shaping ritual and social authority in the Bengal region (Dimock 1958; Sanyal 1985).

Outlining a genealogy of padābalī kīrtan musicians through history and ethnography warrants an overview of the social background of Gauḍīya Vaiṣṇava performance. An underlying claim in the research on Gauḍīya Vaiṣṇava social contexts has argued

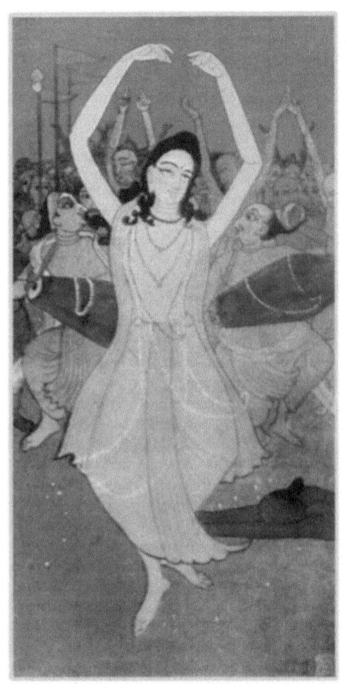

Figure 1.1 Painting of Chaitanya Mahāprabhu by Dipen Bose.

that the devotional ideology and lack of caste-based restrictions in devotional practice led to a lessening of the caste- and gender-based hierarchical structures in the Bengal region (O'Connell 1990; Wulff 1985 and 1997). The genesis of these social shifts is often located in sacred biographies that describe stories of Chaitanya's open opposition to caste- and gender-based religious prohibitions in the sixteenth century.[5] These stories are often featured in contemporary līlā kīrtan performances, where musicians emphasize connections between egalitarian social structures and devotional thought through recounting the stories of Chaitanya's clear opposition to caste-based restrictions as they related to devotional practice. Nevertheless, caste-based practices were incorporated into various Gauḍīya Vaiṣṇava social contexts to varying degrees (Chatterjee 1993, 182; Chakrabarty 1985), and contemporary ethnographies of Gauḍīya Vaiṣṇava communities reveal devotees spread across a range of social backgrounds, from low-caste practitioners to high-caste priests with hereditary rights to temple properties (Sarbadhikary 2015).

Musicians specializing in Gauḍīya Vaiṣṇava song genres similarly come from a diverse landscape of social backgrounds. The earliest historical records suggest that musicians from non-Brahman families bucked social norms by becoming gurus to high-caste Brahmans studying music and scripture (Sanyal 1989). When an emergent middle class of Bengalis adopted Gauḍīya Vaiṣṇava devotional practices in the nineteenth century, their interest in padābalī kīrtan led to its establishment in educational institutions in Kolkata. One result of this phenomenon is the dispersal of this genre across a wide variety of social locations and actors, and it is common to find kīrtan musicians who come from rural, hereditary lineages as well as middle-class and urban-educated backgrounds. In addition, there are a few cases of padābalī kīrtan pad-composers and performers coming from Muslim backgrounds.[6] The case of padābalī kīrtan, then, differs from cases in South Asia, where the designations of service or

professional castes can be linked with specific instruments or genres and their associated service or ritual professions.[7]

The kīrtan ensembles that enact the līlās of Radha, Krishna, and Chaitanya in the present trace their musical and storytelling repertoire through one of five lineages of padābalī kīrtan instruction. These lineages are variously referred to as *schools* or *styles* of performance in this book, and each school is often linked to a paradigmatic Gauḍīya Vaiṣṇava musician and the rural locale where it was established. The performance analysis in this book focuses on what is known as Manoharasāhī kīrtan, a style traced to the Manoharasāhī *pargaṇā* (subdistrict) in the district of Bardhaman, West Bengal. Another school of kīrtan linked with rural Bengal and discussed in the historical analysis is the style of Gaḍanhāṭī kīrtan, which originated in the village of Gader Hāt (present-day Bangladesh) with a musician considered the founder of the style, Narottama Dāsa (1534–1630?). More recently, kīrtan musicians have begun to refer to these schools of performance and their related stylistic features as *gharānās*, a term commonly used in the context of Hindustani music that denotes a similar linkage between region and stylistic lineage (see Neuman 1990 and Kippen 1988).

THE EXPANSIVE MUSICAL AESTHETIC

Throughout this book, padābalī kīrtan is described as a form of performance practice based on an expansive musical aesthetic. The idea that expansion was central to the genre's aesthetic aims was suggested during conversations with musicians who often used the Bangla term bistār (expansion) to describe features of performance. Further discussions and performance analysis revealed a range of techniques that underscore the central role of expansion in the genre's temporal, aesthetic, narrative, and affective work. There are four main characteristics that illustrate padābalī kīrtan's expansive musical aesthetic in this study. The

first is demonstrated in features of temporal expansion that are found in the large-meter musical style (i.e., boṛo-tāl kīrtan) used to accompany the genre's repertoire of devotional poetry. The central characteristic of this musical style is the combination of slow tempos and large tāls—metric cycles composed of a relatively large number of theoretical time units (*mātrās*)—in performance. Tāls composed of twelve or more mātrās constitute the parameters for this colloquial distinction of boṛo-tāl kīrtan and are thought to mark a conceptual space that is somewhat separate from songs accompanied by the "small-meter" (*choṭo-tāl*) style. A second feature of the expansive aesthetic is the body of interstitial and quasi-improvised lyrical lines that musicians add in performance. These lyrics, which I term interstitial lines, not only lengthen a song's duration but further expand on the semantic and affective material during a performance. A third form of expansion is found in the storytelling, didactic speech, and theatric role-playing that are incorporated during a multi-hour līlā kīrtan performance. Musicians feature these modes of performance to interpret and elaborate on song themes, often spinning out expansive stories that depart from a song by exploring other historical and mythical themes for the audience. A fourth and final case of the expansive musical aesthetic does not focus on a performative technique but studies how padābalī kīrtan's song repertoire expands upon a framework of aesthetic theology formulated in Gauḍīya Vaiṣṇava communities in the sixteenth century. Most songs in the genre's archive of more than four thousand compositions can be linked to one of eight categories of the amorous or erotic mood found in the writings of Gauḍīya Vaiṣṇava aesthetics.[8] Together, these techniques comprise a combined form of temporal, performative, linguistic, and thematic expansion that can transform a handful of songs into a multi-hour, long-form performance that combines song, storytelling, and other theatric modes.

Scholars of music in South Asia would surely recognize one or more of these expansive characteristics across of a variety of

performance contexts in the subcontinent and beyond. The San-skrit and Hindi term *vistār* (expansion) is commonly used to describe and discuss performance in various contexts of Hin-dustani music (Slawek 1987; Clayton 2000; Ruckert 2004; Mc-Neil 2017). Moreover, recent scholarship in Hindustani music has considered how the concept of expansion—and the related idea of *baḍhat* (progression)—lies at the center of improvisa-tory techniques, a process that involves moving from "fixed" to "unfixed" features of performance (McNeil 2017). The process of commencing a performance with a song or composition in a slow tempo is found across several Hindustani genres such as Dhrupad (Sanyal and Widdess 2004; Wade 1984, 30) and baṛa-khayal (Ruckert 2004), although these styles may or may not utilize large meters, as in the case of padābalī kīrtan. Similarly, the practice of interjecting additional lines of text—from forms of praise verse or vernacular lyrics—is found in several musical styles from Qawwalī (Qureshi 1986) to Marathi kīrtan (Novetzke 2015). Interjecting storytelling or didactic speeches in between songs is further found across many genres in South Asia such as Nautanki (Hansen 1992) and Marathi kīrtan (Schultz 2013), in the Bengali genres of *kabigāna* (Basu 2017) and *katha-kathā* (Bhadra 1994), and in Southeast Asia as well (Becker 1980). Also, the links between Sanskrit aesthetic theory and performance in South Asia are manifold and can be found in many performance styles spread across various social spheres in the subcontinent.[9]

The connections between the expansive musical aesthetic of padābalī kīrtan and these other spheres of performance may in-deed underscore numerous similarities that have contributed to the genre's history and present practice. And several of these links are explored in this book. Nevertheless, the concentration of these practice-based and theoretical features in padābalī kīrtan illustrates a distinct constellation of performance techniques that rely on features of temporal, semantic, and aesthetic practices. To take the ideas of expansion seriously in the case of kīrtan

performance and discourse points to a fundamental connec-
tion between aspects of Gauḍīya Vaiṣṇava thought and padābalī
kīrtan's musical aesthetics.

ACTING ON TIME I: THREE FRAMES OF SACRED TIME

> Those who are present here are no longer residents of Kolkata.
> Please pay attention to this. . . . Those of you who are here, you are
> residents of Brindaban. Why should you remain silently seated?
> Today, the Rās Līlā of Krishna will be performed. Let all of you
> sound "ulu" loudly!
>
> (Nimai Mitra, Kolkata, November 26, 2012)

Through features of musical time, kīrtan performances draw par-
allels between sacred identities and devotional moods by syn-
chronizing three different temporal frames: the mythical time
of Krishna, the medieval epoch of Chaitanya, and the present.
The borders between these three temporal spheres are porous in
Gauḍīya Vaiṣṇava thought and practice. For example, the songs
and storytelling of kīrtan musicians create connections between
these various time frames through asserting that Chaitanya and
Krishna have a shared identity. The Gaura-candrikā repertoire,
as mentioned, describes how Chaitanya performed līlās that were
identical to those of Krishna. Making temporal connections
through song is also closely tied to evocations of sacred place, as
songs, and the various līlās they describe, suggest how partici-
pating in kīrtan through listening and meditation can transport
one through time and space. This section's opening quote attests
to this fact, as the singer Nimai Mitra suggests how a līlā kīrtan
performance can deliver residents of Kolkata over a thousand
kilometers away, and back in time, to Krishna's boyhood home
of Brindaban—a claim that is not simply figurative but rooted in
conceptions of sacred space in Gauḍīya Vaiṣṇava thought (Sar-
badhikary 2015). That Krishna and Chaitanya are two versions

of the same sacred identity, appearing in different time periods, represents a core tenet of the devotional temporality that shapes Gauḍīya Vaiṣṇava knowledge and practice (Stewart 2010, Sarbadhikary 2015). And making links between these two time frames through aspects of musical style and form represents a key aspect of padābalī kīrtan performance.

The temporal wellspring and primary time-space depicted in a kīrtan performance is the divine play of Krishna. Devotees believe he came to earth in the present-day north Indian city of Brindaban in the ancient past, a period that functions as a form of "paradigmatic time" through its influence on the present (Hawley 2015, 194). Gauḍīya Vaiṣṇava sacred texts draw from a larger body of Puranic literature to describe how he descended with his friends, lovers, and parents and other members of his sacred entourage to perform his līlā (Bryant 2007), a term signaling a ludic and unencumbered sphere of action.[10] Aside from Krishna, the central character in these līlās is his paramour, the young Radha (fig. 1.2). The majority of līlā kīrtan performances focus on the amorous trysts of these two divine characters that appear as a form of "microtime"—a temporally condensed version of what takes place in his non-earthly abode or *dhāma* (Dimock 1968, 10). Listening to the songs and stories of Radha and Krishna told by kīrtan musicians is thought to bestow religious merit and, most importantly, evoke an emotional experience of devotion through visualizing their sacred play.

The second temporal frame of kīrtan is the divine play of the fifteenth-century mystic Chaitanya. In 1486 CE, Chaitanya was born into a Brahman family in Nabadwip (present-day West Bengal). Though the location of his birth in Bengal might appear random, there is a significant theology of place that defines Nabadwip as another version of the same dhāma, or holy abode, as Brindaban where Krishna was born.[11] Though trained as a Sanskrit scholar, he underwent a devotional transformation as a young man and began to participate in emotionally

Figure 1.2 Krishna and Radha. Painting in opaque watercolor and tin alloy on paper, ca. 1830, Kolkata. Used with permission by the Victoria & Albert Museum.

Figure 1.3 Followers of Chaitanya in a procession with flags and drums, dancing and singing. Transfer lithograph with watercolor.

charged kīrtan performances described in the sacred biographies that document this period.[12] These secluded events gradually led to public kīrtan performances in the streets of the village (fig. 1.3). Early performances took the form of what is known as nām kīrtan, a participatory musical event where devotees repeat the names of Radha and Krishna in a responsorial fashion. Chaitanya was joined in these public kīrtans by various associates from the Nabadwip area, and chief among these was Nityānanda, who is often referred to as an incarnation of Krishna's brother, Balarāma, from the Puranic literature.[13] The hagiographies of this period further tell us of caste Brahmans in Nabadwip who were especially hostile to Chaitanya's egalitarian, street-based musical practice, as this group was "afraid of its strength, for the emotionalism of it all seemed to them antagonistic to orthodox brahmanical Hinduism" (Dimock and Stewart 1999, 14.). At the age of twenty-four, Chaitanya joined a monastic order (sannyāsa) and relocated to the coastal city of Puri in present-day Odisha.

There, a key facet of his devotional practice consisted of listening to the amorous līlās of Radha and Krishna, as told in the songs of three earlier composers of Vaiṣṇava padābali: Jayadeva (twelfth century), Vidyāpati (fourteenth and fifteenth centuries), and Boṛo Caṇḍidāsa (fifteenth century).[14] Chaitanya's practice of meditating on the līlās of Radha and Krishna found in song established this as a central practice in Gauḍīya Vaiṣṇava communities, as reflected in the hagiographical literature. The songs of these three early authors further served as a blueprint for later composers to add to the repertoire of padābali kīrtan. The collective group of song composers in the padābali kīrtan sphere became known as the *mahājana padakartās*, or "great composers of verse," who wrote the majority of this repertoire between the fifteenth and eighteenth centuries in the Bengal region.[15]

The third temporal frame for līlā kīrtan performance is the present. Mythological and historical time merge in the frame of musical time and evoke new affective meanings when a kīrtan musician takes the stage. In performance, kīrtan musicians not only seek to enact episodes of divine play through song and storytelling; they further reinforce parallels between Krishna and Chaitanya through song texts and temporal features of musical sound. As these episodes unfold, the rhetorical power of Chaitanya's life and teachings is amplified as musicians attest that he is an incarnation (*abatāra*) of Krishna; or, in a more complex theological perspective, he is often described as the embodiment of a combined form of Krishna and his intimate lover, Radha.[16] Chaitanya's golden-hued body points to this link, as Radha is also thought to have a golden complexion, which Chaitanya adopts because of his absorption of her devotional mood. To tell these līlās, kīrtan musicians interweave song, spoken dialogue, dance, and instrumental music into a performance that lasts between three and four hours. Because of the mixed modes of presentation, a kīrtan performance might be seen as interlinked with the performance sphere of theater and the textual domain of drama. Though song and instrumental music dominate a full-length

performance, musicians make forays into a theatric mode, adopting the role of Krishna, Radha, or another character in the story. Contemporary performances that retell Krishna and Chaitanya's līlās underscore two meanings found in the act of translating līlā as "play": each performance is a theatric *play* staged to remember a divine act of *play* (Sax 1995).

Kīrtan's relationship with theater in South Asia is not only evident through a shared form of presentation but is also found in the common aim of evoking a series of standardized emotional "moods" (*rasas*) in performance (see chap. 5). The repertoire of padābalī kīrtan songs was composed according to the aesthetic framework found in an earlier tradition of Sanskrit theater and poetics (Wulff 1996). This structure became central to Gauḍīya Vaiṣṇava devotional thought through its influence on the composition of dramas (Wulff 1984) and practices of devotional meditation (Haberman 1988). The link between theater, the embodied expression of rasa, and padābalī kīrtan further emphasizes the centrality of the body in the performance of bhakti in South Asia, when the body links various time-spaces through song and storytelling. As Barbara Holdrege argues, the body in devotional practice in South Asia is not a "problem to be overcome . . . on the contrary, [it] is ascribed a pivotal role on multiple levels— divine and human . . . material and nonmaterial—as the very key to realization" (2015, 15). The centrality of the body to devotional religion in South Asia in general (Novetzke 2008a; Pechilis 1999; Schultz 2013) and in Bengal in particular (Sarbadhikary 2015) underscores the key role of singing and storytelling bodies in present-day performance.

ACTING ON TIME II: NATIONAL TEMPORALITIES AND REGIONAL POLITICS

In a wide-ranging social history of kīrtan in Bengal, the historian Hitesh Sanyal noted the links between Chaitanya, the Bengali nation, and kīrtan. "Chaitanya," he wrote, "represented the light of new life in the history of the Bengalis. . . . In many ways, Chai-

tanya tried to unite the divided Bengalis on the ground of toler-
ance and assimilation and restore the vision of Bengalis toward
a national culture. . . . Kīrtan is a permanent facet of Bengali
society" (1989, 10–15). Though the three frames of sacred time
described above remain integral to the sphere of musical time in
the present, this quote illustrates how kīrtan, and the devotional
practices associated with Chaitanya, became a lodestar for an
emergent Bengali national sentiment in the late nineteenth cen-
tury. In this discourse, kīrtan was defined as part of a uniquely
Bengali set of cultural practices that articulated various con-
nections with regional political projects. The particular form
of cultural nationalism in this discourse was not focused on a
pan-Indian sense of national identity; rather, it actualized a form
of *regional* nationalism, or, more specifically, Bengali regional
nationalism—what Roma Chatterji has referred to as a form of
"nonstatist cultural nationalism" (2016, 388). In her study of folk-
lore in Bengal, Chatterji notes how the geopolitical boundaries
of the nation-state do not always neatly overlap with the flows of
folklore performance and transmission: "the discourse of folk-
lore comes to constitute a cultural region . . . formed by cultural
flows and modes of transmission shaped by oral, print, and visual
media" (2016, 379). Though Bengal was surely a location where
forms of pan-Indian nationalism and its related anticolonial sen-
timent percolated in the early 1900s, there were simultaneous
efforts to define a Bengali nation, one that might have overlapped
with a pan-Indian national identity yet also retained its ontol-
ogy through an aggregation of regionally significant features
such as language, literary culture (Kaviraj 2003), folklore (Chat-
terji 2009), and a sense of shared history. When the nation was
invoked in attempts to link padābalī kīrtan with an imagined
community, scholars and politicians worked to link expressive
culture with a form of regional cultural nationalism, similar to
what David Dennen describes in his study of Oḍiśi music as a
form of regional identity in South Asia (2010).

 The act of blurring boundaries between devotional expressive
culture and national sentiment is well documented in South Asia

as numerous scholars have considered how devotional images be-
come redefined in the arena of politics (Novetzke 2008b, Schultz
2013). The role of devotional thought and practice in Bengal's
regional politics is also a testament to how ideologies of identity
traffic in an ambiguity that can conflate nationalist and religious
meanings (Stokes 1992). The imbrication of Bengali kīrtan with
nationalism and modernity did not erase the genre's relationship
with the theoretical and praxis-based sphere of devotional tem-
poralities; rather, it revealed another perspective on how kīrtan's
influence derives from time. For the Bengali nationalist elite in
the early twentieth century, kīrtan's power—and the potency of
its expansive musical style—was located in a past that was unsul-
lied by the orbit of urban modernity and colonial influence. If
one facet of forging a national identity involves connecting with
a mythic past (Chatterjee 1993), part of the nationalist project in
Bengal aimed to anchor this past in the expansive musical aes-
thetic as performed by rural kīrtan musicians from outside the
colonial center of Kolkata. This form of a nationalist temporality
thus took shape around a belief that kīrtan, and its musical style,
expressed a number of social values that were considered inher-
ent markers of Bengali identity.

Forging links between kīrtan and Bengali cultural nationalism
involved a series of collaborations between a cadre of cosmo-
politan, reform-minded nationalist elites and non-cosmopolitan
musicians from rural areas of Bengal in the early decades of the
twentieth century.[17] The nationalist elite actors were the Bengali
bhadralok ("gentle folk"), a designation that did not mark an ex-
clusive demographic but referred to Bengalis distinguished by
levels of education, salary, and professional training (Bhattacha-
rya 2005). Through forms of education, employment, and service
to the British Raj, the bhadralok were key actors in the colonial
encounter, often defined by their position as cultural medi-
ators between the Raj and the Bengali population (Chatterjee
1993). The surge in bhadralok interest in kīrtan and Chaitanya's

devotional religion in the late nineteenth century hinged on a project of cultural recovery, which was dedicated to locating and preserving forms of Gauḍīya Vaiṣṇava knowledge, literature, practices, and material culture (Bhatia 2017). The twin motivations of "anxiety" and "inspiration" defined this project of recovery (1), and the anxiety of the bhadralok involved in this project was linked to the sense that forgetting Chaitanya, and the complex of devotional practices he introduced, was tantamount to a form of a Bengali nationalist self-forgetting. The inspirational work of this period further sought to preserve, disseminate, and, in some cases, re-create forms of devotional practice that were close to disappearing. If the temporalities of the devotional sphere discussed above often focused on mythic time, the work of the Gauḍīya Vaiṣṇava recovery emphasized *historical* time, as bhadralok actors searched for manuscripts and other facets of material culture that would serve to mark the past of the nation. This search to link the past of Chaitanya's life within the confines of historical time illustrates a "politics of time," as Prathama Banerjee argues, which can be seen as a "politics through which colonial modern societies seek to make a time of their own"— a past that is not fully derivative of their colonial subjugators (2006, 1). In this politics of time, devotional music represented a sonic connection to an imagined past that might bolster a shared regional identity.

The forms of cultural nationalism that emerged in the bhadralok recovery were animated by a variety of social values. Indeed, these forms percolated in an ideational space where "the new interpretive frames . . . of the colonial encounter worked alongside and in tandem with older concerns" (Bhatia 2017, 7). As Bhatia notes, one theme in this project focused on emphasizing the importance of features of devotional thought and practice through forms of positivist research such as manuscript preservation; however, another trajectory for this work was based on redefining aspects of Gauḍīya Vaiṣṇava history through a

"secular-humanist" lens, with a clear emphasis on linking features of thought and practice with post-Enlightenment values (3). This type of creative reassembling of the past was not exclusive to forms of cultural nationalism in Bengal, of course. In her study of cultural nationalism and devotional performance in western India (specifically *rāṣṭrīya kīrtan*), Anna Schultz studies how the Marathi nationalist elite would occupy both neo-traditionalist and reformist stances in their projects (2013). Drawing on the work of Anthony Smith (1994), Schultz defines the neo-traditionalists as national leaders "who have encountered modernist ideas and rejected them in favor of traditional belief systems" while reformists are those who "turn 'home' in attempts to locate the 'eternal' truths of their indigenous religions and customs while ridding them of extraneous superstitions that do not mesh with ideas of progress and individual self-determination" (Schultz 2013, 10). Though not absolute categories, these two ways of thinking about cultural nationalism shed light on how forms of religious practice such as padābali kīrtan were defined in the context of Bengali nationalism.

The reformist and neo-traditional stances animated two ways that padābali kīrtan related to projects of regional politics. In the first case, kīrtan became associated with a reformist and secular-leaning revival of a Gaudīya Vaiṣṇava practice that focused on connecting a range of social values to Bengali regional identity. The quote that leads this section is emblematic of this trend, as it cites how qualities such as tolerance and assimilation were linked to Chaitanya and, derivatively, an inherent sense of Bengali national identity. Another secular cause that was linked with padābali kīrtan in the bhadralok recovery was the focus on education, as kīrtan songs were seen as educating the Bengali masses in esoteric features of Sanskrit aesthetic theory. The reformist impulse was further aimed at distancing the genre from its links with the morally questionable sphere of female courtesan performance in the early twentieth century, when certain

bhadralok actors sought to promote a lineage of male performers from rural Bengal.

A second neo-traditionalist strain in the work of the Bengali bhadralok in the early twentieth century stressed the genre's links with Sanskrit aesthetics and features of the large-meter musical style. Such aspects of devotional thought and practice stood in contradistinction to the colonial other and were studied and valorized by the bhadralok through their connections to a non-cosmopolitan male lineage of rural performers. These rural musicians came to represent a golden age of the genre, and, con-comitantly, a nation's past through their connections with a body of oral knowledge from rural locations of Bengal. The politics of determining the nation's past in the neo-traditional fold further included attitudes toward the role of gender in public perform-ance. The musical style of male kīrtan musicians was defined as representing the nation's past, which further marginalized female kīrtan singers in Kolkata during the first decades of the twentieth century. The rural male musicians' musical and religious know-ledge was abstracted in bhadralok writings to create an image of a ritually knowledgeable and skilled musician, referred to as the *sādhaka* ("one who performs *sādhana*") kīrtanīyā.[18]

SONIC SYNCHRONIES: THEORIES OF
MUSICAL TIME RECONSIDERED

The frames of devotional and national time are variously acti-vated in kīrtan performance and discourse. Presenting them as ways of acting *on* time stresses the dynamic role that sounded aesthetic forms play in the construction of ritual and temporal imaginaries (Jankowsky 2010; Kapferer 2004). In this book, the claim that these devotional and national temporal frames are linked with the time-related features of musical style is expressed through the concept of synchronies of musical sound. If this idea is meant to focus on the actions of musicians, it further attempts

to avoid some of the inherent risks that are found in drawing connections between musical time and aspects of social time. One example of this is the reductive tendency to suggest that time-related features of music emanate from deeply held cultural tropes,[19] a frame of reference that downplays the agency of musicians in the creation of musical time. The enigmatic nature of the relationships between social temporalities and musical time, and the manner in which this topic has occupied ethnographers and music theorists, warrants situating the present study within the landscape of research that has studied musical time's relationship with the social sphere.

The primary orientation in ethnomusicological scholarship on musical time has considered the temporalities of musical sound from an analytic perspective. Comparative analyses of disparate musical genres and styles have considered musical time—often framed as periodicities—from a cross-cultural perspective (Tenzer 2006; Clayton 2000) and proposed ambitious global typologies of temporal structures that can account for a wide-ranging array of music (Tenzer 2011). This work has often reflexively acknowledged its lack of attention to historical and cultural context (e.g., Tenzer 2006, 5); nevertheless, it offers detailed readings of musical time to "serve ethnomusicology's consideration of music in culture, by enabling the description and comparison of sound patterns, and of the cognitive schemas that shape how they are heard" (Roeder 2011, 3).

A related research focus is located at a crossroads between detailed music analysis and studies of culturally specific time practices. Questions in this strand of research seek to answer how culturally specific temporal knowledge influences the structures of musical time (Waterman 1993, 245). The orientation of this work has generally been unidirectional, as musical time has been though about as a domain influenced by social temporalities, while the opposite direction of study has been less researched. One thread in this discourse has been studies that connect

diverse senses of temporality in various social settings with music and other forms of cultural practice. This work has been influenced by early work in the anthropology of time and the search for the ways that different cultures experience disparate senses of time, strains of which are found in the work of Durkheim (1915), Geertz (1973) and others.[20] Combining detailed ethnography with studies of musical time has not typically been prominent in this approach to music research. Rather, work in this vein has drawn connections between culturally derived forms of temporality (often based on previous historical or anthropological research) and features of musical time (e.g., Kramer 1988; Rowell 1992).[21] Martin Clayton usefully defines scholarship in this vein as the "cultural symbolism" perspective (2000, 17), a theoretical approach focusing on the ways that musical time is analyzed to find symbolic similarities with social time.

Claims about music's relationship with temporal knowledge and practice in this approach present interesting if generalized conclusions. In the case of South Asia, for example, there has been a frequent assumption that the cyclic and recurrent nature of tāl is emblematic of aspects of temporality found in Hindu cosmology. For example, the cyclic nature of cosmological time, represented in the revolving set of four "ages" (*kalpas*), is considered a core aspect of temporal knowledge that further derives from aspects of Hindu ritual practice. Similarly, Balinese and Javanese *gamelan* performances have been viewed as representing aspects of Southeast Asian temporal knowledge and practice. While Judith Becker emphasizes how a shared iconicity of temporal coincidence defines a relationship between Javanese time reckoning and gamelan (1979), Jonathan Kramer has considered Balinese gamelan's musical time as reflective of "non-linear cultural attitudes and styles" (1988, 24). Recent work from ethnomusicologists has questioned such unidirectional and generalized conclusions in both South Asian meter (Clayton 2000) and gamelan cyclicity (McGraw 2008).

If previous research on musical time might be characterized as emphasizing a type of one-way analysis, which suggests musical time derives from cultural time and promotes a version of the cultural symbolism argument, then more recent work has challenged this in at least two significant ways. Though perhaps arriving in music scholarship only in a derivative way, Gell's influential discussion of A-series (human) and B-series (objective) time has at least begun to complicate the idea that disparate cultures function according to a monolithic sense of time (1992).[22] Through extending an earlier argument (see McTaggart 1908), Gell engages a philosophy of time in an anthropological frame to illustrate the manifold ways that temporality is experienced irrespective of a cultural origin, providing a counter to early Durkheimian arguments for temporal diversity. Another approach from anthropologist Nancy Munn also stresses the multidimensional nature of human temporality as "a symbolic process continually being produced in everyday practices. People are 'in' a sociocultural time of multiple dimensions (sequencing, timing, past-present-future relations, etc.) that they are forming in their 'projects.' In any given instance, particular temporal dimensions may be foci of attention or only tacitly known. Either way, these dimensions are lived or apprehended concretely via the various meaningful connectivities among persons, objects, and space continually being made in and through the everyday world" (1992, 116).

A second corrective to one-way analysis and situated firmly in music scholarship is Georgina Born's recent theorization of a "bidirectional mediation of music and time," suggesting that "music produces time through the contingent articulation of its several temporalities, while in turn the variant temporalities immanent in social, cultural, political and technological change mediate the evolution of music and musical genres" (2015, 371). In addition to pluralizing temporality, which was also found in the earlier examples, Born takes seriously the musical-aesthetic-cultural object or event in a way that was not the focus of earlier

studies of temporality. This focus leads Born to highlight the way that aesthetic and cultural objects can be traced through "material, social, and discursive genealogies" that invoke and evoke features of the past and future as they exist in the present (373). Her suggestion that music articulates several temporal vectors brings the scale of this analysis beyond previous work on musical time, which has insistently focused on the "time-form of the singular musical object or event" (372). Drawing on these ideas, I present three frames of musical time that I focus on throughout this book.

A first perspective, what we might call musical time 1, focuses on what Born refers to as "intra-musical temporality" that includes "the qualities of temporal unfolding of musical sound as it enlivens musico-social experience" (Born 2015, 372). The focus in this level is on the temporal features in the immanent domain of musical sound, including rhythm, meter, tempo, duration/time span, and sequence in formal structures. A second view—musical time 2—emerges from the phenomenological language of Husserl and refers to temporality in music—what Born refers to as the "dynamics of retention and protention proffered by the musical object" (372).[23] This feature of musical time refers to how the listener can experience an expired moment of musical time again as a form of retention after the temporal duration of a sounding moment has expired, thus creating a new instance of retention (Husserl 2019, 50). This process of "retention points to the making and remaking of genealogies by each object or event," and a focus on pretension "anticipates new openings—potential musical futures" (Born 2015, 372). Another feature of retention I pursue steers away from the domain of phenomenology, as I consider how musical sound can also produce links with a past that has not been experienced but might exist only as a religious ideal, thus activating a type of historical consciousness. This is similar to what Patrick Eisenlohr refers to as the "ancestral chronotopes" that are evoked when present-day Mauritian Hindus

use Hindi, their ancestral language, in ritual contexts that reference alternate temporalities, or the "world of the ancestors" (2015, 285). Musical time 2, then, refers to the ways that the language and features of musical style make connections with real and imagined temporalities, which, in the case of padābalī kīrtan, are devotional chronotopes rooted in the mythical time-space of Radha and Krishna's Braj and the historical Bengal of Chaitanya. A third temporality—musical time 3—refers to the ways that music participates in larger temporal ontologies, usually discursive, that are used to organize large swathes of music history. Citing the work of Peter Osborne, Born notes how "particular ways of 'temporalizing history' enter into creative and critical practices . . . supervising the creation of musical objects and the constitution of genres" (374). If the temporal periods covered in music history survey classes might be one example of this, the historical analysis in this book studies how reformers of kīrtan in the early twentieth century became focused on a "golden age" of padābalī kīrtan in the colonial era as an imaginary that came to stand as a temporal lodestar for redefining features of the genre in the present.[24] These three frames of analyzing musical time are not only insightful in their own right; rather, as Born notes, we might "examine their interrelations, including the potential for either parallels and synergies or disjunctures between them" (375). Indeed, the interrelationships between these different forms of musical time occupy my sustained attention throughout this book.

These considerations provide a starting point for the conceptual frame I term *synchronies of musical sound*. The concept of synchrony is meant to draw attention to moments of concurrence that exist between the features of intra-musical time (musical time 1) and other forms of social temporality (musical times 2 and 3). Though synchrony seems to privilege acts of concurrence, there are numerous cases of asynchronization in the discussions that follow. Nevertheless, making synchrony a focus underscores the ways that matching musical time and ritual temporalities

occupies a place of privilege in padābalī kīrtan performance and discourse. A focus on synchronization is meant to exceed a purely definitional or discursive mode, as it is often a representation *of* temporality made *within* the frame of musical time. Much of the discussion about tāl or other aspects of musical form in this book seeks to avoid the suggestion that these sonic features are somehow cordoned from a different sphere that might be called "ritual." The analysis intended here is close to Steven Friedson's suggestion that focusing on either ritual *or* ethnomusicological analysis alone misses the bigger picture, as he argues for a form of "ontomusicology that engages music *as* ritual and ritual *as* music" (2009, 12).[25] Aside from the phenomenological view, however, these synchronies of musical sound often rely on discourse to anchor their rhetorical power, as in the case of kīrtan's links with Bengali nationalism. Studying synchronizations between musical time and devotional and nationalist temporalities not only frames musical time as reflective of time-related thought and practices but also focuses attention on the active role that performers play in cultural production through aesthetic formations. Three examples of synchronies of sequence and duration illustrate this point.

One instance of sonic synchrony in padābalī kīrtan involves parallels of *sequence* that exist between musical sound and features of devotional theology. This approach to studying the links between musical form and temporality focuses on a "temporal order" that prescribes the sequence of genres or songs while further implicating features of musical form in a normative schema (see Widdess 2013). In the case of kīrtan, the compulsory Gaura-candrikā song about Chaitanya represents the process of synchronization through its specific temporal location. As it precedes the divine plays of Radha and Krishna in the context of a performance, it is a sonic embodiment of a theological assertion made through temporal sequence: to approach the amorous līlās of Radha and Krishna, the devotee must first pay homage to

Chaitanya through song. The process of synchronization found in the temporal location of this song is more complex than simply offering a prefatory function, though. It further works to conflate the three temporal frames of mythical, early modern, and present-day time discussed previously in this chapter. The textual material of this song repertoire further works to synchronize the identities of Krishna and Chaitanya when it offers a representation of Chaitanya performing the same activities as Krishna. In sum, the temporal sequences found in the organization of the song repertoire underscore the links between intra-musical time and a past chronotope that collapses mythical time with the present.

A second example involves a synchronic relationship of *duration* shared between the intra-musical domain of musical sound and processes of devotional meditation. As mentioned, a key facet of the Gauḍīya Vaiṣṇava devotional practice involves the process of meditating on the līlās of Radha and Krishna, which requires a prolonged amount of time (Sarbadhikary 2015; Stewart 2005). The large-meter musical style, through its use of slow tempos and large meters, provides a form of musical temporality that supports and directs processes of mediation, a connection that has been made by kīrtan scholars and contemporary musicians.[26] What I refer to as kīrtan's expansive musical aesthetic thus represents a relationship of synchrony between a long-duration process of mediation and a similarly lengthy time span expressed in musical style. Of course, moments when similar time spans found between intra-musical time and other ritual temporalities cannot be matched highlights processes of asynchronization that are influenced in moments of temporal compression.

A third example that underscores the features of musical time 3 mentioned above is found in the ways that musical time plays a role in the larger schemes of historiography. In the case of the national temporalities in colonial Bengal discussed previously, defining the parameters of intra-musical temporality was also a

way of establishing the time of the nation, to underline the links between musical times 1 and 3. In this case, there is a connection between padābalī kīrtan's large-meter style and the work of historical periodization. In the early twentieth century, the large-meter style became symbolic of a national past that was used to define forms of regional politics. The politics of time in these definitions further involved ideas about gender, which became synchronized with features of musical time when professional female kīrtan singers were distanced from the construction of kīrtan's national history in the early twentieth century.

Considering instances of sonic synchronies in this book offers a way to think about how musicians act *on* time. However, the exclusive focus on seeing musical time as active in the work of cultural production is only one side of the story. Many of the perspectives above have productively drawn from phenomenology to highlight new ways to think about music's temporalities; however, one topic not significantly addressed in this work involves question of time's materiality and the links between musical time and labor. How do issues of temporal conflict shape opportunities for musical performance in the present-day context of West Bengal? And what are the related issues that go hand in hand with decisions about adapting features of intra-musical time?

ACTING WITHIN TIME: MODERN SOCIAL TIME AND CULTURAL ECONOMIES

The ethnographic perspective presents a means of contextualizing the various temporal and social factors that influence the time-spaces of performance in the present. A central concern here is a study of how musicians work within the frame of "modern social time" (Bear 2014a), an analytical orientation that takes an ethnographic and materialist focus to consider the "circulating representations, social disciplines, and technologies of time" that constitute the time-spaces of social life (7). A defining

characteristic of this work studies the temporal conflicts that inevitably arise when the effects of disparate methods of temporal thought or practice converge. These divergent temporal influences include the global time practices of capitalism and their abstract processes of time-reckoning, features of social time organization, and the various forms of bureaucratic and institutional time practice that affect everyday life (7). Another layer of temporal influence includes assertions of "deep historical and cultural time" that are part of political projects that seek to unite communities and nations, like features of past chronotopes mentioned previously (7). The attention focused on these and other temporal influences, Laura Bear argues, constructs "modern time [as] characterized by unprecedented doubt about, and conflict in, representations of time" (6). Studying the convergences and disjunctures that arise when different temporalities overlap is thus at the center of ethnographic work on modern social time.

Though the analytic frame of modern social time is indebted to Gell's perspective (1992), a crucial addition is the consideration of how the abstract temporal practices of capitalism and economic liberalization impact present-day time-spaces. For example, Bear's work studying the conflicts in time practice found in ship navigators on the Hooghly River in Bengal not only illustrates temporal contestations; it also studies the work that social agents do to resolve temporal conflict as they navigate the various temporalities involved in circuits of capitalism, local austerity measures, and tide patterns (2014b; 2015). The pressure on ship pilots to navigate unsafe tide depths is spurred on by the demands of international shipping and the austerity measures of the local port administration, which aim to have goods brought to harbor as soon as possible to increase the "speedy circulation of capital" (Bear 2014b, 78). The work of pilots thus seeks to bring the asynchronous flows of social and nonhuman time patterns into harmony, such as the circulation of capital (social) and the rhythms of tide flows (nonhuman). This work demonstrates how

contemporary time-spaces "thicken . . . with ethical problems, impossible dilemmas, and difficult orchestrations" (Bear 2014a, 6).

How does the perspective of modern social time apply to a study of contemporary musical performance and the work of acting within time? Like the case studies explored in the anthropology of modern social time, the time-spaces that constitute professional opportunities for kīrtan musicians feature the convergence of several incongruous social rhythms and periodicities. In the case of promotional music festivals, for example, musicians encounter and navigate a variety of temporal influences. These include the periodicities of the lunar calendar that determine the dates of the event and the shortened durations offered to performers with the growing number of professional musicians. Added to this complex mix, of course, are the ethical imperatives of synchronization that determine how features of musical form and style are linked with devotional affect and political belonging in Bengal.

This final point might add a wrinkle to how a consideration of modern social time might be applied to music research. As cultural and aesthetic forms with predetermined temporal features, songs and pieces of musical repertoire represent another level of potential conflict in the time-spaces of the present. Indeed, the ethical domain of musical performance in South Asia includes numerous strictures relating to the maintenance of aspects of musical form and style (e.g., Neuman 1990, 227). When kīrtan musicians perform songs in the long-duration style today, the historically situated values found in their sonic synchronies cannot be easily disentangled from musical sound itself. Decisions about transforming musical style thus spark debates that pit economic and social values against one another. As one prominent historian of kīrtan has written, "Recently, some professional singers have tried to shorten and simplify . . . kīrtan songs as much as possible. The result of this is that kīrtan music has been significantly damaged" (Sanyal 1989, 222–23). This is not an isolated

assessment of the current state of kīrtan performance but alludes to a recurrent perspective heard in present-day discourse.

One way to approach the disconnect between the imperatives of musical style and the various layers of time practice is through the lens of *temporal abstraction*. Acting within time, I contend, underscores how musicians adapt aspects of musical form and style to contexts that are shaped by representations, social practices, and material forms that challenge the fulfillment of the genre's sonic synchronies. In short, performance contexts for professional musicians are increasingly affected by influences that are *abstract* in the sense that they present situations divorced from the genre's earlier social history. If, for example, the emergence of the large-meter style can be linked with forms of religious practice in rural Bengal, the adaptations of this expansive musical style in the present demonstrate how the music has been extracted from an earlier context and adapted to new time frames. A first step in thinking about temporal abstraction is to consider the distinction between the categories of *concrete* and *abstract* time in studies of time and social practice.

The concept of concrete time in social theory presents a frame of temporality that derives from actions and events. A first instance of concrete time is found in the periodicities of nonhuman or natural time. The solar day, for example, is often presented as an example of concrete or nonhuman time because its duration is linked with features of the natural world and dependent on the rhythm of the sun's rising and setting. Because the duration of a day depends on the movement of the sun, Moise Postone argues, it is a "dependent variable," a form of time measurement *dependent* on the *duration* of a discrete natural pattern (1993, 201). Another example of concrete time focuses on temporal periods linked to actions. The amount of time needed to complete a song can also be considered an instance of concrete time, as its duration depends on the completion of a musical task. Postone thus defines concrete time frames as the "function of events: They are

referred to, and understood through, natural cycles and the periodicities of human life as well as particular tasks or processes, for example, the time required to cook rice or to say one *paternoster*" (201). To think about concrete time, then, is to conceptualize a temporal frame that adheres to actions and events. Commenting on Postone's definition of concrete time, Sumit Sarkar adds that the "conception of concrete time is broad enough to cover an immense range of time-notions: 'task' or 'job-oriented' times which could differ very widely in precision; time dominated by moral quality, as in the Brahmanical four-yuga cycle; [and] ritual time points as in astrology or medieval European monasteries" (2002, 16). Presenting such diverse forms under the umbrella of concrete time also brings attention to the role of language in describing time (Eisenlohr 2015) while nevertheless recognizing the similarities and differences found in various cases.

The early history of padābalī kīrtan explored in chapters 2 and 3 in this book considers how the temporal durations that musicians formed through performance were concrete in their basic constitution. These musicians created definite and intentional temporal relationships between aspects of musical style and features of religious praxis. Indeed, there was a shared temporal variable that mediated between a musical style and practices of visualization, a devotional practice that illustrated a link between a task and its temporal time frame. Of course, the duration needed to complete this practice was a time dominated by a moral quality, and violating temporal frames was tantamount to transforming the sphere of devotional temporality in Gauḍīya Vaiṣṇava thought and practice. The relationships that kīrtan musicians produced between ritual and musical frames were instances of *temporal concretization*, as it were. Creating these connections was further linked with political economy, as there was robust economic support from a *zamindār* class in Bengal, an aristocratic lineage of landholders and tax collectors who supported features of Gauḍīya Vaiṣṇava practice and kīrtan performance.

The economic support of this zamindār class was key to offering musicians the independence to create features of the expansive musical aesthetic and the sonic synchronies that were part and parcel of the genre's early history.

What is often presented as a contrast to the idea of concrete time is the frame of abstract time. If measurements of concrete time are dependent variables, the frame of abstract time is theorized as an "independent variable" that measures actions and events (Postone 1993, 202). To illustrate this, we might consider how the most pervasive form of abstract time in the twenty-first century, the hour, functions as a means of measuring events and, crucially, not as a measure of events. Indeed, to cite the previous example, there is no dependent form of correlation between the hour and the act of saying one paternoster. As a definition, Postone writes how forms of abstract time such as the hour represent "an independent framework within which motion, events, and action occur. [And] ... such time is divisible into equal, constant, nonqualitative units" (202).

Postone further locates the genesis of abstract forms of time in the late Middle Ages, when work bells were introduced as a way of marking the beginning and end of the workday (1993, 211). What came into focus during this period was the distinction between the workday of peasants—which followed the natural and concrete time frame of sunrise and sunset—and the workday of urban factory laborers, which was marked by the tolling of the work bells. For Postone, the rise of the workday as an abstract time measure was clearly linked with early capitalist forms of exchange in Western Europe, as "the system of work bells ... developed within the context of large-scale production for exchange, based upon wage labor." (211). Though abstract forms of time measurement find their genesis in modes of measuring labor, they gradually became further embedded in social life in Europe through the spread of capitalism and technological change. This point is emphasized in E. P. Thompson's well-known article

"Time, Work-Discipline, and Industrial Capitalism," where he discusses how the rise of industrial capitalism began a gradual shift from "task-oriented" work toward that of "time-orientation," as laborers became increasingly conditioned by the technology and labor management of the industrial landscape in eighteenth- and nineteenth-century Europe (1967, 60). Surely, "the 'progress' of abstract time as a dominant form of time is closely tied to the 'progress' of capitalism as a form of life" (Postone 1993, 213). Studying how musicians adapt to abstract temporal frames in the present thus moves hand in hand with analyzing how they adjust to the temporal features of late capitalism.

Abstract time offers an interpretive category to think about the time allowances that devotional musicians encounter as they act within time. From administrators at devotional music festivals who assign fixed time slots to musicians, to the predetermined temporal allowances of media forms, musicians in the present find their agency curtailed in contexts of professionalization. On the one hand, the independent temporal variables of early twentieth-century technological capacities, such as wax cylinders and shellac discs, were based on their technological and physical characteristics. On the other hand, however, the robust adoption of media production cannot easily be disentangled from the larger context of capitalist expansion that was clearly fueling this phenomenon.[27] As musicians adapted to these new performance contexts, there was no shared and dependent time variable that mediated between a musical style and practices of devotional meditation. Instead, the music's temporal dimensions, which reflected features of devotional temporality from Gauḍīya Vaiṣṇava thought and practice, were reconfigured according to the abstract durations that defined features of the music economies of early twenty-first-century India. These acts of confrontation, I argue, are instances of *temporal abstraction*, and they are found in historical and ethnographic moments when the difficulties of creating synchronic relationships are challenged. Focusing on

a politics of musical time in this book stresses the musical work of musicians as they engage in acts of temporal concretization or abstraction. Instead of taking the categories of concrete and abstract time as absolute categories (Sarkar 2002), I emphasize musicians' actions with the terms concretization and abstraction to recognize how musicians adjust within the larger frames of concrete and abstract time. If abstract and concrete time are not stark binaries but end points on a larger continuum, then we can conceptualize temporal abstraction as a way to think about how musical performances might tack one way or another. How musicians adapt to abstract time frames is a process that might be particularly heightened during moments of exchange that are capitalist-influenced. Two key contexts of temporal abstraction at the center of present-day kīrtan performance are promotional music festivals and media production. What these two settings require, crucially, are adaptations to *shrinking* time allowances to flourish in the contemporary *market* for musical performance.

The most significant cases of temporal abstraction might relate to the reforms of neoliberal economic liberalization that had a significant influence on India's social life in the 1990s. Tejaswini Ganti summarizes a common thread in anthropological work that considers "neoliberalism as a structural force that affects people's lives and life-chances" (2014, 90). The recurrent focus in this research has been to locate the material effects of neoliberal policy shifts in local contexts and study how marginalized populations adjust to economic and social transformations. In India, the ushering in of a new neoliberal phase led to a variety of governmental reforms including the relaxation of custom duties, a decrease in state-based industrial monopolies, and lower taxes, among other policy shifts. These various reforms led to an increase in global capital entering Indian markets and a concomitant economic boom and rise of a consumer culture in middle-class Indian society (Oza 2006). If these changes led to several transformations of the music industry in India (Booth and Shope

2014), the temporal impact of the neoliberal phase has received little attention.

Neoliberal time has been characterized by several factors such as time-space compression, a focus on speed and instantaneity in cultural production, and an uncertainty that pervades everyday life (Harvey 1989 and 2005; Comaroff and Comaroff 2001; Hope 2006). David Harvey connects the free-market ideology of neoliberalism to a time-space compression that takes place on global scale, arguing that "a strong case can be made that the history of capitalism has been characterized by a speed-up in the pace of life, while so overcoming spatial barriers that the world seems to collapse inward upon us" (1989, 240). The compression of time practices under capitalism and its acceleration in the more recent neoliberal period form a recurrent point of analysis in studies of social time (Adam 2004, 41). Another perspective on time, communication, and global capitalism argues that the search for "real-time" in systems of electronic communication features a "drive toward instantaneity and simultaneity" (Hope 2016, 7) that is often fueled by media and electronic finance systems seeking ever-increasing means of speeding up the transfer of data. Indeed, the qualities of instantaneity and simultaneity that Wayne Hope notes as part of the frame of neoliberal time practice seem at odds with the features of sequence and duration that mark the domain of musical time in padābalī kīrtan.

These perspectives offer several compelling ways to consider the role of neoliberal time and the manner in which it interfaces with forms of expressive culture. But how can we trace the influence of neoliberal time into the time-spaces of musical performance? In the case of promotional music festivals, the influx of professional kīrtan musicians at events has increased in the wake of recent economic shifts in India. Neoliberalism's impact as a structural force has led to an increase in surplus capital in the hands of devout Bengalis who are increasingly interested in sponsoring live performances. This has further led to a distinct

rise in the number of musicians attending promotional music festivals to advertise their groups. A second case of time abstraction involves the use of media and, more specifically, the digital medium known as the video compact disc (VCD), which was widespread during my research in the early 2010s. Shortening aspects of the large-meter style on VCDs is a necessary requirement for musicians who use this media to promote their groups and arrange future live performances. It further underscores how regional and localized music in South Asia is required to undergo temporal changes during the process of media production (Fiol 2011). The function that VCDs have played in the contemporary Indian media landscape, then, is part of a larger shift of regional music producers challenging the hegemony of the pan-Indian film music industry (Manuel 1993). Because of its association with a range of music in the global South (Stobart 2010; Morcom 2008; Manuel 2012), the VCD medium has also been marked by a particular class consciousness of being associated with rural and subaltern groups. Developed by Philips and Sony in 1993, the VCD format was first prominent in China, as media production in North American already had its vision set on the newly emerging and more valuable DVD medium (Wang 2003). Moreover, the adaptation to VCDs illustrates how transformations of musical sound "are not dictated solely by the traits of the technology, but arise out of broader contexts, whether economic, cultural, or aesthetic" (Katz 2010, 14). The ubiquitous presence of the VCD medium has featured as a form of temporal abstraction in the live-music markets of padābalī kīrtan, connecting musicians with a global web of temporal influence.

Another more recent case of neoliberal time is found in the rising ubiquity of the internet and social media in the promotional work of kīrtan musicians. Though this was rare during my fieldwork in the early 2010s, the use of social media and media-sharing platforms such as YouTube has increasingly allowed musicians to share prerecorded or live videos of performance

over the past five years (chap. 10). Being able to watch a live—if truncated—performance of kīrtan from thousands of miles away has now become commonplace as the internet has begun to allow for instantaneous performances of devotional song that traverse multiple continents at once.

The prominence of promotional music festivals and media production in present-day kīrtan performance can be linked with another feature of neoliberalism that has been a focus of anthropological and music-focused research. In addition to playing a role in the reshaping of temporal structures that influence performance durations, as mentioned above, neoliberalism has further been considered "an ideology of governance that shapes subjectivities" (Ganti 2014, 90). In the past decade, kīrtan musicians have adopted new entrepreneurial roles to promote their professional careers, including the establishment of music production companies and the techniques of economic risk-taking. Acting in this capacity, musicians forge new subjectivities that illustrate the self-management roles in neoliberal India (Weidman 2014; Morcom 2015).

Though significant, the way in which kīrtan performance has been impacted by global aspects of neoliberalism either as a structural shift or in crafting new subjectivities is only one ingredient in the complex mix that is modern social time. Indeed, considering only the temporal logics and practices emerging from global flows would paint an incomplete picture and privilege only the "temporal imagination of modernity," a top-down optic that assumes a "singular modernity [and] a common globally shared experience of time" (Mukhopadhyay 2012, 20). This mode of analysis excludes ethnographic work that questions how neoliberal time compression is experienced in diverse settings (Mains 2007) in addition to studies that consider the multiple temporalities at the center of mediating religious life (Eisenlohr 2015). Moreover, it further misses theoretical considerations from musical scholarship that consider how notions of the modern are defined in

conversation with what is deemed nonmodern (Weidman 2006, 7). In this sense, a consideration of neoliberal time is treated as one feature in the theoretical frame of modern social time to illustrate the fragmented and fraught time-spaces where musicians work. Complementing this focus is the acknowledgment that local features of time organization, as well as deep-rooted ideas and practices, combine to create the time-spaces of musical performance in the present.

MUSICAL MARKETS, LABOR, AND CULTURAL ECONOMIES

Through acting within time, musicians adapt to shortened durations to create value in the live-music markets that constitute the professional sphere of performance. I thus extend the concept of musical markets from scholarship that has defined them as either concrete retail spaces (Beaster-Jones 2016) or more abstract and widespread networks where musical recordings and technologies for listening circulate (Laing 2003; Blake 2004). Live-music markets where musicians are paid for a three- to four-hour performance are the primary context in which professional kīrtan musicians create economic value and make a livelihood. The prominence of this context underscores the importance of musical labor as a frame of analysis, an orientation that studies relationships between music, labor, and value (Stokes 2002; Mason 2013; Shipley and Peterson 2012). The theoretical shift in this work has involved reinterpreting how value is created in the labor of musical performance. Countering the "longstanding dichotomy that opposes aesthetics to productive labor," Shipley and Peterson consider musical labor a "form of embodied practice that creates, challenges, and transforms value" (2012, 405). Viewing social and economic values as mutually intertwined is a starting point for this research, a perspective drawn from anthropological studies of value theory (Graeber 2001) and work in cultural studies that has argued for the hybrid nature of cultural economies (Amin

and Thrift 2004). "Labor is therefore not only a useful category for describing how musicians earn a living or part of a living," Kaley Mason writes, "but rather a way of thinking about musical experience as a describable form of action and interaction aimed at altering material life" (Mason 2013, 444). While the frame of musical labor brings attention back to the everyday concerns of translating one's musical skill into remuneration, it is further about producing social values, conceived of as a "conception of what is good, proper, or desirable in human life" (Graeber 2001, 1). Considering musical labor a practice that creates both economic and social values places an emphasis on action as a fundamental element in the creation of value. As Graeber notes, "Value emerges in action; it is the process by which a person's invisible potency—their capacity to act—is transformed into concrete, perceptible form. . . . Value, then, is the way people represent the importance of their own actions to themselves" (45).

Though informed by the more rigid Marxian focus on labor, this perspective departs from it. Writing about the history of capitalism, Marx theorized labor as the work done in a capitalist political economy that produces surplus economic value resulting from the sale of commodities. Marx called this form of value *exchange-value*, and it represented the production of excess capital through the process of labor. He contrasted this category of value with *use-value*, which was correlated not with the abstract time of wage labor but with concrete activities that were meant to fulfill basic human needs and maintenance. Based on this bifurcation of value, it is not surprising that the term *labor* became divorced from practices of aesthetic creation. Recent work has attempted to underscore "a more flexible understanding of labor [that] brings intersections of creative processes, bodily exertion, social and economic relations, self-crafting, identity politics, spirituality, and sensory experiences together in one frame of reference" (Mason 2013, 444). Indeed, as Graeber has noted, Marxist theories of labor often fail to account for diverse and nonindustrial

practices that occur outside of the context of capitalist-focused societies (2001). Part of what I consider labor in this book, then, is far from the simple creation of exchange-value. Following Jim Sykes's study on the musical gift in Sri Lanka, another way of thinking about sound and music is found in a "discourse of the gift that validates musical labor on a local level . . . where musicians are *required* for sustaining the world" (2018a, 58). Indeed, one value found in musical exchanges I was part of was the generous and gift-like way that musical transmission occurred as a form of imparting religious knowledge that seemed unconcerned with economic value.

Producing social or economic value through musical labor is dependent on the social and historical contexts in which it takes place (Beaster-Jones 2016; Shipley and Peterson 2012). While maintaining a musical form or sonic synchrony may garner appreciation from one social group, to another it may seem irrelevant. Similarly, the rate of remuneration offered to one musician in one social context might seem astronomical relative to another performer in another social setting. Indeed, the cultural economies where musical labor creates value are manifold, and ethnomusicological scholarship has studied how musicians straddle different contexts and economies to make music work (Kapchan 2007; Morcom 2015; Mason 2013).

How musicians move between divergent value systems and cultural economies is often signaled by the language they use to refer to processes of economic exchange. In an example from South India, Mason describes how the term *dakṣina* is used to refer to a payment considered a "gift or token of recognition" by hereditary musicians in contexts where their service as Hindu ritual specialists is recognized (2013, 458); conversely, when the same musicians perform outside of their immediate and local ritual contexts, they refer to their payment with the local linguistic equivalent of "salary" (458). Linguistic markers similarly distinguish two networks of social actors and material

circumstances that are fundamental to the cultural economies that make up the sphere of kīrtan performance in the present. The first is an *instructional cultural economy* located in university settings and private lesson contexts where the value of the large-meter musical style is emphasized through a focus on processes of education (*śiksa*) and instruction (*carcā*). In these settings, instruction is linked with the repertoire of Vaiṣṇava padābalī and its connections with Sanskrit aesthetics. My own interactions in these settings featured monetary interactions with teachers that were defined by the exchange of dakṣina—a nonspecific amount given as a form of reciprocation for the knowledge that was received. The second network is a *professional cultural economy* where musicians depend on paid performances in live-music markets for their livelihood and perform primarily in rural areas of West Bengal. Kīrtan musicians in this economy are referred to with the English-language term "professional" and, in performance, are often required to omit features of the expansive musical aesthetic while also focusing on the storytelling mode and the inclusion of popular devotional songs from outside of the Vaiṣṇava padābalī repertoire. The amount of money musicians receive in this context is exact and often spelled out in contracts that determine the nature of the performance and amount of remuneration. In this book, these two economies are not seen as binary oppositions to each other but networks of social actors and material circumstances that provide various settings for the creation and transformation of value.

RESEARCH METHODS ACROSS URBAN AND RURAL SETTINGS

During my fieldwork in 2011, and again in 2012–2013, debates about transformations of musical style and professionalization surfaced. My work began in instructional contexts, where, in formal and informal lessons in urban Kolkata, I studied the history, perfor-

mance practice, and theory behind the padābalī kīrtan repertoire. With Pandit Nimai Mitra, an octogenarian singer and khol musician, I continued a focus on khol performance that had begun in earlier research trips to India between 2002 and 2008. Singing lessons with Kankana Mitra constituted another facet of my instruction; I took private lessons at her home in Kolkata and attended her classes at Rabindra Bharati University, where she is a faculty member. The relaxed, multi-hour lessons with these two musicians not only offered a seemingly ideal time-space for learning the large-meter style but also provided ample opportunity to converse, meet musicians who would come for lessons, and accompany singing lessons on the khol. The instructional setting in Kolkata also included conferences and demonstrations organized by music associations that offered longer-duration lectures and performances of padābalī kīrtan. This setting in the instructional economy focused on learning features of musical style, and the fact that these lectures and demonstrations occurred in state-sponsored educational institutions in urban Kolkata further highlighted the genre's links with facets of regional politics and identity.

The opinions and perspectives found in these research settings contrasted with another mode of research: traveling throughout rural areas of West Bengal with professional kīrtan musicians. In many cases, the musicians had begun their studies in instructional settings such as the types mentioned above. However, the lack of performance opportunities in urban settings like Kolkata has required musicians to travel throughout rural areas of West Bengal to perform for interested clients. In these locales, I not only attended and studied performances but also paid attention to the promotional limbs of music festival activities and media production that worked to secure paid performance opportunities. My discussion of the professional cultural economy will focus on the three interlinked contexts that define contemporary performance: exclusive līlā kīrtan events where musicians are featured as the main performers, promotional music festivals,

and media production with a specific focus on VCDs. Traveling with professional kīrtan musicians brought me to dozens of performances and VCD production shoots located throughout the districts of Birbhum, Bardhaman, East Midnapur, Hooghly, and Nadia.

It is important to wonder how my presence as a professional academic and a white and non-Bengali researcher influenced my lessons, conversations, and attendance at performances. It would be an exaggeration to say that my interest in padābalī kīrtan was unexceptional; that said, there has been a long history of Americans and Europeans coming to India to study music in Bengal and India more generally.[28] Among the various groups I worked with—senior music gurus, university professors, and professional kīrtan musicians—various social scripts were followed, as discussed in chapter 4. For example, there were certain ritual acts that would mark my interactions and instruction with Nimai Mitra, the octogenarian kīrtan guru. It is possible that I gained more access to senior musicians such as Nimai Mitra during my time in India because I was part of the professional academic apparatus in North America, though I did notice he was generous with his time and knowledge with many people during lessons and other interactions. Other relationships, such as my travels with Rahul Das and his group, were more informal, though there were often expectations that I would be able to provide performance opportunities abroad in the future, which I was also interested in and have been able to accomplish. In sum, my time performing fieldwork in West Bengal has morphed into long-term relationships with the musicians I worked with, and I have returned to India and stayed connected with online lessons for the past decade.

The importance of the rural districts in West Bengal where I traveled with the professional kīrtan musicians underscores features of the genre's longer history. Until the early twentieth century, the social spaces of padābalī kīrtan were firmly located in

rural settings of West Bengal. These locales were part of a network of Gauḍīya Vaiṣṇava thought and practice that came to define the sonic synchronies of padābalī kīrtan. The next chapter examines the earliest records of padābalī kīrtan by studying how the genre came to link features of intra-musical time with features of ritual time in the Vaiṣṇava pilgrimage region of Braj, where the coterminous elements of devotional practice, musical aesthetics, and social structure contributed to the genre's emergence. The debates that surround issues of musical transformation in the present gain traction because of the ways that the earliest padābalī kīrtan performance has been defined as the apotheosis of the genre's history of devotional affect.

NOTES

1. The particular verse is found in Mukhopadhyay (2010, 175).
 phulaban dekhi vṛndavaner samān (Seeing the flower garden, [he considered it] like Brindaban)/*sahacaragaṇa gopī sama anumān* (He considered his companions to be gopīs [milkmaids of Brindaban]).

2. Gauḍīya Vaiṣṇavism is also referred to as Bengal Vaiṣṇavism, and, more recently, Chaitanya Vaiṣṇavism. Research on the texts and practices of Gauḍīya Vaiṣṇavism is extensive. For bibliographies, see Gupta (2013) and Wong (2015).

3. Concerning music, Gauḍīya Vaiṣṇava devotees have similary created a variety of distinct musical styles and song repertoires throughout the ensuing centuries. See Chakrabarty (1996); Hein (1976); and La Trobe (2010).

4. One example of this took place in the līlā kīrtan performance I analyze in chapter 7.

5. Sen argues that Chaitanya did not seek to fully dismantle the caste system but rather openly ignored its strictures in his public dealings (1992, 88).

6. See Mukhopadhyay's anthology of Vaiṣṇava padāvalī for a case of Muslim composers of devotional song (2010, 1075). See also Sen (1992, 124). At the Jaydeb Melā in 2012, I saw one kīrtan musician from a Muslim background.

7. For examples of the relationship between specific performance genres and caste identities, see Wolf (2014); Henry (1988); and Groesbeck (1999).

8. The term *amorous* in this book refers to a sphere of religious and aesthetic thought communicated with the Sanskrit terms *sṛṅgāra, ujjvala,* and *mādhurya,* the latter two being translations of *sṛṅgāra* from Gauḍīya Vaiṣṇava authors but with different shades of meaning (*ujjvala* = "blazing" and *mādhurya* = "sweet"). Often, these ideas are further connected with concepts of eroticism, especially in earlier Vaiṣṇava poetry (see Wulff 1984), though themes of eroticism do surface in contemporary līlā kīrtan performances (see chap. 7). The genealogy of these ideas and their influence in padābalī kīrtan are described in chapter 5.

9. See Schwartz (2004) for an overview.

10. *Puranic* refers to texts in the Hindu and Jain spheres that are called *purāṇas,* a term that can be translated as "ancient" and thus refers to a body of literature presenting images of a mythical past.

11. See Sarbadhikary (2015) and Bhatia (2017).

12. One sacred biography of this period is the *Chaitanya Bhāgavata,* which is considered the first Bengali biography of Chaitanya's life, written by Vṛndāvana Dāsa c.1548. See Dimock and Stewart (1999, 85–87) for a discussion of this text and its author.

13. Nityānanda was not Chaitanya's biological brother but was rather seen to be an incarnation of Balarāma—that is, Krishna's brother in his Braj līlās. See *Caitanya Caritāmṛta of Kṛṣṇadāsa Kavirāja* (1999) 1 śloka 7.

14. These song composers are commonly described as belonging to the "pre-Chaitanya period" (*prākcaitanya jug*). See Mukhopadhyay (2010).

15. There were several song composers who lived in the period before Chaitanya, though the majority of songs were written during and after his lifetime—that is, from the end of the fifteenth century until c.1750 CE. This final date corresponds to the completion of a well-known Vaiṣṇava padāvalī manuscript anthology discussed in ch. 5 titled *Śrī-Śrī-Pada-Kalpataru* (*The Beautiful Wish-Fulfilling Tree of Lyrics*) and thus presents a rough estimate as to when much of this repertoire was fixed in manuscript form. See Dimock (1958, 168).

16. See Stewart (2010).

17. I use the term *non-cosmopolitan* to describe musicians who were from outside of the bhadralok sphere in terms of their English education and professional training. These musicians might not best be described as subaltern, however, because their position as religious and musical authorities did place them in a position of relatively high social influence. Schultz (2013) uses this term in her study of musicians in western India.

18. The term sādhana has a long history in musical performance in South Asia. For an overview, see Ruckert (2004, 27). For use of the term in

late nineteenth- and early twentieth-century Kolkata, see Rosse (1995, 35). David Haberman (1988) and Tony Stewart (2010) offer discussions of the term sādhana in the context of Gaudīya Vaiṣṇavism.

19. See McGraw (2008) for one example of this argument. Another perspective on this topic is found in the argument that musical time "models" forms of experiential time (Burrows 2007), a thesis that is perhaps more concerned with the phenomenology of time than with the materialist focus on social time that is studied in this book.

20. See Munn (1992) for an overview of the different ways that Durkheim and Geertz theorize time in their respective work, which does include significant differences. See also Munn for a reference to "temporal diversity" (1992, 94). Tenzer (2011, 369–70) offers a perspective on how work in the anthropology of time is often at odds with the theoretical work of music scholars.

21. As an example of this unidirectional approach, we might consider Lewis Rowell's writing, which suggests that "music is not only an art the employs or occupies time . . . [it] is also a model of time and . . . music gradually comes to reflect cultural ideas on the nature of time" (1978, 578).

22. Tenzer (2011) and Born (2015) refer to Gell's work.

23. See Husserl (2019), especially 44–52.

24. See Mitra (1333 BS [1926], 379) for an instance of this. I discuss this more in chapter 3.

25. In addition to this, I would argue that the sonic synchronies described in this book have been created and maintained by various composer, performer, and audience "stances" defined as "the affective, stylistic, or valual quality of [an] engagement" between subject (composer, performer, or audience member) and the cultural object (Berger 2009, 21).

26. The earliest record of a kīrtan scholar making this point may be Mitra (1352 BS [1945], 56); the musician Nimai Mitra underlined this point to me more recently (personal communication, September 26, 2012).

27. For an overview of the history of the commercial music industry in India, see Beaster-Jones (2016, 30–58).

28. See van der Linden (2019) for the case of Arnold Bake. I also met musicians who had studied with other academics in previous decades. The history of American and European ethnomusicologists and musicians studying with musicians in India is well known, of course.

THE SEEDS OF KĪRTAN: HISTORIES AND IMAGINARIES OF DEVOTIONAL SONG IN EARLY MODERN BENGAL

"Slowly, slowly, the instrumental playing unfolded, as Śrī Gaurāṅga Dāsa began the performance of tāl . . . a new tempo gradually developed, like the unfolding of an ambrosial sprout."

(Narottam-bilāsa, 62–3, lines 21, 1)

THE VERSES ABOVE PRESENT THE image of a newly sprouted seed to describe what musicians and scholars suggest is the earliest depiction of a padābalī kīrtan performance. This organic metaphor compares the expansive unfolding of the sprout to the features of musical sound presented at a religious festival in the village of Kheturī (present-day Bangladesh) during the late sixteenth century. The main singer and leader of the ensemble was Narottama Dāsa, a devotee from a wealthy family of tax collectors in the Bengal region. After leaving his home at a young age to study with disciples of Chaitanya, he eventually became a prominent guru in the Gauḍīya Vaiṣṇava social sphere. For kīrtan musicians, the prominence of his status as a religious leader is slightly

69

overshadowed by being considered the founder of padābalī kīrtan. In addition to the organic metaphor of tempo, another new development at this performance was the introduction of the Gaura-candrikā song repertoire, a type of lyric focusing on Chaitanya that links his identity with Krishna. The durational and sequential features of Narottama Dāsa's inaugural kīrtan performance were early sonic synchronies that expressed ideas of devotional thought and practice through features of musical sound, and remain key facets of the genre's musical style in the present.

An analysis of this all-important early kīrtan performance lies at the center of this chapter. The accounts of Narottama Dāsa's slow-moving musical style and his inclusion of songs from the Gaura-candrikā repertoire are details from the past that contemporary musicians cite to underscore links between the affective range of the genre and this formative event. During informal discussions, public lectures, and performances, musicians link their performances with this early event as a way of acting on time and framing the genre's temporal imaginary. Musicians thus connect the schools of padābalī kīrtan central to my discussion— Gaḍanhāṭī and Manoharsāhī—to the time of Narottama Dāsa as a way of emphasizing the importance of genealogical links and religious legitimacy found in the context of Gauḍīya Vaiṣṇava practice (Okita 2014) and devotional religion in South Asia more generally (Hawley 2015). The descriptions of instrumentation, form, musical style, and repertoire introduced at this early event continue to shape present-day līlā kīrtan performance, as musicians return to these early depictions to maintain and reinvent features of musical sound.

In addition to illustrating the way that Narottama Dāsa's performance contributes to the construction of devotional chronotopes, studying the inclusion of the Gaura-candrikā repertoire at this religious festival further demonstrates its complex links with the political sphere. The emergence of this repertoire

occurred after the passing of Chaitanya, when divergent theo-
logical conceptions of his identity were proliferating across dif-
ferent Gauḍīya Vaiṣṇava communities in north India. In Bengal,
the hagiographies of Chaitanya emphasized his role as the all-
powerful Viṣṇu while a community of Chaitanya's followers in
the Braj region worked to frame his identity as a reincarnation of
Krishna, or the combined manifestation of Radha and Krishna.
The inclusion of the Gaura-candrikā song, and, more crucially,
its placement in the larger sequence of this performance, was
thus a political act that sought to promote an emergent group
of scholars and their particular theological vision of Chaitanya
(Sanyal 1985). The song's sequential location and its specific lyri-
cal content, then, were part of a politics of musical time initiated
at this early kīrtan event.

In histories of padābalī kīrtan, Narottama Dāsa's performance
is often framed as holding a unique influence on the genre's direc-
tion in subsequent years. However, the features of musical style
and song repertoire introduced at this religious festival emerged
from an earlier period of study outside of Bengal. The analysis of
the Kheturī festival in this chapter is thus preceded by a discus-
sion that considers Narottama Dāsa's initiation into features of
devotional thought and practice in the Braj region of north In-
dia, where he studied with a nascent community of Chaitanya's
disciples in the sixteenth century. It was here that the practice of
līlā-smaraṇa was being developed as a process of visualizing the
divine play of Radha and Krishna. One way that this devotional
exercise was expressed was through a repertoire of long-form
verses composed by Narottama Dāsa that underscored the long-
standing connection between meditation, padābalī kīrtan, and
features of temporal duration. Another seed of influence in this
story considers the musical links that Narottama Dāsa forged
while living in Braj, as historians of padābalī kīrtan often suggest
that he studied with the doyen of the north Indian Dhrupad style
of performance, Svāmī Haridās (c.1480–1575 CE).

THE MUSICAL SEEDS IN BRAJ

During Chaitanya's lifetime, the locale of Brindaban was little more than a dense jungle. The hagiographies that document his pilgrimage to Brindaban paint a picture of a remote and pastoral forest teeming with wildlife.[1] This description pairs well with the definition of Brindaban as the forest (-*ban*) full of Brinda— another name for a sacred tulsī plant used in Krishna worship. Brindaban is one of twelve forests that constitute the larger constellation of sacred spaces that make up the greater Braj region (Haberman 1994); nevertheless, devotees accord Brindaban a heightened status because it is the place where many intimate līlās of Radha and Krishna occurred. In addition to its association with the mythical time-space of Radha and Krishna, a historical link between the Braj region and padābalī kīrtan is found in the writings and practices of a group of Chaitanya's disciples who relocated to the Braj region in the sixteenth century. Indeed, Chaitanya ordered several of his followers from Bengal to relocate across the Indian subcontinent to this remote forest with at least two major objectives. The first was to engage in a method of religious archaeology that sought to identify the specific locations where Radha and Krishna's līlās had occurred in the ancient past; the other was to write scriptures that outlined the theology and practical aspects of the emerging Gauḍīya Vaiṣṇava doctrine. Because the members of this group had accepted the renounced order, they became known as the Gosvāmīs of Brindaban, the title *Gosvāmī* referring to male renunciants exclusively engaged in religious work. The establishment of this nascent Gauḍīya Vaiṣṇava community in the Braj region can be linked with two specific influences in the history of padābalī kīrtan. The first was the development of the process of līlā-smaraṇa in the writings of a disciple of Chaitanya known as Rūpa Gosvāmī (late fifteenth century–1564), and the second is found in the temporal connections between musical

style and the durational aspects of this meditative practice developed in Braj.[2]

Rūpa Gosvāmī was one of the first Gosvāmīs to arrive in the Braj region in 1517 CE. Originally from south India, his Karnāṭaka Brahman family had relocated to the Bengal region and taken up residence near the capital city of Gauḍa, the seat of power for the local Muslim administration of the Bengal Sultanate (1205–1576 CE), a regional offshoot of the larger polity of the Delhi Sultanate. Before relocating to Braj, Rūpa Gosvāmī had escaped from the employ of a regional governor in the Bengal region, the Nawāb Husain Shāh, where he had worked along with his elder brother, Sanātana Gosvāmī, another disciple of Chaitanya who would eventually relocate to Braj as well. In the court of Husain Shāh, Rūpa Gosvāmī had been known as Dabīr Khās, a title signifying his role as a private secretary; his brother's title in the administration of Husain Shāh had been Sākar Mallik, noting his role as chief minister to the governor and further emphasizing how Bengali Hindus had achieved high-ranking positions in the local Muslim administration (Hussain 2003, 235–36). Nevertheless, after meeting Chaitanya the brothers were inspired by a devotional fervor that caused them to leave their official positions under Husain Shāh and flee to Braj, where they would develop key ideas of Gauḍīya Vaiṣṇava practice and theology through their writings.

The theoretical and practical writings of Rūpa Gosvāmī during this period ranged over many topics, but visualization emerged as a key devotional practice. One technique outlined in his writings became known as līlā-smaraṇa, a meditational practice that emphasized the devotee's visualization or remembrance (smaraṇa) of the divine play (līlā) of Krishna and his associates. The act of visualization was part of a larger constellation of practices that fell under the term rāgānugā-sādhana bhakti, a practice (sādhana) "informed by classical Indian aesthetic theory [that] involves assuming the role of a character in the ultimate reality" (Haberman 1988, 3). The act of visualizing the līlās and devotional chrono-

tope of Krishna was, as Haberman further suggests, part of a "religio-dramatic technique that Rūpa established as a means for entering and participating in the ultimate reality as envisioned by the Gaudīya Vaiṣṇavas" (3). Though the practice of visualization has a longer history in Hindu (and Vaiṣṇava) practice, the trajectory that Rūpa Gosvāmī initiated was informed by his work as a Gauḍīya Vaiṣṇava aesthetic theologian and playwright.[3] Indeed, Rūpa Gosvāmī's meditational practice drew from a longstanding connection between the domains of dramaturgy, aesthetic thought, and religious practice in South Asia. He outlined this practice in two Sanskrit aesthetic treatises written in the Braj region. The first was his magnum opus, titled the *Bhakti-rasāmṛta-sindhu* (*The Ocean of the Essence of Devotional Rasa*, c. 1541), which offered a detailed outline of the theory and practical aspects needed to experience the devotional mood (*bhakti-rasa*).[4] A second work, titled the *Ujjvalanīlamaṇi* (*The Blazing Sapphire*), focused exclusively on the amorous or erotic mood, which he re-named the *ujjvala-rasa* (blazing rasa) in his writings on Gauḍīya Vaiṣṇava practice.[5]

These two texts outlined a practice for the devotee to visualize her own entrance into Radha and Krishna's līlā. "The practice involves," Haberman writes, "visualizing a particular dramatic scene of Vraja in great detail, establishing its setting (*deśa*), time (*kāla*), and characters (*patra*)" (Haberman 1988, 126). A key verse in the *Bhakti-rasāmṛta-sindhu* describes the practice of līlā-smaraṇa: "(The Rāgānugā practitioner) should dwell continually in Vraja, absorbed in the stories (of the cosmic drama of Vraja), remembering (*smaraṇa*) Kṛṣṇa and his beloved intimates one is most attracted to" (BRS 1.2.294; trans. Haberman 1988, 124). The desired aim of this technique was for the devotee to see the activities of Radha and Krishna in her mind and thus attain the "direct vision" of Krishna and his companions (Haberman 1988, 126).

Rūpa Gosvāmī's approach to the practice of līlā-smaraṇa is also found in the songs he composed to serve as templates for

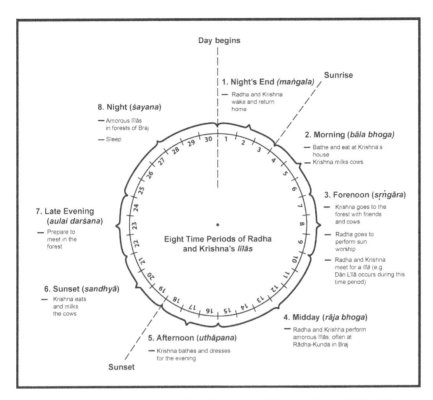

Figure 2.1 The eight time periods of Radha and Krishna's Braj Līlā. This figure is my own adaptation of a similar image found in Haberman (1988).

meditation. One example of this is his composition "Auspicious Praise for the Remembrance of the Līlā Divided into Eight Time Periods" ("Aṣṭa-kālīya-līlā-smaraṇa-maṅgala-stotram"), which was written as a form of Sanskrit praise poetry known as a stotra.[6] As Haberman notes, this composition is a form of "meditative poetry" that serves as a guide for the inner visualization of Radha and Krishna's līlās. The mention of eight time periods in the poem's title referred to how these līlās were divided in a single day, as each period was associated with a specific activity (Haberman 1988, 128–9). A diagram illustrating the eight periods of the day, and how they correspond to the time measurement unit of a muhūrta (forty-eight minutes), is found in figure 2.1.[7]

Compositions such as this stotra verse illustrate the connection between temporality and the practice of līlā-smaraṇa. One facet of this was how these texts emphasized the correspondence between the time of the day when the meditation took place and the time of day when the līlā was thought to occur. For example, to meditate during the first period of the day—called "night's end" (maṅgala), which begins three muhūrtas before sunrise—one would focus on the verse that describes what was taking place in Radha and Krishna's līlā at the same time, as found in the third verse for this praise poem: "At night's end, I remember Rādhā and Kṛṣṇa who are awakened by the songs of parrots and cuckoo birds, both pleasing and displeasing, and by many other noises sent by a concerned Vṛndā (goddess of the forest). Arising from their bed of joy, these two are looked upon and pleased by their female friends (sakhīs), and though filled with desire and trembling from the passion that arises at that time, they return to the beds of their own homes, fearful of the crossing cock" (trans. Haberman 1988, 161). As a form of meditative poetry, the images presented in this verse were meant to guide one visualizing Radha and Krishna's līlās. Simultaneously, they were also considered records that documented the vision of the advanced meditator.

Another practice-related feature of these poems was the importance of temporal duration. The previous example illustrating the connections between the day's thirty muhūrtas and the eight periods of Radha and Krishna's līlā was not only a time-map to guide the meditator. It further emphasized the correlation between the duration of the līlā and the act of meditation. In the example of the three-muhūrta period of the night's end, the temporal relation constructed in practice of līlā-smaraṇa dictated that the meditator would require three muhūrtas, or two hours and twenty-four minutes, to visualize this event. There was thus a one-to-one correspondence between the process of līlā-smaraṇa and the time needed to visualize a specific līlā of Radha and

Krishna. The practice of devotional visualization was linked to these līlās through a dependent temporal variable, which resulted in a process of temporal concretization that has left an imprint on features of musical style in padābalī kīrtan.

The links between meditative poetry and temporality that emerged in the writings of Rūpa Gosvāmī may have remained limited to the textual sphere. Indeed, there does not seem to be any evidence suggesting that Rūpa Gosvāmī was involved in the genesis of padābalī kīrtan's expansive musical style or musical performance more generally. However, a suggestive case for how the durational features of meditation began to influence musical sound took place in subsequent years, when Narottama Dāsa arrived in Braj from Bengal to live and study with the nascent community of Chaitanya's followers in the Braj region in the generation after Rūpa Gosvāmī.

THE AUSPICIOUS VISUALIZATIONS OF NAROTTAMA DĀSA

Narottama Dāsa was from a wealthy Kayastha family of tax collectors for the Bengal Sultanate in the Rajshahi district (present-day Bangladesh). The information we have on his life is found in two seventeenth-century Bangla hagiographies, *Narottama-bilāsa* (*The Divine Activities of Narottama*) and *Bhakti-ratnākara* (*The Mine of Devotional Jewels*). These texts describe how Narottama Dāsa escaped from his family and court duties in the Bengal region to arrive in Braj during the mid-sixteenth century, shortly after the passing of Rūpa Gosvāmī.[8] He then began to study the writings of Rūpa Gosvāmī such as the *Bhakti-rasāmṛta-sindhu* and the *Ujjvalanīlamaṇi* with another member of the Gosvāmī cohort of Braj, Rūpa Gosvāmī's nephew and disciple, Jīva Gosvāmī (c. 1517–1608).[9]

Narottama Dāsa's connection with the practice of līlā-smaraṇa is particularly evident in his compositions of Vaiṣṇava padābalī and long-form songs. The latter genre refers to songs he

composed that comprised dozens or hundreds of couplets, a form much larger than most found in the Vaiṣṇava padābalī repertoire, which are often between four and eight stanzas in length. In one example, the song "*Smaraṇa-maṅgala*" ("Auspicious Visualization" or "Auspicious Remembrance") describes the daily līlās of Radha and Krishna in a composition that unfolds over the course of more than three hundred couplets. What is especially telling here is the way that the līlās that Narottama Dāsa describes in verse explicitly conform to the eightfold structure found in Rūpa Gosvāmī's meditative poetry just described. After a series of invocations, Narottama Dāsa opens the song with a description of the night's end, when Radha and Krishna wake in the forest after spending the night together. Upon rising, they are surrounded by a contingent of Radha's friends, who help them dress before returning home. After describing how they sneak into their beds before sunrise, the song depicts how Radha and Krishna perform their morning routines of bathing, dressing, and eating; throughout the song, Narottama Dāsa includes details to anchor the meditator's concentration. Radha emerges from her room wearing a yellow garment that belongs to Krishna, which had been mistakenly placed on her in the morning when they were hastily departing. Later in the morning, Radha's friends quickly formulate an explanation to avoid an embarrassing situation and navigate her mother-in-law's pointed questions about the dress. While describing these events, Narottama Dāsa's song explicitly references the eightfold daily organization that underpins these līlās. For example, he concludes the opening section of the song by noting that he has "described the topics of the three time periods" (*SM* 610, line 10), a statement that refers to the first three temporal sections of Rupa Gosvāmī's eightfold structure (maṅgala [night's end], bāla bhoga, and sṛṅgāra) (See example 1.1). The rest of the song similarly references this temporal framework as it continues to depict the līlās of Radha and Krishna that took place during the remaining periods of the day.

The Braj region was not only the locale where Narottama Dāsa would study the links between poetry and devotional meditation. It was also the location connected with Narottama Dāsa's musical education. Although direct evidence might be missing, a common opinion regarding his musical training is that Braj was the location where he studied with the Vaiṣṇava musician Svāmī Haridās (c.1480–1575 CE), the founder of the Haridāsī Sampradāya, a Vaiṣṇava lineage centered in the region.[10] Various legends of Svāmī Haridās abound in the historical consciousness of Hindustani music, and he is commonly referred to as one of the earliest performers of the Dhrupad style of north Indian classical music and the musical guru of Mian Tansen, a famed singer in the court of Emperor Akbar (Beck 2011, 330).[11] The kīrtan historian Swami Prajnanananda may have been the first person to argue for the link between Svāmī Haridās and Narottama Dāsa when he noted that Svāmī Haridās was active as a musician in the Braj area from roughly 1542 to 1608 CE, a period that generally coincided with the time when Narottama Dāsa was living in Brindaban (1956, 6–7). Despite the limited evidence, the belief that Narottama Dāsa studied with Svāmī Haridās has become widespread in textual and oral histories of the genre, illustrating the way that historians and musicians connect padābalī kīrtan with the history of Dhrupad in South Asia.[12]

Though crafted by influences from the region, the introduction of Narottama Dāsa's style of padābalī kīrtan did not occur in Braj. Instead, Narottama Dāsa's guru, Jīva Gosvāmī, ordered him to return to Bengal along with two other devotees, Śrīnivāsa Ācārya (1525?–?) and Syamananda Pandit. His mission was to bring the books written by the Braj Gosvāmī school to the Bengal region, to ameliorate a growing schism that had been emerging in the decades since the passing of Chaitanya in 1533. The rift between these two regions and communities rested on a key theological difference about the identity of Chaitanya. The dominant conception among religious communities in Bengal was that Chaitanya

was an incarnation (*abatāra*) of Viṣṇu, a theological identity that emphasized elements of his power and opulence. As Dimock and Stewart suggest, in Bengal Chaitanya's identity related to an ability "to overwhelm the evil-doers . . . and to reinstitute the proper law (*dharma*)" (1999, 86). However, the writings of the Braj Gosvāmīs—and, notably, the Gaura-candrikā repertoire—described how Chaitanya embodied a combined form of Radha and Krishna, and in this characterization he was more interested in forms of intimate play with his companions that mirrored his previous life as Krishna. The writings of the Braj Gosvāmīs sent with Narottama Dāsa would attempt to mitigate the schism between these two conceptions of Chaitanya by presenting an image of Chaitanya that might encompass the seemingly distinct identities of Viṣṇu and the combined form of Radha and Krishna. One hagiography of Chaitanya that Narottama Dāsa carried back to Bengal, and that became the vehicle for presenting this theological image, was the *Chaitanya-Caritāmṛta*, composed by Kṛṣṇadāsa Kavirāja (1517–1615? CE). This text eventually became the final word on the identity of Chaitanya in Gauḍīya communities across north India and beyond, a status that it still holds in the present (Stewart 2010).

The writings of Braj Gosvāmīs were not the only media sent with Narottama Dāsa to Bengal. Indeed, the musical style of padābalī kīrtan and the repertoire of Gaura-candrikā were further vehicles of expressive culture that could carry features of devotional thought and practice. The Gaura-candrikā repertoire emphasized the image of Chaitanya as the combined incarnation of Radha and Krishna (Sanyal 1985) while the slow-moving musical style of padābalī kīrtan emphasized features of durational meditation that were central to the practice of līlā-smaraṇa in Braj. These two features of musical style were methods of acting on time that would be introduced at the important Kheturī Melā in the late sixteenth century, soon after Narottama Dāsa returned to Bengal from Braj.

KHETURĪ MELĀ: SHAPING THE GAUḌĪYA VAIṢṆAVA
COMMUNITY THROUGH MUSICAL SOUND

After returning to Bengal, Narottama Dāsa and Śrīnivāsa Ācārya organized a succession of seven melās in the greater Bengal region to disseminate the teachings of the Braj Gosvāmīs. These melās attracted devotees from throughout Bengal and Orissa and were "primary vehicles for reaching out to and consolidating the larger community" (Stewart 2010, 285).[13] The fifth and largest festival attracted thousands of attendees to the village of Kheturī, located in the district of Gaḍer Hāt in present-day Bangladesh, sometime between 1576 and 1582.[14] The festival coincided with the birth anniversary of Chaitanya and included lectures on the Gosvāmī scriptures brought from Braj, worship of devotional images, feasting, and kīrtan performances. During this monthlong festival, Narottama Dāsa introduced his new form of padābalī kīrtan; the record of this performance is found in the two hagiographies previously mentioned (*Narottama-bilāsa* and the *Bhakti-ratnākara* [*BR*]) written by Narahari Cakravartī (c.1643–c.1730).[15] The poetic depiction of the performance was part of the same project of legitimizing the theology of the Braj Gosvāmīs. For example, Cakravartī's description of Narottama Dāsa's kīrtan performance was filtered through a Sanskritic terminology borrowed from the sphere of *saṅgīta-śāstra* (doctrine of music), which was another idiom of Cakravartī's expertise. Indeed, his description of Narottama Dāsa's inaugural kīrtan performance was part of the larger project of describing the ideal religious life, and for Cakravartī one mode for communicating this was through the use of a Sanskrit terminology that linked this sixteenth-century performance with the centuries-old discourse of musical theory.

Narottama Dāsa was the main singer of the kīrtan ensemble at the Kheturī Melā, a group of performers who were "learned in singing, dance and instrumental performance" (*BR* 10.527). Narottama Dāsa's shared singing duties with a second singer,

Gokulānanda, a pairing that suggests a connection with the form
of early Dhrupad ensembles and contemporary kīrtan ensem-
bles.[16] Other instrumentalists in the group included Debīdāsa
performing on the khol; Śrī Ballabadās, whose instrument is not
specified; and, finally, Śrī Gaurāṅgadāsa, who performed on a
pair of bell-metal hand cymbals (kāṅgsya-tāla).[17] The basic con-
figuration of this early ensemble—featuring two singers, a khol
musician, and a hand-cymbal player—continues in present-day
kīrtan ensembles and highlights the formative role of this early
performance.

Cakravartī's description of the two opening sections under-
scores how this performance evoked a number of devotionally
charged responses in the audience. The khol musician, Debīdāsa,
began the performance with the presentation of a solo composi-
tion (hastā-ghāt).[18] The description of the khol strokes, which
were onomatopoetically represented as "tā te," were described as
expressing a "sound composed of divine love" (BR 10.528). This
opening percussion section was then augmented as the hand-
cymbal players joined Debīdāsa with their "minds delighted,"
while their clashing cymbals "revealed the demarcations of tāl"
(BR 10.530). Similarly, the second section, which featured an un-
metered vocal improvisation (ālāp), was charged with affect;[19]
Cakravartī describes that "there was a deep gamak (vocal modula-
tion) during the singing of [Gokulānanda's] ālāp; [and] whoever
heard that ālāp became peaceful" (BR 10.533). Gokulānanda's vo-
cal ability, couched in Cakravatī's terminology from the domain
of saṅgīta-śāstra, further emphasized his musicianship; we are
told that during the ālāp performance his "rāgs and rāginīs exhib-
ited a visible form," and the "śrutis (microtones), svaras (tones),
grāmas (scales), and mūrchanās (ornaments) were all displayed"
(BR 10.539). After an increase in the kīrtan's tempo and the intro-
duction of a metered ālāp section, Cakravartī describes how "lit-
tle by little the speed of the singing and instruments increased,"
thus affecting the audience by "increasing their blissful divine
love" (BR 10.542).

The percussion composition and ālāp section were preambles to the third section of the kīrtan, when Narottama Dāsa introduced the Gaura-candrika song.[20] The description of this song performance at the Kheturī melā not only stressed its novelty; it also illustrated the key role of this repertoire in depicting how Chaitanya was experiencing the emotional state of Radha—a clear case of how this repertoire was presenting Chaitanya as the combined incarnation of Radha and Krishna. With another reference to Sanskrit music theory, Cakravartī describes the musical setting for the song as *nibaddha* (bound), referring to how the text was set to a tāl: "Narottama, with his associates, then spread a new arrangement of nibaddha song. This song was suffused with emotion and described how the Moon of Nadiyā (Chaitanya) was submerged in the emotional mood of Śrī Rādhikā. . . . Then the pastimes of Rādhā and Krishna were sung, fulfilling the desire in everyone's mind" (*BR* 10.546–547; 10.549). The link made between Chaitanya and the mood of Radha was a clear reference to the emerging theological view of the Braj Gosvāmīs, which presented Chaitanya as the combined form of Radha and Krishna. The order and sequence of the songs in Narottama Dāsa's kīrtan were another means of emphasizing this theological point. The Gaura-candrika song was explicitly placed before songs that described the līlās of Radha and Krishna, a point that demonstrates, as Sanyal notes, the influence of the Braj Gosvāmī school: "the practice of prefacing *Kṛṣṇa-līlā* by *Gaura-candrika* represents the idea of identifying Chaitanya with Kṛṣṇa but with a particular emphasis on Kṛṣṇa worship" (1985, 61–62). Indeed, the overall form of Narottama Dāsa's kīrtan performance progressed through four major sections and outlined a temporal sequence that demonstrated the theological conclusions of the Braj school as follows:

1. Instrumental khol and kartāl composition
2. Vocal *ālāp* containing metered and unmetered sections
3. Gaura-candrika song
4. Songs of Radha and Krishna's līlās

As will become clear in chapter 7, this intra-musical sequence remains central to the way that līlā kīrtan performances are structured today.

While the features of temporal sequence are central in the *Bhakti-ratnākara* depiction mentioned above, the other record of Narottama Dāsa's kīrtan—the *Narottama-bilāsa* (*NB*)—adds details about the performance's durational features. In the verses briefly mentioned in the opening of this chapter, Cakravartī details features of tempo in Narottama Dāsa's performance of the Gaura-candrikā song. His description outlines how "slowly, slowly, the instrumental playing unfolded, as Śrī Gaurāṅga Dāsa began the performance of meter" (*NB* 62, line 21). The focus on musical sound is then compared to an organic image as Cakravartī describes how a "new tempo gradually developed, like the unfolding of an ambrosial sprout" (*NB* 63, line 1). To emphasize the unique quality of Narottama Dāsa's performance, Cakravartī's depiction mentions how devotees at the festival affirmed that Narottama Dāsa had indeed created a new musical style and further suggests that the features of musical sound in his performance were the creation of Chaitanya himself, and this knowledge had been revealed to Narottama Dāsa (*NB* 63, lines 4–5).

The link between Narottama Dāsa and Chaitanya in the above narrative was found not only in aspects of musical transmission. In what is surely remembered as the highlight of Narottama Dāsa's līlā kīrtan, the departed Chaitanya and his associates appeared dancing during the singing of the Radha-Krishna līlā. In the description below, we see how the devotional potency of Narottama Dāsa's performance bridged his own present with another reality:

> [During the kīrtan] everyone was drunk with dance. Such astounding streams of tears flowed down the faces of all, their bodies glistening with garlands and sandal paste. Narottama

became intoxicated singing of Gaura's [Chaitanya's] qualities—
and that Gaura appeared, agitated, and with his company. . . .
When they became perceptible, visible to the eyes of everyone
present, the devotees were ecstatic. . . . The manner of that dance
intoxicated the worlds, filling them with delight. . . . Both the
manifest and unmanifest came together as one. Just how amazing
[it was] to be possessed in that dance—that experience cannot be
fully disclosed. Hearts were thrilled at the wonderfully exhilarat-
ing music, accompanied by clapping cymbals and the yells of all
present (*NB* 7, [94, line 6; 95, line 11]; trans. Stewart 2010, 294–95).

Surely, the fact that the departed Chaitanya manifested during
the kīrtan performance signaled its potency to those who were
in attendance. One could argue that in the centuries since, this
event has further become key to the ways that the musical rep-
ertoire, form, and style debuted there have remained central to
lineages of musical transmission and performance. Though often
overlooked, we might argue that the features of musical time that
structured this miraculous event are embedded in features of
song repertoire, temporal sequence, and duration that remain
practices in the present.

Chaitanya's appearance during the kīrtan was also key to the
social imagination of the emerging Gauḍīya Vaiṣṇava com-
munity. Presenting a unified theological image of Chaitanya
was central to the project of ameliorating the doctrinal differ-
ences that existed between the Braj Gosvāmīs and commu-
nities in Bengal. The word that Narahari Cakravartī used to
describe the community of devotees in his hagiographical de-
pictions of the melā was *maṇḍalī*, a term that, as Stewart notes,
"denotes 'group,' but can more formally connote the tightly
circumscribed, ranked, and ordered community of sanctioned
members" (2010, 294). Considered a spatial metaphor, the term
maṇḍalī is related to the Sanskrit term *maṇḍala*, a symmetri-
cal, circular shape with a clear and unambiguous center. The
work of the Braj Gosvāmīs, as expressed in the formal aspects

of Narottama Dāsa's kīrtan, was to put a specific theological
conception of Chaitanya in the center of the community—
namely, that Chaitanya represented the combined form of Radha
and Krishna. If hagiographical texts were one medium for mak-
ing this connection, another mode featured song texts and fea-
tures of musical time in Narottama Dāsa's līlā kīrtan. Connect-
ing the mythical līlās of Radha and Krishna with Chaitanya's
sixteenth-century Bengal was not only a connection made across
time; it could further be considered a relationship made *in time,*
as features of sequence and duration in Narottama Dāsa's per-
formance invited the listener to draw connections between two
different temporal frames, thus underscoring the bidirectional
flows that link musical and social time.

CONCLUSION

The miraculous events of Narottama Dāsa's kīrtan performance
act like a touchstone in the history of padābalī kīrtan through the
ways they affirm devotional power. His initiation into features
of devotional thought and practice by the Braj Gosvāmīs were
sonically expressed through features of musical style and form
during his performance at the Kheturī Melā. Narottama Dāsa's
connection with the practice of līlā-smaraṇa is not only evident
in his own long-song compositions; it also finds expression in
the durational parameters of kīrtan's slow-moving musical style
evident at what kīrtan musicians frame as padābalī kīrtan's debut
performance. The public demonstration of this musical style and
the inclusion of the Gaura-candrikā song at the Kheturī melā are
remembered in the hagiographical literature as sonic events that
summoned the departed Chaitanya from beyond; and this music
and its representation affirmed the potency of Narottama Dāsa's
kīrtan performance and the features of devotional thought and
practice that it expressed through features of musical time.

The hagiographical record that offers a glimpse into this early modern setting of padābalī kīrtan gives way to other forms of historical description as we move forward. In the next chapter, I continue to trace the genealogy of kīrtan musicians that informs the histories and historical consciousness of the genre through two interrelated phenomena. The first studies the histories of kīrtan musicians who emerged in rural locales of Bengal following the Kheturī Melā and how the westward movement of musicians across the Bengal region shifted the geographic center of the genre's performance and instruction in the eighteenth and nineteenth centuries. Another historical development focuses on the movement of musicians into Kolkata in the early twentieth century when the colonial capital's indigenous elite, the bhadralok, became central to the ways that padābalī kīrtan was defined and performed in this new urban setting. The movement of rural kīrtan musicians into the intellectual spaces of the colonial capital brought into focus the ways that the genre and its performers would be reimagined during the colonial period, as they adjusted to new forms of patronage and locations of performance that were part of a larger bhadralok recovery of forms of Gauḍīya Vaiṣṇava thought and practice.

NOTES

1. See the CC 2.17.

2. The dates of Rūpa Gosvāmī are discussed in Delmonico (1990, 279–80). See also Buchta (2017) for an overview of Rūpa Gosvāmī's writings.

3. See Haberman (1988, 124–26) and Sanford (2008) for examples of visualization in Hindu (and Vaiṣṇava) practice. Regarding Rūpa Gosvāmī's dramatic works, he composed two full-length Sanskrit dramas (*nāṭakas*) that focused on the līlās of Radha and Krishna, a point that suggests Rūpa Gosvāmī's theoretical treatises were based on his own attempt at expressing devotional sentiment through drama (Wulff 1984, 4).

4. It is commonly believed that Rūpa wrote the *Bhakti-rasāmṛta-sindhu* and *Ujjvalanīlamaṇi* in the vicinity of present-day Brindaban, and the importance given to his texts derives in no small part from the belief that Chaitanya personally instructed Rūpa by delineating to him the particulars of *rasa-tattva* ("the truth of *rasa*"); see *Chaitanya-caritāmṛta* 2.19.103–120 (trans. Dimock and Stewart, 1999).

5. The title of the work refers to Krishna as a "Blazing Sapphire" and draws from Rūpa Gosvāmī's translation of the Sanskrit term *śṛṅgāra-rasa* into *ujjvala-rasa* (the brilliant rasa), used to define the amorous mood in his writings.

6. See Buchta (2017) for more information on the stotra genre and Rūpa Gosvāmī.

7. A similar link made between the periods of the day and devotional practice is found in the case of Vaiṣṇava kīrtan in the Puṣṭi Mārg temples in Braj. See Ho (2006). Figure 2.1 is based on a similar image found in Haberman (1988, 127).

8. See Rosen (1991, 31–32) for a discussion of the possible dates when Śrīnivāsa may have arrived in Braj.

9. For more on Jīva Gosvāmī, see Gupta (2007).

10. See Beck (2011).

11. See Sanyal and Widdess (2004, 63–64) for a discussion of Svāmī Haridāsa's place in Dhrupad history and memory. The assertion that Svāmī Haridāsa was the guru of Mian Tansen is often contested; see Rosenstein (1997).

12. See Mukhopadhyay (1971, 210–13) and Chakrabarty (1996, 191) for examples of textual accounts. One assertion that Narottama Dāsa studied with Svāmī Haridāsa in oral accounts is based on my discussions with Nimai Mitra (personal communication, December 2, 2012).

13. Stewart suggests that Śrīnivāsa was the first to begin organizing these melās (2010, 285).

14. See Sanyal (2019, 44).

15. Narahari Cakravartī goes by two other names: Naraharidās and Ghanaśyāma Dāsa. These are often used in the signature lines of his numerous song compositions. See Prajnanananda (1956, 3–4). Narahari Cakravartī was most likely not at the festival. His writings operate on the idea that he reconstructed the events based on descriptions by his father and others who were in attendance. As Stewart notes, these two hagiographies "served as templates to the ideal religious life, and those templates in turn produced an ideal religious history" (2010, 313).

16. See Stewart (2010, 289) for more information on the singer Gokulānanda. The earliest depictions of Dhrupad performance were documented in the early seventeenth-century *Sahas-ras* from Mān Singh's court. Sanyal and Widdess note that Dhrupad performance at this time featured the presence of a solo ālāp (improvisatory introduction) that preceded a song composition, and the ensemble further featured accompanying singers who would sing in conjunction with the lead artist (2004, 49–51).

17. See *BR* 10.527–532.

18. The word used to describe Debidāsa's drum in this verse is *mardal*, a term often used to refer to double-headed drums such as the *pakhavaj* and other regional drums in north India. However, the term khol is used in Narahari Cakravartī's other writings that describe the Kheturī melā such as the *Narottama-bilāsa*, suggesting that Debidāsa was indeed playing the khol. See chapter 7 of *Narottama-bilāsa*.

19. The term used to refer to this section of the kīrtan in the *BR* is *anibaddha* (unbound), which refers to an unmetered portion of the performance. The next section, referred to as *nibaddha* (bound), references a segment where the tāl is introduced. The use of these two terms in Sanskrit treatises dates back to the fourth-century *Nāṭyaśāstra* but has become a key component of determining musical form throughout the ancient and medieval periods. See Rowell (1992, 238) and Slawek (1987).

20. The specific Gaura-candrikā song that Narottama Dāsa performed at the melā is unknown, but because some early authors of these songs were Chaitanya's boyhood companions from Nabadwip, it may have been a song from this collection. See Dimock (1958, 159) for more information on early Gaura-candrikā songs.

—〰—

DEVOTIONAL SONG ARRIVES IN THE CITY: HISTORIES OF PATRONAGE AND IMAGES OF THE DEVOUT MUSICIAN IN THE COLONIAL PERIOD

A SET OF PARTNERSHIPS BETWEEN kīrtan musicians and patrons animates the history of padābalī kīrtan during the transition from the early modern period into the colonial era. One network of collaborations following the Kheturī Melā occurred in rural areas of Bengal, as landed zamindārs actively worked to support musicians who specialized in the expansive musical aesthetic. These relationships gradually receded as devotional musicians arrived in the colonial center of Kolkata at the turn of the twentieth century, when bhadralok actors engaged kīrtan in part of a larger project to construct forms of a Bengali regional national culture. The engagements of these groups with kīrtan musicians demonstrate the ways that both zamindārs and bhadralok actors worked to construct a "social infrastructure" for performers (Zarrilli 1992) by using their economic or educational capital to support, learn, and play a role in defining features of padābalī kīrtan performance. As Philip Zarrilli notes, this work involves "providing the economic and social infrastructure for [a genre's]

realization, engaging . . . in making decisions about performative realization of texts, and finally serving as ideal audience members" (1992, 105–06). The networks where we find padābalī kīrtan in this period thus illustrate how features of musical relationality worked to shape and maintain its discursive and sonic features. The discussion in this chapter thus considers the ways that music embodies social relations through the "large-scale social, cultural, economic and political forces that provide for [music's] production, reproduction, or transformation" (Born 2010, 232).

To uncover the ways that patronage created various social infrastructures, this chapter shifts away from the hagiographical record to an examination of the earliest historical sources of padābalī kīrtan. These oral and written histories illustrate how kīrtan musicians interacted with the social networks of a zamindār class that offered economic and institutional support for musicians in the nineteenth and twentieth centuries. Their patronage of kīrtan musicians was part of a larger distribution of largesse to Gaudīya Vaiṣṇava temples and devotees during a time that witnessed the development of several regional styles of padābalī kīrtan in rural networks of performance and instruction. The continued prominence of the expansive musical aesthetic in these lineages of kīrtan links zamindārī patronage with forms of temporal concretization that connect the spheres of meditation and musical style in the genre's earlier history.

A second set of relationships that gradually replaced zamindār patronage was forged when kīrtan musicians relocated to the urban center of Kolkata. Though the social spheres of the zamindār and bhadralok certainly overlapped to some extent (Chowdhury 1998, 6), the networks of kīrtan instruction and performance that spread across rural north India had mostly bypassed the growing metropolis until the turn of the twentieth century. It was during this time that a growing interest took root among the bhadralok social class to connect forms of Bengali expressive culture with a regional identity. One narrative that illustrates this larger project

involves Deshbandhu Chittaranjan Das (1870–1925), a prominent Bengali political leader who founded the Swaraj (Independence) Party in Bengal in the early twentieth century. In the account of the kīrtan musician Nimai Mitra, C. R. Das, as he was known, is described as playing a key role in the arrival of the kīrtan musician and protagonist of this chapter, Nabadwipchandra Brajabashi, in Kolkata c. 1898.[1] Brajabashi was a kīrtan musician living in Braj who would become a kīrtan guru for several leading bhadralok figures in the colonial city in the first half of the twentieth century.

> C. R. Das [Chittaranjan Das] once visited Brindaban. He met Gadadhar Das Babaji, who was a sādhaka kīrtanīyā. Sitting on the banks of Radha-kunda [in Braj], he would joyfully perform līlā kīrtan. Not as a profession, but as a form of worship.... Hearing his wonderful kīrtan, C. R. Das was moved. He then asked Gadadhar Das Babaji to come to Kolkata with him. "This is such a wonderful thing," [C. R. Das] said. "Should it just remain here in the isolation of Brindaban? ..." Gadadhar Das Babaji did not accompany C. R. Das back to Kolkata.... Instead, he sent Nabadwip Brajabashi and Haridas Brajabashi as his representatives. They traveled to Kolkata and began the practice of kīrtan.[2]

The links between devotional song, the city, and the Bengali nation are evoked here through the central role that a nationalist leader played in bringing this musical style to Kolkata. Indeed, C. R. Das would play a prominent role in establishing padābalī kīrtan in the city through initiatives such as forming a music association dedicated to the genre, called Śrī Braj Mādhurī Sangha, a name that referred to an association (sangha) of devotees who could experience the sweetness (mādhurī) of the Braj region through kīrtan. Though C. R. Das played a key role in bringing padābalī kīrtan musicians to Kolkata, the collaboration that lies at the center of this chapter involves University of Calcutta professor Khagendranath Mitra (1880–1961) and Nabadwipchandra Brajabashi. A key part of the collaboration that emerged in Mitra's

writings and speeches was the formulation of a neotraditional image of the sādhaka kīrtanīyā, a multivalent term that referred to a kīrtan musician (kīrtanīyā) who was a *sādhaka*, or "one who performs sādhana." The qualification of sādhaka in this discourse carried two meanings: a musician engaged in Gauḍīya Vaiṣṇava ritual practice (sādhana) and a performer with a high level of musical skill, the latter point linked with Brajabashi's training in the Gaḍanhāṭī and Manoharasāhī schools of kīrtan. Through an analysis of the discourse of Mitra and other bhadralok writers, the cultural template of the sādhaka kīrtanīyā was formed according to four key discursive markers that would describe Brajabashi and others as: (1) "expert in music" (*saṅgīte pāradarśī*), (2) "imaginative" (*bhābuk*), (3) "dedicated to worship" (*bhajanaśīla*), and (4) "knowledgeable of *rasa*" (*rasa-jñā*).[3]

This chapter begins by setting the stage for this later collaboration by examining the formation of the regional schools of kīrtan that emerged after the Kheturī melā. Not only did these regional styles define a key part of the genre's history but they also further contributed to the ways in which padābalī kīrtan came to index a type of rural authenticity that aligned with bhadralok conceptions of regional nationalism in Bengal. The regional schools of padābalī kīrtan and their movement into bhadralok spaces thus sought to posit rural areas not only as reservoirs for Gauḍīya Vaiṣṇava cultural forms but also as symbols of Bengali nationalism that had their origins outside of the urban center and its association with colonial rule.

FROM HAGIOGRAPHIES TO HISTORIES: TRACING THE GENEALOGY OF KĪRTAN AFTER THE KHETURĪ MELĀ

In the wake of the Kheturī Melā, there was a gradual proliferation of kīrtan styles throughout the Bengal region. The connection between place and performance style was emphasized in the names of these regional schools, which carried the

designations of the rural locations where they were established. The style based on the Narottama Dāsa's melā performance became known as Gaḍanhāṭī kīrtan, as it was performed in the Gader Hāt region in present-day Bangladesh. This school was further established as the archetype for the four additional regional styles of padābalī kīrtan that were formed later. The style known as Reneti was linked to the village of Ranihati, near the town of Satgachia in the Bardhaman district.[4] The school of Mandarini kīrtan was tied to the village of Mandaran in the Hooghly district.[5] The style known as Jharkhandi kīrtan was connected with areas in the Indian state of Jharkhand.[6] And the fifth school, which is central to this book, was the Manoharasāhī style, which can be traced to a region known as the Manoharasāhī *pargaṇa* (district), a region near the present-day city of Katwa in the Bardhaman district of West Bengal, located roughly two hundred kilometers west of the village of Kheturī. The geographic spread of these four regional schools illustrates a shift westward from the location of the Kheturī Melā (see Map with Key Locations for Padābalī Kīrtan), a phenomenon that reflects the dispersion of devotees to their home villages after the conclusion of the melā.

The two regional schools of performance that became most closely linked in the years following the Kheturī Melā were Gaḍanhātī and Manoharasāhī kīrtan. One reason for this close association is found in aspects of repertoire, as the earliest historical records describe how musicians performing in this region might have been knowledgeable of both Gaḍanhātī and Manoharsāhī styles (see below). Another explanation for the close relationship between these two schools is found in their mutual establishment in the Rāṛh region of northwest Bengal that overlaps the districts of Bankura, Birbhum, Bardhaman, Howrah, Hooghly, Midnapore, and Purulia and further extends into parts of the Indian state of Bihar. Evidence suggests that as performers of the Gaḍanhātī style spread westward from Kheturī, this musical style was adopted and learned in the Rāṛh

region as well. Though they would also spread widely through-
out greater Bengal, the Manoharsāhī and, to some extent, the
Gaḍanhāṭī schools thus became known as forms of Rāṛh Kīrtan
because of their prominence in the region.[7]

In the Rāṛh region, we find kīrtan musicians central to the lin-
eage presented in this book who also present the most probable
links with the hagiographical time of Narottama Dāsa. One musi-
cian central in this genealogy is Advaita Das Babaji (1837–1930),
a singer who specialized in Gaḍanhāṭī and Manoharasāhī kīrtan
who is also linked with key sites of musical performance and
education in both Bengal and the Braj region.[8] Throughout his
life and career, he was supported by Bengali zamindārs who were
active in supporting the transmission of the large-meter musical
style.

ZAMINDĀR PATRONAGE IN BENGAL AND BEYOND

At the center of a nexus between social structure, political econ-
omy, and musical performance in padābalī kīrtan's history in
the eighteenth and nineteenth centuries was the figure of the
zamindār. An aristocratic lineage of landholders and tax collec-
tors across wide swathes of the Indian subcontinent held the Per-
sian-language title of zamindār, and, in Bengal, the title and role
dates to the period of the Bengal Sultanate, when zamindārs were
the primary revenue agents collecting taxes for remittance to the
sultan. Despite its origins in the sphere of Islamic governance, the
role of the zamindār worked within a larger social infrastructure
that continued after the time of the Bengal Sultanate. Indeed,
the role of the zamindār remained central to the administrative
structure of both Mughal and British rule in South Asia, and
its administrative function was permanently ended only shortly
after Indian independence in 1947. Though Hindu and Islamic
zamindārs functioned as tax collectors throughout this period,
it was a group of Hindu zamindārs who would provide a cru-

cial form of economic support for padābalī kīrtan musicians between the sixteenth and nineteenth centuries. It was common for zamindārs in Bengal to use their wealth in support of various philanthropic aims, and one target of their economic support was religious institutions and individuals.[9] More specifically, it was not uncommon to find Hindu zamindārs in Bengal who were devotees of Chaitanya; these individuals would frequently direct economic support toward the maintenance of temples and other forms of devotional practice associated with his worship. Features of padābalī kīrtan's expansive musical aesthetic, then, cannot be easily disentangled from the effects of patronage that allowed musicians significant time frames in which to create, perform, and transmit features of this musical style and its links with the durational features of Gauḍīya Vaiṣṇava meditation. The results of patronage and the relationality that defined the links between kīrtan musicians and their patrons underscores the material dimensions of economic support that were part of the genre's history in this period.

Evidence of zamindār support for kīrtan musicians can be found in the early depictions of Narottama Dāsa's līlā kīrtan performance at the Kheturī Melā. One example is found in Cakravartī's description of the interconnected strands of economic patronage and musical style that were evident in this early context; his depiction makes clear how a specific zamindār from the city of Gauradvāra, Santoṣa Rājā, supported the festival by funding the costs for housing, food, and the construction of the musical instruments used in the kīrtan performance (NB 59, line 12). Though Hindu, Santoṣa's title of rājā suggests his role in the administrative sphere of the zamindār in the final years of the Bengal Sultanate.[10] In addition to his support for the festival, Santoṣa Rājā played a more extensive role in supporting padābalī kīrtan and the musician Narottama Dāsa, as he is credited with providing "permanent substantial financial support for Narottama's activities" (Stewart 2010, 282). Stewart further notes that

during this period there were a number of zamindārs in the general region of Kheturī, including Santoṣa's brother, Cānda Rāya, and his father, Rāghavendra Rāya, who were influenced by the devotional work of Narottama Dāsa and Śrīnivāsa (282) The economic support of zamindārs during this early period was most closely linked with goods and the construction of musical instruments but would soon be directed to funding musical education.

One example of this connection between zamindār patronage and padābalī kīrtan is found in the case of the previously mentioned Advaita Das Babaji, born in 1837 in the village of Shiraganj (present-day Bangladesh). As a young orphan, Advaita Das Babaji was adopted by Padmalocan Nag, a zamindār who had been granted administrative and tax-collection rights from the East India Company after the overthrow of the last Nawab of Bengal, Siraj ud-Daulah, in the Battle of Plassey in 1757.[11] Nag was a Gauḍīya Vaiṣṇava, and in his household Advaita Das Babaji was trained in the devotional worship of Chaitanya. This early instruction would have a profound effect on him, and later in life he adopted the role of an itinerant ascetic in the Gauḍīya Vaiṣṇava line. Though married, at the age of twenty-seven he left his wife to accept the role of an ascetic in 1864, denoted by his adopted title of Babaji. Over the course of the next several decades, Advaita Das Babaji entered a network of Gauḍīya Vaiṣṇava monasteries and temples that linked Bengal with the Braj region. Indeed, Braj had remained a central location for Gauḍīya Vaiṣṇava worship and education since the time of Narottama Dāsa while also remaining a center for the Gaḍanhāṭī and Manoharasāhī schools of kīrtan on account of the well-documented travel route that connected this area with the Bengal hinterlands (Das 1955, 281–86). Though he began his study of padābalī kīrtan with Bengali musicians in the Braj region, he often returned to Bengal to continue his musical education. In one instance, he was sent to study Manoharasāhī kīrtan with Krishnadoyal Canda (1794–1881 CE), a musician from the village of Panchthupi, located close to

the Katwa region. The musical education that Advaita Das Babaji received from Krishnadoyal Canda might provide one of the earliest links between the present and the time of Narottama Dāsa.[12]

Much of Advaita Das Babaji's ability to travel and study kīrtan rested on forms of zamindār support. A key patron with a long-term history of supporting kīrtan musicians in Braj was the Bengali zamindār of the Tarash district (situated between Kheturī and Shiraganj in present-day Bangladesh), Rājarshi Banamali Roy (1863–?). Roy inherited his zamindār title from Raja Banavari Lal in Bengal after being adopted as a young boy, and he was only seventeen years old when he inherited the management of the Tarash district in Bangladesh (c. 1880), an administrative post that also oversaw the maintenance of two temples in the Braj region. In the late nineteenth century (c. 1887), Roy established a school for kīrtan in Tarash Mandir, one of the Braj temples associated with his zamindār title and a location where Advaita Das Babaji became a kīrtan guru (fig. 3.1). Moreover, Roy's support for the school extended to students who received a monthly stipend of six rupees to learn padābalī kīrtan in addition to studying Sanskrit with Advaita Das Babaji. One of Advaita Das Babaji's leading students, Nabadwipchandra Brajabashi, also took up residence in the Tarash Mandir,[13] where they both performed kīrtan and worshiped the images of Radha and Krishna housed in the temple.

In addition to the Braj kīrtan school at Tarash Mandir, other institutions dedicated to the study of the large-meter style of padābalī kīrtan appeared in the Bengal region with zamindār support.[14] One example was a school established in the Rajbari (Zamindār Palace) of Manindra Chandra Nandy (1860–1929), the zamindār of Kasim Bazaar (present-day state of West Bengal). Nandy, who was from a family lineage that traced its zamindār rights to Kanta Babu (?–1778), had earned the title after saving the life the East India Company official Warren Hastings in the Battle of Plassey in 1757. Patronage of Vaiṣṇava musical forms had

Figure 3.1 Tarash Mandir in Braj; Radha and Krishna images in the Tarash Mandir; and Photo of Banamali Ray on the temple altar (clockwise from top left). Photos by Suvarna Goswami.

been a long-standing interest in the Kasim Bazaar zamindār line, and Nandy's aim in establishing the padābalī kīrtan school in the palace was based on a desire to preserve features of the expansive musical aesthetic.[15] Nandy invited Advaita Das Babaji to teach at the school because of his knowledge of the Gaḍanhāṭī and Manoharasāhī schools of kīrtan. Advaita Das Babaji's student Brajabashi was also in residence at the school for three years to study features of the large-meter musical style. The zamindār Nandy provided meals, clothing, and a monthly stipend of

Rs. 15–25 to students who would come and study padābalī kīrtan, and he further arranged for a noted Dhrupad singer from nearby Vishnupur to come and create a notation system that would aid the students in their study.[16] The connection between the patronage offered in the school and the time needed to study the large-meter musical style was emphasized in Brajabashi's recollections of this period: he commented that "in order to learn kīrtan, extreme effort is required; this people do not know. To learn one song, it takes between 3–5 months, and even up to one year" (Das 1392 BS [1985], 271).

The relationship between zamindār patronage and the durational features of padābalī kīrtan was illustrated in performance settings from this period as well. Similar to the accounts of musical performance from the Kheturī Melā, descriptions of Advaita Das Babaji's kīrtan performances emphasize the lengthy time spans central to the genre. For example, in a kīrtan performance in the house of Radhikanath Gosvami, he sat to sing from nine in the morning until eleven at night without a break.[17] Another depiction of Advaita Das Babaji's musical skill and its links with duration is found in the account of Khagendranath Mitra, who witnessed his performance at the house of the zamindār Jagadindranath Ray of Natore (present-day Bangladesh). The kīrtan performance was noted for Advaita Das Babaji's combination of "slow tempos and difficult-to-attain melodies" (Mitra 1333 BS [1926], 380). Indeed, the social values of temporal duration found in the early performance of Narottama Dāsa remained central to the descriptions of kīrtan performance across several centuries. The role of the zamindar throughout this time further suggests that the economic support of this landed class played a key role in allowing for the extended time spans where musicians continued to synchronize features of musical time with aspects of temporal knowledge and practice from the Gauḍīya Vaiṣṇava sphere.

PADĀBALĪ KĪRTAN ARRIVES IN KOLKATA

Though Advaita Das Babaji was influential in the zamindār sphere in rural areas, there is little evidence to suggest that he performed extensively in Kolkata. Instead, one of his students, the previously mentioned Brajabashi, would play a key role in padābalī kīrtan's transition into the urban center. Brajabashi's key collaborator in the urban center was Khagendranath Mitra, a university professor who was one of the main voices to promote the image of the sādhaka kīrtanīyā. On the one hand, Mitra's work of defining the sādhaka kīrtanīyā in Kolkata drew from an earlier history of the genre and its links with sādhana or ritual practice. On the other hand, the term sādhana emphasized musical skill in this discourse and worked to compare features of padābalī kīrtan with the growing interest in Hindustani music in the urban center of Kolkata (Williams 2014). Mitra made this comparison explicit when he offered what might have been his own neologism to describe the musical style found in Brajabashi's performances as *uccāṅga kīrtan*, or a form of "high art" or "classical kīrtan."[18] This term modified the Bangla term *uccāṅga saṅgīt*, used to describe Hindustani music, and was thus one way of borrowing from the social capital that had accrued around the sphere of Hindustani music in bhadralok circles. If promoting the image of a religiously devout and musically skilled performer was found in other forms of cultural nationalism in South Asia (Subramanian 2006), the discourse of the sādhaka kīrtanīyā in Bengal drew from the well of Gauḍīya Vaiṣṇava theory and praxis in creating a Bengali-specific framework of the four discursive markers mentioned previously (imaginative, knowledgeable of rasa, dedicated to worship, and expert in music). Mitra's project of partnering with Brajabashi was also timed to coincide with a more general interest in Gauḍīya Vaiṣṇavism among the bhadralok that had gathered steam in the middle of the nineteenth century.

THE BHADRALOK TURN TOWARD
GAUḌĪYA VAIṢṆAVA KĪRTAN

A series of intellectual shifts were taking place in nineteenth-century Kolkata that would set the scene for the adoption of padābalī kīrtan among the bhadralok. Beginning in the mid- to late nineteenth century, prominent bhadralok were shifting their attention away from an exclusive focus on Western Enlightenment philosophy. This was an intellectual trend that precipitated a renewed focus on Hindu ritual and social practices that started to gain a more secure foothold among the Bengali bhadralok (Chaudhuri 1988). One example of this was the influence that Gauḍīya Vaiṣṇava kīrtan had on the author and prominent nationalist Bankimchandra Chattopadhyay (1838–94), a development that contributed to the manner in which he foregrounded aspects of religious thought in his vision of a social identity for the bhadralok (146). Another instance of the growing influence of Gauḍīya Vaiṣṇava musical genres among the bhadralok was the gradual adoption of the idiom of kīrtan among reformist Brahmo Samāj members such as Keshab Chandra Sen and Bijay Krishna Goswami in the nineteenth century (Rosse 1995, 14). In one of the most well-known cases, Keshab Chandra Sen introduced the Gauḍīya Vaiṣṇava musical practice of Chaitanya's *nagar saṅkīrtan* (participatory kīrtan in the streets) within Brahmo Samāj circles in urban Kolkata (Chatterjee 1993, 39).

Bhatia's study of the bhadralok recovery of Gauḍīya Vaiṣṇava practices illuminates how this project involved both ideational and material aspirations (2009). In the case of the former, she notes how the figure of Chaitanya became symbolic of a Bengali national identity. One key figure in crafting and publicizing Chaitanya's conflation with a collective Bengali identity was the author Sishir Kumar Ghosh (1840–1911), who published a serialized biography of Chaitanya between 1885 and 1911. In Bangla and English versions of this text, Ghosh presented Chaitanya as

a "prophet for the Bengalis," an image that became "the founda-
tion for a certain kind of Bengali exceptionalism ... [that] easily
lapsed into parallels between religion, region, and nation" (343).
One particular focus of bhadralok interest in Gauḍīya Vaiṣṇavism
during this period sought to preserve items of material culture
that represented a history of the Bengali nation, including manu-
scripts that documented the written archive of Gauḍīya Vaiṣṇava
scripture and padābalī kīrtan song texts (1). Indeed, in the case
of the latter, a fascination with Vaiṣṇava padābalī became a fo-
cus of the bhadralok in the first half of the twentieth century,
when numerous anthologies were published to preserve an earlier
manuscript archive of song texts (See chap. 5).

One platform for recovering and publishing these song texts
was the Gauḍīya Vaiṣṇava periodical *Bishnupriyā Patrikā*, pub-
lished between 1891 and 1899 and edited by Sishir Kumar Ghosh.
Of central concern to the editorial staff of this journal was col-
lecting and publishing the song texts attributed to the compos-
ers of Vaiṣṇava padābalī, the mahājana padakartās. Though the
editorial staff of *Bishnupriyā Patrikā* was based in Kolkata, much
of the work done for the recovery of Vaiṣṇava padābalī occurred
in rural areas of Bengal. In addition to sending out emissaries to
locate song manuscripts in the Bengal hinterlands, *Bishnupriyā
Patrikā* featured debates regarding how aspiring song text col-
lectors could decide on the authenticity of lyrics. In a correspon-
dence published in the journal, one song collector, Jagadbandhu
Bhadra, discussed strategies used to determine the authenticity
of Vaiṣṇava padābalī lyrics. In this exchange, Bhadra offered the
case of a sub-judge in Pabna who traveled through various rural
districts of Bengal asking kīrtan musicians to sing specific songs.
If the singers refused, he argued, then one could be sure that
these lyrics were not authentically part of the Vaiṣṇava padābalī
repertoire (Bhatia 2009, 253–54). Through methods such as
these, Bhatia argues, "the *Bishnupriyā Patrikā* began to posit the
countryside as the authentic repository of Vaishnava literature,

history, and devotional practices" (226). Rural provenance thus came to stand not only for devotional authenticity but also as a form of national cultural expression that could stand outside of an urban sphere tainted by colonial influence.

This neo-traditional focus on features of recovery was tempered with reformist views as well. Indeed, the bhadralok were undoubtedly hesitant to embrace the ritual practices associated with a variety of rural and low-caste Gauḍīya Vaiṣṇava communities. Often collectively referred to as Sahajiyā Vaiṣṇavism, individual sects such as the Kartabhajas were slandered by the bhadralok for the perceived immorality of their tantric sexual practices (Urban 2001, 10). Though prominent bhadralok authors would lecture and write in minute detail on the relevance of Chaitanya's message, they would simultaneously attempt to distance Gauḍīya Vaiṣṇava thought from the practitioners of Sahajiyā Vaiṣṇavism.[19] Bhatia further notes the complicated relationship that existed between the bhadralok and rural Gauḍīya Vaiṣṇava kīrtan musicians from low-caste backgrounds. On the one hand, she notes, bhadralok projects such as *Bishnupriyā Patrikā* aimed to align Chaitanya and Gauḍīya Vaiṣṇava practices with a bhadralok respectability that prized conflations of "education, urbanity, and salaried service" (2009, 257). On the other hand, however, the writings of bhadralok agents such as Sishir Kumar Ghosh revealed an abiding appreciation for kīrtan musicians from low-caste backgrounds, by writing laudatory descriptions of their transformational musical performances (269).[20]

Despite these cases of appreciation, Sishir Kumar Ghosh and other bhadralok forms of interaction with the rural schools of padābalī kīrtan appear minor compared to the prolonged collaborations that defined the work of Khagendranath Mitra. Arriving in Kolkata during the 1890s, at a time when bhadralok interest in Gauḍīya Vaiṣṇava thought and practice was squarely in the public discourse, Mitra began an ambitious project to promote padābalī kīrtan in colonial Kolkata with Nabadwipchandra Brajabashi,

who arrived in the colonial center in 1898, only one year before the last issue of *Bishnupriyā Patrikā* had left the presses.

KHAGENDRANATH MITRA AND
NABADWIPCHANDRA BRAJABASHI

As a University of Calcutta professor and advisor to the colonial government, Khagendranath Mitra exhibited an intense and prolonged interest in padābalī kīrtan. In public lectures, such as one he delivered to a group of kīrtan enthusiasts in Pabna (present-day Bangladesh) in 1926, Mitra reflected on the history of the genre and the threats confronting its survival. Mitra warned the attendees that this genre was on its way to extinction unless drastic measures were taken, and he thus urged his audience to action by speaking about a purported "golden age" that had defined its earlier history (1333 BS [1926], 379). The central personalities from this era were the musicians and poets such as "Jñāna Dāsa, Govinda Dāsa, and Narottama Dāsa [who] excited the region with the sweet rhythms of padābalī compositions and their singing" (379). In Mitra's view, the remedy to return to this golden age was to assist in the reemergence of the genre's "high art" status (*uccāṅga*), a project that was concerned with the promotion of male musicians from outside of the urban center. Indeed, this connection between gender and this musical style was emphatically made in Mitra's work when he described that "with the increasing appreciation of male kīrtanīyās, uccāṅga kīrtan's re-emergence is slowly taking place" (1352 BS [1945], 36). Mitra noted how "that kīrtan which was once spread throughout Bengal, today those kīrtan singers (*gāyak*) are scarce" (377). In fact, speaking in the early twentieth century, Mitra suggested that their number was so meager it could be counted on the fingers of one's hands and named several male singers such as Advaita Das Babaji, Rasabihari Mitra Thakur, and others. It should be noted that the musicians Mitra referenced, and the gender-indicative term for

singer, *gāyak*, designated the category of kīrtan musicians who performed in the uccāṅga style as exclusively male. But why this insistence on only male kīrtan musicians?

The subtext that undergirded much of this discourse was an anxiety surrounding the popularity of the devotional genre of ḍhap kīrtan in early twentieth-century Kolkata. Though the genre had its roots in rural Bengal (Graves 2017a, 5), it had gradually been brought to the city with migrant workers as part of a larger arrival of rural genres of song, theater, and dance from the Bengal hinterlands (Banerjee 1989). Ḍhap kīrtan had developed as an offshoot of padābalī kīrtan in the nineteenth century, and though a number of the genre's stylistic features might be discussed, one defining feature of its musical sound was the use of quick tempos and short tāl structures in performance—two features that have caused it to be defined as a "light" performance genre.[21] In Kolkata, performances of ḍhap kīrtan were common in a northern part of the city referred to as Black Town during the colonial period, where female performers remembered as Bengali *baijis* performed light-classical forms and ḍhap kīrtan in opulent multistory homes that belonged to *nouveaux riche* Bengali *banians* (commercial agents) and *dewans* (personal secretaries). Ḍhap kīrtan also flourished in the commercial recording industry in Bengal in the early decades of the twentieth century. The commercial connotations of these performance contexts led Mitra to pejoratively refer to the female singers linked with ḍhap kīrtan recordings as *kīrtan-wālīs*, a term that marked them within the sphere of popular kīrtan performance (1352 BS [1945], 35).

As Mitra himself noted, one of the most popular commercial singers of ḍhap kīrtan in the first decade of the twentieth century was Punna Moyee Dassi (Mitra 1352 BS [1945], 35). Indeed, her voice can be heard on dozens of commercial recordings categorized as kirton in the Gramophone Company's Kolkata recording studio between 1904 and 1911. One example of the small-tāl style of the genre is demonstrated on a recording released in 1909

Table 3.1. Relationship of text and tāl in *"kanu kahe rāi kahite ḍarāi"*
("Krishna says, Rāi [Radha], I am afraid to tell you")

1	2	3	4	5	6
ka-	*-nu*	*ka-*	*-he*	*rāi*	
1	2	3	4	5	6
ka-	*-hi-*	*-te*	*ḍa-*	*-rāi*	
1	2	3	4	5	6
dha-	*-ba-*	*-lī*	*ca-*	*rāi*	
1	2	3	4	5	6
mu-	*-ñi*				

where Punna Moyee Dassi sings *"kanu kahe rāi kahite ḍarāi"* (Krishna says, Rāi [Radha], I am afraid to tell you) (table 3.1).[22] The transcription of only the first couplet of this recorded performance demonstrates the relationship between the song text and tāl, as the six-mātrā Lophā Tāl is used to accompany this song at a relatively quick tempo. The fact that approximately each syllable of the song text lasts for only one mātrā in performance suggests a clear case of a "text-dominated" musical style that is common among so-called light genres of performance in South Asia (Manuel 1989).[23] In contrast, another method of song realization featured in so-called classical genres in South Asia is a "music-dominated" style (Manuel 1989), where a single syllable of song text is elongated over multiple mātrās in a melismatic style, found also in the large-meter forms of padābalī kīrtan.

In addition to a text-dominated musical style, there is another facet of Punna Moyee Dassi's identity communicated in this early twentieth-century record. Her connection with the baiji social sphere was marked with the alternate name used on her recordings during this period: Roma Bai. The surname Bai, linked with the term "*bai-ji*," denoted a hierarchical position in what is imperfectly communicated by the term *courtesan*. The surname Bai often referred to a female performer who solely specialized in singing, while female performers who danced or worked in

prostitution would hold a lower social standing (Maciszewski 2007, 162). However, the specific construction of hierarchy in these social contexts was overshadowed in colonial-era binaries that saw female performers as either courtesans or wives. If the *bai*-ji identity of performers such as Punna Moyee Dassi/ Roma Bai might have carried a more positive connotation in an earlier period, in colonial Kolkata women performers were often stigmatized for falling on the wrong side of the wife/courtesan "dichotomy" (Srinivasan 2006). And, as Anna Morcom argues, the courtesan role threatened the social dominance of patriarchy and the masculine-determined nationalist project in pre-independence India (2013 3). The combination of this small-tāl musical style and the socially dubious position of courtesan singers thus presented a foil for musical reformers such as Mitra, who sought to return to a golden age of male (i.e., non-courtesan) and large-meter (i.e., non-commercial) performance. There was thus a politics of musical time at work throughout Mitra's writings and speeches as he worked to distance the genre from the small-tāl style and its associations with the courtesan sphere as he emphasized the four discursive markers of the sādhaka kīrtanīyā.[24]

(1) Expert in Music (saṅgīte pāradarśī)

Brajabashi's expertise in the large-meter musical style was foregrounded in his own writings and collaborations with Mitra. Unlike previous bhadralok interest in the recovery of Vaiṣṇava padābalī song texts, Mitra's project sought to document features of musical accompaniment used for the realization of lyrical repertoire. Because padābalī kīrtan was dependent on an oral-aural system of transmission from guru to disciple, there was no uniform or widespread system of musical notation used to learn the melodies and tāls used in performance. Mitra would thus note the opportunity that presented itself when he met his musical guru: "One day, during an auspicious moment, an opportunity

Figure 3.2 Nabadwipchandra Brajabashi photo
and relics in his family home, Kolkata. Photo by
Moushumi Bhowmik.

arrived. The Respectable Pandit Nabadwipchandra Brajabashi
Mahashoy of Brindaban arrived in Kolkata. A famous instrumen-
talist and well-educated, skillful singer, such a golden, jewel-like
combination cannot be found in a book" (1948, i–ii). In Mitra's
writings, Brajabashi's musical knowledge represented an intact
genealogy of performance that had its provenance in rural sites
of Gauḍīya Vaiṣṇavism. Brajabashi had been born into a family
of kīrtan musicians in Brindaban, where he'd learned from his
father and uncle before continuing his studies with Advaita Das
Babaji.

Mitra elaborated on Brajabashi's musical skill when writing about his performances. In one instance, Mitra described a kīrtan performance he had seen at the house of Maharaj Jagadindra-nath Ray, the zamindār of Natore (present-day Bangladesh), where Brajabashi accompanied Advaita Das Babaji on the khol. According to Mitra, the combined musical texture of these two musicians at this performance was the "result of an extraordi-nary sādhana" (1333 BS [1926], 381). To underline this point, Mitra wrote of a confidential discussion he'd had with the Maharaj fol-lowing this same kīrtan performance, when the Maharaj, a noted admirer of Hindustani music, had informed him that "he had never before heard a kīrtan consisting of such slow tempos and difficult-to-attain melodies" (380). The musical skill represented in Mitra's vignette was gained through ardent sādhana and fur-ther framed how it was clearly different from the style found in the commercial recordings of ḍhap kīrtan.

Another way that Brajabashi's musical knowledge was cir-culated in bhadralok circles was in the Bengali journal *Saṅgit Vijñān Praveśikā* (*Introduction to the Science of Music*), produced in Kolkata from 1924 until c. 1948. In 1931 (1338 BS), Brajabashi published a serial in this journal that included detailed analyses of the symbols used in notating the complicated tāl system of the genre, song transcriptions, and philosophical discussions that connected padābalī kīrtan with Sanskrit musical provenance. One article in this series, titled "The Emotional Riches of Gaura-candra [Chaitanya]," presented a transcription that Brajabashi made for the padābalī song "*bimala-hema-jini, tanu anupamare!*" ("His [Chaitanya's] incomparable body surpasses the beauty of gold!").[25] In addition to a discussion of the song text, he included two forms of visual representation to communicate features of the song in graphic form: the first illustrated the relationship between the first line of the song text and the tāl used to ac-company this song, and the second represented the khol strokes used in performance. The tāl used was Madhyam Daśkośī Tāl,

and, in Brajabashi's graphic notation, it comprised twenty-eight mātrās.[26] However, the short portion of song text that Brajabashi presented was spread out over two iterations of the tāl, spanning a total of fifty-six mātrās. Studying the transliterated version of Brajabashi's representation in table 3.2 quickly demonstrates features of the large-meter musical style, as single syllables of song text are carried across numerous time units in the song.[27] Each separate table represents one iteration of Madhyam Daśkośī Tāl, and, as is common in padābalī kīrtan visual representation, Brajabashi does not include the melodic structure as part of the representation, though he does mention that the *rāg* (melody type) used for this song is Dhānasī.

Brajabashi's graphic representation reveals a musical style where single syllables of the text are spread out over several mātrās. For example, the first word in the song, *bimala,* spans six mātrās in the tāl (2–7). And in the most extreme instance of textual expansion, the syllable *re* is spread between over fifteen mātrās in performance (14–28 in table 3.2). Comparing the relationship between song text and tāl here with the ḍhap kīrtan example discussed previously underscores how features of musical style came to differentiate between styles of ḍhap and padābalī kīrtan. In Brajabashi's table the music-dominated style of the performance illustrates how the song text becomes increasingly abstract and subsidiary to the structure of the large-tāl form, thus demonstrating the musical expertise of the sādhaka kīrtanīyā.

(2) Imaginative (bhābuk)

If Brajabashi's article spoke to the sādhaka kīrtanīyā's attention to musical skill, he also wrote about the breadth of the padābalī kīrtan metric repertoire. In an appendix to a song anthology titled "Khol Performance" ("*khol bādya*," 1933), Brajabashi offered a comprehensive list of 108 tāls from the khol repertoire. In their combined attempt to document these tāls, Brajabashi and Mitra wrote at length about how this tāl repertoire was connected

Table 3.2. Relationship of text and tāl in Brajabashi's representation of "*bimala-hema-jini, tanu anupamare!*"

1	2	3	4
o	*bi-*	*-i-*	*-ma-*
5	**6**	**7**	**8**
-a-	*-la-*	*-a*	*he-*
9	**10**		
-e-	*-e-*		
11	**12**	**13**	**14**
-e-	*ma-*	*-a*	*ji-*
15	**16**	**17**	**18**
-i-	*-i-*	*-i-*	*-ni-*
19	**20**	**21**	**22**
-i-	*-i-*	*-i-*	*-i-*
23	**24**		
-i	*ta-*		
25	**26**	**27**	**28**
-a-	*-nu-*	*-u*	*a-*
1	**2**	**3**	**4**
-a-	*-a-*	*-a-*	*-a-*
5	**6**	**7**	**8**
-a-	*-a-*	*-a-*	*-pā-*
9	**10**		
-ā-	*-ā-*		
11	**12**	**13**	**14**
-ā-	*-ā-*	*-ma-*	*-re-*
15	**16**	**17**	**18**
-e-	*-e-*	*-e-*	*-e-*
19	**20**	**21**	**22**
-e-	*-e-*	*-e-*	*-e-*
23	**24**		
-e-	*-e-*		
25	**26**	**27**	**28**
-e-	*-e-*	*-e-*	*-e*

with meditative processes in Gauḍīya Vaiṣṇavism, hinting at the long-standing link between visualization and musical style discussed in the previous chapter. For meditation, Mitra argued, the use of large tāls was only one piece of the equation; just as important was the use of a slow tempo (bilambit lay) that would lengthen the duration of a performance and come to encapsulate an aesthetic preference for temporal expansion. Together, the combination of large tāls and slow tempos offered a sonic platform for another quality of the sādhaka kīrtanīyā—namely, that he was imaginative (bhābuk). In Mitra's publications, this term pointed to the relationship between a specific musical form and the process of visualizing the Gauḍīya Vaiṣṇava deities described in song texts. Underlining the correlation between a repertoire of large tāls and visualization, he elaborated on the effect they have in the sphere of padābalī kīrtan: "In kīrtan music, especially in uccāṅga kīrtan, a bilambit lay (slow tempo) has been used for a long time. . . . It gives the listener sufficient time to form a mental image (bhābibār). This means that the listener, in his or her mind, is given the time to imagine that same picture [of the līlā] that the singer has drawn. Many important kīrtan masters (ustāds) have amazed audiences by giving kīrtan arrangements in this bilambit lay" (1352 BS [1945], 56).

Descriptions of Brajabashi's performance found in bhadralok discourse throughout the twentieth century elaborate on how his musical skill was related to meditation. The following vignette demonstrates the persistent connection made between Brajabashi, musical style, and the process of visualization. As the biographer Das notes, Brajabashi performed padābalī kīrtan before the famous Bengali mystic Ramakrishna (1836–86) in 1883.[28] The performance took place at a temple in Dakshineshwar in northern Kolkata, when Brajabashi was brought to the city with one of his father's acquaintances, Nandalal Sarkar:

> Nandababu [Nandalal Sarkar] brought Nabadwipchandra
> with him to meet Paramahamsadev [Ramakrishna] in the

temple. Then, after a brief conversation, Ramakrishna or-
dered Nabadwipchandra to sing a kīrtan. While playing khol
himself, Nabadwipchandra began to sing the famous song by
Vidyāpati, "mādhaba minati karu tay" ["O Krishna {Mādhaba},
I beseech you intensely"]. Many people were in the temple. Śrī
Ramakrishnadeb, along with the entire congregation, listened
with rapt attention to this teenager's [Nabadwipchandra's]
style of singing and playing. . . . Then Śrī Ramakrishnadeb,
unaware of his external surroundings, went into an emotional
samādhi (state of trance). After being absorbed in the words
of Nabadwipchandra's singing for a long time, he returned
to consciousness. After, when the song had finished, Śrī
Ramakrishnadeb, overcome with emotion, slowly opened his
eyes and offered a blessing to the young singer. (Das 1392 BS
[1985], 272–273)

The narrative of Brajabashi's kīrtan performance and its ability to
evoke a meditative state further connected the domains of musi-
cal style and visualization in this remembrance.

(3) Dedicated to Worship (bhajanaśīla)

A third marker for the sādhaka kīrtanīyā is hinted at in Braja-
bashi's surname. Though originally from Bengal, Brajabashi's
family were temple priests in Brindaban, where they performed
image worship and other duties associated with the temple under
their stewardship. The family's adopted surname is commonly
found among temple priest-proprietors in the region and denoted
their residency (bashi) in the region of Braj. Brajabashi's family
traced this occupation back twenty-two generations (Das 1392 BS
[1985]), underscoring the family's history as part of a hereditary
line of male priests.

Descriptions of Brajabashi's attention to worship are promin-
ent throughout his life. For example, when the period of musical
instruction at Kasim Bazaar ended sometime in the late nine-
teenth century, Brajabashi returned to the Tarash Mandir in Braj,
where he took charge of the images of Radha and Krishna in the

temple: "He would perform the service to his household deity, Radha-Rasabihariji, with his own hands, including cooking and offering the food to Thakur [Krishna]; and only once in a day would he eat this offering (*prasād*). He only took a single meal every day. During the occasions of religious austerities and festivals, he was regulated and fixed [in his ritual duties]" (Das 1392 BS [1985], 269). Brajabashi's focus on kīrtan and worship further made him withdraw from features of familial life. In one description of Brajabashi's life, we hear that his attention to worship caused him to engage with his familial duties in an "apathetic manner," as "in his heart he was single-mindedly focused on God (*bhagabān*)" (270).

(4) Knowledgeable of Rasa (rasa-jñā)

The fourth discursive marker of the sādhaka kīrtanīyā that emerges in depictions of Brajabashi was his extensive knowledge of the body of rasa theory that underpinned the padābalī kīrtan repertoire. Reports of Brajabashi's knowledge of rasa described a scholarly rigor that defined his project of organizing and publishing padābalī kīrtan song anthologies. A key component of this project was Brajabashi's interpretation and implementation of a detailed system of Sanskrit-language headings and subheadings used to organize the song repertoire (see chap. 5 as well). The primary level of headings used to arrange song texts derived from the eight "divisions of the amorous mood" (*sṛṅgāra-bheda-prakaraṇam*) from Rūpa Gosvāmī's previously mentioned *Ujjvalanīlamaṇi*.[29] Emphasizing these Sanskrit-language markers referenced an erudite sphere of cultural expression and worked to connect these song texts with the theory found in Rūpa Gosvāmī's treatise.

The clearest example of this project was Mitra and Brajabashi's project to coedit a four-volume anthology of Vaiṣṇava padābalī titled *Śrī-Padāmṛta-mādhurī* (*The Sweet Elixir of Verse*). The genesis for these publications originated in Brajabashi's relocation to

Kolkata, when he brought Vaiṣṇava padābalī manuscripts that he had inherited from his father and his guru to the city. For Mitra, Brajabashi's manuscripts offered an opportunity that could not be missed: "Having seen those [manuscripts], I had wanted to publish them for a long time. I said to [Nabadwipchandra] Brajabashi Mahashoy that we should compile a song anthology. . . . Arranging the padas according to their proper order (*parjāy-ānurupa*), he has introduced his extraordinary erudition and perseverance. I have organized those songs according to my own small realization after tasting their commentaries. This is this *Śrī-Padāmṛta-mādhurī*" (Ibid., iii). These volumes offer numerous examples of Brajabashi's use of headings to organize song texts and his more general knowledge of rasa, but perhaps the most detailed work can be seen in how he categorized songs that were meant to evoke the mood of Radha's infatuation (*śrī-rādhikār-pūrva-rāga*). Songs in this category describe how Radha, having seen Krishna from afar, becomes overwhelmed with the mood of "first attraction" or "infatuation" (*pūrva-rāga*). And the overarching heading for groups of songs in anthologies would be "*śrī-rādhikār-pūrva-rāga*" ("Radha's First Attraction or Infatuation"), the first of the eight divisions of the amorous mood previously mentioned.[30] Though earlier padābalī kīrtan anthologies would use only the general heading of "*śrī-rādhikār-pūrva-rāga*" to organize songs, Brajabashi included a system of subheadings titled "*daśa daśā barṇana*" ("Description of the Ten States") (178).[31] Indeed, Brajabashi's task of categorizing specific songs within the exacting terminology of these ten subheadings derived from Gauḍīya Vaiṣṇava rasa theory yet also marked a departure from earlier padābalī kīrtan song anthologies and the sphere of ḍhap kīrtan performance. For example, each of the ten subheadings used to organize songs in the four-volume *Śrī-Padāmṛta-mādhurī* highlighted a specific "state" in a progressive sequence of increasing devotion, as listed here: *lālasā* (ardent desire), *udvega* (anxiety), *jāgaryā* (sleeplessness), *tānava* (thinness of the body), *acetana*

Table 3.3. Three couplets from *"sahaje nanīka putali gorī"* by Jñāna Dāsa

phurala kabarī urahi lola *sumeru upare cāmara ḍola*	[Radha's] braid hangs loosely on her breast, as if a fan was swinging lightly on top of a mountain.
galāya e gajamotima hāra *basana bahite guruyā bhāra*	There is an elephant pearl necklace around her neck; she feels her clothes are too heavy to carry.
aṅgula aṅguri balayā bhela *jñāna dāsa kahe dukha madana* *dela*	The ring she wore on her finger became loose like a bangle. Jñāna Dāsa says this suffering was given by Madana [Krishna].

jaḍimā (inertia), *vaiyagraya* (impulsiveness), *vyādhi* (disease), *unmāda* (dementedness), *moha* (unconsciousness), and *mṛtyu* (death) (178).

In one example of this organizational project, Brajabashi's knowledge of rasa is demonstrated in how he categorized the three couplets from the song *"sahaje nanīka putali gorī, jārala biraha-ānale tori"* ("White-complexioned Radha, who is as soft as a doll of cream, was easily burnt in the fire of separation provoked by you [Krishna]") under one of the ten subheadings known as tānava ("thinness of the body") (table 3.3).[32]

The images of loose bangles and heavy clothing index the emotional field of Radha's first attraction: she has become so infatuated with Krishna that she is experiencing bodily transformation. Yet there is an ever more detailed level of analysis hinted at here through the manner that Brajabashi categorized this song under one of the substates of infatuation: thinness (tānava). These pictures of the languishing Radha are given a new shade of meaning when placed in the order of Brajabashi's Sanskrit headings, where the pining of the young Radha for Krishna is not only an expression of the amorous mood—it is also inserted within a larger system of Sanskrit theory derived from Rūpa Gosvāmī's *Ujjvalanīlamaṇi* and given expression in Brajabashi's knowledge of rasa.

ESTABLISHING THE SĀDHAKA KĪRTANĪYĀ IN KOLKATA

The cultural template of the sādhaka kīrtanīyā communicated through these discursive markers opened a new space for bhadralok interest in Gauḍīya Vaiṣṇava performance in Kolkata and the public sphere more broadly. In addition to Śrī Braj Mādhurī Sangha, the previously mentioned school in the home of C. R. Das, Brajabashi began another school named Shankar Mitra Kīrtan Sikshalaya and was further appointed to a post of kīrtan lecturer at Ashutosh College (University of Calcutta) with the help of Mitra (Mukhopadhyay 1971, 272). Through various teaching networks, a cadre of leading bhadralok studied with Brajabashi, including Professor Nandigopal Mukhopadhyay, MA (Bangabasi College); Professor Nilamani Chakrabarti, MA (Presidency College); Indubhushan Basu, MD; Shrisacandra Roy Chaudhury (architect for the city of Kolkata); and Dilip Kumar Ray (author and composer). In addition to these Bengali figures, Arnold Bake, a Dutch ethnomusicologist and scholar of music in South Asia, also learned padābalī kīrtan from Brajabashi and performed with him on at least one occasion (Linden 2019, 81–84).

In addition to prominent male students, the school in the home of C. R. Das offered a space for women to learn padābalī kīrtan when his eldest daughter, Aparna Roy (née Debi) (1898–1972) became one of Brajabashi's leading students in the first decades of the twentieth century. That female performers were entering a respectable sphere of public performance during this period indicated some of the new roles that middle-class women (i.e., bhadra-mahilā) were adopting. As Sumanta Banerjee suggests, this shift relied on the marginalization of women performers from the courtesan sphere, which led to a twentieth-century phenomenon that "produced a new breed of women in bhadralok homes who, by their writings, cultivated patterns of behavior which displaced women's popular culture from Bengali middle

class society" (1990, 130). The positive reviews of Aparna Debi's performances shed light on the ways that padābalī kīrtan had been distanced from the courtesan sphere and linked with the category of high art with Mitra's formulation of uccāṅga kīrtan. One review of her performances from the 1930s by Hemandranath Das Gupta asserts that her kīrtan ensemble was "highly appreciated and extolled by all classes of society from High Court Judges to the common men" (1934, 157). Indeed, through public performances, participation in anticolonial demonstrations, and a robust career in the recording studio and on All India Radio, Aparna Debi's presence in the bhadralok sphere affirmed not only the success of the work that Mitra and others performed;[33] it also charted the way for middle-class women performers going forward, as will be seen in following chapters.

CONCLUSION: RURAL PASTS, URBAN PRESENT

The collaborations that defined much of the course of padābalī kīrtan in the colonial period involved both material and aspirational aims. In the case of zamindār patronage, the partnerships between kīrtan musicians and members of this landed class such as Banamali Roy illustrate the ways that a social infrastructure was key to establishing features of the expansive musical aesthetic in rural Bengal in the eighteenth and nineteenth centuries. In the case of Roy and other zamindārs, their homes and temples became sites for musical instruction and ritual practice. The figure of the zamindār in the region's political economy was crucial to the maintenance of the large-meter style throughout this period, as depicted in the performances of the itinerant musician and ascetic Advaita Das Babaji.

When Advaita Das Babaji's student Brajabashi relocated to Kolkata, the ritual and musical sphere of Gauḍīya Vaiṣṇava thought and practice became enmeshed in the promotion of the image of the sādhaka kīrtanīyā. The expression of the im-

age of the devout and musically skilled musician also marked
the entrance of padābalī kīrtan into a discussion about gender
and forms of national cultural expression in colonial Bengal. In
a reformist mode, Mitra and others assumed a middle position
between non-cosmopolitan musicians and a new elite audience
to "mediate" acts of musical promotion and reception (Chat-
terjee 1993). The stakes of this project were further established
through a language of cultural loss and degeneration, as the
bhadralok initiated a recovery of Gauḍīya Vaiṣṇava forms of
cultural expression that involved ideas about gender, nation,
and musical skill. Indeed, Mitra himself would argue that keep-
ing padābalī kīrtan from extinction "should be a national com-
mitment of all Bengalis" (1333 BS [1926], 381). The rural schools
of padābalī kīrtan mentioned previously were thus not only
sites of performance and instruction; their geographic coor-
dinates were markers of a regional nationalism that bhadralok
actors such as Mitra would evoke to mark the location of the
Bengali nation. The rural genealogy of kīrtanīyās was thus a
"usable past" in the sense articulated by Amanda Weidman in
her study of Karnatak music (2006, 103), as the conjoined fea-
tures of rurality and devotion marked a sphere of action outside
of the urban dominion of colonial subjugation. As such, the
work of bhadralok actors such as Mitra was part of a larger pro-
cess of classicization that linked padābalī kīrtan with the task
of regional cultural nationalism.[34] Rural provenance, Sanskrit
theoretical systems, and a high level of musical skill were but
some of the elements that defined padābalī kīrtan in terms of
both nation and a gendered identity. One way that the uccāṅga
kīrtan of rural provenance became marked as classical when
compared to the sphere of popular performance found in ḍhap
kīrtan was through the contrast of small and large tāls. The mu-
sical rigor of Brajabashi's abstract and music-dominated style
found in bhadralok journals marked a social distance between
the religiously devout musician and the courtesan sphere.

The bhadralok project of establishing padābalī kīrtan in Kolkata sets the stage for the next chapter and this book's shift to an ethnographic mode. In the following section I will consider the kīrtan musician Nimai Mitra, the nephew of Khagendranath Mitra and a student of Nabadwip Brajabashi who teaches features of the expansive musical aesthetic in his music studio and other locations in present-day Kolkata. Despite the opportunities offered for instruction in the city today, a younger generation of kīrtan musicians encounters limited opportunities for compensated performance and thus travel throughout areas of rural West Bengal to pursue careers in professional performance. These contexts rest on newer forms of professionalization and media production that have come to define the time-spaces of padābalī kīrtan in the twenty-first century.

NOTES

1. For more information on Nabadwipchandra Brajabashi, see Graves (2020).

2. Nimai Mitra, interview, September 28, 2011.

3. Mitra (1333 BS [1926], 378) offers an outline of these four makers.

4. Two sources that connect the village of Ranihati with the Reneti style are Mitra (1352 BS [1945], 32) and Nimai Mitra (personal communication, December 2, 2012, Kolkata). The singer Bipradash Ghosh was considered an important performer in this style (Nimai Mitra, personal communication, December 2, 2012, Kolkata).

5. Nimai Mitra suggested to me that the origins of the Mandarini style are either from the village of Mandaran (present-day district of Medinipur in West Bengal) or from the performer Sarkar Mandaran (personal communication, December 2, 2012, Kolkata).

6. The Jharakhandi style of kīrtan is from the present-day Indian state of Jharkhand and was begun by Gobinda Gokul (Nimai Mitra, personal communication, December 2, 2012, Kolkata).

7. One key location where the Manoharsāhī style was established was in the village of Moynadal, located within the present-day village of Panchra in the Bardhaman district and situated roughly one hundred kilometers to the west of the Katwa area. It was probably during the

early seventeenth century that Nrisimha Mitra Thakur established the Manoharasāhī style in Moynadal. After studying with Mongol Thakur in the Katwa area, Nrisimha Mitra Thakur established a kīrtan school in Moynadal where the Mitra Thakur lineage instructed students in the Manoharasāhī style. The Manoharasāhī style had a significant presence in Moynadal as recently as the mid-twentieth century, as Rasabihari Mitra Thakur (1868–1947), the eleventh-generation kīrtanīyā of the Mitra Thakur line, was well known throughout West Bengal as a performer of līlā kīrtan. Recordings of members of the Mitra Thakur family from the first half of the twentieth century have been preserved in the field recordings of Arnold Bake held at the ARCE in Gurgaon and in the commercial recording *Songs of Krishna*, released on Argo Records and produced by Deben Bhattacharya. The Mitra Thakur and Mongol Thakur lineages underscore some of the hereditary lines of musicians that are part of the fabric of kīrtan's early modern history, a point that continues to animate schools of performance in the present (Mukhopadhyay 1971). In addition to Moynadal, the Manoharasāhī style further spread into areas of the Murshidabad and Nadia districts in West Bengal as well the cities of Pabna and Dhaka in Bangladesh in the seventeenth through nineteenth centuries (Chakrabarty 1996, 191), slowly becoming the most common style of padābalī kīrtan throughout the Greater Bengal region. For an example of how historians have linked the two schools with the Rāṛh region, see Chakraborty (1992, 199). Another reason for the association between these two musical schools is that many historians believe that Śrīnivāsa, Narottama Dāsa's associate from Braj, was the founder of the Manoharsāhī style. For one example of this perspective, see Mitra (1352 BS [1945], 32). Another theory regarding the name Manoharasāhī is that the Vaiṣṇava Manoharadāsa created it. Chakraborty offers some arguments why this theory has generally been discredited (1995, 142). That Śrīnivāsa was present at the debut of the Gaḍanhāṭī style, coupled with the fact that his maternal village of Jajigram was located at the center of the Rāṛh region, have led many to suggest that he played a key role in the development of the school. Of course, the fact that Śrīnivāsa is held in high esteem in the hagiographical literature serves as another key reason that Gauḍīya Vaiṣṇava sources have associated his name with this widespread school of kīrtan. However, the lack of direct evidence regarding Śrīnivāsa's musical training and performance, coupled with the fact that numerous theories abound regarding who founded the style, have led some to characterize the claim that Śrīnivāsa was the originator of the Manoharsāhī style as "hearsay" (Sanyal 1989, 207). Despite this controversy, there is little doubt among historians that the Katwa

region, where the maternal home of Śrīnivāsa was located, was the regional launchpad for the Manoharsāhī style, as there are several musicians in this area whose histories are linked with the school (Chakraborty 1995, 142). Not only did Śrīnivāsa permanently relocate to the village of Jajigram in the Katwa region after returning from Braj, but Jñāna Dāsa, the prolific composer of Vaiṣṇava padābalī who lived in the village of Kandra, roughly twenty kilometers outside of Katwa, is often mentioned as being influential in the creation of the Manoharsāhī style. Two other musicians from this region linked with the genesis of the style are the musicians Raghunandana Ācārya and Mongol Thakur. The latter, based in Shrikhand (on the outskirts of Katwa), was an early link in a family lineage known for performing līlā kīrtan in Shrikhand well into the twentieth century (Mukhopadhyay 1971).

8. The sources that offer a biography of Advaita Das Babaji are Das (1955), Das (1392 BS [1985]), Mukhopadhyay (1971), and Mitra (1333 BS [1926]).

9. See, for example, Sen (1992, 110–11) and Sen (2009).

10. The title of rājā was taken as a marker that signified the social status of zamindār during the period of the Bengal Sultanate. See Hussain (2003, 106–07). The exact date of the Kheturi festival is a matter of debate. However, the c. 1574 date would mean that the region was still under the rule of the last ruler in the Bengal Sultanate, Daud Shāh Kararani. He was finally defeated in 1576 CE, and the region came officially under Mughal rule (212).

11. Padmalocan Nag was a devotee of Chaitanya and one of several zamindārs in Bengal who had been granted administrative and tax-collection rights from the East India Company after the overthrow of the last Nawab of Bengal, Siraj ud-Daulah, in the Battle of Plassey in 1757. During this period, Padmalocan Nag was thus part of a larger shift that saw many Bengali Hindus take over tax-collection duties from the Nawab's regime on behalf of the East India Company.

12. Because his musical education took place in the early decades of the nineteenth century, and his musical guru, Krishnahari Hazra, was a senior musician, his lineage of musical transmission might take us back to the mid- to late-eighteenth century, which would present a gap of little more than a century to the lifetimes of Narottama Dāsa and his associates. See Mukhopadhyay (2011, 169–70).

13. This date is based on the timeline of Brajabashi's life offered in Das (1392 BS [1985]).

14. The details of this account are found in Das (1392 BS [1985]).

15. The grandson of Kanta Babu was Rājā Harinath (1803–32), a Vaiṣṇava fond of the Gauḍīya Vaiṣṇava–themed genre of kabi-gān that was popular among the newly rich of Kolkata during the same period (Walsh 1902, 207).

16. The singer brought to the school to create a system of notation was Radhika Prasad Goswami. See Das (1955, 265).

17. This example is found in Das (1955, 286). Radhikanath Goswami was an editor of the influential Gauḍīya Vaiṣṇava periodical *Bishnupriya Patrika*. See Bhatia (2017, 128) for more information on Radhikanath Goswami.

18. See Mitra (1333 BS, 380) for a mention of uccāṅga kīrtan.

19. See, for example, Sen (1922, 335). Contemporary examples of this are documented in Sarbadhikary (2015).

20. Sishir Kumar Ghosh's response might not be surprising considering the long-held prominence and social acceptance of low-caste Gauḍīya Vaiṣṇava kīrtan musicians. For example, see Sanyal (1989).

21. The description of ḍhap kīrtan as a "light" musical style is widespread in textual and oral sources. See, for example, Mukhopadhyay (1971, 120).

22. The date the recording was made is unknown. It was first released in March 1909. See Kinnear (2000, 77).

23. See Alaghband-Zadeh (2015) for more about the associations made between gender and light forms of Hindustani classical music. See Du Perron (2002) for the links between light classical genres and eroticism that are in part supported by text-dominated musical styles.

24. The account of Nabadwipchandra Brajabashi in the following section is based on Mukhopadhyay (1971) and Das (1392 BS [1985]).

25. There is a slight discrepancy between the text of the song title as listed by Brajabashi and the text of the transcription he offers (shown in table 3.2).

26. Madhyam Daśkośī Tāl is often depicted as a fourteen-mātrā tāl (see chap. 6). However, one way of doubling the mātrā count, and thus doubling the length of the tāl, is to perform the first fourteen mātrās with resonant strokes (*guru*) and the second fourteen as non-resonant strokes (*laghu*). This creates a version of Madhyam Daśkośī Tāl consisting of twenty-eight mātrās. See Bhattacharya for a version of this in a book on khol instruction (1317 BS, 29–30).

27. The purpose of this figure is primarily analytic. Therefore, I have omitted some minor symbols from the original graph as published in the journal.

28. Ramakrishna was a religious leader among some bhadralok of Kolkata in the late nineteenth century. For more information, see Sarkar (1992) and Chatterjee (1993).

29. The eight headings are divided in two groups of four. The first four are considered indicative of the mood of *vipralambha*, or "devotion-in-separation," while the second overarching category is considered representative of *sambhoga*, or "devotion-in-union." The eight headings are as follows: *pūrva-rāga* (infatuation), *māna* (pique), *prema-vaicittya* (separation in the presence of the beloved), *pravāsa* (separation based on a distant journey), *saṃkṣipta-sambhoga* (brief union), *saṅkīrṇa-sambhoga* (union mixed with contrary emotions), *sampanna-sambhoga* (developed union), and *samṛddhimān-sambhoga* (complete and excessive union). See Rūpagosvāmī 1341 BS [1934], and chapter 5.

30. Donna Wulff translates *pūrva-rāga* as "first redness" or "first love" (1996, 76).

31. For example, see Durgadas Lahiri's *Vaiṣṇava-Padalahirī* (1312 BS [1905]).

32. The source for this verse is Brajabashi and Mitra 1948, 199.

33. For example, she was called on to sing the invocatory strains of the national song "Vande Mataram" at a gathering organized by Bengali leaders to promote the exclusive use of Khadi cloth among Kolkata residents. See "Khaddar Prochar Sampradaya" in *Amrita Bazaar Patrika*, November 21, 1922. As for her presence on All India Radio, see *Amrita Bazaar Patrika*, September 13, 1960 under "*Akashbani.*"

34. See Schofield (2010, 490) for a discussion of how the classicization process operated in Mughal India as it relates to Hindustani music.

INSTITUTIONAL PASTS AND PROFESSIONAL FUTURES: TEMPORALITIES OF INSTRUCTION AND PERFORMANCE IN CONTEMPORARY WEST BENGAL

BEHIND KHAGENDRANATH MITRA'S ENTHUSIASM FOR promoting the cultural template of the sādhaka kīrtanīyā in colonial Bengal were practical concerns. Not only did advancing the image of the religiously devout and skilled musician link a genealogy of rural musicians with the emerging history of the Bengali nation. It also was a means of connecting these musicians to bhadralok economic support and positioning them within the larger project of imagining the genre's social infrastructure. The creation of music associations such as the Śrī Braj Mādhurī Sangha represented one such attempt to coordinate an infrastructure for patronage and the image of the sādhaka kīrtanīyā, as this association assisted rural kīrtan musicians such as Nabadwipchandra Brajabashi in shifting to the urban center. As Mitra himself noted when speaking about the future of padābalī kīrtan, "Without encouragement, and in the absence of sufficient patronage, a fine art cannot become established" (1352 BS [1945], 34).

Despite attempts to establish bhadralok support, the vast majority of padābalī kīrtan musicians aspiring for public performance careers in the second half of the twentieth century could not depend on forms of urban patronage. Indeed, the performance networks created by bhadralok proponents such as Khagendranath Mitra, C. R. Das, and others were only rivulets in comparison to the rivers of support that were given to performers of Hindustani music in urban Kolkata during the early twentieth century.[1] Therefore, despite the attempt to create an infrastructure for bhadralok patronage in the first half of the twentieth century, urban interest in the genre declined significantly after c. 1950. In fact, the decade that witnessed the passing of Nabadwipchandra Brajabashi (1951) and Khagendranath Mitra (1961) might be considered a span that marks the beginning of a downward trajectory of bhadralok interest in Kolkata. In what ways, then, have padābalī kīrtan musicians forged careers since the middle of the twentieth century?

To answer this question, this chapter studies the social contexts of kīrtan in the decades since the bhadralok recovery of the genre. Shifting to ethnography, I move across three case studies to examine how the aesthetic aims of performance have been maintained and transformed across three generations of public kīrtan performers. The theme of temporality runs through this chapter as the kīrtan musicians with whom I studied, traveled, and spoke affirmed the significance of the past and the precarity of the present in their representations of the genre. The chapter begins in north Kolkata with the late Pandit Nimai Mitra, an octogenarian singer, khol musician, and guru with whom I studied; he was also the nephew of Khagendranath Mitra. Nimai Mitra studied briefly with Nabadwipchandra Brajabashi as a boy, and the contours of his career as a līlā kīrtan singer over the past fifty years underscore the continuing influence of the template of the sādhaka kīrtanīyā in the present, as the markers of the religiously devout and musically skilled performer

demonstrate the ways that retention of the genre's past direct features of his own performance and instruction. The chapter then turns to one of Nimai Mitra's students, the singer and scholar Kankana Mitra, who directs the padābalī kīrtan program at Rabindra Bharati University. Through her university teaching and writing, Kankana Mitra's approach to padābalī kīrtan outlines the contours of an instructional cultural economy in present-day Kolkata, a network of discursive and performance-based spaces that feature an emphasis on preserving features of the large-meter musical style. While the stories of Nimai Mitra and Kankana Mitra focus on the Kolkata metro region, the final section expands into the roadways of West Bengal with the two musicians Rahul Das and Dyuti Chakraborty. Though they both began studying padābalī kīrtan at Rabindra Bharati University, their careers in līlā kīrtan and, more recently, Bhagavat kathā, have brought them into networks of performance and promotion that constitute a professional cultural economy operating in rural areas of West Bengal. Rahul Das and Dyuti Chakraborty are representive of a larger demographic of musicians who work in a period of neoliberal economic transformation in contemporary India, as they produce new media forms and develop novel promotion techniques to advance their careers and act within the temporal constraints of contemporary music markets. The accounts of the instructional and professional contexts in this chapter consider how the social and musical values engendered by the bhadralok recovery have bifurcated into two overlapping yet distinct cultural economies in the present. Each of these settings is further defined by a politics of musical time that revolves around issues of temporal abundance or scarcity. One feature of this is found in how the instructional economy offers abundant time durations for learning the genre's long-duration forms while the professional economy requires musicians to adapt their performances to shortened time allowances.

The cultural economies through which kīrtan musicians move in the present underscore the various ways that musical actions are made meaningful and valuable in contemporary West Bengal. Instead of considering the cultural economy as simply a market where cultural forms are exchanged, Amin and Thrift suggest how "the pursuit of prosperity must be seen as the pursuit of many goals at once, from meeting material needs and accumulating riches to seeking symbolic satisfaction and satisfying fleeting pleasures" (2004, xiv). The theoretical frame of cultural economies in this chapter focuses on the dynamic interplay between social and economic values within various discursive and performance-based settings. For example, for a salaried professor teaching kīrtan in a university classroom, there is little difficulty in maintaining features of the large-meter musical style in a pedagogic context. Conversely, for kīrtan musicians working the professional economy, the production of economic value in a specific performance setting might require modifications to aspects of musical style and related social values. The focus on ethnography in this chapter thus aims to discuss how the production of social or economic value through musical labor depends on the specific social and historical contexts in which musicians operate (Beaster-Jones 2016; Shipley and Peterson 2012). The cultural economies where musical labor creates value are manifold, and the focus on ethnography in this chapter seeks to be "attuned . . . to the complexity and unpredictability of meaningful practices by grounding individual action and consciousness in unified and yet multiply determined social processes" (Erlmann 1996, 44).

The ways in which kīrtan musicians move between these overlapping economies is often signaled through language. The presence of an instructional cultural economy found primarily in university settings and private lessons is hinted at by the way musicians emphasize the processes of education (śikṣā) and instruction (carcā) that take place in these contexts. Some of the central areas of focus in the instructional economy include an

emphasis on the large-meter style of musical accompaniment and the genre's links with the field of Sanskrit aesthetics. Operating within the professional economy is often marked by the English-language word *professional*, a term that denotes a multivalent semantic sphere in present-day West Bengal. In some instances, a kīrtan guru might use this term to refer to the success of his or her students by proudly referring to the dozens of "professional" students who earn a living through performing kīrtan. At other times, however, an association with professionalism can carry a pejorative meaning when seen as a mode of musicking primarily based on the production of economic value; the modification of musical form in these settings was seen as standing in contrast to images of the religiously devout sādhaka kīrtanīyā that continue to dominate much of the discourse surrounding the genre. The interplay between instruction and professionalism thus underscores an ambivalent relationship between the spheres of instruction and public performance in the present, a discursive terrain that adds another facet to the careers of professional padābalī kīrtan musicians today.

The turn to ethnography, of course, highlights the role of the ethnographer. My interactions with the musicians described in this chapter differed according to the levels of cultural and professional identity of each musician. The octogenarian guru Nimai Mitra was afforded the honorific title Pandit, and, on account of this and other reasons, many interactions with him were ritually formalized, such as offering salutations when beginning a lesson, being expected to bring dakṣina, and studying and practicing the lessons he gave fastidiously. Nevertheless, my initial meetings with him were different from what James Kippen describes in other circles of musical instruction in north India, where there was significant skepticism on the part of the musical teacher toward the foreign student (2008, 125–6). Far from being questioned about why I would want to study khol and padābalī kīrtan, and what I would do with this knowledge, Nimai Mitra clearly

expressed pleasure regarding my intentions to study this genre and repertoire. Of course, one reason for this might be linked with the decades-long history of non-Indian practitioners of Gauḍīya Vaiṣṇavism from ISKCON in West Bengal who study facets of devotional music and religious practice.[2] When studying with Nimai Mitra lessons would stretch on for hours, and I stayed for the lessons of other singers and would accompany them on the khol. Though my presence as an interested foreigner was not an overt focus during these sessions, when Nimai Mitra rebuked a singer for missing a previous lesson, to my own embarrassment he would often use my presence as part of his complaint, inquiring why a student from an hour away could not make it to his house while I had traveled from the United States. My relationship with Dr. Kankana Mitra was less formally structured by facets of religious ritual and more grounded in our shared academic interest in padābalī kīrtan. She was a full-time university professor but still found time for lessons in her private home with me every weekend during my time in Kolkata. I was closest in age with professional kīrtan musicians such as Rahul Das and Dyuti Chakraborty, whom I traveled with throughout West Bengal and took several lessons with as well. They were eager to assist me in my research, though it was more challenging for them to find time for this on account of their busy travel schedule. There were also discussions about how I might be able to further their careers by organizing events and performances in the United States, a shared interest that has led to ongoing projects.[3]

STUDYING THE EXPANSIVE MUSICAL
AESTHETIC IN NORTH KOLKATA

An important node in the network of padābalī kīrtan instruction in contemporary West Bengal is the home of Nimai Mitra in north Kolkata. Less than one kilometer from the Sobhabazaar-Sutanuti Metro station, his residence indexes a relationship with

one of the three original villages (i.e., Sutanuti) where the British East India Company established the city of Kolkata beginning in the late seventeenth century. This neighborhood is situated near the bank of the Hooghly River and linked to the Bay of Bengal; during the colonial period this area was further marked as part of Kolkata's indigenous Black Town discussed in chapter 3. At the turn of the twentieth century, when Nabadwipchandra Brajabashi arrived in the city, the population of the entire Kolkata metro area was about 1,000,000 people. Today, the same area contains a population of about 14,630,000. Symptomatic of what is termed an Asian megacity, present-day Kolkata is defined by a continually increasing population adjusting to a fixed geographic area (Nijman and Shin 2014, 147). Indeed, the shrinking spaces of the dense neighborhoods of north Kolkata viscerally confront one passing through this congested residential area developed ad hoc in the late nineteenth and early twentieth centuries.

Throughout the years I knew Nimai Mitra—from 2011 until his passing in 2021—musicians from across West Bengal traveled to his house in north Kolkata to study padābalī kīrtan. Upon arriving at his apartment building for my lessons in 2012, I followed a wide staircase to the second story, where I reached Nimai Mitra's one-room living space that he shared with his family. Here, musicians and friends met and relaxed before and after lessons. Above a bed that occupied a large part of his room, the walls were covered with photos that evidenced a long career in padābalī kīrtan performance; other images scattered across the room showed Nimai Mitra during līlā kīrtan performances around West Bengal. Performance photos were surrounded by publicity shots and framed awards given by government and cultural institutions. One photograph displayed prominently above his bed showed him dressed in performance attire, his forehead and upper body marked with Gauḍīya Vaiṣṇava symbols made of clay (*tilak*) and wearing necklaces of sacred wood (*tulsī mala*) (fig. 4.1). Another photo near the ceiling displayed one of his kīrtan gurus, Nanda-

Figure 4.1 Nimai Mitra in his room and photo of Nandakishor Das.

kishor Das, a prominent musician and teacher in West Bengal in the second half of the twentieth century (fig. 4.1). Behind his bed was a storage cabinet filled with songbooks, cassettes of his performance recordings, and documents and awards from his career.

Nimai Mitra taught in a cinderblock room on the roof of this north Kolkata building. Against one wall of the room, he sat positioned behind a harmonium, flanked by a cabinet filled with anthologies of Vaiṣṇava padābalī and a cassette recorder. For several hours each morning and evening, Nimai Mitra sat here to teach students who would come from across the urban Kolkata region and from throughout the state of West Bengal. Small marble images of Radha and Krishna occupied a wooden altar-like piece of furniture in one corner of his music room (fig. 4.3). Krishna held a flute to his lips, and Radha leaned close. The two images were draped in shiny clothing and surrounded by fresh flowers that Nimai Mitra and family members offered every morning, demonstrating a dedication to image worship (*bhajanaśīla*) found

Figure 4.2 Images of Radha and Krishna in Nimai Mitra's music room. Photo by the author, 2012.

in the earlier histories of the sādhaka kīrtanīyā. Pictures of his guru and Chaitanya flanked the white marble figures on the worship platform, and an image of Krishna as a young butter thief sat in the front, his wide eyes staring at those who crossed into this space. When students entered the music room, they first bowed their heads to the ground in front of the images of Radha and Krishna and then repeated the same respectful ritual before Nimai Mitra by reaching out to touch his feet.

NIMAI MITRA'S MUSICAL TRAINING
AND PERFORMANCE CAREER

Though Nimai Mitra was not from a hereditary kīrtan family, his boyhood household was known as a meeting place for musicians. It might not be a surprise that his uncle, Khagendranath

Mitra, and his father, Narendranath Mitra, encouraged his interest in kīrtan. "As a small boy in our house," he recounted, "I saw many famous music artists. [And] my father gave many kinds of assistance and encouragement to all of them. Because he was a topmost Vaiṣṇava and kīrtan enthusiast, his only wealth and interest was to spread and publicize kīrtan" ("Nimai Sannyasa," n.d.). These connections led to an early start in kīrtan education; Nimai Mitra began to study khol at the age of eight with the musician Jatin Das and singing with Radharaman Karmakar, a singer from Nabadwip who would travel to teach in Kolkata.[4] Of course, another early figure in his musical education was Nabadwipchandra Brajabashi, whose musical legacy loomed large in his imagination; Nimai Mitra would often recount how Brajabashi had brought the large-meter musical style to Kolkata from the Braj region in the early twentieth century. In one remembrance of him, Nimai Mitra recounted the advice he had received from Brajabashi: "Hey you, kid, it will take some time to understand ... music. You should grow up, then it will be possible to know how to perform [instrumental] accompaniment [with the khol]. It is a subject comprised of rasa, no?"[5]

Nimai Mitra's earliest performance opportunities took place within the network of musical instruction that was formed through the sphere of bhadralok interest in padābalī kīrtan. One of Nimai Mitra's earliest memories from his public performance career was accompanying Aparna Debi at the meetings of the Śrī Braj Mādhurī Saṅgha mentioned previously: "My father ... together with Roy Bahudar Khagendranath Mitra, all of them belonged to the same group [Śrī Braj Mādhurī Saṅgha]. I was young then. I don't remember very well. [But] my father loved this ... [so] he would take me along. . . . I would play khol by myself. I was a young boy and would be dressed up nicely, and I would sit there and play khol. That drew a lot of attention."[6] Despite the relatively robust opportunities he had for learning kīrtan in the urban center, Nimai Mitra's public performance career required

extensive travel. Beginning in the 1970s, he led a kīrtan ensemble that presented līlā kīrtan performances throughout West Bengal and north India. These were events where his ensemble was the featured group, receiving payment from the patron or committee sponsoring the event. At the height of his career in the 1970s and '80s, Nimai Mitra's group would give as many as forty līlā kīrtan performances in a month. During busy times in the year, especially on Gauḍīya Vaiṣṇava festival days, he recounted, his group would offer two or three performances in a single day. His exhausting travel schedule not only crisscrossed the state of West Bengal but further ventured into other areas of north and northeast India: "We had to travel by car: today, Midnapur, tomorrow, Bankura, next day, Birbhum, next day, Murshidabad, next day, Bihar, [followed by trips to] Uttar Pradesh, Orissa, even as far as Shillong [in the northeastern state of Meghalaya]."[7] The intensity of his performance schedule was such that his accompanying musicians "would search in my diary for blank dates, so that they could get some leave."[8] Not only was his busy schedule focused on a succession of one-time trips across north India, but his constant engagement as a traveling musician was, as he notes, because "audiences loved my singing. Otherwise, why should they repeatedly invite the same artist to the same place the next year, or again the following year? [In some cases] I have performed at the same gathering for thirty-three years. . . . This is an immeasurable blessing given by God (bhagabān)."[9] The intensity of Nimai Mitra's touring schedule suggests that he was keenly aware of how to further his own career. As the leader of the kīrtan ensemble, he organized a series of performances to maximize the earning potential of his group, a fact compounded by the constraints of seasonal travel in Bengal. For example, traveling musicians target the period from January to June each year as the busiest time for scheduling līlā kīrtan performances because it avoids spells of intense heat and the annual monsoon. The autonomy involved in determining a performance schedule in Nimai Mitra's career

might not be seen as an inevitable development; rather, it underscores how musical performance and time were linked in the ways that kīrtan musicians were entering new contexts for performance during the second half of the twentieth century. Not only were kīrtan musicians beginning to sell their musical knowledge; they were also reconfiguring their travel schedules to sell their time, which was commensurate with a certain economic value they would receive from a patron.[10] Nimai Mitra's busy touring schedule and constant traveling presaged the current situation of musical labor in Bengal, where musicians earn their livelihood through negotiating a fee for the time of a performance in a live-music market, though within a series of relatively new temporal constraints.

Nimai Mitra's success as a public performer was not only due to his singing. In a multi-hour līlā kīrtan performance, he featured the expansive musical aesthetic through a combination of singing, storytelling, and dance to depict features of Radha and Krishna's divine play. The social value of storytelling has remained central to the way musicians craft their performances in the present, a point made evident in Nimai Mitra's instruction. In numerous lessons in his music room, he dedicated significant time to teaching students how to link one song with one another through the presentation of the līlā's narrative and didactic speeches. In līlā kīrtan scripts that he had published, and in the copious notes that students made in lessons, he presented detailed instructions on how to insert storytelling segments to connect one song with another and advance the narrative of the performance. Indeed, in the dozens of lessons I attended, a recurrent focus of his instruction was guiding students in the process of effectively linking songs and storytelling to depict a specific līlā. The multi-hour līlā kīrtan performances that students would learn offered opportunities to perform at music festivals, temple events, or other settings where this mixed mode of song and storytelling was in demand. To be sure, musicians often achieve

success in the professional economy on the strength of their sto-
rytelling prowess, as the narrative mode often carries a greater
value than adhering to the abstract rules of music theory that
dominate the instructional economy.

STUDYING TĀL

I studied khol and tāl theory more generally in the *guru-siṣya*
(teacher-student) system with Nimai Mitra. During my fieldwork
between 2011 and 2012 and on later trips to Kolkata, we met sev-
eral days a week in his north Kolkata music room. These lessons
involved detailed study of the padābalī kīrtan tāl system, which
included learning the abstract categories of mātrā, the manner
in which they were combined to form larger metric structures,
and the various forms of pedagogical and performative repertoire
used with the khol. What came into focus in these lessons was
the value placed on theoretical structure and the internal variet-
ies found in the genre's tāl system. Indeed, the sheer number
of individual metric patterns introduced in our lessons under-
scored how studying tāl theory is central to learning features of
the genre. As a point of contrast with other musical styles in north
India, the emphasis on tāl in padābalī kīrtan overshadows the
prominence of melodic theory and practice found in rāg-based
music to the extent that Nimai Mitra would unambiguously sug-
gest that "kīrtan's influence derives from tāl." The abundance
of time in pedagogic settings that allowed for discussions and
lessons about music theory were key to learning features of the
large-meter style and working toward realizing this statement.

The statement "what is tāl?" was a rhetorical question that
marked the beginning of kīrtan lessons with Nimai Mitra.[11] An-
swers to this question formed a significant part of our discussions
as we studied the practical dimensions of music theory and the
"symbolic systems for conveying musical knowledge" (Roeder
2011, 3). Although we began with practical, hands-on exercises for

developing drumming competence found in the division of reper-
toire known as *hasta sādhana* (hand practice), our conversations
frequently veered into the conceptual substratum lying beneath
the sounds of musical performance. In other words, learning tāl
theory was only partly about studying formal systems that would
lead to the ability to re-create patterns of musical sound. Another
facet of this education was to learn an intricate system of taxono-
mies that itself carries value in the work of musical transmission.

One social value that defines the parameters of tāl theory is
based on a quantitative assessment. Large tāls, defined by rela-
tively large mātrā counts, are often afforded a greater social value
in discourse than short tāls. Indeed, features of the large-meter
kīrtan style carry a heightened value in a hierarchy of musical
skill, and musicians who possess theoretical and practical knowl-
edge of this style are afforded a place of privilege. In contrast, one
way that a kīrtan musician might be disparaged in discussion
would be through the claim that he or she only knows "small
tāls." A repeated point of study in my lessons with Nimai Mi-
tra was a focus on the history and repertoire of the large-meter
musical style. In lessons, then, we spent a significant amount of
time studying the detailed structures of large tāls, such as the
twenty-eight-mātrā Som Tāl and Kāṭā Daśkośī Tāl, or the forty-
four-mātrā Śaṣīsekhar Tāl. One might even characterize the time
spent on this repertoire as disproportionate to more practical
concerns, as these large tāls figure less prominently than shorter
ones in the context of a līlā kīrtan performance.

The currency of the large-meter style is not only measured in
the quantitative register. Rather, ideas about musical duration
and tempo that are built into the large tāls and theoretical struc-
ture are connected to discussions about its affective influence. A
recurrent idea that Nimai Mitra explained in connection to the
large-meter style was how this repertoire was linked with pro-
cesses of "meditation" (*dhyān*).[12] The features of temporal dura-
tion that result from the combination of large tāls, such as Som

Tāl, and slow tempos in performance are associated with the time needed to visualize the līlās of Radha and Krishna described in song texts. Nimai Mitra's assertion that a connection exists between a long temporal duration and meditation underlines the way that musical style is synchronized with features of Gauḍīya Vaiṣṇava devotional practice.

Though our meetings took place in the music room on the roof of his apartment building, Nimai Mitra was formulating plans to expand his ability to teach padābalī kīrtan in Kolkata. In 2013, he registered the Kirtan Charyashram: Baisnab Literature and Cultural Centre (school/retreat for the study of kīrtan) with the West Bengal state government, a project that is currently seeking donors for procuring land and developing a school with housing in the Kolkata metro region.[13] His work to establish this school was part of the larger focus on aspects of the instructional cultural economy that not only provide time-spaces for study but further work to establish the social values that foreground features of performance and theory connected with this repertoire. Though the framed registration form hung on the wall of his music room, displaying the authorizing stamps of the West Bengal government, Nimai Mitra explained to me in February 2020 that the project was temporarily halted until more donations could be raised.

Though Nimai Mitra enjoyed a relatively long career as a public performer throughout West Bengal, he had retired from the arduous travel schedule that had defined his earlier career. Of course, Nimai Mitra had more pressing concerns when I met him last in February 2020. He was recovering from a stroke, which had put his work of teaching a new generation of performers on hold. Nevertheless, he had clear links to the instructional and professional cultural economies that define the present-day landscape of kīrtan performance in Bengal; another key node in the network of the instructional economy in the present is found in the context of kīrtan lessons at Rabindra Bharati University in Kolkata.

Though Nimai Mitra was not on the music faculty there, he did serve on several advisory and exam committees at the university. Moreover, he played a role in the hiring of the university's only full-time faculty teaching padābalī kīrtan: his student Kankana Mitra. In lessons at Rabindra Bharati University, Kankana Mitra focuses on teaching students features of the large-meter musical and kīrtan's relationship with the sphere of Sanskrit aesthetics, two features that define the social values that constitute the instructional economy in the present.

THE INSTRUCTIONAL CULTURAL ECONOMY
AT RABINDRA BHARATI UNIVERSITY

Today, Rabindra Bharati University's Emerald Bower Campus is situated only four kilometers north of Nimai Mitra's house in north Kolkata. As I arrived to visit with Kankana Mitra and her class in 2012, the campus gate served as a border between a deluge of busy traffic and a quiet, verdant university campus. On the outside was the Barrackpore Trunk Road, a north-south route congested with buses, cars, and motorcycles throughout the day. On the inside, however, one entered a large, green field that spread out across the line of sight. A large statue of the Nobel Laureate poet Rabindranath Tagore stood on the edge of the campus field as I entered, commemorating the fact that Rabindra Bharati University was originally founded in 1962 to mark Tagore's birth centenary. Tagore's memory also influenced the development of the school's curriculum, which has focused on expressive forms of dance, drama, and music since it was first established. Though kīrtan instruction represents only a minor part of the music curriculum, as most of the instruction is in Hindustani music and the eponymously named genre Rabindra Sangeet (music and songs of Rabindranath Tagore), a small kīrtan faculty has remained at the school throughout the second half of the twentieth century into the present. Notable kīrtan scholars and instructors at

Rabindra Bharati University have included the author and performer Mriganka Shekhar Chakraborty, the singer Brindaban Banik, and the noted khol musician Manoranjan Bhattacharya. Indeed, the instruction that has taken place at Rabindra Bharati University has had a significant influence on the trajectory of padābalī kīrtan performance in West Bengal over the course of the past several decades, as many noted performers studied formally and informally with university faculty.[14] University instruction thus influences the professional cultural economy, as a significant number of contemporary professional kīrtan musicians studied at Rabindra Bharati University or took private lessons from university faculty.

Classes in padābalī kīrtan at Rabindra Bharati University are part of the vocal music degree track. Through discussions with students during my visits there in 2012, I learned that most students who take kīrtan lessons are focusing on Hindustani vocal music or Rabindra Sangeet. Nonetheless, the students who take lessons with Kankana Mitra are serious about the work, which requires them to learn a new system of tāl to be able to learn features of vocal performance. In discussions with me, Kankana Mitra defined the social value of padābalī kīrtan as a form of "regional classical music."[15] This formulation surely seeks to borrow some of the capital that the term *classical* carries with it from the sphere of Hindustani music, which is, of course, often referred to as north Indian classical music; however, it further signals how attempts to redefine padābalī kīrtan as uccāṅga kīrtan in the colonial period have informed present-day definitions of the genre as a form of expressive culture linked with the domain of regional cultural nationalism. Most students studying padābalī kīrtan I met at Rabindra Bharati University were young women from middle-class families in West Bengal. Though there has been a surge in the number of female kīrtan singers performing in the professional sphere in West Bengal, the young women studying at Rabindra Bharati University, for the most part, would not be the

ones establishing their own traveling kīrtan ensembles.[16] Rather, they were exploring padābalī kīrtan as part of a larger study of Bengali and north Indian vocal music in their pursuance of a university degree.

The focus on studying the large-meter musical style at Rabindra Bharati University was demonstrated during one class I attended in December 2012 (fig. 4.3). On that day, four students sat waiting in the classroom for the lesson to begin. On a raised platform at front of the room, Kankana Mitra sat with the khol accompanist Shib Prosad Paul. After a short introductory warmup with a *ṭuk pad*, a partial verse, the focus of the lesson turned to the song *"māna-biraha-jvare pahun bhela bhora"* ("In the mood of separation induced by pique, many months passed"), performed in the large-meter style with the twenty-eight-mātrā Som Tāl. This song, *"māna biraha,"* is from the līlā kīrtan known as "Kalahāntaritā," a common story focusing on Radha's dejected mood that was the result of a quarrel she had with Krishna. This particular Gaura-candrikā song of course presented the image of Chaitanya, but it was a Chaitanya who had adopted Radha's mood in this instance, and not the more common case of when he assumes Krishna's identity. As is common with the Gaura-candrikā repertoire, the song began with a decidedly slow tempo and melismatic melody stretched out across the twenty-eight-mātrā tāl. Though this was not their first time performing this song, the students were still unsure about how to synchronize their singing with the slow-moving tāl structure. The khol musician, Shib Prosad Paul, marked out the structure of the tāl with a sparse time-keeping pattern, and while singing, the students glanced back and forth between their notebooks and the instructors, marking the tāl structure through a series of hand claps and gestures, trying to match these movements to Kankana Mitra's left hand, which was pumping the harmonium and marking the passage of the tāl. As the song progressed, however, the relationship between the khol musician and the students' singing

became increasingly tenuous, eventually falling out of sync. The performance abruptly stopped, and Kankana Mitra asked, "What happened?" Mitra then informed the students that their hand movements were not deliberate enough. She counted the correct tempo aloud while also executing the corresponding hand gestures: "One, two, three, four." Each gesture ended forcefully and deliberately at a final resting point as she counted the tāl; "This way!" she exclaimed. As a way of imitating the students' incorrect method, she counted again and loosely waved her hand through the air. These motions clearly lacked the same intentionality as the gestures that had marked her performance. The students began the song again, this time attempting to mirror the same deliberate hand motions as their teacher.

The focus on the large-meter style I witnessed in classes at Rabindra Bharati University hints at Kankana Mitra's early studies in padābali kīrtan. When discussing this with me, she mentioned how she would always ask the guru with whom she studied to teach her rare large-meter-style songs. This continued interest is evident in her teaching; for example, the ṭuk-pada song that began the lesson mentioned above was performed in Indrabhāṣa Tāl (twenty-six mātrās) and is considered one of only two extant songs that use this tāl in the entire padābali kīrtan repertoire. Her desire to learn songs such as this in the large-meter musical style led her to study with numerous gurus throughout West Bengal. In addition to Nimai Mitra, she studied with Bangshidhari Chakroborty, Manoranjan Bhattacharjee, and Brindaban Banik, three kīrtan teachers who formerly taught at Rabindra Bharati University. She further emphasized that the repertoire she studied with these gurus represented the "original songs," or the "root" of padābali kīrtan. To draw a contrast, she further defined these songs as not "fusions" that express features of a "modern singing style."[17] Indeed, a common theme that emerged in my lessons and discussions with Kankana Mitra was her affirmation that teaching and studying padābali kīrtan required a process of

Figure 4.3 Padābalī kīrtan lesson at Rabindra Bharati University with Kankana Mitra (harmonium) and Shib Prosad Paul (khol). Photo by the author, 2012.

unearthing its connections with the past through an analysis of its links with Sanskrit musical and aesthetic theory, two wellsprings of thought often invoked in the construction of padābalī kīrtan's temporal imaginary.

One instance of this is found in the features of the padābalī kīrtan repertoire studied in the classroom. In the case of songs from the Gaura-candrikā repertoire, such as *"māna-biraha-jvare pahun bhela bhora,"* there is a specific formal principle found across these songs in Manoharasāhī kīrtan: each couplet in the song moves progressively from larger tāls to smaller ones, and a variety of different tāls are used to accompany the various lines of song text. In one common form found in the Manoharsāhī style, the first line of the first couplet of the song is set to the twenty-eight-mātrā Som Tāl while the second line of the first couplet

Table 4.1. Gaura-candrikā Tāl form

	Som Tāl							
First half-couplet →	**1** (tāl/ sam)	**2** (kāl)	**3** (phānk)	**4** (kāl)	**5** (kol)	**6** (kāl)	**7** (phānk)	**8** (kāl)
	9 (tāl)	**10** (kāl)	**11** (phānk)	**12** (kāl)	**13** (kol)	**14** (kāl)	**15** (phānk)	**16** (kāl)
	17 (tāl)	**18** (kāl)	**19** (phānk)	**20** (kāl)				
	21 (tāl)	**22** (kāl)	**23** (phānk)	**24** (kāl)	**25** (kol)	**26** (kāl)	**27** (phānk)	**28** (kāl)

	Madhyam Daśkośī Tāl			
Second half-couplet →	**1** (tāl/sam)	**2** (phānk)	**3** (kol)	**4** (phānk)
	5 (tāl)	**6** (phānk)	**7** (kol)	**8** (phānk)
	9 (tāl)	**10** (phānk)		
	11 (tāl)	**12** (phānk)	**13** (kol)	**14** (phānk)

	Jhānti Tāl						
Couplets 2-5 →	**1** (tāl)	**2**	**3** (kāl)	**4**	**5** (phānk)	**6** (kāl)	**7**

	Lophā Tāl					
Couplet 6 →	**1** (tāl/ sam)	**2** (kāl)	**3** (phānk)	**4** (kāl)	**5** (kol)	**6** (kāl)

uses a fourteen-mātrā tāl (in this case Madhyam Daśkośī Tāl; table 4.1).[18] After the first couplet, the song uses a seven-mātrā tāl, Jhānti Tāl, which accompanies the remainder of the song except for the final couplet, which uses the six-mātrā Lophā Tāl. In other iterations of this form, various fourteen-mātrā tāls might be used and shorter four-mātrā tāls might also accompany the final couplets.

One way that this specific form is defined in the instructional context is through underscoring its links with an older sphere

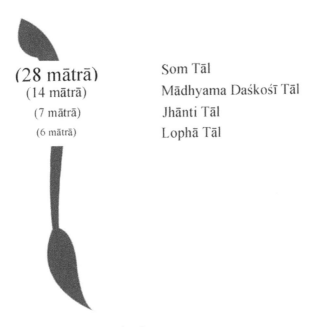

(28 mātrā)
(14 mātrā)
(7 mātrā)
(6 mātrā)

Som Tāl
Mādhyama Daśkośī Tāl
Jhānti Tāl
Lophā Tāl

Figure 4.4 Go-puccha form.

of Sanskrit theory. The reduction in the mātrā count for each tāl in this form can be correlated with a spatial reduction in size, from large to small, that occurs as one traces a cow's tail from its base to its tip (fig. 4.4). Kankana Mitra thus referred to this particular structure used for the Gaura-candrikā repertoire as the *go-puccha* form, or the form of the "cow's tail." Mentioning the go-puccha classification worked to identify this form within the sphere of Sanskrit musical provenance, as she further described the go-puccha form as emblematic of the "*mārga* tāl system."[19] As descriptions of the go-puccha term and concept date to the earliest Sanskrit treatise dealing with music, Bharata's *Nāṭyaśāstra* (c. 100–500 CE), linking the Gaura-candrikā form with the mārga tāl system makes a connection between contemporary kīrtan performance and Sanskrit music theory. Moreover, in both premodern and modern periods, the term mārga has often functioned as a gloss for both a long history and a sense of

authoritativeness. In Sanskrit treatises, the term mārga, contrasted with its binary *deśī* (regional), often suggested an "ancient music of divine origin" (Widdess 1994, 94). The work of mentioning these two Sanskrit musicological terms not only traces a specific cultural heritage but is part of linking features of musical style with the temporal ontologies—musical time 3—that mark out large intervals of music history.

It might not be surprising, then, to find a corresponding ethical stance directed toward deviating from this musical form, as Kankana Mitra explained: "The starting tāl is a long tāl, [containing] 28 beats [mātrās]. Then we have to perform the 14-beat [tāl]; then the 7-beat [tāl]. . . . So we have no option to come back to the tāl with 28 beats. This structure is an ancient form in our tāl system. . . . It is [called] go-puccha which is a mārga tāl system."[20] A clear ethical stance is thus linked with features of musical form, and deviation from the tāl structure in the Gaura-candrikā repertoire would seem to violate the social value that links kīrtan with an older sphere of Sanskrit music theory.

In addition to focusing on the large-meter musical style, Kankana Mitra's research also explores the relationship between Sanskrit aesthetic theory and padābalī kīrtan. Though this topic was explored in her PhD dissertation, titled "An Aesthetic Survey on Rasa Kīrtan from Sixteenth to Seventeenth Century AD,"[21] this interest is more recently documented in her composition of an entire līlā kīrtan script titled "Śrī Rādhār Aṣṭanāyikā Lakṣana" ("Radha as the Eight Types of the Heroine"). The title for this script draws on the aesthetic framework known as the "Eight Types of the Heroine" (*aṣṭanāyikā*), which outlines a series of situational and emotional episodes of a dramatic heroine that adhere to an eightfold structure originally codified in Bharata's *Nāṭyaśāstra*. The script mixes padābalī kīrtan songs, Sanskrit verses, and storytelling and didactic speeches (kathā) to depict a līlā where Radha experiences this series of eight different emotional-dramatic states (see table 4.1). The story follows her

Table 4.2. The eight types of the heroine

Eight Types of the Heroine (nāyikā)	Description
1. *abhisārikā*	The heroine, possessed by love, abandons shyness and modesty and goes to meet her lover, forsaking social convention.
2. *vāsaka-sajjā*	The heroine who happily adorns herself and eagerly awaits amorous union with her lover.
3. *virahotkaṇṭhitā*	The heroine who becomes anxious because her lover does not arrive at the appointed time.
4. *vipralabdhā*	The heroine whose lover does not arrive at the appointed time feels disappointed and betrayed.
5. *khaṇḍitā*	The heroine who becomes enraged learning that her lover did not arrive because of being with another woman.
6. *kalahāntaritā*	The heroine who is separated from her lover because of a quarrel. After her lover leaves, she feels remorse.
7. *proṣita-bhatṛkā*	The heroine, whose lover is far away on a journey, thus feels lethargic and cannot sleep.
8. *svādhīna-bhatṛkā*	The heroine's lover is under her full control.

through her anticipation for a nighttime tryst with Krishna, her disappointment when he does not arrive, a period of pique, and a final reconciliation.

Though the earliest source text for the eight types of the heroine may be the *Nāṭyaśāstra*, the more immediate point of reference for Kankana Mitra's script was Rūpa Gosvāmī's *Ujjvalanīlamaṇi*. In her līlā kīrtan script, she combines songs, Sanskrit verses from the *Ujjvalanīlamaṇi*, and portions of Bangla kathā to describe the acts and emotional moods of Radha as she progresses through each of the eight types of the heroine. Each of these modes of song and storytelling, Mitra suggests, illustrate the "emotional structure" of Radha's mind: "In Radha there are different types of emotions that were aroused when she tried to

meet with Krishna. . . . In this time span, Radha [experienced] eight types of emotional arousal. These are called: *abhisārikā, vāsaka-sajjā, utkaṇṭhitā, vipralabdhā, khaṇḍitā, kalahāntaritā, proṣita-bhatṛkā,* and *svādhīna-bhatṛkā.* . . . When [Radha] wants to meet with Śrī Krishna . . . the *emotional structure* of her mind is called abhisārikā. . . . What she was doing at that time . . . is called abhisārikā."[22] The musical and storytelling expression of Radha as the abhisārikā nāyikā begins in Mitra's script with the following Bangla text, meant to be memorized and read out loud: "Only by hearing the sound of Śrī Krishna's flute, Radha fell into the trance of abhisārikā nāyikā. Who is the abhisārikā nāyikā? In the scripture *Ujjvalanīlamaṇi,* Śrī Rūpa Gosvāmī has written" The script then instructs the kīrtan musician to intone Rūpa Gosvāmī's Sanskrit verse from *Ujjvalanīlamaṇi* describing the abhisārikā nāyikā:

> *yābhisārayate kāntaṁ svayaṁ vābhisaraty api/*
> *sā jyautsnī tāmasī yāna-yogya-veṣābhisārikā//*
> *lajjayā svāṅga-līneva niḥśabdākhila-maṇḍanā/*
> *kṛtāvaguṇṭhā snigdhaika-sakhī-yuktā priyaṁ vrajet//* (5.71–72)

"She who either invites her lover or approaches him alone is an abhisārikā. She is one who approaches her lover during moonlit nights or in the dark, and she wears clothes suitable for her mode of movement. It is as if she is merged in her own body out of bashfulness, and all her ornaments are silent. She may approach her lover with a single bosom girlfriend."

Because most of the audience would not understand Sanskrit, the script then offers a Bangla translation of this verse to be read by the performer: "The meaning is: that heroine whose lover comes to meet her, or goes herself to meet her lover, she is called abhisārikā. This heroine, at the time of going to meet her lover, becomes ashamed. Her bangles and the bells on her feet remain silent; and she wears a veil while going to meet [her lover]. For example, here she [Radha] goes to meet [her lover] in the light of the full moon." This last sentence is meant to evoke a theme from

the song that comes next in this līlā kīrtan: *"cāndbadani dhani calu abhisāra,"* a text that illustrates the mood of the abhisārikā nāyikā through both the original song and ākhar texts.[23]

pad: *cāndbadani dhani calu abhisāra/ nava nava raṅgini raser pāthār*
"The moon-faced one [Radha] went for a meeting, [to experience] newer and newer rasa"

ākhar: *abhisāre cale dhani/ laye āge saba saṅginī/ cale śyāma abhisāre*
"She [Radha] goes for a meeting with all her companions; she goes to meet with Śyāma [Krishna, the dark-one]"

pad: *karpūr candan saṅge birāja/ mālatīmāla hiye bani sāja*
"Her body was scented with camphor and sandalwood paste, and she was wearing a garland of mālatī flowers, hanging in the center of her breast."

ākhar: *āj kata māja sejecche/ ganda puṣpa candane/ kṛṣṇa-manohārinī*
"Today she [Radha] decorated herself with a flower garland and sandalwood paste; she is the one who steals the mind of Krishna"

Interweaving Sanskrit verses, explanations in Bangla, and song performances is common in līlā kīrtan performances and not unique to Kankana Mitra's script. Moreover, the importance of imagining Radha through the eight types of heroine found in Sanskrit treatises is a well-worn path in the historiography of padābalī kīrtan (Prajnanananda 1970, 127–29). However, composing a script that fastidiously tracks Radha through the eight types of the heroine does represent Mitra's keen interest in explicitly linking performance with the linguistic categories of Sanskrit aesthetics. The specific use of Sanskrit terminology here underscores the ways that language features in forms of religious thought, which, as Eisenlohr notes, often works to minimize features of "temporal disjuncture" that are wedged between our

present and a sacred past (2015, 284). Kankana Mitra's work of reemphasizing Sanskritic categories in the composition of her līlā kīrtan script thus illustrates one way that language mediates the presentation and experience of expressive culture in the case of kīrtan.

In its premier performance in Kolkata in 2011, the script for "Śrī Rādhār Aṣṭanāyikā Lakṣana" was performed by a group of Rabindra Bharati University students. Kankana Mitra described to me how this three-hour event, performed in Kolkata, was specifically focused on attracting an urban and educated audience to the genre of līlā kīrtan through emphasizing the archetypes of the eight heroines. Indeed, one reason that this framework might attract such an audience is that this archetype is found in a variety of other drama and dance forms.[24] The attempt to link present-day performance with a past chronotope through the use of Sanskritic music and aesthetic theory continues the work of the bhadralok recovery of kīrtan mentioned previously and further locates the genre in the instructional cultural economy of the present. Her teaching position at the state-funded Rabindra Bharati University, as one of the only full-time professors of padābalī kīrtan at any institution in India, underscores the fact that there are very few opportunities for kīrtan musicians to make a living in the instructional context through teaching or performance.[25] In contrast to the scarce performance opportunities found in Kolkata, however, robust networks of audiences populate rural areas of West Bengal, where musicians move across a professional cultural economy that crisscrosses the state. The final section of this chapter turns to a study of how musicians operate within this professional cultural economy.

TEMPORALITY IN THE PROFESSIONAL ECONOMY: SM MUSIC, KĪRTAN VCDS, AND NEOLIBERALISM

To study the sphere of professional kīrtan performance in contemporary West Bengal, I worked closely with two musicians:

Dyuti Chakraborty and Rahul Das (fig. 4.5). Though they are now married, they were only engaged when we first met, and working as the lead musicians in a kīrtan ensemble as singer (Dyuti Chakraborty) and lead khol musician (Rahul Das). Early attempts to meet regularly with them were complicated by their busy schedule that was packed with bookings that required travel throughout West Bengal for līlā kīrtan performances, recording studio dates, video shoots, and occasional television appearances. When originally hearing about their schedule, I was reminded of Nimai Mitra's busy career, though significant differences were evident as well. In addition to a full schedule of līlā kīrtan performances, Rahul Das and Dyuti Chakraborty were actively pursuing several promotional avenues that included performances at music festivals and media production. Indeed, Rahul Das had established a music production company that created and distributed VCDs of their kīrtan ensemble, a mode of promotion that differed from the types of engagements that defined Nimai Mitra's career. These forms not only required modifications to aspects of musical performance; they further formed the contours of a busy temporal landscape through the scheduling of promotional events, recordings, and other opportunities for self-promotion. In my own fieldwork, the challenges of locating a day for meeting or attending a performance was emblematic of the intertwined strands of the temporal and promotional work that animate the lives of professional kīrtan musicians and define the ways that they act within time.

Dyuti Chakraborty and Rahul Das were emerging as full-time musicians in kīrtan's professional cultural economy when I was living in West Bengal in 2012. The ability to make a livelihood as a musician in this context involved successfully understanding and negotiating the relationship between three different contexts: exclusive live-music performance, promotional music festival appearances, and media production. As mentioned, an exclusive live-music performance is an event where a kīrtan ensemble has been hired as the sole performer, receiving a fixed

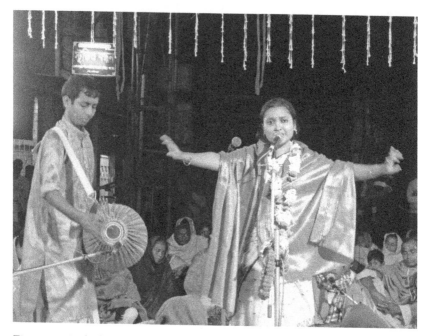

Figure 4.5 Rahul Das and Dyuti Chakraborty. Photo taken by the author, 2012.

payment amount from the patron or event organizer. In this type of performance, which lasts three to four hours, a kīrtan ensemble has considerable flexibility in structuring their performance. In the other two settings—promotional festivals and media production—kīrtan musicians encounter shortened time frames that require adjustments of musical form and style. Despite the temporal differences, however, in all of these contexts musicians present a līlā kīrtan performance that focuses on the divine play of Radha and Krishna or Chaitanya. A basic monetary demarcation further exists between exclusive performances and promotional contexts: individual live-music performances offer musicians a chance to make a profit for their labor while performances at promotional festivals and media production generally involve economic loss on account of the musicians' investments in travel, accommodations, and studio fees. Promotional

opportunities, then, are seen as ways to book exclusive live per-
formances, and the monetary investment that musicians make
in these other contexts can be covered through the payments
received for exclusive events. There is thus a close relationship
between these three settings, as musicians often make connec-
tions with future clients for exclusive līlā kīrtan performances
at promotional music festivals and through media distribution.

Dyuti Chakraborty and Rahul Das's interest in padābalī kīrtan
began in the instructional context of Rabindra Bharati Univer-
sity. Though pursuing a master's degree in Hindustani vocal mu-
sic, Dyuti Chakraborty began studying padābalī kīrtan in class
settings much like the one described above with Manoranjan
Bhattacharya and Kankana Mitra. After graduation, her attention
turned to a study of līlā kīrtan with Nimai Mitra. In weekly visits
to his north Kolkata music room, Dyuti Chakraborty augmented
her study of the large-meter musical style with a focus on learning
the mixed modes of song and storytelling that are central to līlā
kīrtan performance. Demonstrating a similar shift, Rahul Das's
main course of study at Rabindra Bharati University was focused
on Hindustani music and *tabla* performance. However, he also
studied with the khol guru Manoranjan Bhattacharya with a fo-
cus on learning features of khol performance and tāl theory. After
graduating, Dyuti Chakraborty and Rahul Das formed a kīrtan
ensemble in the mid-2000s. In addition to being one of the main
performers, Rahul also worked as the arranger and producer for
their studio recordings and managed the ensemble's logistics and
schedule.

SELF-MANAGEMENT AND RISK-TAKING
IN THE PROFESSIONAL ECONOMY

In 2012, Rahul Das launched SM Music, a company to produce
and distribute VCDs for kīrtan ensembles. The first two letters of
the company's name are an acronym for Śrīman Mahāprabhu, an

honorific title for Chaitanya; the name thus underscores the link between the enterprise's production goals and the aim of spreading the devotional message of Chaitanya. Of course, the work of VCD production in general, and the case of Rahul Das's production company in particular, was dependent on India's neoliberal reforms of the 1990s. The arrival of the recording, editing, and duplication technologies needed to produce VCDs in India was dependent on the high-level structural influences of neoliberalism and India's shifting importation policies in the 1990s. Because of these policy changes, digital media technologies became more common and more affordable as import sanctions were lifted throughout this period. Because of this, kīrtan musicians were able to record līlā kīrtan performances in new digital formats. One of first cases of this was when kīrtan musicians used CDs with the MP3 format, a case that was only marginally popular before a robust switch to the VCD format in the early 2010s.

The release of SM Music's first two VCDs in 2013 marked Rahul Das's move away from the Bengali regional music industry where he and Dyuti Chakraborty had released two previous recordings. Their first two VCD releases had been produced and distributed by Bengali regional labels based in Kolkata, organizations that specialized in the production of Bangla-language or regional forms of Bengali expressive culture. Though Rahul Das assisted with the production of these two VCDs—*Jagai-Madhai Uddhār* (*The Deliverance of Jagai and Madhai*), released by S Music, and *Naukā-bilās* (*The Boat Pastime*) (fig. 4.6), released by Raga Music—his complaint with these labels was that they asked for a large upfront payment from musicians and made little attempt to promote or distribute their VCDs throughout West Bengal. In one case, a regional music label asked Rahul Das for a payment of INR 50,000 to produce a VCD yet spent only INR 30,000 on the production process. With a certain amount of frustration, Rahul Das suggested to me that the only tangible result gained from the

Figure 4.6 Dyuti Chakraborty's *Naukā-bilās (Boat Līlā)* VCD (cell phone number in box).

relatively large sum of money he paid to these producers was the icon representing the production company that was stamped on the VCD case.[26]

Despite these issues, experiencing the production process first-hand when working with these companies afforded Rahul Das the chance to learn the techniques of creating VCDs, a skill he would apply to his own production company. Indeed, the founding of a production company signals a shift in how kīrtan musicians approach career management in twenty-first century India and further hints at the rise of a form of neoliberal self-management common among musicians in the present (Weidman 2014). Such work suggests how musicians began to adopt a subject position that was "refashioned in alignment with values of individualism, entrepreneurialism, and market competition" (Ganti 2014, 94), values that resonate throughout the labor of managing SM Music. In addition to managing the dates and travel for his own kīrtan

ensemble, Rahul Das was in frequent dialogue with recording studios, video production teams, and other kīrtan musicians to promote and create their VCDs.

These values were evident in his schedule, which was filled with successive meetings to promote his group and identify other musicians emerging across the kīrtan network in West Bengal. In discussion, he would relate his plans to sign younger kīrtan musicians to his company so he could produce their VCDs for a reasonable price and distribute them throughout West Bengal. He also made sure the VCDs he produced included contact information for potential clients to book his kīrtan ensemble for exclusive līlā kīrtan performances (fig. 4.6). While successful kīrtan musicians in the second half of the twentieth century, such as Nimai Mitra, could rely on networks of audiences familiar with their musical skills, the landscape of managing an emerging ensemble in the twenty-first century requires finding a competitive edge among the expanding number of musicians. While features of this undoubtedly surface in general musical skill and performance decisions (see chap. 8), another aspect of neoliberal self-management in this context is that emerging musicians, simply put, attempt to outwork their competition. Emerging kīrtan musicians thus engage a crowded temporal landscape of live performances, recordings, and networking opportunities in the early twenty-first century to promote their ensemble and make a livelihood.

Another marker that hints at the emergence of new subjectivities in the work of kīrtan is the economic risk-taking involved in the production of VCDs. For example, to produce a VCD, Rahul Das might invest Rs. 50,000 ($768), which, coupled with duplication costs (Rs. 10 [$0.15] per VCD), means that he must sell ~1,400 units at an average cost of Rs. 48 ($0.74) to cover his investment. Because he sells a low number of units in retail stores and at live performances, one of the main aims of VCD production and distribution is not to reap a profit; rather, the

fundamental function is to arrange future exclusive performances. In 2012, Dyuti Chakraborty and Rahul Das earned between Rs. 8,000 and 10,000 ($123–154) per performance, a figure that could quickly counterbalance any financial losses incurred in the course of media production. The VCD, it could be said, is akin to a business card, albeit one with audio and video capabilities. The design of the VCD thus mixes images of the lead singer, devotional iconography, and various email addresses and cell phone numbers on the back of each unit (fig. 4.6). This contact information proves to be just as important as the price tag on the front, as VCD consumers constitute the same audience that hires professional musicians for remunerated performances. There is similar economic risk-taking in the professional musicians' traveling to promotional music festivals, such as the Jaydeb Melā discussed later in the book. Rahul Das informed me that their kīrtan ensemble would spend between Rs. 18,000 and 20,000 ($276–307) for the entire melā, a fee that covered travel expenses, food, accommodations, and payment of hired musicians. However, this investment would lead to dozens of paid performances, each of which would pay between Rs. 8,000 and 10,000 ($123–154). In fact, Rahul Das's kīrtan ensemble secured most of their yearly performance opportunities on the strength of their promotional work at the Jaydeb Melā.

Engagement with features of entrepreneurialism, self-management, and risk-taking clearly mark the influence of the temporal period of neoliberalism in the musical labor of musicians such as Dyuti Chakraborty and Rahul Das. Nevertheless, it would be an exaggeration to suggest that these promotional techniques completely supplant the range of ritual practices that derive from the sphere of Gauḍīya Vaiṣṇava thought. Indeed, the fact that features of neoliberal entrepreneurialism nest comfortably alongside aspects of ritual action suggests how musicians work within a "hybrid economy," a context where "economic

formations around the world today, including the West, are composed of both capitalist and noncapitalist forms" (Yang 2000, 477). As in the cases that Yang studies in rural China, the introduction of entrepreneurial techniques that we might most readily associate with forms of neoliberal capitalism have not rooted out precapitalist forms of economic exchange. The rise of a middle class in India in general and West Bengal in particular has led to a marked rise in kīrtan ensembles and, crucially, forms of monetary exchange that are part of performance. The most striking example of this is the manner in which audience members give dakṣina to musicians throughout the course of a performance. One result of working in a hybrid economy, then, is that the penetration of capitalism leads to the "reconstitution" of the very social structures and their related practices that it is thought to dismantle (484).

I encountered features of such a hybrid economy one afternoon at Dyuti Chakraborty's house in the Howrah district, as we were preparing to travel to an exclusive līlā kīrtan performance. I sat in the living room with members of the kīrtan ensemble who would make the multi-hour drive to the town of Kanthi in the district of East Midnapore. Having just finished our lunch, we were waiting for Rahul Das to arrive with the rented vehicle that would take us to the evening's performance. When the car finally arrived, Rahul Das and another musician brought their two khols inside the house and left them next to a large pile of gear and instruments near the front door, including keyboards and several duffel bags filled with the attire the musicians would use for the performance. Rahul Das circulated throughout the house to gather all the musicians who had dispersed to various rooms after lunch. I remained sitting in the living room, where I looked back and forth between the large pile of instruments and gear for the performance and the empty vehicle outside, wondering silently why no one seemed to be initiating the loading of the SUV. After several minutes, Rahul Das's entreaties finally

brought the entire ensemble of seven musicians into the front room. Rahul Das and Dyuti Chakraborty then assembled the group in a straight line that purposefully began at the door and stretched to the back of the room. As the ensemble's main singer, Dyuti Chakraborty stood at the house's threshold and, in a gesture of veneration, touched each of the musical instruments sitting by the front door with her hand, which she then brought to her forehead. Then, standing on the house's threshold with Rahul Das and facing out the front door, she evoked the ritual call: "*jaya nitāi gaura premānande!*" ("Salutations to Nitāi and Gaura [i.e., Chaitanya] in divine love!").[27] This short phrase was a variation of the opening invocation used to begin a līlā kīrtan performance and signaled the group's hopes for an auspicious journey to the site of the performance. As it turned out, my earlier anxieties about the delayed loading of the vehicle had failed to account for the fact that the packing could begin only after this ritually significant invocation had occurred.

Moments such as this in the lives of professional kīrtan musicians suggest how the intertangled strands of social and economic value animate the hybrid economies in which they work and make music. On the one hand, when musicians travel to līlā kīrtan performances they take part in a centuries-long attempt to spread Chaitanya's devotional message through song and storytelling. The ritual acts that initiate these journeys, such as the one described, are thus replete with features of devotional practice that emphasize dependence on powers beyond the self. On the other hand, however, these journeys and performances are part of a project of securing economic value, as musicians perform for money and to spread the name of their ensemble so they may book future performances. The synergies that musician-producers such as Rahul Das seek to spark between the spheres of performance and media production stand as one example of how these musicians seek to harness their own individual power of marketing and promotion. There is a similarity between the

overlapping spheres of religious and economic prosperity that Deborah Kapchan explores in Moroccan Gnawa music, where she analyzes how "money" and "spirit" are "two values [that] seem oppositional on the surface ... [but] on closer examination ... are, in fact, seen to be convertible" (2007, 131). Offering prayers before embarking for a performance underscores the mutually constitutive roles of religious and economic value in the lives of professional musicians. To return to the claim that value ultimately emerges in action (Graeber 2001), we might even consider how the forms of religious and economic value invoked here are not really two *different* values; rather, they are both ways of representing the value of one's actions, their perceptible forms, and the ways these forms are thus convertible.

CONCLUSION

One vision for the future of padābalī kīrtan formulated in the early twentieth century imagined how the genre might become established among the educated society of Kolkata. Though limited in number, kīrtan musicians such as Nabadwipchandra Brajabashi developed bhadralok networks of instruction and performance in the colonial capital. This task grew amongst a network of kīrtan scholars and supporters as Khagendranath Mitra and others built an infrastructure of patronage in the early twentieth century. The hopes for this urban future found some traction in the next generation, when kīrtan musicians such as Nimai Mitra found instructional opportunities in the city; nevertheless, the majority of his performance career took place in rural areas of Bengal, where the interest in līlā kīrtan was more robust. The modes of teaching and performance that have defined his career demonstrate a strong link with the markers of the sādhaka kīrtanīyā that were promoted earlier in the twentieth century. To be sure, the tentative foothold established for kīrtan musicians in the urban center during the first half of the twentieth century

has gradually waned. Throughout my years of research, kīrtan musicians and Kolkata residents have consistently attested to the dwindling number of performances of līlā kīrtan that take place in the city. In the present, kirtan musicians come to Kolkata to study features of the genre and are further educated in the social values that animate these settings such as the markers of the sādhaka kīrtanīyā, features of the large-meter style, and the genre's links with Sanskrit aesthetics.

The networks and promotional techniques of musicians who work in the context of the professional cultural economy present a divergence from the instructional sphere of Kolkata. Though musicians such as Dyuti Chakraborty and Rahul Das aspire to book exclusive līlā kīrtan performances, where many of the features of the instructional context are highlighted, they also must confront the time constraints of media production and promotional music festivals. A current temporal influence of recent neoliberal reforms in India brings opportunities and challenges for musicians. New media materialities and the embrace of entrepreneurialism and risk-taking are two examples of how musicians are adapting to the social landscape that they move through and help create. The undercurrents running in tandem with these shifts are formed by the contours of modern social time. In this chapter, the case of Dyuti Chakraborty and Rahul Das has presented how the work of managing a kīrtan ensemble through a variety of promotional contexts does require musicians not only to adapt to the abstract time parameters found in promotional contexts; it further means that undertaking a career in professional performance requires navigating the contours of a busy temporal landscape filled with promotional events, recordings, and other opportunities for self-promotion. The fact that musicians who move primarily in the professional cultural economy, such as Rahul Das and Dyuti Chakraborty, originally studied kīrtan in instructional contexts such as Rabindra Bharati University demonstrates how ethnography can underscore this con-

tinued coexistence and synergy of various cultural economies. In seeing these various relationships between social structure and economy as "almost immutable constellation[s], actors, productive forces, and ideologies" (Erlmann 1996, 44), we might consider how a mode of production is a "force field in which certain forms of power, practices, symbols, and meanings constantly converge and diverge" (44).

The genealogies sketched out in the chapters of part I make the case for aspects of both musical retention and transformation. Certainly, there is a prominent chorus of scholars, historians, and cultural critics who would define the present professional context as detrimental to many of the genre's long-standing social values and features of musical style. Kankana Mitra, as one example, would often suggest that līlā kīrtan performances at promotional music festivals were marked by an inauthenticity on account of the changes in musical style and form that musicians introduced. Nimai Mitra also was wary of media production, pejoratively referring to it as simply a "business" that runs against features of the genre's history and wellspring of social values.[28] Despite these transformations, however, features of the expansive aesthetic that are linked with devotional visualization still work to synchronize the genre's spheres of performance and theory, a topic explored in the three chapters that constitute part II.

NOTES

1. See Rosse (1995) and Williams (2014).

2. ISKCON stands for the International Society for Krishna Consciousness, a Gauḍīya Vaiṣṇava institution begun in the 1960s and known colloquially as the Hare Krishnas. For more about ISKCON in West Bengal, see Fahy (2018).

3. Dyuti Chakraborty and Rahul Das gave an online padābalī kīrtan performance for the Yale Institute of Sacred Music in May 2021. A video recording of the concert can be found at https://www.youtube.com /watch?v=FB1FdBHbg9s (accessed October 22, 2021).

4. In other places, Nimai Mitra describes his first khol guru as Jatindranath Das, which is most likely the same person. Other instructors included Gaura Das Adhikari, Dhiren Gupta, Pareshchandra Majumdar, and Radhika Mohan Goswami. In addition to padābalī kīrtan, he studied ḍhap kīrtan with the recording artists Indubala Dasi and Krishnachandra De.

5. Personal communication, November 16, 2012, Kolkata.

6. Personal communication, November 26, 2012, Kolkata.

7. Personal communication, November 26, 2012, Kolkata.

8. Personal communication, November 26, 2012, Kolkata.

9. Personal communication, November 26, 2012, Kolkata.

10. See Mason (2013, 458).

11. Personal communication, September 16, 2012, Kolkata.

12. Personal communication, September 26, 2012, Kolkata.

13. Initial plans for this school were outlined in the 1423 B.S. [2016] volume of the journal that Nimai Mitra published, titled *Braj-Mādhurī*.

14. For example, the well-known singer Suman Bhattacharya studied with several Rabindra Bharati University instructors though not a student at the university; his teachers included Mriganka Shekhar Chakraborty, Vrindaban Banik, and Manoranjan Bhattacharya. Similarly, the two musicians discussed in the next section on the professional cultural economy— Rahul Das and Dyuti Chakraborty—both studied with Manoranjan Bhattacharya (khol) and Kankana Mitra (voice) at the institution.

15. Personal communication, September 29, 2012, Kolkata.

16. The singer Dyuti Chakraborty, discussed in the next section, would be an exception to this.

17. Personal communication, January 10, 2012, Kolkata.

18. Based on my study of dozens of Gaura-candrikā performances, Som Tāl is used in the vast majority of instances. However, some Gaura-candrikā songs do use other tāls. For example, the song "*dekhata jhulata gauracandra*" uses Boṛo Teoṭ Tāl.

19. Personal communication, January 17, 2012, Kolkata.

20. Personal communication, January 17, 2012, Kolkata.

21. Her degree is from Netaji Subhas Open University in Kolkata.

22. Emphasis added, personal communication, September 15, 2012, Kolkata.

23. The composer of this pad is Balarāma Dāsa.

24. One example would be the sphere of Kathak dance. See Singha and Massey (1967, 144).

25. During my fieldwork, Kankana Mitra occupied the only full-time position in padābalī kīrtan that I knew of in India. Since then, the kīrtan

musician Suman Bhattacharya has taken up a position at Visva-Bharati University, also in West Bengal.

26. Personal communication, Rahul Das, December 12, 2012, Rishra.

27. *Nitāi* is an epithet for Nityānanda, an important associate of Chaitanya described in various hagiographies and often considered to be an incarnation of Balarāma, Krishna's brother in the time-space of mythical Braj.

28. Personal communication, October 8, 2012, Kolkata.

THE DEVOTIONAL AESTHETICS OF MUSICAL EXPANSION

WORD-PICTURES: EXPANSIONS OF MOOD AND MEANING IN KĪRTAN SONG TEXTS

"Each verse (pad) is a description that gives rise to rasa."

(Nimai Mitra, November 6, 2012, Kolkata)

IN THE EARLY YEARS OF the twentieth century, Khagendra-nath Mitra and Nabadwipchandra Brajabashi coined a new term to define the meaning and aim of padābalī kīrtan song texts. In the first volume of their four-part song anthology, they described kīrtan songs with the compound "word-picture," a translation of the Bangla term *śabda-citra*.[1] This moniker emphasized a relation-ship between the words that constituted a song and the images they sought to bring to life through contemplation. They noted that the process that linked the domains of word and image was the practice of meditation performed by the original composers of padābalī kīrtan song texts, the mahājana padakartās, or great composers of verse. Referring to the practice of līlā-smaraṇa, Mi-tra and Brajabashi suggested that it was during a meditational absorption that these composers gained sight of the mythical time-space of the Hindu deities Radha and Krishna, and they

thus "composed each verse or song based on a direct vision of the
līlā" (1317 BS [1910], vii). But the potency of these songs was not
only linked to the process behind their creation; another reason
for defining these song texts as word-pictures was to emphasize
how a singer or listener's devoted attention to these songs could
reveal these acts of divine play in the present. The songs were thus
both records of and guides to the practice of devotional visualiza-
tion (Haberman 1988, 129).

The distribution of these word-pictures proliferated through
the publication of manuscript collections beginning in the late
nineteenth century. One of the most comprehensive and volu-
minous anthologies was titled *Śrī-Śrī-Pada-Kalpataru*, or the
Beautiful Wish-Fulfilling Tree of Lyrics, a five-volume anthology
containing over three thousand songs. The work of compiling
and publishing anthologies of Vaiṣṇava padābalī was widespread
in nineteenth- and twentieth-century Bengal and part of a larger
project of developing a literary culture in the region (Kaviraj
2003). These song-poems, often referred to as forms of literature
(*sāhitya*), were thus absorbed into a web of connections that high-
lighted the written, the published, and the act of reading.[2] The
word-pictures found in devotional songs thus became prized as
forms of literary culture that were tied to Bengali national senti-
ment (Bhatia 2017), as they were thought to be inextricably linked
to the formation of the Bangla language. Their existence as forms
of written text thus became central to the work of analyzing and
organizing songs in the twentieth century.

In the present, however, these word-pictures are spread across
both written and sounded archives. In addition to the published
manuscript collections, there exists an equally large corpus of lyr-
ics that are actualized and sounded only in performance. These
song lines materialize when kīrtan musicians insert lyrics in be-
tween the original verses of a song to elaborate on the images,
emotions, and meaning of the original text and are thus a crucial
part of the expansive musical aesthetic. Because of the location

where these lyrics are placed, this sounded repertoire is com-
posed of *interstitial lines* of song. Indeed, these texts are sung in
between the lines of the original song and occur as two distinct
types of repertoire known as the *kāṭān*, which accompanies songs
that feature the large-meter musical style, and the *ākhar*, which
is used in songs set to smaller tāls. Each of these types of lyrics
is paired with specific melodic structures that further cue their
performance (chap. 7). Like other performance genres in South
Asia, where it is common for performers to interject verse and
text during performance (Qureshi 2006 [1986]), the interstitial
lines of lyrics of padābalī kīrtan elaborate on the message of the
original song. At the same time, they further work to expand a
song's time span. A third key aspect of these lyrical interjections
is to translate the older literary language of the original songs
into a more colloquial register. Musicians learn these interstitial
lyrics through an oral-aural mode of transmission, and because
of this they are not included in published versions of song collec-
tions. They exist, then, in the collective memory of musicians, in
a limited archive of sound recordings, and in informal forms of
record keeping such as the notebooks musicians use for transmis-
sion and study.

In addition to these aims, these word-pictures further elaborate
on a framework of aesthetic thought from early Sanskrit theater
that underpins the entire lyrical repertoire. As mentioned, each
song is meant to evoke a specific rasa (mood) in the listener and
simultaneously present the images, settings, and emotions that
animate one of Radha and Krishna's divine plays. To illustrate
this vital connection between the divine plays described in song
and an emotional sphere, Mitra and Brajabashi referred to songs
as vehicles to experience the *"līlā-rasa"* of Radha and Krishna.[3]
The names used to refer to līlā kīrtan performances often mark
these overlapping spheres, as in the case of the popular theme
Śrī-Rādhār Pūrva-Rāga (*Radha's Infatuation*), a performance
moniker that refers to an aesthetic mood (infatuation) and a well-

known story of Radha's budding love for Krishna. Indeed, infatuation is one of eight categories of the amorous mood discussed in this chapter that were central to the project of organizing songs in published anthologies. These eight categories of the amorous mood were codified in a Gauḍīya Vaiṣṇava theory of devotional aesthetics traced to Rūpa Gosvāmī's sixteenth-century Sanskrit treatise *Ujjvalanīlamaṇi*.

A theoretical focus in this chapter studies how the song texts of the padābalī kīrtan repertoire engage in the work of mediation. Patrick Eisenlohr draws on an intentionally broad definition of media in his research on South Asia and its diaspora, which not only includes technological and material forms within the sphere of media and mediality but also considers how language mediates the temporalities of religious and political belonging (2015). Media and mediality, in his words, "refer to objects and processes that connect people, concepts, or social formations standing in relations of difference" (294). The relations of difference he considers in the Mauritian Hindu diaspora and Twelver Shi'ite Muslim worship are constituted by "spatial, temporal, or qualitative disjunctures . . . and media provide links across such gaps" (294). Drawing on the connective power of media, two forms of mediality are particularly salient to this discussion. The first example considers how song anthologies not only made the repertoire of Vaiṣṇava padābalī widely available but also served to mediate the reception of this song repertoire by emphasizing the genre's link with Sanskrit aesthetics. Using headings that located each song within the eight categories of the amorous mood, these anthologies were part of a larger discourse that sought to foster discussion about kīrtan song texts and their aesthetic aims. One example of this was the way that the padābalī kīrtan repertoire was seen as part of a relational process that would educate Bengalis in the esoteric knowledge of Sanskrit aesthetics (Sanyal 1989, 235). In addition to this, a second form of mediality is found in the interstitial lines of song. Because the repertoire of Vaiṣṇava padābalī was composed

in multiple linguistic registers, including the older and literary dialects of Middle Bengali and Brajabuli, a large part of the repertoire is only marginally understood by contemporary audiences. These interstitial lines thus translate an older linguistic register into a more colloquial and contemporary one while further elaborating on the meanings and images conveyed in song (Wulff 1996). These interstitial lines of song, then, are part of a larger process of what Christian Novetzke refers to as vernacularization, which is not only about shifting linguistic registers but also a process where "expressive idioms . . . and all other spheres of affect" are located into new social spheres (2017, 6). Despite the crucial translational and expansive work that interstitial lines perform, they were nevertheless caught up in a politics of representation in colonial Bengal that saw them excluded from the written record and thus posited as "lower" cultural forms, similar to other cases of Bengali oral expressive culture (Lorea 2016, 236).

The chapter begins with an investigation of the links between the eight categories of the amorous mood and two individual padābalī kīrtan songs to illustrate how these texts were linked with a preexisting categorical structure found in Sanskrit aesthetics. The chapter then turns to the larger history of Sanskrit aesthetics in South Asia before concluding with an analysis of the two types of interstitial lines of song that further expand the temporal and semantic work of the padābalī kīrtan repertoire.

EXPANSIONS OF THE AMOROUS MOOD:
SONGS OF SEPARATION

The publication of padābalī kīrtan song anthologies was a central part of the bhadralok recovery of Gauḍīya Vaiṣṇavism in the early decades of the twentieth century. Though numerous collections were published, the anthology that emerged as the largest and most comprehensive collection of songs was the *Śrī-Śrī-Pada-Kalpataru* [*SSPK*]. In its final form, this five-volume anthology,

Table 5.1. Eight categories of the amorous mood

1. *pūrva-rāga* (Infatuation)	2. *māna* (Pique)	3. *prema-vaicittya* (Separation in the presence of the beloved)	4. *pravāsa* (Separation based on a distant journey)
5. *saṃkṣipta-sambhoga* (Brief union)	6. *saṅkīrṇa-sambhoga* (Union mixed with contrary feelings)	7. *sampanna-sambhoga* (Developed union)	8. *samṛddhimān-sambhoga* (Complete and excessive union)

which contained over three thousand songs, was published over the course of sixteen years (1322–38 BS [1915–31]). Despite its size, one posthumous biographical account of the anthology's editor, Satishchandra Ray, noted that he had earmarked at least another thousand songs to be part of a planned sixth volume (Vaishnava and Ray, 1338 BS, v). The anthology's title references a mythical wish-fulfilling tree, thus citing an organic theme that alludes to the analogy of the newly sprouted seed mentioned previously (chapter 2). This metaphorical reference is mirrored in the anthology's structure, which starts with the overarching organizational framework of the tree (*kalpataru*) while the major sections of the anthology are referred to as branches (*śākhā*) and the subsections that list the songs are called leaves (*pallaba*).

Despite the large size of the repertoire found in this anthology, most of the song texts focus on a single theme: the amorous līlās of Radha and Krishna. This thematic focus is further organized according to an eightfold theoretical structure shared across the vast majority of Vaiṣṇava padābalī anthologies (table 5.1). Song anthology editors borrowed this template from the fifteenth and sixteenth chapters of Rūpa Gosvāmī's *Ujjvalanīlamaṇi*. The first four categories—from pūrva-rāga to pravāsa—are considered indicative of the mood of separation, and each one represents an increase in intensity from the early pangs of infatuation (pūrva-rāga) to the separation evoked when one's lover departs on a

distant journey (pravāsa). Similarly, there are four subcategories that index devotion in union, each of these increasing in intensity from a brief meeting (saṃkṣipta-sambhoga) to one of a longer duration (samṛddhimān-sambhoga). In anthologies, song texts were linked with one of these eight forms through a system of headings and subheadings; the images, dramatic situations, and locales described in song were thus categorized according to their ability to invoke one of the underlying eight forms, which were considered paradigmatic structures of a devotional aesthetic.

One way song composition expanded upon the underlying eight forms of the amorous mood is illustrated through the category of infatuation (pūrva-rāga). And one example of how the number of songs linked to mood of infatuation increased was when song composers designated two characters who could experience this emotion. Hundreds of songs were thus split across two basic categories: Radha's infatuation (śrī-rādhār pūrva-rāga) and Krishna's infatuation (śrī-krṣṇer pūrva-rāga).[4] The outline of this basic division is found in published song collections where the topical indexes in anthologies list songs grouped within these two main categories (e.g., SSPK I, i). A common dramatic situation found in each of these categories describes the emotions Radha and Krishna feel after they have either briefly met or heard about each other during a discussion with a friend; after this short encounter, Radha and Krishna are then separated from one another, thus marking pūrva-rāga as an early stage of devotion-in-separation.

One song found in the SSPK that depicts Radha's infatuation is titled "rādhār ki hoila antare bethā" ("What is tormenting Radha?") (table 5.2). In this song, the fifteenth-century pad-composer Caṇḍīdāsa describes Radha's emerging state of infatuation by means of a discussion between several of her friends.[5] After the song's refrain—"what is tormenting Radha?"—the lyrics present images of Radha that index her emotional state.[6] In the song, Radha's friends wonder what might be causing her pain, as she "sits in silence and stays apart." A recurrent focus in

Table 5.2. *"rādhār ki hoila antare bethā"* ("What is tormenting Radha?").
Song describing Radha's infatuation

rādhār ki hoila antare bethā/	What pain is within Radha?
basiyā birale thākaye ekale	She sits apart and stays alone,
nā śune kāhāro kathā//	hearing nothing anyone says.
sadāi dheyāne cāhe megha pāne	Forever in a trance, she stares at the clouds;
nā cale nayāna-tārā/	her eyes do not move.
birati āhāre rāṅgā bāsa pare	She has no taste for food and wears saffron,
jemata joginī pārā//	like an ascetic woman.
āulāiyā benī phulaye gāthanī	She loosens her braid with its chain of flowers
dekhaye khasāñā culi/	and looks at her cascading hair.
hasita-badane cāhe megha pane	With smiling face, she watches the clouds.
ki kahe duhāta tuli//	What is the meaning of her raised hands?
eka diṭha kari mayura-mayurī-	She happens to glance at a peacock and peahen,
kaṇtha kare nirakhane/	then she stares at the peacock's throat.
caṇḍīdāsa kaya naba paricaya	Caṇḍīdāsa says she has just come to know
kāliyā bandhura mane//	her friend Krishna.

the song is Radha's gaze, and in the second couplet Caṇḍīdāsa describes how she stares at the clouds with unmoving eyes while hearing nothing around her. This couplet also compares her to a female ascetic because of the saffron clothing she wears. After a third couplet where Radha's friends wonder what her raised hands might signify, the final verse describes how her vision has focused on the neck of a peacock. Her fixation on the bird is due to the specific hue of its neck, a bluish color that reminds her of Krishna and her newfound infatuation for him. The identity of this song's author is revealed in the final couplet of the song, known as the *bhaṇitā*, where Caṇḍīdāsa mentions the newfound nature of Radha's attraction.

Not surprisingly, the *SSPK* groups this song together with dozens of other padas that depict Radha's infatuation with Krishna.[7]

Yet there were more subtle ways that editors would expand on each of the eight categories of the amorous mood in Vaiṣṇava padābalī anthologies. In the first volume of the *SSPK*, for example, the editor dedicated four "leaves" (*pallabas*) to the topic of Radha's infatuation, and, within each of these leaf-like sections, subheadings were used to group songs according to further levels of organization. In the case of dramatic settings, for example, the song "*rādhār ki hoile antare bethā*" is categorized under "Friends Speak to One Another" (*paraspara sakhyūkti*), a subheading that contains songs where Radha's friends are conversing among themselves about her emotional state. But song anthology editors also made further links between specific songs and details of Rūpa Gosvāmī's aesthetic theory. For example, the editor of the *SSPK* included an explanation of the song under discussion, which located Radha's state of infatuation more specifically. In a commentary, or *ṭīkā*, on this song, Satishchandra Ray suggested that this text illustrated the first two (ardent desire and anxiety) in the list of ten states (*daśa daśā*) that mark Radha's progression through ever heightening stages of infatuation (discussed in chap. 3).[8] This method of organizing songs according to these exacting categories of devotion is further found in the table of contents in volume I of the *SSPK*, where a number of songs are earmarked with the heading "Description of the States of Ardent Desire (*lālasā*) and Anxiety (*udvega*)."[9] Through the use of commentaries, headings, and groupings, editors such as Ray mediated between Vaiṣṇava padābalī songs and the domain of Sanskrit theater and aesthetics, illuminating the links between the eight forms of the amorous mood and the word-pictures of the song repertoire.

EXPANDING SONGS OF UNION

In addition to songs that index the mood of devotional separation, a complimentary number of songs were linked with the mood of devotional union that constituted the second four-part

grouping in the structure mentioned above. A number of these songs are composed around dramatic situations where Radha and Krishna meet in the forest, engage in playful banter, and flirt as Radha and her friends meet with Krishna away from their homes. The songs that focus on Radha and Krishna's union are found in some of the most well-known stories of the līlā kīrtan repertoire. One example is the popular Rās Līlā kīrtan performance that depicts the famous circle dance where Radha and Krishna meet in the forest by the river's edge (Schweig 2005). Another līlā that portrays the devotion in union is the Dān Līlā, a story that describes how Krishna adopts the dress of a road-tax collector to stop Radha and her friends on the path to the market (see chap. 7). And a third is the Naukā-bilās, a līlā kīrtan that describes Radha and Krishna's journey on a boat in the Yamunā River (see chap. 9). Although these līlās are commonly found in the folklore and performance genres of Bengal, less known is how they are categorized within the eight forms of the amorous mood in Vaiṣṇava padābalī anthologies.

One way that anthology editors expanded on the amorous mood was through aligning specific līlās of Radha and Krishna with each of the eight categories. In early twentieth-century editions of the Ujjvalanīlamaṇi, the basic framework for this approach involved the construction of a detailed list where each of the eight categories of the amorous mood was linked with eight different līlās or dramatic settings (Rūpagosvāmī [1341 BS {1934}]). The quantitative result of this work was a list of sixty-four different settings that categorized how each of the eight types of the amorous mood might be evoked. An example of this expansive substructure can be seen in table 5.3, which lists the eight līlās that were associated with the mood of saṅkīrṇa-sambhoga (union mixed with contrary feelings). The first līlā on the list is the previously mentioned Rās Līlā, though it is referred to here as the Mahārāsa (The Great Rās [Līlā]); other popular stories contained under this heading include the Dān Līlā and

Table 5.3. The eight subdivisions of *saṅkīrṇa-sambhoga*

1.	2.	3.	4.	5.	6.	7.	8.
pūrva-rāga	*māna*	*prema-vaicittya*	*pravāsa*	*saṃkṣipta-sambhoga*	*saṅkīrṇa-sambhoga*	*sampanna-sambhoga*	*samṛddhimān-sambhoga*

↓

Eight Subdivisions of *saṅkīrṇa-sambhoga*
(Union mixed with contrary feelings)

1. *Mahārāsa* (The Great Rāsa [Dance])
2. *Jala Krīḍā* (Water Sport)
3. *Kuñja Līlā* (The Divine Play in the Forest Bower)
4. *Dān Līlā* (The Divine Play of the Taxman)
5. *Baṃśī Cūri* (The Theft of the Flute)
6. *Naukā Vilāsa* (The Boat Pastime)
7. *Madhupān* (Drinking the Honey)
8. *Sūrya Pūjā* (Worship of the Sun)

Naukā-bilāsa. Detailed lists that matched all sixty-four līlās with their associated moods were included in published versions of Gauḍīya Vaiṣṇava theoretical treatises beginning in the early twentieth century, though this trend might have reflected the developments of an earlier manuscript practice.[10] The construction of this list of sixty-four settings led to the common claim among kīrtan scholars and musicians that padābalī kīrtan had the ability to evoke sixty-four different rasas, an assertion that spoke to the range of emotions that could be evoked in performance (e.g., Mitra 1333 BS [1926], 377).

How did the eight līlās associated with saṅkīrṇa-sambhoga represent the emotional sphere of "union mixed with contrary feelings"? In the case of the Dān Līlā, Radha and Krishna's meeting by the side of the road takes place after a previous episode where they were in an argument that resulted in a period of pique (*māna*). At the commencement of this līlā, then, there is a simmering discontent that marks the interactions between Radha and Krishna, which is one reason Krishna approaches

them in a disguise as a road-tax collector. The contrary feelings—the resentment from a previous argument and the happiness of union—are illustrated in features of the songs and storytelling that are used to depict this divine play.

Features of the contradictory emotional field that mark the Dān Līlā are found in the song "*ki balile sudhāmukhi*" ("Oh one with a nectar-filled mouth, what did you say?"), which features in performances of this līlā kīrtan.[11] The song presents Krishna speaking to Radha and her friends, who, in the context of the līlā, have rebuked him for brazenly approaching them to collect a road tax. Their resentment represents the mixture of contradictory emotions that characterize this episode, which is one reason why Krishna has adopted the dress of road-tax collector (*dānī*) to interact with Radha and her friends. Krishna has chosen this location because Radha will be away from her watchful family members and mother-in-law; Radha is married to another man in the mythical time-space of these līlās.

The song opens with Krishna responding to Radha and her friends. In the preceding narrative of the līlā, Radha's friends tried to keep Krishna away by suggesting that he is from a lower social position than Radha and thus not a proper acquaintance. They have derogatorily called him a cowherd and asked him how he dares to approach a princess such as Radha for a tax. The response that Krishna gives in the first couplet offers a rebuke that links the spheres of labor, gender, and supernatural identity. In addition to defending his work as a cowherd, Krishna suggests that any type of work is auspicious for a man. The word used for "man," however, can also mean "God" (*puruṣa*), thus establishing a case of wordplay where Krishna declares that his status as both man and God makes him able to adopt any activity:

pad: *ki balile sudhāmukhi, āmi māṭhe dhenu rākhi, puruṣe sakali śobhā pāya/*

What did you say, one with a nectar-filled mouth [Radha]? That I only tend cows in the field? For a man/God, every [activity] is auspicious.

In the next half-couplet, Krishna questions the claim that Radha is indeed a princess; he wonders aloud how a princess could be doing such a banal task as carrying yogurt to the market. Krishna thus further challenges the claim of Radha's friends that he and Radha are from such divergent social backgrounds:

pad: *rājāra nandinī haiye, dadhira pasarā laye, māṭhe hāṭe ke dheye beṛāya//*

There is a princess carrying yogurt to the market; who roams in the fields and marketplaces in such a way?

After working to lessen the differences of social background that Radha's friends have emphasized, Krishna praises Radha's beauty in the next couplet as a way to ameliorate the situation:

pad: *padma gandha uṛe gāya, madhu lobhe ali dhāya aparupa śobhā āhiriṇī//*

dekhite cānder sādha, koṭī kāma unamāda, nirupama amiyā nichani//

With the scent of the lotus flower in the air, the bees, greedy for nectar, are flying there [to drink] the exceptional beauty of the milkmaid [Radha].

The moon desires to see [her], millions of cupids have become mad; her beauty is an incomparable nectar.

In the final section of the song, Krishna addresses Radha directly by asking how her husband has allowed her to go to the market alone. In addition to telling Radha how he would treat her differently, he concludes by telling her that even though he is a cowherd, he possesses wealth in the form of his righteous work. Krishna's final message to Radha is followed by the composer's signature line, where the pad-composer, Yadunātha, asks Radha why she is going to the market to sell her goods when she might make a sale to Krishna under a tree by the side of the road:

pad: *tomāra nija pati je, kemane dhoreche de, tomāre pāṭhāiyā diyā hāṭe/*

emana rupasī jadi, more milāite bidhi, basāiyā rākhitām soṇāra khāṭe//

Your husband, the one who is sending you to the market, how is he feeling?

If such a beauty were given to me by providence, I would keep her on a bed of gold.

pad: *kānu kahe śuna rāi, je puruṣer dhana nāi, dhana dharma sakali kapāle/*

yadunātha kahe ebe, dure bike kene jābe, biki kini kara tarutale//

Krishna says, "Listen, Radha, the man/God without wealth, [his] entire fortune is righteous work."

Now, Yadunātha says, "Why are you going so far? Why not make a sale under this tree?"

The composer's final question reveals his desire to see the amorous union of Radha and Krishna, a theme that runs through the entire song and its surrounding līlā kīrtan performance.

The two songs studied here demonstrate how the categorization of padābalī kīrtan song texts developed along the twin tracks of aesthetic and narrative aims embodied in the compound formation of līlā-rasa mentioned earlier. The eight forms of the amorous mood, and the manner in which editors multiplied this structure to the sixty-four rasas of kīrtan, emerged within a larger discussion on aesthetic experience in South Asia. The centrality of these aesthetic structures is thus part of a larger concern with the past and its relevance to the temporal imaginaries of the genre in the present.

SONG ORGANIZATION AND SANSKRIT AESTHETICS

The eight forms of the amorous mood central to structuring the padābalī kīrtan song repertoire emerged in the latter stages of a much longer history of Sanskrit aesthetic theory. The first textual source for classical Indian aesthetics was the *Nāṭyaśāstra* (*Treatise on Drama*), attributed to the sage Bharata and dated to the early centuries CE. Importantly, this treatise is the first textual

source where we find mention of the twofold division of separation and union central to the padābalī kīrtan song repertoire.[12] The majority of chapters in this early treatise deal with practical topics for theatric production such as the modes of linguistic delivery, bodily gestures, the costumes of actors, and music, among other subjects. However, the *Nāṭyaśāstra*'s relatively short exposition on the theory of rasa and its constituent elements sparked a centuries-long conversation on the nature of aesthetic experience. Despite the wide variety of topics covered in this text, the theme of rasa came to have the most concrete influence on padābalī kīrtan.

Defining the word rasa as "mood" can be submitted to another level of translation according to the theory of aesthetics offered in the *Nāṭyaśāstra*. Indeed, a more literal and less contextual definition of rasa is "taste," and the relevance of this translation becomes obvious when considering points of rasa theory. The constitution of rasa in the *Nāṭyaśāstra* depended upon the combination of several "aesthetic elements" (*vibhāvādi*) (Pollock 2016, 202). These elementary components included various transitory, psychophysical, and catalytic emotional states that contributed to a core or "foundational emotion," which was known as the *sthāyi-bhāva*.[13] The eight foundational emotions in the *Nāṭyaśāstra*—passion, humor, anger, sorrow, effort, astonishment, disgust, and fear—were thought to be actualized when combined with the other aesthetic elements. The experience that resulted when these elements were combined—the actual "tasting" of emotion—was thus called rasa. A standard analogy used to explain the relationship between the aesthetic elements and the concept of rasa in the *Nāṭyaśāstra* "is that of a blend of a basic foodstuff, such as yoghurt, with a number of spices; the resulting decoction has a unique flavor (rasa) identical with none of the single elements that comprise it" (Wulff 1984, 26). The idea that rasa is a mood that can be "tasted" through the process of listening remains central to the discursive sphere of padābalī kīrtan, as performers and scholars frequently describe how, by hearing songs of Radha

and Krishna's līlās, one can in fact "taste" the emotions expressed in song.[14]

If the *Nāṭyaśāstra* was the earliest written record of Sanskrit aesthetics, the work of the sixteenth-century Gauḍīya Vaiṣṇava theologian, poet, and playwright Rūpa Gosvāmī appeared in the latter stages of this discussion in South Asia. As mentioned, Rūpa Gosvāmī's formulation of the eight forms of the amorous mood used to categorize songs appeared in his *Ujjvalanīlamaṇi*, written c. 1541.[15] Rūpa Gosvāmī and others in the Braj Gosvāmī cohort worked to formulate a set of theological, ritual, and philosophical texts for this nascent devotional community, and his specific contribution was to formulate features of a Gauḍīya Vaiṣṇava aesthetic theory in two key treatises: the previously mentioned *Ujjvalanīlamaṇi* and *Bhakti-rasāmṛta-sindhu*. Together, these two texts reimagined how the concept of rasa from early Sanskrit theater might be applied to the domain of devotional aesthetics. Instead of the diverse landscape of possible moods found in earlier theories of rasa, numbering eight or nine, Rūpa Gosvāmī presented a theory that focused on *bhakti-rasa*, the mood of devotion to Krishna. The shift from rasa as a theatric experience in the *Nāṭyaśāstra* to a devotional one in Rūpa Gosvāmī's writings was part of a larger "theologization of rasa" that predated the *Ujjvalanīlamaṇi* by several centuries (Pollock 2016, 22). It nevertheless proved influential, as Rūpa Gosvāmī's approach to rasa, as Schweig and Buchta suggest, presented the idea that "*rasa* finds its original source in the person and divinity of Kṛṣṇa, and its true forms manifest between Kṛṣṇa and his eternal associates within his transcendental acts or *līlās*" (2018, 626). According to this formulation, the word-pictures of the kīrtan song repertoire were not only aids to visualization; they were also texts that could evoke rasa through the contemplation of Radha and Krishna's divine play.

Although outlining several varieties of bhakti-rasa in his earlier text, Rūpa Gosvāmī focused on the amorous mood of devotion

in the *Ujjvalanīlamaṇi*. As mentioned previously, the title of this treatise was based on Rūpa Gosvāmī's modification of the earlier term for the amorous rasa, śṛṅgāra-rasa, which was used in the *Nāṭyaśāstra*. Instead of śṛṅgāra-rasa, he used the term ujjvala-rasa (the brilliant rasa) to refer to the amorous mood; in other writings, however, Rūpa Gosvāmī further used the term mādhurya-rasa (the rasa of sweetness) to define the amorous mood. The fifteenth and sixteenth chapters of the *Ujjvalanīlamaṇi* focus on the eight types of the amorous mood as Rūpa Gosvāmī explains the contours of each category with examples of devotional poetry and verses from his Sanskrit dramas.[16] Surely, the apparatus of the eight forms of the amorous mood are only one part of the theoretical apparatus that Rūpa Gosvāmī built in this treatise. Nevertheless, the eight forms of the amorous mood presented in the *Ujjvalanīlamaṇi* became central to the project of song organization that worked to links the repertoire of padābalī kīrtan with earlier theories of aesthetic thought.

INTERSTITIAL LINES AS WORD-PICTURES

Despite the intense effort directed toward linking padābalī kīrtan song anthologies with the sphere of Sanskrit aesthetics, the work of editors never captured the full extent of the genre's lyrical repertoire. One reason for this is that the song archive published in anthologies did not include the vast collection of interstitial lyrics passed through oral transmission. To focus only on the song texts found in manuscripts and anthologies thus overlooks an auditory history of the genre central to the work of the expansive musical aesthetic. These interstitial lines enact other features of mediality in performance as they connect the sounded domain of music and language to the social sphere and theories of Sanskrit aesthetics.

The most obvious work that musicians perform when singing interstitial lines is to bridge one linguistic register with another.

As mentioned, the padābalī kīrtan songs found in the manuscript and published anthology archive were written in various languages, including medieval Maithili, Brajabuli, and Middle Bengali,[17] which were not easily understood by contemporary audiences. For example, the compositional period of Middle Bengali dates from between the fifteenth and eighteenth centuries (Thompson 2012, 3) and thus features a vocabulary and other grammatical variations that make the language difficult to understand in the present. The interstitial lines of song, then, often translate older compositions into a contemporary dialect of Bangla with the use of colloquial words and linguistic forms that an audience can readily understand.

However, as Donna Wulff notes, these interstitial lines of text are not simply translations, but they function as "internal interpretations" that "shape . . . and mediate the poem, allowing the audience to participate emotionally in the drama being sung and enacted" (1996, 76). One way that kīrtan musicians describe the work of interstitial lines is as a form of expansion (bistār). In a lesson, Kankana Mitra used this term to describe how the type of interstitial lyrics known as ākhar elaborate on the theme of the original song. The ākhar lines, Mitra suggested, reveal the "inner meaning" of the song, and she continued to note that "ākhar means bistār," and "bistār means an explanation or spread . . . the spread of the inner meaning of the pad."[18] One way, then, that the "inner meaning" of the song unfurled was through the sounded forms of the interstitial lines.

Of course, the practice of inserting fragments of new text during a performance is not unique to kīrtan. Indeed, in the South Asian context, Regula Qureshi has written incisively about the inclusion of "amplifying insertions" (girahs) by qawwali musicians that elaborate on Sufi religious themes and evoke responses from audience members (2006 [1986], 22). Often, these are verses from other traditions of Sufi poetry that musicians insert within a performance to evoke embodied responses in audience members.

Though there are certainly similarities between the girahs of qaw-wali and the interstitial lyrics of kīrtan, a significant difference is found in the fact that the interstitial lines used in padābalī kīrtan claim no textual identity separate from performance. These lines of interjected song exist only as lyrical appendages to the original song and thus work to mediate the language and message of the original composition. However, one similarity found between these various forms of textual interjection is the manner in which they both elongate the temporal frame of a performance.

KĀṬĀN—EXPANDING RESPONSES

One evocative phrase repeatedly surfaces in the interstitial lines of kīrtan song known as the kāṭān: *"pūraber bhābe"* (in a pre-vious emotional state). Though this phrase is absent from the written archive of song texts, its location relative to the original song is key to understanding its cryptic meaning. This fragment of text often follows the first half-couplet of a Gaura-candrikā song, where images of Chaitanya contemplating his previous identity as Krishna are explored. The expression thus func-tions as a lyrical interpretation that synchronizes the identities of Chaitanya and Krishna. When the singer references Chai-tanya's previous emotional state, she alludes to his identity as Krishna, thus presenting a theological elaboration on the song's text.

The kāṭān section and its interstitial lyrics are exclusive to large-meter songs, which, as discussed, is a colloquial designation that refers to songs that are set to tāls with twelve or more mātrās. In Manoharsāhī kīrtan, then, the kāṭān section is found in the first couplet of a Gaura-candrikā song, as the first two lines of the song are commonly set to the large-meter musical style.[19] As seen below, the first interstitial kāṭān line follows the Gaura-candrikā song's first half-couplet, and the second kāṭān line will be pre-sented after the second half-couplet. While the song's couplet

follows a pattern of meter and rhyme found in devotional poetry, the example shown here illustrates how the kāṭān lyric does not follow a similar prosodic pattern. Indeed, the interstitial kāṭān lines expand on the themes of the original couplet from the Dān Līlā but without the same measured approach to composition as found in the original song lines:

1. First half-couplet: *gaurāṅga-cāndera mane ki bhāba uṭhila*
 "What kind of emotion (*bhāba*) arose in the mind of the moon-like Gaurāṅga?"
2. kāṭān: *āje pūraber bhābe, pūraber bhābe bibhor hoye āhā mori gaurāṅga āmār gauracāndera*
 "Today, my Chaitanya is absorbed in a previous emotion. Oh, my Golden-limbed one, my Golden Moon."
3. Second half-couplet: *nadīyāra mājhe gorā dān sirajila*
 "In Nadīyā, Gorā [Chaitanya] began asking for the tax."
4. kāṭān: *bhāba-nidhi gaura-hari āje pūrab līlā śaraṇ kari*
 "Today, I take shelter of the previous līlā of the Golden Krishna (Chaitanya), the abode of emotion."

The lyrical material in the kāṭān section is taken from one of two sources. The first source is the language of the original song, and the second is a body of conventional phrases associated with the larger kāṭān repertoire found across several different songs. The lyrics of the kāṭān section further share a symbiotic relationship with the original song text. They elaborate on phrases from the original song and, at the same time, respond to the meanings found in the lyrics. This work is encapsulated in one translation of the term *kāṭān*, which is "reply."[20] To be sure, understanding the emotional and interpretive work of the kāṭān depends on studying its relationship with the original song. The first Gaura-candrikā half-couplet used in the Dān Līlā begins to create the setting for the song by asking a question:

Original pad: *gaurāṅga-cāndera mane ki bhāba uṭhila*

What kind of emotion (*bhāba*) arose in the mind of the moon-like Gaurāṅga?

The reply given in the kāṭān lyrics that follow this line offers an interpretive answer to this question, repeatedly referring to Chaitanya as the Golden-Limbed One and the Golden Moon:

> kāṭān: *āje pūraber bhābe, pūraber bhābe bibhor hoye āhā mori gaurāṅga āmār gauracander*
>
> Today, my Chaitanya is absorbed in a previous emotion. Oh, my Golden-Limbed One, my Golden Moon.

The kāṭān section answers the question posed in the song text as it mentions how Chaitanya was remembering his previous identity as Krishna. As is common in this type of interstitial line, the link to the previous song is found in the specific moniker of Chaitanya used in the original song: Gaurāṅga. The kāṭān line thus uses the same name to connect the interstitial line to its source material. In addition to these textual reflections from the original song, the language used in this kāṭān from the Dān Līlā is part of a conventional body of lyrics that one can find across the kāṭān genre. For example, the phrase *"pūraber bhābe bibhor hoye"* (absorbed in a previous emotion) is ubiquitous in kāṭān sections found across the Manoharsāhī repertoire. Other short vocatives such as *"āhā mori"* (oh, my) are similarly found across the body of lyrical material used for the interstitial kāṭān lines. The use of personal pronouns such as *I* and *my* in relation to Chaitanya further play an affective role in these songs, as they "invite the audience to participate in these emotions and their expression" (Wulff 1996, 80) across the kāṭān repertoire. The use of the pronouns to invite the audience and performers might also be linked with the sphere of visualization in the expansive kīrtan, as their presence "gives time for performers and audience alike to reflect on the ideas and experience the emotions more fully" (84).[21]

The second kāṭān line of this song continues to emphasize Chaitanya's previous emotional state but with a more explicit focus on the Dān Līlā where we find this song:

Second half-couplet: *nadīyāra mājhe gorā dān sirajila*
 In Nadīyā, Gorā [Chaitanya] began
 asking for the tax.

kāṭān: *bhāba nidhi gaura-hari (āje) pūrab līlā*
 śaraṇ kari
 Today, I take shelter of the previous līlā
 of the Golden Krishna (Chaitanya), the
 abode of emotion.

Instead of Krishna becoming the tax collector, here Chaitanya is adopting the role and serves as a signal for the collapsing temporal boundaries that separate Krishna's time-space with Chaitanya's. The intimate focus of the message in the kāṭān describes how the singer takes shelter of Chaitanya and his līlā in the mood of devotion. The kāṭān lines thus mediate the larger process of translation and interpretation that the singer performs, linking the earlier textual archive with contemporary audiences through song.

THE UNWRITTEN LITERATURE OF ĀKHARS

If kāṭān lyrics are brief interpolations, the other type of interstitial text known as the ākhar pervades song performances. In contrast to the kāṭān section, which is associated with larger tāls, ākhar lyrics are used with several smaller tāls, such as the eight-mātrā Daśpahirā Tāl, the six-mātrā Lophā Tāl, and the four-mātrā Canchaput Tāl. The ubiquity of these smaller tāls and their associated ākhar sections means that the work of translation, interpretation, and emotional expansion found in these lyrics is thoroughly incorporated into the sonic fabric of a performance. As Wulff notes, "From the time of their introduction into padāvalī kīrtan, *ākhars* have become virtually all pervasive, penetrating all styles of kīrtan from the most classical to the most popular" (1996, 76). The lack of these interstitial lines in manuscripts from the eighteenth century has led scholars to

suggest that their inclusion in performance might date from the late nineteenth century (Chakraborty 1995, 179). This theory also squares with the fact that the translations that ākhar lyrics present would have become more necessary as linguistic features of Middle Bengali and Brajabuli became less well known to kīrtan audiences. The etymological origin of the term *ākhar* derives from the Sanskrit word for "syllable" (*akṣara*) (Wulff 1996, Chakraborty 1995) and might refer to the manner in which these lyrics are presented as fragments of text that appear during the song.

Because ākhars are not found in the manuscript archive, the kīrtan musician and scholar Mriganka Chakraborty refers to them as forms of "unwritten literature" (*alikhita sāhitya*) (Chakraborty 1995, 179). Designating ākhars as literature underscores their connection with the sphere of theory that underpins song organization, as ākhar lyrics follow the same outline of aesthetic theory used to categorize the anthology repertoire of Vaiṣṇava padābalī. Despite this connection, however, the oral-aural nature of their performance affords singers a degree of liberty in expanding on the meanings and emotions of the original song. "When the emotion and language of the original song are set to a new arrangement in the lines of the ākhar," Chakraborty writes, "the [singer's] artistry and creativity become prominent and dramatize the arrangement of the līlā" (Chakraborty 1995, 179). The interpolations of the ākhar lyrics translate and expand on the setting or image of the original song as singers search out novel methods of performance. There are two basic categories of ākhar lyrics. The first includes ākhar lyrics that a singer has learned from her guru and thus can trace back one or more generations in her lineage of kīrtan performance. In discussion with me, Rahul Das designated this type of lyric as a form of "traditional ākhar"[22]; the lyrics for the ākhar section of the Dān Līlā song discussed below are from this category. A second and less common form of ākhar lyrics are considered improvisatory. In this case, the singer will create lyrics during performance that

elaborate on the text and meaning of the original song, a prac-
tice that is not without controversy to some kīrtan scholars and
aficionados (see Wulff 2009).

Inserting the unwritten ākhar lines in performance quickly
multiplies the amount of lyrical material contained in the original
song. In performance, the ākhar section comprises three short
textual fragments. This structure is fundamental to its relation-
ship with pitch, as each of the three lines moves successively
higher in pitch range when performed. There are also two rhyth-
mic forms of intensification that accompany the ākhar sections,
as there is an acceleration in tempo and increase in rhythmic den-
sity found in the accompanying percussion instruments. During
the ākhar section, the singer will repeat and interweave these
three short textual fragments, often repeating one section several
times or returning to one of the short lines that was previously
sung. The third line of the ākhar section carries a heightened
sense of importance in this overall structure and is referred to as
the mātan. A straightforward translation for the term is "absorp-
tion," yet it refers simultaneously to a fragment of song text, an
accompanying khol pattern, and the emotional state of concen-
tration and absorption that the lyrical and musical components
are meant to evoke. The term mātan, then, refers to a constel-
lation of musical and extramusical concepts and practices that
are meant to lead the listener to a state of devotional absorption.
Audiences in a līlā kīrtan performance offer a response when the
ensemble reaches the mātan section, raising their arms above
their heads and offering various forms of embodied assent to the
message (see chap. 7).

One version of ākhar lyrics used in the pūrva-rāga song "rādhār
ki hoile" demonstrates the work of these interstitial lines in ex-
panding a song. The ākhar lyrics discussed here are taken from
a studio recording of the kīrtan singer Rathin Ghosh.[23] As men-
tioned, the setting for the song is a discussion between Radha's
friends who are concerned about her state of infatuation with

Krishna. It opens with an inquiry and description of Radha's delicate state in the first section of the tripartite original pad:

original pad:

rādhār ki hoila antare bethā/	What pain is within Radha?
basiyā birale thākaye ekale	She sits apart and stays alone,
nā śune kāhāro kathā//	hearing nothing anyone says.

The ākhar section composed of three parts then follows this opening couplet of the original song:

ākhar:

1) *rāi hṛde eta kiser bethā*	What kind of pain is in the heart of Radha?
2) *thāke birale śune nā kathā*	She stays alone, hearing no talk.
3) *śukāye gela kanaka latā*	The Golden Creeper [Radha] had dried up.

In the first two lines of the ākhar section, Rathin Ghosh offers a straightforward translation and restatement of the song's first couplet. For example, ākhar line one restates the first line of the song in a colloquial Bangla yet also specifies that the term "within" (*antare*) refers to "in the heart." The second ākhar line aims for concision in the manner that the singer includes two lines of the original song in only one short interstitial line of song. In the third ākhar line, which is the mātan, Ghosh presents new material through the vehicle of a metaphor that compares Radha's golden complexion to a golden-colored creeper and her state of separation to its process of desiccation. The image of Radha as the dry creeper indexes the mood of separation and, more specifically, the infatuation evoked by her thoughts of Krishna.

The work of ākhar lyrics proves to be even more extensive in the song's second couplet. Here, the three-part structure of the ākhar section is inserted between each half-couplet, thus more than doubling the amount of song text and duration of the performance. The dominant image used to convey Radha's mood

of infatuation in this half-couplet is a description of her state of trance. The lyrics depict how the intensity of her mood of separation from Krishna has caused her to stare at the clouds in the sky. The mention of the clouds is a further reference to Krishna's body, which is often compared with the blue-black hue of storm clouds, a reference that is underscored in the first ākhar line:

First half-couplet:

sadāi dheyāne cāhe megha	Forever in trance, she stares at the
pane nā cale nayāna-tārā/	clouds; her eyes do not move.

ākhar:

1) *bujhi legeche cokhe*	It seems that the mascara of the dark
megher kājal	clouds is [painted] on her eyes.
2) *kakhane ānkhi haye*	At any moment her eyes will
bā sajal	become moist,
3) *nāmbe bujhi megher*	[like] rain falling from the clouds.
bādal	

The central image of the cloud in the original song directs the thematic material of the ākhar, as Radha's eyes are characterized as resembling clouds in two ways. In the first line of the ākhar, Ghosh describes how the dark mascara of her eyes matches the dark storm clouds in her view; in the second and third lines, her tears are compared to rain falling from a cloud. There is a new interpretation offered in these interstitial lines, which expands on the images and emotional potential of the original song.

Still considering the song's second couplet, the three-part ākhar section that accompanies the next line of text as performed by Ghosh employs another technique. Here, the tripartite structure of the ākhar section is not sung at the conclusion of the entire half-couplet but is instead sung after only the first two words (*birati āhāre*) of the original song are voiced. It thus serves to evoke a moment of heightened expression when Ghosh chooses to interject the ākhar lyrics before completing the half-couplet.

After the insertion of the ākhar section during the line, the entire half-couplet is restated:

Second half-couplet (interrupted):
birati āhāre . . . Ceasing to eat . . .

ākhar:
1) *ā mari jāy āhā re āhā re* Oh, I will die!
2) *ruci nāi āhāre* There is no taste for food;
3) *dukha kaba kāhāre* With whom shall I share this
 sadness?

Second Half-couplet:
birati āhāre rāṅgā bāsa She has no taste for food and wears
pare saffron,
jemata joginī pārā// like a female ascetic.

The wordplay of this section transforms the word *āhāre* (to eat) into the homophonic combination of two vocative phrases that are common in padābalī kīrtan lyrics—*āhā* and *re*—in the first line of the ākhar section. This short interpellation is followed by the return of the word *āhāre* in the second line of the ākhar, followed by the rhyming *kāhāre* (whom) in line three.

A similar form of textual expansion occurs in an ākhar section from the Dān Līlā song *"ki balile sudhāmukhi,"* discussed above. The source for these ākhar lines is a līlā kīrtan performance by Dyuti Chakraborty described in detail in chapter 7. As mentioned, the song presents Krishna's rebuttal to Radha's friends, who have claimed that he should be ashamed for approaching Radha for a road tax because of his status as a cowherd. Like other examples of the ākhar genre, the lyrics translate the older dialect into a contemporary linguistic register, yet here we see how ākhar lyrics present further sections of dialogue between Krishna and Radha's group:

First half-couplet:
ki balile sudhāmukhi, Oh, one with a nectar-filled mouth
 [Radha], what did you say?

āmi māthe dhenu rākhi,	That I only tend cows in the
puruṣe sakali śobhā pāya/	field? For a man/God, every
	[activity] is auspicious.

ākhar:

1) *āmār to sakali śobhā*	For me every [activity] is auspicious.
2) *āmār sarba-karma* *māna-lobhā*	All my activities charm the mind,
3) *su-karma ki ku-karma*	whether good acts or bad.

The wordplay surrounding the term *puruṣa* (God/man) from the original song becomes the focus of the lyrics in the ākhar section, as the somewhat abstract proclamation in the original song—that any work is auspicious—is given more context here. Specifically, Dyuti Chakraborty links Krishna's perspective on work to his identity as the puruṣa (God) with the presentation of the idea that Krishna's work as a cowherd is not only admissible but also auspicious. This idea is advanced when Krishna says that any so-called "good" or "bad" work that he performs can charm the mind (*māna-lobha*), as his auspicious work as God is beyond such dualities.

The singer's use of a first-person presentation to deliver Krishna's message continues in the interstitial lines that follow the second half-couplet. Here, Krishna begins to question why Radha is traveling to the market with her goods for sale when her friends are describing her as a princess:

Second half-couplet:

rājāra nandinī haiye, dadhira	A princess, carrying yogurt
pasarā [māthāy] laye,	to the market on her head?
māthe hāṭe ke dheye beṛāya//	Who roams in the fields and marketplaces in such a way?

ākhar:

1) *āmi śuni nāi to emana kathā*	I have never heard of such a thing.
2) *rājā-nandinī dāṛāy jathā tathā*	A princess standing here and there.
3) *hāy hāy dekhe pāy mane byathā*	Alas, seeing this pains me.

The ākhar lyrics following the second half-couplet continue to address the lingering discontent that animates the Dān Līlā, as it responds to the criticism of Radha's friends that preceded this song. Krishna's amazement that Radha would be going to the market is accentuated by the claim that he has "never heard of such a thing," as he wonders why Radha is roaming the country-side alone. Though this statement insinuates that Radha's husband is not taking proper care of her, on another level, it hints at the fact that Radha wants to meet with Krishna and ultimately resolve their earlier disagreement.

CONCLUSION: TEXTS, IMAGES, AND AFFECT

There exists an intricate and symbiotic relationship between padābalī kīrtan song texts, the images they seek to evoke, and the repertoire's semantic and emotional aims. The published anthologies and the earlier manuscript archive not only present this large corpus of word-pictures through the medium of print; they also mediate the experience of song through their manner of organizing song texts and linking them to the eight categories of the amorous mood. Connecting the readership of these song-poems to an earlier tradition of Sanskrit aesthetic thought represents a form of mediality that uncovers the genre's theoretical underpinnings. The two songs presented here—each indicative of one of the eight forms of the amorous mood—are only two examples in a vast repertoire of thousands of songs that have been created, disseminated, and performed in conversation with a longer history of Sanskrit aesthetics in South Asia.

Connected with this written record is a vast body of interstitial lines of song that are materialized in performance. Though virtually absent from the written record, these interstitial lines perform acts of mediation and vernacularization when they translate songs from an older linguistic register into a more colloquial idiom. More than this, however, they also elaborate on the themes found in

the original songs and expand from the structural wellspring of aesthetic theory that can be traced back to the fields of dramaturgy and poetics. Indeed, these interstitial lines exceed aspects of the written word, as their materialization calls forward a range of other performative modes that contribute to the emotional field of kīrtan song texts. These "texts contain a possibility of meaning," as Sudipta Kaviraj notes in regard to padābalī kīrtan, "but this meaning often waits on something that exists even before meaning begins—the sensuous, pre-semantic attractiveness of the aural or the musical. This stratum of the text must be brought into presentation (i.e., into aural presence) by means of oral mediation" (2003, 525). Studying the interactions between the original verses of song and the interstitial lines hints at some of the emotional and semantic possibilities that expand from the ways they interact in performance.

The process of realizing the performative stratum of these song texts depends on a variety of conventions that lead to the creation of musical sound in kīrtan performance. The word-pictures described in this chapter materialize through vocal and instrumental performance, a sphere of musical activity that relies on an underlying body of musical theory and form, among other factors. The work of semantic and emotional expansion analyzed in this chapter is thus dependent on features of the expansive musical style that are needed for song texts to become musical sound. The next chapter explores the domains of instrumentation, music theory, and performance that inform how kīrtan musicians manifest these word-pictures as sound. A central factor in this process is the role that time organization and tāl play in the genre's performative and theoretical domains.

NOTES

1. One example can be found in Brajabashi and Mitra (1317 BS [1910], vii).

2. The use of the term *sāhitya* (literature) for Vaiṣṇava padāvalī is commonplace. See Sen and Mitra 1943, for example.

3. See, for example, Brajabashi and Mitra (1317 BS [1910], vii).

4. One example of Krishna's infatuation is the song *"sakhi rādhā nāma ki kahile"* in *SSPK* I, 59.

5. Caṇḍīdāsa is a composer from the period that historians refer to as the "pre-Chaitanya period" (*śrīchaitanya-pūrbbabarttī*) (c. 1100–1486), a time span that witnessed the creation of a number of songs that remain central to contemporary performances. As Chakrabarty notes, there is a controversy about the various identities ascribed to the poet Caṇḍīdāsa (1996, 184). It is now accepted that there were at least two different Caṇḍīdāsa composing kīrtan lyrics. Mukhopadhyay suggests there were three different Caṇḍīdāsa poets: Baṛu Caṇḍīdāsa, Dvija Caṇḍīdāsa, and Dīna Caṇḍīdāsa (1971). For a discussion of the identity of the various poets who signed their poems "Caṇḍīdāsa," see also Dimock (1966, 56–67).

6. This version is found in *Śrī Śrī-Pada-kalpataru*, vol. I, 25. This translation is adapted from Wulff (1996).

7. This version is found in *Śrī Śrī-Pada-kalpataru*, vol. I, 23–40.

8. The ten states of Radha's infatuation, as previously given in chapter 3: *lālasā* (ardent desire), *udvega* (anxiety), *jāgaryā* (sleeplessness), *tānava* (thinness of the body), *acetana jaḍiman* (inanimate stupidity), *vaiyagrya* (impulsiveness), *vyādhi* (disease), *unmāda* (dementedness), *moha* (unconsciousness), and *mṛtyu* (death) (Brajabashi and Mitra 1948, 178).

9. The original Bangla is *lālasodvegadaśā-barṇana*. See Vaishnava and Ray (1322 BS [1915], i).

10. See Rūpagosvāmī (1341 BS [1934]).

11. This song can be found in *Śrī-Padāmṛta-mādhurī*, vol. 3 (1937, 357).

12. See Bharata Muni (1950, 108).

13. See Schweig and Buchta (2018).

14. See chapter 7.

15. See Pollock (2016, 300).

16. See Okita (2016) for a discussion of how a fourteenth-century aesthetic treatise written by the king-scholar Śiṅgabhūpāla II from Andhra may have influenced Rūpa Gosvāmī's text.

17. Scholars writing about the repertoire of Vaiṣṇava padābalī commonly refer to Brajabuli as a hybrid and synthetic language that combines Maithili with Middle Bengali, used for song composition. William Smith (2000) argues that Brajabuli is not a mixed or hybrid language but rather a variant of Maithili. See Hubert (2018) for a further discussion.

18. Personal communication, December 1, 2012, Kolkata.

19. The first half couplet is commonly set to the twenty-eight-mātrā Som

Tāl while the second would typically be set to a fourteen-mātrā tāl. See chapter 6.

20. See Dev's Student's Favourite Dictionary [Bangla], 28th ed., s.v. "kāṭān."

21. It should be noted that this specific transformation of text in the ākhar section is representative of Manoharasāhī kīrtan. Gaḍanhāṭī kīrtan, conversely, uses a less dramatic transformation of the original pada in the ākhar section (Suman Bhattacharya, personal communication, November 29, 2012, Kolkata).

22. Personal communication, August 24, 2017, video conference call.

23. See https://www.youtube.com/watch?v=NIleQf86SqM for a version of this recording.

SIX

—〰—

SONIC SYNCHRONIES OF
TĀL THEORY

A DETAILED SYSTEM OF TĀL theory and practice is central to the way that musicians organize features of musical sound in padābalī kīrtan. This area of tāl theory includes a robust discursive sphere that determines the way musicians term, categorize, and assemble a hierarchy of time units known as mātrās. This body of theory is further key to the genre's repertoire of tāl, a body of music theory that might share similarities with other tāl systems in South Asia yet represents a significantly distinct corpus of musical knowledge. Tāl theory in padābalī kīrtan is a wellspring that informs performance decisions. One example of this is that an individual song can use as many as five different tāls in performance; another is that the melodic structures used in song performance are determined by the specific tāl being used, and not informed by the pan-South Asian concept of rāg, for example. To a significant extent, then, studying the theoretical field of padābalī kīrtan illustrates the ways that tāl theory is central to features of musical realization, underlining the claim that kīrtan derives its influence from tāl.

A study of padābalī kīrtan tāl theory lies at the center of this chapter. This discussion introduces the terminology and theory that kīrtan musicians use to learn and perform the genre's

repertoire of devotional song. Substantial points of similarity are found between this system and features of tāl found in Hindustani music in north India, though differences exist as well. The study of tāl theory and practice featured in this chapter is preceded by an introduction to the vocal and instrumental performance modes that constitute the texture of the kīrtan ensemble. This analysis introduces not only the roles that musicians adopt during performance but also the various ways that vocal and instrumental techniques and materialities are tied to the ritual and theological sphere of Gauḍīya Vaiṣṇava thought and practice. To illustrate the manner in which melodic structures emerge in performance, the final section of the chapter analyzes the relationship between melody and tāl. If one compares the performance practice of padābalī kīrtan with other classical musical genres in South Asia, what emerges is that the melodic structures that guide song rendition are determined by the specific tāl used in accompaniment. Here, we might pay attention to the links inherent in Wolf's conjoined term "rhythmic-melodic" as opposed to "rhythmic" and "melodic" as a way to "problematize the idea that rhythm and melody are inseparable . . . either in South Asian experience or in cross-cultural musicological analysis" (2014, 8).

To address the links found between musical and social temporality, this chapter not only examines the central role of tāl theory in kīrtan but further considers the ways that this body of theory contributes to the aims of duration and sequence found in concepts of temporality in Bengali devotional performance. If the link between meditation and the large-meter musical style rests on features of duration, the following discussion explores how the process of *creating* time spans cannot be separated from the genre's system of musical theory. In sum, I argue that there is a dialectical relationship between the social values of duration in devotional performance and the genre's system of music theory. The interest invested in developing tāl theory in padābalī kīrtan reflects an interest in creating songs with a lengthy time span,

which constitutes an overlapping focus on the durational param-
eters of visualization in Gauḍīya Vaiṣṇava practice.

THE MUSICAL TEXTURES OF A KĪRTAN ENSEMBLE

Tone Producers—Voice and Instruments

The central focus in the kīrtan ensemble is a solitary singer who
voices the body of devotional poetry described in the previous
chapter. Male and female singers similarly occupy this key role
in the kīrtan ensemble, referred to as the *mūl gāyen* or "main
singer."[1] Because enacting a līlā kīrtan requires the use of vari-
ous performance techniques that go beyond the act of singing,
the main singer adopts a variety of extramusical roles throughout
a performance. These acts include prolonged narrations (*kathā*)
embellished with theatric elocution and gesture; role-playing
segments where the singer enacts the perspectives of saints and
deities; didactic religious speeches with moral messages; and
presentations of dance. The variety of roles in an evening perfor-
mance thus ranges across the domains of music and theater in
a way that is common in other performance traditions in north
India (Hansen 1992) and in other forms of kīrtan in western India
(Schultz 2013). The mixed modes of performance and the central
role of this singer-storyteller transform a līlā kīrtan into what the
musician Kankana Mitra refers to as a "drama enacted by one"
(*eka nāṭak*).[2]

The title of mūl gāyen further references the singer's position
at the center of the ensemble's musical texture. In one discussion,
Nimai Mitra emphasized the meaning of the term *mūl* when he
offered another translation of the term: "root."[3] This metaphori-
cal designation illustrated how the main singer supports and co-
ordinates the entire musical ensemble, similar to the way that
a "tree is held up by its root."[4] This role further evokes the or-
ganic connection found in the image of the newly sprouted seed

discussed previously and presents an image of the main singer as the central trunk in a sprouting plant of musical sound.

Another metaphor Nimai Mitra offered illustrates the role of the main singer as an ocean, a liquid form where the numerous "rivers" of the musical ensemble join:

> If the accompanists can match the singer's expression, then together they can all accomplish the full *rūp* (form) of padābalī kīrtan.... That way, the [main] kīrtanīyā and the accompanists will be of one mind and mood. Just like one river merges with another river, and then with more and more rivers, eventually mixing into the ocean. Similarly, the śrī khol is one river, the kartāl is another river, the Yamaha [electronic keyboard] is another river, the flute is another river, and you [the kīrtanīyā] are the ocean. They are all meant to merge in you, and your mood. This is the process of kīrtan.[5]

To coordinate this musical texture, the main singer stands in the middle of the stage during a kīrtan, flanked by two khol musicians and in front of several singers and instrumentalists. From this position, the main singer directs the slow tempos and large meters of the genre's musical style through a series of hand gestures and signals transitions between song and storytelling to the rest of the ensemble.

Supporting the mūl gāyen is the *dohār*, a "second singer" working synergistically with the main singer during the performance to enhance the musical texture. Sitting directly behind the main singer, the dohār repeats fragments and complete lines of song and intoned verse, following the main singer's lead and often finishing lines of song midphrase. The dohār's musical contribution is best described as a form of doubling and support. Unlike accompanists in Hindustani and Karnatak music who, for example, might playfully interact with the lead vocalist or instrumentalist, the dohār works for a clear repetition of song text. Instead of the accompanist's role in Karnatak music, which Amanda Weidman describes as a "mixture of support and competition, imitation

and creativity, shape-giving and self-effacement" (2006, 34), the dohār adds only minor embellishments to song renditions so that the song text remains clearly presented. The work of the dohār also has a practical side during a performance, as her repetition of lyrical lines allows the singer to catch her breath. This repetition further allows the main singer to propel the narrative forward using dance or theatric gestures, enacting the story or image depicted in the lyrics. During sections of instrumental performance, the second singer repeats a specific vocal line several times while the khol musician performs several solo compositions. The dohār's singing thus links and supports the ensemble's musical texture, and her contributions run throughout the entire performance, making her an "indispensable assistant" to the main singer (Chakraborty 1995, 198). This tight-knit relationship is at once both musical and social; prominent main singers are often linked with specific dohār singers in popular memory (198). This link continues in the present, as main singers often repeatedly perform with the same dohār on account of their shared knowledge of song repertoire.

Though the focus in a līlā kīrtan is on song and storytelling, a variety of instruments support the ensemble's sonic texture. Keyboard instruments such as the harmonium and electronic keyboard are most common. The dohār, for example, often plays the harmonium to double the melodic contour of the vocal line while seated behind the main singer on the stage. Kīrtan musicians adopted the harmonium c. 1950,[6] but the more recent addition of the electronic keyboard, in use since the mid-1980s, has expanded the role of keyboard instruments in the ensemble.[7] Indeed, in a contemporary līlā kīrtan ensemble the electronic keyboard sounds a mixture of timbres, arpeggios, and melodic explorations that underpin the lengthy sections of storytelling. Other accompanying instruments include the bamboo flute, the violin, and, in studio recordings, the sitār. Each of these instruments performs a function similar to the keyboard instruments,

either doubling the vocal part or creating a sonic background for the storytelling sections.

Tāl Producers—Kartāls and the Śrī Khol

While the tone-producing instruments are newer additions to the līlā kīrtan ensemble, the two percussion instruments central to the longer historical arc of the ensemble are the śrī khol (or simply khol) (see fig. 6.1), a double-headed barrel drum, and the kartāls, a pair of small brass hand-cymbals. Unlike the accompanying instruments mentioned above, the presence of these percussion instruments can be traced to the seventeenth-century *Bhakti-ratnākara*, where they are described as playing a key part in Narottama Dāsa's ensemble. In these early hagiographies, we hear how these two instruments were worshiped before performance and thus included in the ritual sphere of the Kheturī Melā, a practice that remains crucial in the present.[8] Their importance during the time-space of Chaitanya is emphasized in the following Gaura-candrikā song, where these instruments play a key part in Chaitanya's nocturnal kīrtan events:

> *khol karatāl gorā sumela kariyā/*
> *tār majhe nace gorā jaya diyā//*

> Gaura [Chaitanya] arranged the performance
> of khol and kartāl/
> In the midst of [the kīrtan] Gaura danced and shouted,
> "All glories, All glories!"//

Another narrative that khol musicians tell links these two instruments with the mythical time-space of Krishna. It is a story that articulates an oral history of the drum that posits its ontology as a miraculous manifestation of Krishna's flute. One version of this story begins in the mythical and otherworldly time-space of Brindaban, where Krishna was contemplating his descent to the earthly domain.[9] Because Krishna would change his appearance from the young flute-playing cowherd to the Bengali brahman

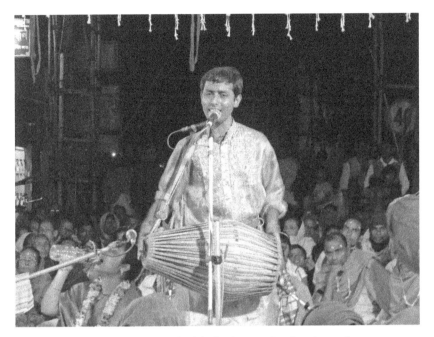

Figure 6.1 Rahul Das playing the khol. Photo taken by the author, 2012.

Chaitanya, he expressed his intent not to carry his well-known flute, as it would give away his identity as Krishna. After hearing this, the personified image of Krishna's flute began to lament, and Krishna, affected by the instrument's emotional state, decided that his flute could descend with him but would be transformed into the shape of the khol drum. Despite their apparent morphological differences, this one-to-one relationship between the flute and the khol is one of several identity transpositions that take place in Gauḍīya Vaiṣṇava thought. As Haberman notes, "It is well known that Chaitanya was considered to be an incarnation of Kṛṣṇa, and later a dual incarnation of Rādhā-Kṛṣṇa. What is less well known, however, is that every major figure associated with Chaitanya was considered to be a particular 'mythical' character from the Vraja-līlā also incarnated as one of the various 'historical' figures during the time of Chaitanya" (1988, 107). This story about the drum's identity further suggests

that not only figures were transposed from one temporal frame to another; objects such as musical instruments were also part of this larger process, or what Stewart refers to as a "phenomenology of repetition" that dominates Gauḍīya Vaiṣṇava historical consciousness (2010, 273). Because of the various ritual practices that surround their use, these instruments possess an "affecting presence," to use Robert Armstrong's term, as they act "as subject, asserting [their] own being, inviting the perceptor's recognition and, in culturally permitted ways, structuring that subsequent relationship" (1971, 25).

The affecting presence of the khol emanates from a specific material form. A defining characteristic of this double-headed barrel drum, common in regions of eastern India and Bangladesh, is an asymmetric clay body that is roughly fifty-four centimeters long. This asymmetry is a result of the fact that the drum features a treble head (*dahine*) that is one-half the diameter of the bass head (*bahine*). This 1:2 ratio contributes to a distinctive bulge in the drum's body, which stands in contrast to the related South Asian drums known as *pakhāvaj* and *mṛdaṅgam*. Despite this difference, the composite construction of the khol's drumheads does resemble the construction of these two instruments used in Hindustani and Karnatak music.[10] On the khol, a long leather strip is wound between both heads to apply tension thirty-two times. The resultant thirty-two straps carry a further sacred meaning in connection with the drum's morphology, representing a group of thirty-two particularly important personalities in the history of Gauḍīya Vaiṣṇava practice.[11]

This material form of the khol inspires several ritual acts that precede the performance. For example, the khol, along with the kartāls, are commonly worshiped before a līlā kīrtan performance, as offerings of flower garlands and sandalwood paste are placed directly on the instruments.[12] In addition, the recitation of ritual verses, or mantras, is another practice that takes place before a musician will touch the drum. For example,

the following Sanskrit verse, referred to as a *pranām mantra* (verse of salutation), is intoned before performing on the khol and illustrates a wide variety of theological and affective points that are connected to the drum and its performance:

namaste śrī-jagannāthāya gaurāṅgāya namo namaḥ/
namaste śrī-khol-kartālāya namaḥ śrī-kīrtan-maṇḍalī//
mṛdaṅga-brahmarupāya lāvaṇya-rasa-mādhurī/
sahasra-guṇa-saṅyukta mṛdaṅgāye namo namaḥ//

Salutations to Krishna (Jagannātha). Repeated salutations to the Golden-Limbed Chaitanya. Salutations to the khol and kartāl, and to the kīrtan ensemble. Repeated salutations to the khol (*mṛdaṅga*), endowed with a form of spiritual potency and possessing the quality to evoke thousands of sweet rasas.[13]

Like other percussion systems in north India (Kippen 2006), khol repertoire is learned through a series of spoken syllables called *bols* (words) that represent specific drum strokes. Indeed, the entire khol repertoire is taught through learning bols, which, like other drumming systems in north India, can be defined as "quasi-onomatopoeic" (77). One purpose of this practice found across South Asian drumming is clearly mnemonic (Wolf 2014, 20), as memorizing these syllables is one way a musician remembers the pattern of strokes that will be played. In most cases, these bols do not carry semantic meaning; nevertheless, they do share an iconic relationship with linguistic systems that suggest features of confluence with phonetic features of South Asian languages. As Wolf notes in the context of Hindustani music, "aspirated syllables with voiced consonants (/d/ or /g/) connote a heavy or 'full' (*bharī*) sound and involve the continuous resonance of the bass drum (or bass side of the drum). Voiced and unvoiced velar consonants (/g/ and /k/) distinguish resonating and nonresonating bass sounds. Nonresonating sounds on the treble or bass drum (or side) may also be indicated by a closed syllable with unvoiced consonants" (2014, 20–21). There is a vast

body of repertoire communicated through bols in khol performance, and one short example is found in a ritual composition known as the khol pranām (khol salutation), which is a pattern played by the musician before any kīrtan accompaniment occurs (Video Example 6.1):

> khol pranām: *dho kheṭā tād dho tātā kheṭā ghenā tini dāghe netā ghenāo—tākhi tākhi tā tākhi tākhi tā guru—dhei nā dhei nā dhei tākhi tātā dhei nā dhei jhān.*

Several of the links between the spoken bols and the drum sounds are immediately obvious. For example, *dho*, the first bol in the khol pranām, presents an aspirated and voiced syllable (*dh*) and thus represents a resonant stroke played on the bass and treble heads simultaneously. The second syllable, *khe*, presents an unvoiced consonant that refers to a nonresonant stroke on the bass head. The bol *ṭā*, which follows directly after *khe*, comprises a closed and unvoiced consonant and typically represents an open stroke on the treble head. In a similar manner to bol systems in Hindustani music, syllables that begin with a *t* or *k* often represent nonresonant strokes; and in Hindustani music these cases are termed as k͟hālī (empty or light). However, while syllables and their corresponding strokes in other north Indian drumming systems use the terms *bharī* (full/heavy) and k͟hālī (empty/light), the corresponding terminology in padābalī kīrtan is *guru* (heavy/resonant) and *laghu* (light/nonresonant).[14] Therefore, a segment of a khol composition that features resonant strokes (and their corresponding voiced consonants) would be called the guru section while the segment featuring nonresonant strokes would be termed the laghu section. Other similarities between different drumming systems in north India would certainly emerge with further analysis, but the connections between language and khol performance begin to suggest the presence of a "voice in the drum," as found by Wolf in other drumming styles in South Asia (2014).

The khol praṇām composition is an invocatory drumming rite that precedes the performance. However, when a song begins, the khol musician chooses from a large repertoire of timekeeping and elaborative compositions to accompany the song (See table 6.1). And while the khol praṇām example stands outside of the sphere of tāl, each of these other pieces of repertoire are set to one of the numerous tāls used in padābalī kīrtan (see below). In explaining the khol repertoire, Nimai Mitra compares each category to a different article of clothing. The specific tāl in use is compared to the body while each individual pattern in the khol repertoire is thought to be a form of dress. Each category of this repertoire serves a different purpose during a performance. For example, the *ṭhekā* is a rhythmic pattern that supports the vocalist and un-ambiguously marks the progression through the tāl. Other pieces of repertoire, such as the *ghāt*, also adhere to the structure of the tāl yet further present moments for the musician to demonstrate features of rhythmic elaboration found in the repertoire.

The ritual practices that mark the khol's importance in Gauḍīya Vaiṣṇava thought also apply to the kartāls. These hand-cymbals are worshiped in a similar fashion as the khol before a līlā kīrtan performance. The central role they occupy in the context of a kīrtan performance is reflected in their name, which can be translated as "doing tāl" (*kar* = doing). In a performance, either the main singer or another musician uses the cymbals to sketch out the basic framework of the tāl structure. For example, especially in songs that feature the large-meter musical style, the hand-cymbal musician uses a cheironomic pattern that consists of four gestures marking the ensemble's progression through the divisions of tāl. As will be shown below, there are four gestures: one sounded and three nonsounded. In the sounded gesture the two hand-cymbals are brought together; the nonsounded gestures use hand motions in a predetermined pattern but do not bring the hand cymbals together. In a song performance, this combination of sounded and nonsounded motions serves to

Table 6.1. Categories of khol repertoire

Name of Khol Repertoire	When Performed	General Features
ṭhekā or *laoyā*	Common time-keeping pattern used during a song performance.	Outlines the structure of the tāl to fulfill the role of accompaniment.
kāṭān	Accompanies the kāṭān song text found in large-meter forms.	Displays an increase in rhythmic activity during the song performance.
mātan	Played during the final section of the ākhar section in short-tāl forms.	Considered the climactic rhythmic piece during the ākhar section.
ghāt	A composition that the khol musician performs over a repeated vocal line, often at the end of the Gaura-candrikā song.	Develops and combines rhythmic motives according to the tāl, often ending with a thrice-repeated motive (tehāi).
tehāi	Performed at the end of a vocal phrase or khol composition to lead to the first mātrā of the tāl.	A thrice-repeated rhythmic motive, often eight mātrās in length.
mūrcchan	Used at the end of various ṭhekā, kāṭān and mātan patterns to signal a return to the ṭhekā.	A short decorative pattern, often four mātrās long.
lahar	Played at the beginning of the ākhar section during a song.	Typically increases the rhythmic density of the texture and features more muted strokes on the khol.
hātuṭi	Solo khol composition that is used at the beginning of a līlā kīrtan performance.	Features a short rhythmic pattern that is repeated and gradually increases in speed. Often ghāt compositions are included during the hātuṭi, which is concluded with a tehāi.

direct the rest of the ensemble, and might be considered as part of a larger constellation of "gestural-sonic link[s]" (Rahaim 2012, 92) found in musicking in North India, albeit with a focus on tāl in this particular case. The actions of the kartāl musician, then,

are crucial to directing the entire ensemble through the cycle of the tāl, a temporal and theoretical order that is key to understanding the sphere of meter in padābalī kīrtan.

Learning Tāl Theory in Padābalī Kīrtan

The organization of musical sound that accompanies song lyrics in padābalī kīrtan rests on a rigorous theoretical base. Tāl theory directs and controls the organization of musical sound in an abstract temporal system that guides the contours of the genre's expansive musical aesthetic. Tāl theory is central to two forms of temporal expansion. The first is a flexibility of structure where the addition and subtraction of time units (mātrās) results in new metric forms. For example, the smallest theoretical elements of tāl theory—mātrās—are combined and organized to form larger aggregates that become discrete tāls. One example of the flexibility inherent in kīrtan tāls is the manner in which one size of tāl is transformed into another. Tāls that contain fourteen mātrās, for example, are easily elongated into cycles of twenty-eight time units through the addition of a specific mātrā type (see below). A related second link between tāl theory and the expansive musical aesthetic is the manner in which such a flexible system aids in the creation of a relatively large repertoire of metric forms that constitute the kīrtan repertoire. The musician Nimai Mitra would communicate the breadth of the genre's tāl repertoire when mentioning to me how knew eighty-seven different tāls.[15] To achieve these aesthetic-cum-temporal aims, kīrtan tāl theory includes a detailed system of nomenclature, a series of gestures that communicate temporal progression, and a collection of compositions performed on the khol used to accompany and embellish various tāl structures. Perhaps surprisingly, this detailed body of theory about meter and rhythm stands in contrast to the rather meager amount of terminology and concepts used to articulate ideas about melodic structure in kīrtan. Learning the large-meter style in instructional contexts, therefore, requires the student to

learn tāl theory in addition to the vocal or instrumental repertoire required for performance. Lessons in vocal and drumming performance thus begin with an examination of the conceptual substratum that undergirds musical performance.

The progression from abstract theory to performed patterns in kīrtan tāl theory is not altogether dissimilar from other systems of meter in north India. It is useful, then, to begin with a consideration of the twofold organization of tāl that Martin Clayton analyzes in his study of the theory and practice of tāl in Hindustani music. As Clayton notes, the tāl system in north India is comprised of two related yet distinct features (2000). On the one hand, the tāl system is made up of a series of "quantitative" characteristics that derive from an abstract theory of meter. For example, this quantitative level includes several features that differ between various tāls, such as the number of mātrās that constitute one cycle, the manner in which mātrās are subdivided within the tāl, the classification of specific metric groupings, and the clap-wave pattern that accompanies each tāl.[16] Together, these features articulate a theory of tāl that is shared across the repertoire. On the other hand, Clayton notes how a second feature of tāl is the collection of certain "qualitative" or "accentual" features that are formed through actual performance techniques and thus constitute the level of "surface rhythm" (2000). The performed patterns that make up the surface level share various relationships with the tāl's quantitative level. Perhaps the most basic feature of this relationship is the manner in which the vocal or instrumental performance will adhere to the number of mātrās that makes up the tāl. The relationship between these qualitative and quantitative aspects is most apparent in how a musician's performance will synchronize with the overall duration of the tāl. Indeed, the first mātrā of the cycle, known as the *sam*, acts as a point of temporal coincidence where musical ideas frequently converge. Another way that the surface rhythm conforms to the durational level is the manner in which the performance coincides

with the basic divisions of the tāl structure. In this case, the musical patterns share a structural relationship with the divisions of the tāl. One example commonly found among tāl structures is the relationship between subdivisions of the tāl that are categorized as "full" (bharī) with resonant drumming strokes (guru in padābalī kīrtan), while strokes that fall within the "empty" (khālī) correspond with nonresonant strokes (laghu in padābalī kīrtan). To reference the metaphor of clothing mentioned previously, in Clayton's description of tāl as a hybrid system, the structure of the body correlates to the durational-quantitative aspect while the clothing represents the qualitative-accentual perspective. This twofold way of viewing the quantitative and qualitative features of tāl provides a convenient starting point for kīrtan tāl theory.

The characteristics of padābalī kīrtan's tāl system come into focus when we examine a single case. In dozens of khol lessons with Nimai Mitra, the particulars of this theoretical system emerged through discussions about the tāl system's abstract nature as well as in the process of learning specific time-keeping patterns. In the music room on the roof of his apartment building, Nimai Mitra would often dedicate a single lesson to studying one particular tāl. On one warm October afternoon in 2012, Nimai Mitra sat behind his harmonium with a khol on his lap. The noisy breeze of the ceiling fan rippled our clothes and the pages of my lesson notebook as I wrote down the specifics of one tāl that Nimai Mitra introduced. The lesson on that day focused on a tāl central to the Gaura-candrikā song repertoire: Madhyam Daśkośī Tāl. As I sat with my notebook, Nimai Mitra first outlined its quantitative features, explaining that this tāl was composed of fourteen mātrās, a point I quickly captured in my notebook. The next theoretical detail I wrote down for this tāl involved the way these fourteen mātrās were subdivided into the asymmetric pattern of 4+4+2+4 (table 6.2); this characteristic of the tāl is known as its *bibhāg* (subdivisional structure).[17] Our lesson then turned

Table 6.2. Madhyam Daśkośī Tāl

1	2	3	4
tāl (sam)	phānk	kol	phānk
5	6	7	8
tāl	phānk	kol	phānk
9	10		
tāl	phānk		
11	12	13	14
tāl	phānk	kol	phānk

to a discussion of how this particular asymmetric arrangement of mātrās was based on an underlying theory of classification. Crucially, this point represents a key theoretical idea in padābalī kīrtan tāl theory—namely, that *each* mātrā in the meter is categorized within a theoretical scheme and assigned what I call here a *mātrā-type*. The three mātrā-types that are found in Madhyam Daśkośī Tāl are shown in table 6.2, which shows that each mātrā is classified with one of three names (*tāl, phānk,* and *kol*). There is a fourth mātrā-type shown in table 6.3 that is not used in this tāl. The arrangement where each mātrā in a tāl is assigned a specific type represents a substantial difference from tāl structures in Hindustani music, as individual metric units in that system are more closely linked with constitutive groups.[18]

In the next part of our lesson, Nimai Mitra explained how each of the three mātrā-types used in Madhyam Daśkośī Tāl is further accompanied by a sounded or silent gesture that marks one's progression through the meter, another key detail of kīrtan's tāl theory.[19] Similar to Hindustani music, a sounded gesture marks the mātrā-type named "tāl." In a pedagogical setting this will often be a hand clap while in performance with a full ensemble the mātrā-type of tāl will be marked by bringing together the kartāls.[20] The placement of the four "tāl" mātrā-types in the structure of Madhyam Daśkośī Tāl determines the main points of accent in the meter. For example, beats one, five, nine, and eleven in

Table 6.3. Mātrā-types in kīrtan tāl theory

Mātrā-Type Name	Function and Gesture
tāl	Marks "strongest" mātrās; represented by a clap or kartāl stroke; always corresponds with the sam (first mātrā of the tāl).
phānk	Marked by a silent gesture; hand moves away from the body on a horizontal plane. Further categorized with the term koś.
kol (also called birām)	Marked by a silent gesture; hand moves toward the body on a horizontal plane. Further categorized with the term koś.
kāl	"Weakest" of the mātrā-types; silent gesture where one or both hands are raised on a vertical plane to a point in front of the face; used to expand tāl structures.

Madhyam Daśkośī Tāl (table 6.2) represent the "stronger" beats in the tāl structure that correspond with a hand clap or cymbal stroke and are further paralleled by accented strokes in an accompanying drum pattern.[21] When combined with the "weaker" mātrā-types described below, which are accompanied by a series of silent gestures, a particular clap-wave pattern emerges for each tāl structure. This pattern articulates a hierarchy of sound where the "stronger" beat in the cycle, marked with a sounded clap, is assigned a more fundamental role vis-à-vis the tāl's structure when compared to the two "weaker" mātrā-types used to fill in the basic form of Madhyam Daśkośī Tāl.

Silent gestures are assigned to the two remaining "weaker" mātrā-types used in Madhyam Daśkośī Tāl. The first silent gesture is called phānk and signaled by a movement of the hand(s) away from the body on a horizontal plane. The Bangla word phānk can be translated as "gap" and points to the physical space that opens as one moves the hand away from the body. The second silent category of mātrā is kol,[22] indicated when the right hand moves close to the body on a horizontal plane, stopping near the

Figure 6.2 Gestures for each mātrā type by Nimai Mitra. Clockwise from upper left-hand corner, the four gestures are (1) Tāl; (2) Kāl; (3) Phānk; (4) Kol. Photos taken by the author, 2012.

hip. The ending location for this gesture is expressed in the name, kol, which refers to the physical position on the body between the ribs and the hip (see fig. 6.2). Both silent gestures fall under an additional classificatory term: koś (pl. kośī).[23] This term also denotes the movement that takes place when the musician moves her arm back and forth between the phānk and kol positions in a type of swinging motion. If kośī thus applies to this motion, then appending the Bangla term for the number ten—daś—creates the central identifying term for the tāl under study: Madhyam Daśkośī Tāl. A literal, if inelegant, translation for this tāl name might be the "Medium-Size Tāl with Ten Silent Gestures." This

translation does underscore the fact that there are indeed ten silent gestures, or kośī, in the meter. An examination of the graphic for this tāl (table 6.2) confirms that every other mātrā except for the tāls (one, four, nine, and eleven) is a silent gesture that falls under the heading of kośi. The theoretical and quantitative substratum of kīrtan tāl theory thus surfaces in the name of this metric pattern. With the theoretical information about Madhyam Daśkośi Tāl covered, our lesson on that day turned to learning the various forms of khol repertoire that would serve both timekeeping and elaborative roles during a song performance.

There was one category of mātrā-type that we had not covered in our lesson yet—a crucial feature of kīrtan's expansive musical aesthetic. This fourth mātrā-type illustrates the flexible system of tāl theory that allows for the straightforward way that new structures are created. This final category of mātrā is named *kāl*, which can be translated as "time" or a "temporal period" and thus tellingly illustrates the role it plays in elongating the underlying structure of a meter. The gesture that accompanies this mātrā-type is the raising of one or both hands on a vertical plane to a position in front of the face (fig. 6.2).[24] In terms of structure, the kāl mātrās are positioned interstitially; when they are used in various tāls, they are often placed in between each of the three categories of mātrā discussed previously. This addition of mātrās immediately results in doubling the number of time units.

One tāl that demonstrates the expansive nature of this theoretical system is Boṛo Daśkośi Tāl (table 6.4), a meter related to the previously considered Madhyam Daśkośi Tāl. In Boṛo Daśkośi Tāl, the addition of the kāl mātrās, which are placed interstitially between each mātrā, doubles the size of the meter by adding fourteen additional time units. Indeed, the addition of these fourteen kāls transforms the Madhyam (medium) version of the tāl into the Boṛo (large) form. Therefore, one translation for the new meter could be "The Large-Size Tāl with Ten Silent Gestures." Although one could note that there are now twenty-

Table 6.4. Boṛo Daśkośī Tāl

1	2	3	4	5	6	7	8
tāl (sam)	kāl	phānk	kāl	kol	kāl	phānk	kāl
9	10	11	12	13	14	15	16
tāl	kāl	phānk	kāl	kol	kāl	phānk	kāl
17	18	19	20				
tāl	kāl	phānk	tāl				
21	22	23	24	25	26	27	28
tāl	kāl	phānk	kāl	kol	kāl	phānk	kāl

four silent gestures, the fourteen kāls that have been added are not technically part of the kośī category. When the fourteen kāls have been added, the aggregate of twenty-eight mātrās in this meter can be divided as 8+8+4+8, a bibhāg that mirrors the divisions of Madhyam Daśkośī Tāl (4+4+2+4). Both tāls thus share an isometric relationship, as the quantitative structure of their subdivisions both reduce to the pattern 2:2:1:2. It might be noted that this movement between larger and smaller tāl structures bears intriguing similarities with Lewis Rowell's study of "expanded states" of meter in early Indian music (1992, 199–201).

The flexible theoretical system that underpins the repertoire of kīrtan tāls allows for the creation of numerous tāls through a straightforward process. This feature of the kīrtan tāl system and the manner in which musicians employ it illustrates connections between the genre's theory and the value of temporal expansion. The relationship between the different categories of mātrā-type, and the manner in which they easily lead to the creation of new tāls, suggests a system of metric theory that prizes the creation of new meters. In addition to the Madhyam and Boṛo Daśkośī Tāls discussed here, there are a variety of other meters that are part of the Daśkośī "family," including Birām Daśkośī Tāl (fourteen mātrās), Kāṭā Daśkośī Tāl (twenty-eight mātrās), and Choṭo Daśkośī Tāl (seven mātrās). One reason for the flexible tāl system and the manner in which it contributes to a large

repertoire of tāls is found in the role that it plays in the structural parameters of devotional song. Indeed, a key characteristic of padābalī kīrtan song performance that distinguishes this genre from other performance idioms in South Asia is that several tāls are used during one song. As mentioned, this is most clearly seen in the repertoire of Gaura-candrikā songs that feature the large-meter musical style.[25]

Gaura-candrikā Form and Tāl

One practical outlet for the flexible way that padābalī kīrtan tāl theory allows for the creation of numerous metric structures is found in the Gaura-candrikā repertoire, where a kīrtan musician might use as many as six different tāls during a single song. As mentioned previously, the specific structural principle that defines this practice is a progression from larger to smaller tāls in the previously mentioned go-puccha form (chap. 4). If we survey most of the tāls used in this form, we quickly see the prominence of the isometric relationship of 2:2:1:2 mentioned above (e.g., tāls with twenty-eight, fourteen, and seven mātrās). Take, for example, the song "brindabaner līlā" as performed in November 2012 by Nimai Mitra (table 6.5). Here, the first half-couplet of this Gaura-candrikā song is set to the largest meter, the twenty-eight-mātrā Som Tāl, featuring an 8+8+4+8 subdivisional structure. The second half-couplet is then accompanied by a fourteen-mātrā tāl (4+4+2+4), which, in many cases, is one of the Daśkośī-type tāls mentioned previously and, in this case, Birām Daśkośī Tāl. Though this particular song then progresses to the seven-mātrā Jhānti Tāl (2+2+1+2), it is also common for Gaura-candrikā songs to proceed to the eight-mātrā Daśpahirā Tāl during the second or third couplet. After this, some songs call for tāls with smaller mātrā counts such as the six-mātrā Lophā Tāl or the four-mātrā Canchaput Tāl for the song's final couplets, though in this particular song the convention for the final couplet is a straight-ahead

Table 6.5. Gaura-candrikā song *"brindabaner līlā"*

brindabaner līlā gorār manete paṛila/ [Som Tāl, 28 mātrās]	Gaura remembered the līlā of Brindaban;/
yamunāra bhāba suradhunīre karila/ [Birām Daśkośī Tāl, 14 mātrās]	He considered the Suradhunī [i.e., Ganga] to be the Yamuna River.
phulaban dekhi brindābaner samān/ [Jhānti Tāl, 7 mātrās]	Seeing the flower garden, [he considered it] like Brindaban./
sahacaragaṇa gopī sama anumān/ [Jhānti Tāl, 7 mātrās]	He considered his companions to be gopīs [milkmaids of Brindaban].//
khol karatāl gorā sumela kariyā/ [Jhānti Tāl, 7 mātrās]	Gaura arranged the performance of khol and kartāl;/
tār majhe nace gorā jaya jaya diyā/ [Jhānti Tāl, 7 mātrās]	In the midst of [the kīrtan] Gaura danced and shouted, "All glories! All glories!"//
bāsudeb ghosh kahe gaurāṅga bilās/	Basudeb Ghosh says, "[In] the pastimes of Gaurāṅga [Chaitanya],/
rāsarasa gorācānda karila prakāś// [Unmetered intonation]	Gaura-chand [Chaitanya] revealed the essence of the Rās Līlā."//

unmetered intonation of the final pieces of text.[26] If the specific combination of tāls used in a song can change from one case to another, the basic large-to-small tāl aesthetic remains standard as the ideal way of structuring musical time in Manoharsāhī kīrtan and underscores the importance of padābalī kīrtan tāl theory.

Another example of the use of various tāls and other features of the expansive musical aesthetic is found if we focus in on the song's first couplet. The first couplet of a Gaura-candrikā song features the largest tāls and slowest tempos in performance, two characteristics found in the beginning of the song that sonically mark this couplet as the "song's face" (*gāner mukh*) (Chakraborty 1995, 177). As further evidence of the genre's need for an expanded range of tāls and features of khol repertoire, table 6.6 presents the two original lines of the Gaura-candrikā song under study with the three additional lines of text used in performance. If we look in between the first and second couplets of the original

Table 6.6. First couplet of the Gaura-candrikā song *"brindabaner līlā"*

1. First half-couplet:
brindabaner līlā gorār manete paṛila [Som Tāl, ṭhekā]
Gaura [Caitanya] remembered the līlā of Brindaban.

2. kāṭān:
āmār gaura āre āmār pūraber bhābe bibhor haye āhā mari brindaban [Som Tāl, kāṭān]
Oh my Gaura, [who is] overwhelmed with previous emotions; oh Brindaban.

3. jāmālī:
āhā re āhā mari mari [Choṭa Daśkośī Tāl]
Collection of vocatives: "oh" (*āhā re*) and "my" (*mori*).

4. Second line of couplet:
yamunāra bhāba suradhunīre karila [Birām Daśkośī Tāl, ṭhekā]
He considered the Suradhunī [i.e., Ganga] to be the Yamuna River.

5. kāṭān:
āje rāser līlā karbe bole bhāba nidhi gaura-hari [Birām Daśkośī Tāl, kāṭān]
Today, Gaura-hari, the abode of emotion, contemplates [Krishna's] Rās Līlā.

Gaura-candrikā song text (1 and 4 in table 6.6), we can see two additional sections that draw from the khol repertoire. The first elaboration is the previously mentioned form of interstitial line known as the kāṭān, which features an eponymous piece of khol repertoire (i.e., also known as the kāṭān) (2 in table 6.6). The piece of khol repertoire known as the kāṭān features a more rhythmically dense pattern and gradually increases in tempo from the slow-moving twenty-five beats per minute until nearly tripling to about sixty-five beats per minute when it concludes.[27] Following the kāṭān is a short section called *jāmālī* (3 in table 6.6), an interlude that precedes the second line of the couplet and includes another tāl into the dense weave of the song with the seven-mātrā Choṭa Daśkośī Tāl. The text for this jāmālī section exclusively uses the vocative phrases "oh" (*āhā re*) and "my" (*mori*). After these two additional sections, the second half-couplet of the song's face, set to the fourteen-mātrā Birām Daśkośī Tāl, is followed by a second kāṭān section (5 in table 6.6). Like the kāṭān section for the first line of the couplet, the khol pattern in this

section increases the rhythmic density and tempo as the singer describes Chaitanya's contemplation on the Rās Līlā of Krishna.[28] Taken together, the addition of these interstitial lines, the various tāls used, and the other instrumental techniques contribute to a process of temporally expanding on a relatively small amount of original song text. In full-length performances, an additional technique is the inclusion of segments of spoken narration inserted between each line of song. In sum, the four couplets that constitute this Gaura-candrikā song can require nearly one hour to complete in performance.

Conspicuous by its absence in the foregoing discussion is any mention of how pitch and melody are organized in kīrtan performance. Indeed, for one familiar with the parameters of South Asian musical performance and the well-known cases of Hindustani and Karnatak music, the absence of any mention of the concept of rāg might seem curious. This lacuna, however, points to the fact that melodic structure in kīrtan performance is tied to the specific tāls being used to frame a song.

Kīrtan's Melody Derives from Tāl

On a warm fall day in October 2012, I traveled by train from metro Kolkata to the maternal home of Dyuti Chakraborty. After numerous attempts, I had found a free day when she and Rahul Das were not traveling or giving any līlā kīrtan performances, and we had arranged to meet for a vocal lesson. Getting to Dyuti Chakraborty's home in the Howrah district required navigating a series of taxis, trains, and rickshaws, which eventually deposited me in the quiet neighborhood. We settled down for a lesson in the family dining room on the first floor; a busy fan spun loudly from the ceiling as we began a lesson in the Gaura-candrikā song "āre mora āre mora gaurāṅga rāya" ("Oh, my Gaurāṅga Rāya [Chaitanya]"). As our class began, I recorded Dyuti Chakraborty singing the first half-couplet of the song (āre mora āre mora gaurāṅga

rāya), set to the twenty-eight-mātrā Som Tāl and its slow, meandering melodic structure. She placed her own notebook on a harmonium as she sang and marked the progression of the song and its relationship with Som Tāl using the cheironomic patterns of padābalī kīrtan tāl theory. After listening to her two-minute rendition of this short text, it was my turn. To assist, Dyuti Chakraborty sketched out a graph in my notebook to mark my progress through the text and melody. First, she instructed me to write the numbers one through twenty-eight horizontally across the top of the page. Next, after taking my notebook, she wrote the word, or sometimes the individual syllable, that corresponded to each mātrā below the numbers at the top of the page, as a way of representing when the word should be intoned relative to my progression through the tāl structure. Of course, there were many mātrās in this tāl that did not feature a new piece of text but were rather associated with a melismatic elongation of a vowel. This led to many blank spaces in the graph, which I would later fill in with a shorthand *sargam*, a type of solfège used in singing instruction. Singing the syllable -*re*, for example, lasted from mātrā five to mātrā ten in this song and my graph and was simply represented with dashes written underneath the numbers in between. With this basic graph in place, I haltingly sang through one cycle of the tāl, sounding out the basic melodic structure of the first half-couplet. To accompany the lesson, Rahul Das played the khol, and Dyuti Chakraborty played the basic melody on the harmonium to help guide my singing. After the lesson, seeing I was somewhat overwhelmed by the material, Rahul Das told me that learning the melodic structure for only *this* song would lead to the ability to sing *any* song text set to the twenty-eight-mātrā Som Tāl. In so doing, he confirmed something that had been nagging at me over the years as I had listened to dozens of song texts set to Som Tāl: they all had seemed to conform to a similar melodic structure. Indeed, I had already encountered the melodic structure that I learned in that lesson in dozens of song performances

in the Manoharasāhī style. And I would encounter it many more times as I listened more and studied more texts set to the all-important Som Tāl.

Each tāl in the kīrtan repertoire is linked with several melodic structures. During a song performance, the melody a singer uses is determined by the tāl that is used while singing. In other words, the *same* line of song text will adhere to a *different* melodic structure depending on which tāl underpins its performance. The melody is thus not determined by an abstract modal system (rāg) nor a conventional tune associated with the lyrics. This point cannot be overstated, as it would seem to represent a case where the melodic form of a song is determined by a meter or tāl. One example of this is found in the previously mentioned Som Tāl. Though there are dozens of different song texts used to begin a Gaura-candrikā song, in each case the melody supporting the lyrics follows a general pattern repeated with minor variations—what I refer to here as a melodic structure. This term focuses on the contours of pitch, as it expresses what is the dynamic interchange between a core skeletal melody and the ways that it is ornamented and altered in performance. An analysis of Som Tāl songs further supports this point.[29]

The most common Bangla word used to refer to pitch organization in padābalī kīrtan is *sur*, a term that can be roughly translated as "melody." The use of this term to speak about melody illustrates how the general contours of pitch structure are relatively fixed in relation to the song text. The various melodic structures that are linked with specific tāls serve to shape the basic outline of a song rendition, though musicians do make significant alterations to these structures in performance. A fragment of song text might be repeated several times before progressing, or a single syllable in the melodic structure might serve for a melismatic vocal performance that pauses the progression of the text. The forms of notation that are presented in this section, therefore, are not meant to be descriptive graphic forms that capture the exact

details of a specific performance; rather, they present the basic melodic structures that form a starting point in performance and are linked to specific tāls. Despite the more common usage of terminology that focuses on melodic structure (i.e., sur), references to rāg are not completely excluded from the sphere of kīrtan. In fact, a līlā kīrtan performance sometimes features improvisatory sections where musicians actualize the theoretical structures of rāgs, especially in the case of singers who have studied forms of Hindustani music. Despite this connection, one feature of Hindustani music rarely found in kīrtan performances is the use of sargam during improvisatory sections, a technique of solfege found in Hindustani music.[30] Though some Vaiṣṇava padābalī anthologies do list the rāgs (and sometimes tāls) that were meant to be used in performance, today this appears to be a publishing convention as the published rāg names are generally not followed in Manoharasāhī kīrtan. Moreover, kīrtan musicians and scholars often mention that the theoretical and performative features of rāg are not central to the methods of pitch organization in kīrtan.[31]

The link between specific tāls and melodic patterns manifests in one of two ways. The first case is found in a group of larger tāls where one meter is paired with a single melodic structure. In this case, each time a specific tāl is performed, the same melodic framework is used to accompany the song text in Manoharsāhī kīrtan. This method is commonly found in larger tāls in the kīrtan repertoire, such as the twenty-eight-mātrā Som Tāl mentioned previously and other tāls that are fourteen mātrās long. The second case involves smaller tāls, where each meter is associated with several melodic structures used in song performance. One example of this is found in the seven-mātrā Jhānti Tāl, where several melodic structures are paired with these smaller tāls. In both cases, the basic melodic form and the tāl structure are coextensive and thus expand over an equal amount of musical time. As the tāl and melody duration coincide at regular intervals in

performance, the relationship that unfolds over the course of musical time might be considered isoperiodic.[32] In the cases of the larger tāls, the melody will extend over the same number of mātrās as one iteration of the tāl; in the case of smaller tāls, the melody may extend over two or more iterations of the tāl yet will eventually synchronize with the tāl cycle. Examples from the Gaura-candrikā form will illustrate the basic parameters of the relationship between melody and tāl in the kīrtan repertoire.

Kankana Mitra describes the method of melodic elaboration in the large-meter musical style as embodying a process of "expansion" (bistār). More specifically, this elaboration depends on the increased number of pitches (svaras) that are used to support the song lyrics.[33] The case of Som Tāl illustrates this need for an increasing number of pitches to support the limited syllabic material of the song text. The melodic organization found in this large-meter song thus contains lengthy melismas and scalar passages that attempt to bridge the discrepancy between the limited textual material and duration of the tāl (example 6.1 and audio example 6.1). In Nimai Mitra's performance of the first couplet of the Gaura-candrikā song mentioned above, the first line is set to Som Tāl (brindabaner līlā gaura manete parila), and, as a common tempo for the beginning of this song is ♩= 25 beats per minute, one iteration of the twenty-eight-mātrā meter takes about one minute. The melodic structure used for Som Tāl spans a little more than an octave and features a scale that is like the major scale except for its two variations on the fourth (ma) and sixth (dha) pitches. Several words from the song are repeated to stretch the relatively short text across this large meter and melodic structure. The word brindaban, for example, is repeated twice between mātrās twenty-five and twenty-eight; another case in point is the word līlā, which is restated three times between mātrās twenty-eight and eleven. Added to the repetition is a melismatic delivery, demonstrated again in the single iteration of līlā that is spread out between mātrās twenty-eight and four. The fact that syllables of

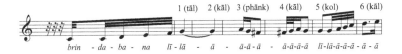

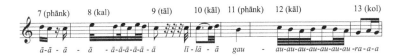

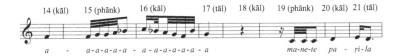

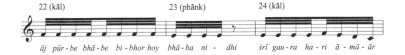

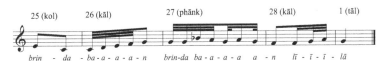

Example 6.1 Melodic structure used for Som Tāl.

song text are stretched over several mātrās suggests a clear case of a "music-dominated," as opposed to a "text-dominated," musical style (Manuel 1989).

A different melodic structure is used for the Som Tāl kāṭān section that occurs after the first half-couplet and ṭhekā section (See example 6.2 and audio example 6.2; the transcription does not begin until :21 into the recording example at mātrā nineteen [bibhor]). Though the kāṭān remains set to the twenty-eight-mātrā Som Tāl, the most evident difference in its melodic structure

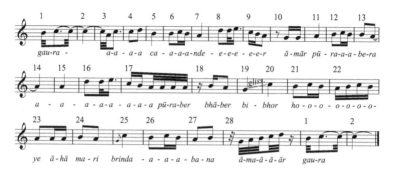

Example 6.2 Melodic structure used for the Som Tāl kāṭān section.

is a reduced number of pitches. Indeed, the frequent melodic runs and melismas used in the ṭhekā section are less common in the kāṭān; one reason for this is the significant increase in tempo that occurs over the course of this section. Beginning with the slow-moving tempo of twenty-five beats per minute, this section will gradually increase to about sixty-five beats per minute, a concluding tempo that would make the melodic runs and melismas of the pad section nearly impossible.

The use of a melodic structure that is linked with a specific tāl continues with the fourteen-mātrā Daśkośī tāl that commonly accompanies the second half-couplet of a Gaura-candrikā song. Like the case of Som Tāl, fourteen-mātrā tāls are part of the group of larger tāls where one meter is exclusively paired with a single melodic structure in performance. Perhaps the most common tāl used in the Gaura-candrikā repertoire is Birām Daśkośī Tāl, which shares a similar structure with the previously mentioned Madhyam Daśkośī Tāl, and its melody continues the trend toward a reduced number of pitches found in the Som Tāl kāṭān section mentioned above. The new rhythmic development that occurs here is that each mātrā in the Birām Daśkośī Tāl melody, and its accompanying khol pattern, is subdivided in the ṭhekā section into groupings of three (example 6.3 and audio example 6.3). This type of subdivision shifts to a duple pattern during the kāṭān

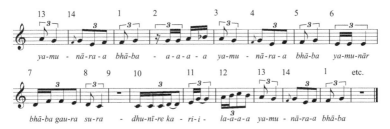

Example 6.3 Melodic structure used in Birām Daśkośī Tāl ṭhekā.

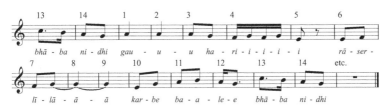

Example 6.4 Melodic structure used in Birām Daśkośī Tāl kāṭān.

section (example 6.4 and audio example 6.4), which, like the section of the same name mentioned above, gradually increases in tempo and features several khol compositions that increase the rhythmic density of the section.

The second group of tāls that demonstrate the connection between meter and melody consists of several smaller tāls. One example of this is found in the seven-mātrā Jhānti Tāl, a metric structure that is featured in the Gaura-candrikā form. The factors that determine the melodic structure for song texts set to this tāl involve convention. Because there are several melodic structures that can be paired with Jhānti Tāl, decisions about which one to use are determined by musical transmission. To put it another way, musicians use a specific melodic structure to accompany a line of song text based on their instruction in the song repertoire.

The third couplet of the Gaura-candrikā song studied in this section (*khol karatāl gorā sumela kariyā*) features one of the

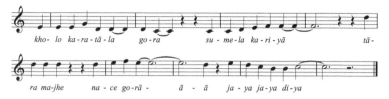

kho- lo ka-ra-tā-la go-ra su - me-la ka-ri-yā tā-

ra ma-jhe na - ce go-rā - ā - ā ja - ya ja-ya di-ya

Example 6.5 Melodic structure for Jhānti Tāl ṭhekā for "*khol karatāl.*"

melodic structures connected with Jhānti Tāl. The basic form
of this two-part melodic structure is modular (example 6.5 and
audio example 6.5). The first part of the melody uses an intervallic
range of a fifth and is used to accompany the first half-couplet.
The second part of the melodic structure, used with the second
half-couplet, also covers the range of a fifth yet is recentered to
an upper constellation of five notes. The movement from a lower
group of notes, centered around a lower tonic pitch, to an up-
per constellation of pitches that circle around an upper tonic
pitch is common throughout several genres and performance
styles in South Asia. Though theoretical descriptions of Jhānti
Tāl describe how it is composed of seven mātrās, in perfor-
mance its sounded realization appears to consist of six, and for
this reason the notation examples here comprise six notes per
measure.

When adapting lyrics to the structure of Jhānti Tāl, singers rep-
licate this core melodic structure irrespective of the specific song
text. One example of this is evident in another Gaura-candrikā
song used in the Dān Līlā narrative discussed in the previous
chapter (example 6.6 and audio example 6.6). Indeed, comparing
example 6.5 to 6.6 demonstrates a similar core melodic structure
that underpins these two sets of lyrics, despite the fact that they
are found in different songs and līlā kīrtan performances.[34] In
fact, numerous other examples of couplets set to Jhānti Tāl would
illustrate how the same core melodic structure is used to support

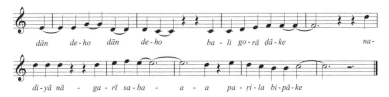

Example 6.6 Melodic structure for Jhānti Tāl ṭhekā for "*dān deho.*"

a song performance, demonstrating the ways that kīrtan's melody derives from tāl.

CONCLUSION: TĀL AND TEMPORAL ORDER

The robust and intricate body of knowledge that makes up the system of tāl theory in padābalī kīrtan represents something of a temporal order in at least two ways. One aspect of this is found in the sequential order from which features of musical sound unfold throughout the system. The attention focused on tāl theory in padābalī kīrtan underscores its centrality to learning aspects of performance, illustrated by the way in which features of this system are termed, categorized, and assembled. When walking me through an analysis of the different mātrā-types in the repertoire of tāl, and the manner in which they are connected and structured in performance, Nimai Mitra described these relationships as an interconnected "system" of musical theory.[35] Moreover, the way that singers base their use of melodic structures on the tāl suggests another influence from the body of tāl theory in padābalī kīrtan.

Another way that the body of tāl theory organizes features of musical sound in padābalī kīrtan is through the links that the system of theory makes with the genre's values of synchronization and duration. Indeed, there is a dialectic that exists between the spheres of theory and social value in padābalī kirtan, and this two-way

flow exhibits a relationship that hints at the attention paid to the creation and maintenance of this theoretical system. Studying features of tāl theory in detail sheds further light on aspects of ritual practice, as the features of intra-musical temporality in this system are encoded with other social values related to time. As is common in ritual settings, there is often a substantive link between the sounded aesthetics of a musical style and features of ritual time (Jankowsky 2010, 130). The theoretical features of tāl theory and the ways they are realized in performance exist almost entirely in acts of oral-aural transmission, as there are scant theoretical writings on this topic before the latter part of the twentieth century. Indeed, the descriptions of ensemble instrumentation, the ritual acts that precede performance, and depictions of musical sound all found in the seventeenth-century writings of Narahari Cakravartī (see chap. 2) bear a striking resemblance to the present, suggesting that much of this knowledge has been prized because it links musical sound with the social values of temporality in devotional performance.

Analyzing the relationship between music theory and the features of sequence and duration in this chapter has focused on a fine-grained analysis of musical sound and theory. The next chapter steps backward from this micro-level view to study how the various features of the expansive musical aesthetic are combined in a full-length līlā kīrtan performance. In this setting, the forms of textual and tāl-centered expansion that have been discussed in the two previous chapters combine with features of storytelling and didactic speech that a kīrtan singer uses in performance. Together, these modes of performance elaborate on a divine play of Radha and Krishna in the context of an exclusive līlā kīrtan performance, an event that fuels much of the musical labor found in the professional cultural economy.

NOTES

1. Chakraborty suggests this term was taken from a genre known as Brinda-gān from Bangladesh (1995, 197). Another term used for the main singer is *mūl gāyak*. See La Trobe (2010, 195).

2. Personal communication, September 26, 2012, Kolkata.

3. Interview, September 28, 2011, Kolkata.

4. Interview, September 28, 2011, Kolkata.

5. Interview, September 28, 2011, Kolkata.

6. Personal communication, Nimai Mitra, December 2, 2012, Kolkata.

7. Personal communication, Nimai Mitra, December 2, 2012, Kolkata.

8. See, for example, the *Narottama-bilāsa* (60, line 16).

9. This story can be found in Dāsa (n.d.).

10. For more information on the khol's construction and ritual significance, see Graves (2009).

11. According to Nimai Mitra (personal communication, September 16, 2012, Kolkata), the thirty-two personalities comprise the twelve gopāls, six Chakravartīs, six Gosvāmīs, and eight sākhis (Radha's companions).

12. The ritual worship of the khol before performance dates back to the Kheturī melā (chap. 2), where it was described that Raghunandana, the prominent devotee from Khanda, offered flower garlands and sandalwood paste to these percussion instruments as a form of worship (*BR* 10.544), a practice that continues in the present.

13. I learned this verse from Nimai Mitra (personal communication, September 16, 2012, Kolkata). However, this verse is similar to several other khol invocations. See Bisht (1986, 146), Chakraborty (1995, 229), and Bhattacharya (1317 BS, 3).

14. In the case of Sri Lanka, Jim Sykes (2018b, 6) notes the use of these two terms in Sinhala drumming and the ways they illuminate a close relationship between drumming and language, though there are of course many other clear points of distinction between the two drumming styles, most notably the ways that Sinhala drumming does not adhere to theories of tāl.

15. Personal communication, September 16, 2012, Kolkata.

16. I use the term *clap-wave pattern* as a modification of what Widdess has called the "clap pattern" (1981). I add the qualification of clap-wave pattern because the system of cheironomy in padābalī kīrtan has more nonsounded (i.e., wave) gestures than claps.

17. This is, of course, a linguistic relative to the Sanskrit and Hindi term *vibhāg*. See Clayton (2000, 43).

18. For example, see Clayton (2000, 58–59) for a list of Hindustani tāls.

19. See Rowell 1992 (192–93) for an interesting discussion regarding the use of numerous silent gestures in the tāl theory of early Indian music.

20. It should be emphasized here that the word tāl in this instance refers to a particular mātrā-type and not its more general meaning, which refers to a system of meter. Of course, that the mātrā-type of tāl is synonymous with the gesture of a hand clap is not a coincidence but derives from the term's more direct translation as a "clapping" (see Dev's Student's Favourite Dictionary [Bangla], 28th ed., s.v. "tāla.")

21. This is similar to the realization of tāl in Hindustani music. See Clayton (2000, 62).

22. Another term for this gesture is *birām*.

23. Chakraborty suggests that the term *kośī* is etymologically related to *kol* (1995, 153) and thus points to the location where the gesture ends. An alternate spelling for kośī is *kuśī*.

24. In photo 6.2, Nimai Mitra marks the phank and kāl mātrās with both hands while the birām mātrā is marked with only the right hand. However, it is also common for performers to mark each mātrā with only the right hand.

25. One exception is the *partāl* system used in Gurbānī sangīt. See Cassio (2015).

26. Theoretical descriptions of Jhānti Tāl describe it as a structure composed of seven mātrās (4+3 bibhāg). However, when this tāl is performed it sounds like a six-mātrā pattern, as mātrās two and three are condensed into the time period of a single mātrā's duration.

27. See audio example 6.2.

28. See audio example 6.4.

29. Indeed, a survey of dozens of Som Tāl songs reveals that each uses an extremely similar melodic structure that of course might be embellished differently in performance. Compare, for example, the several renditions of Som Tāl discussed in this book, including Audio Example 1.1 and Audio Example 7.5.

30. Sargam is sometimes used in pedagogical contexts. However, it is not a crucial feature of musical transmission.

31. See Mitra (1352 BS [1945], 39). Mitra's response to the lack of rāg-based improvisation in kīrtan offers several reasons why kīrtan singers may have departed from a focus on systems of rāg. One reason he proffers

is that musicians may have depended on manuscripts that did not use the process of listing rāgs with specific songs.

32. See Tenzer (2006) for more about isoperiodicity and music.

33. Personal communication, December 1, 2012, Kolkata.

34. There is, of course, a significant amount of melodic and rhythmic expansion in this iteration of the Jhānti Tāl core melodic structure when compared to the previous example (audio cxample 6.5). Nevertheless, the basic melodic structure is the same.

35. Personal communication, October 7, 2012, Kolkata.

THE DIVINE PLAY OF THE TAX COLLECTOR: MUSICAL EXPANSION, EMBODIED RESPONSE, AND DIDACTIC STORYTELLING IN A LĪLĀ KĪRTAN

TO PERFORM A LĪLĀ KĪRTAN, musicians enter a network of roads and pathways that branch across real and imagined geographies. The material spaces that kīrtan musicians traverse as professional performers in West Bengal spread across far-flung locations throughout the rural hinterlands of the state. The dwindling interest in kīrtan in the urban center of Kolkata, and the continuing enthusiasm of audiences in rural areas, means that professional musicians navigate networks of passage in rural West Bengal to reach the performance spaces where they promote their careers. These roads represent the infrastructure of the state and are the "material forms that allow for exchange over space, creating the channels that connect urban places in wider regional ... [and] national ... networks" (Larkin 2008, 5). Yet the possibilities that emerge in this network of passageways also introduce peril and risk when musicians encounter unpredictability in the spaces that lie outside of the ambit of urban Kolkata.

The imagined pathways that musicians traverse in a līlā kīrtan also evoke the uncertainties that can be found in passageways and roads. At the center of this chapter is a description and analysis of a 2012 performance of a līlā kīrtan in the village of Kanthi in West Bengal. The narrative of this performance focuses on a roadside encounter where Krishna adopts the guise of a road-tax collector intent on collecting a tax from Radha and her friends. The name of the story, Dān Līlā, reflects this theme through its focus on the divine play of the "tax" (*dān*). The space of the road, and its liminal location outside of the home, is central to the song and storytelling that unfold in this līlā. To meet with Krishna, Radha has slipped away from the house of her in-laws on the pretense of selling goods in the market. The external circumstances of this līlā, then, offer a theatric setting where the aesthetic mood of union (*sambhoga*) between Radha and Krishna takes center stage. If the songs and storytelling in this līlā portray a centuries-old regional theme through the story of the road-tax collector, they further work to evoke a specific shade of the mood of union through the images, narrative, and didactic messages expressed in performance.

The performance analysis in this chapter further pulls together the discussions of lyrical and musical expansion from the previous chapters to illustrate how they are combined and organized in a multi-hour performance. At the center of a līlā kīrtan are features of sequence and duration, which function as sonic synchronies to connect features of devotional temporality within the immanent sphere of musical sound. The overarching principle of temporal sequence is key in the organization of a full-scale līlā kīrtan. The single līlā kīrtan studied in this chapter reflects a basic temporal archetype that I witnessed across dozens of other performances and hundreds of lessons. Indeed, the basic sequence of genres and themes in this performance would be found across most instances of līlā kīrtan in the Manoharasāhī school. There is a prescribed series of songs and genres—many focusing on

Chaitanya—that must be performed before one can progress to the divine play of Radha and Krishna, a topic that is broached only after the necessary invocatory moments. The duration of this performance further underscores the links between the practice of līlā-smaraṇa (visualization) and features of the large-meter musical style, as musicians make concrete links between these practices throughout the performance. Each of these facets of musical time thus demonstrates links to the temporal aspects of devotional practice that unfold as forms of sonic synchronization in performance.

One feature of temporal expansion demonstrated in a līlā kīrtan is storytelling and didactic messaging that are interjected between song performances. This mode of speech, known as kathā, fulfills several functions in a performance, as kīrtan musicians use storytelling interludes to transition from one song couplet to another, make connections between the disparate timespaces of Krishna and Chaitanya, and present devotional and didactic messages based on features of Gauḍīya Vaiṣṇava thought and practice. In this regard, the main singer in the līlā kīrtan ensemble performs a social role often referred to as the *kathak*, a singer-narrator of pious and devotional stories that, in the Bengal region, has its origins in early modern Gauḍīya Vaiṣṇava practices (Bhadra 1994). Gautam Bhadra notes several features that define the kathak's performance, referring to the singer-narrator with gender-indicative pronouns despite the more recent rise in female kathaks: "His performance is usually held in the evening. He invariably speaks in the vernacular. He compiles his own text out of many sacred and accepted texts; he retells the story, interspersing his own narrative with suitable songs and poems and popular tales. He makes a number of variations, juxtaposing various versions of a tradition, and at the same time remaining true to the main structure of a well-known plot" (244). The work of the kathak found across several different performance genres is her ability to engage a form of "intermediality," as Priyanka Basu

notes in the case of the *Kabigāna* idiom (2017, 2). This is a form of performance that highlights how "imaginations of Hindu gods and goddesses converge . . . with real-life characters from the contemporary Bengali milieu" (2). Similarly, in the case of Bengali Baul performance, Carola Lorea notes how song and speech work as "transitional texts" that communicate esoteric religious knowledge from guru to disciple (2016, 236). The form of intermediality found in these practices thus explores common themes across various mythical and contemporary time frames that animate the narrative space of a līlā kīrtan.

Though the qualities of the kathak role can be applied to many different performance genres in contemporary Bengal, one shared feature is the manner in which this singer-narrator commands a particular time-space during a performance. Several types of ritual acts during a līlā kīrtan mark the authority of the kīrtan musicians and main singer and afford them the power to control the time-space of the performance. The ritual authority of the kathak, as described in this chapter, underscores how the performer can synchronize the ritual and musico-performative time frames and fulfill the work of temporal concretization. The ability to adopt the role of the kathak in performance thus provides a location for a kīrtan musician to fulfill the sequential and durational features of the genre that depend on lengthy time spans to complete.

The interpretive role of the kīrtan musician-as-kathak in the Dān Līlā performance studied here is perhaps most evident in Dyuti Chakraborty's transformation of the dramatic setting of Krishna's tax episode. One of the messages that runs throughout the performance is her interpretation that Krishna is not actually seeking a monetary tax; rather, she suggests that Krishna is seeking acts of selfless service (*sebā*) from his devotees. There is an extended interplay between two meanings of the word dān throughout the performance: on the one hand, dān refers to Krishna's request for a tax from Radha and her friends in the

narrative of the songs and storytelling, yet on the other hand the term also refers to a ritual gift, and this meaning takes root in the singer's repeated request to the audience to offer ritual gifts to the deities described throughout the līlā kīrtan. The interplay between these two meanings of dān lies at the center of this līlā in the song and verbal work of the kathak.

TEXTUAL SOURCES OF THE TAX EPISODE

Perhaps the first textual account that depicts Krishna as the road-tax collector is found in Baḍu Caṇḍīdās's fourteenth century Śrī-kṛṣṇa-kīrttana. The section "Dān-khaṇḍa" ("The Tax Chapter/Episode") is one of thirteen sections of this early Bangla-language text, a collection of over four hundred songs that translate the literary conventions of an earlier idiom of Sanskrit court poetry (kāvya) for provincial and nonelite audiences (Knutson 2014, 89).[1] However, as Klaiman notes, this early text was not the first Vaiṣṇava literature featuring the image of the tax collector; this narrative can be traced to written and architectural sources from previous centuries (1984, 47). Nevertheless, depicting Krishna in the role of the taxman became central to Gauḍīya Vaiṣṇava writings in the generation after Chaitanya, when two of his disciples featured the image of Krishna as the tax-collector in Sanskrit dramas. Indeed, Rūpa Gosvāmī wrote the short play (bhāṇikā) titled Dāna-keli-kaumudī (The Moonbeam of the Play of Tax-Collecting) in 1549 CE,[2] which was followed by Dāna-keli-cintāmaṇi (The Crest-jewel of the Play of Tax-Collecting), another text written by Raghunātha Dāsa Gosvāmī, a different member of the Braj Gosvāmī group.

Several narrative conventions animate the early depictions of Krishna across these early sources. These texts often begin with a description of Radha and her friends making their way to the market to sell dairy goods such as milk, clarified butter, and yogurt. While Radha and her friends are on their way, Krishna,

in the disguise of a road-tax collector, blocks their progress and then demands they pay a duty for the goods they are bringing to market. An argument ensues with back-and-forth repartees between Krishna and Radha's contingent; Radha and her friends question the legitimacy of Krishna's taxman role while Krishna wonders aloud why these young women are traveling the road alone. Though Krishna feigns concern over the fact that Radha is traveling without her husband, he is inwardly pleased that she is now away from her watchful spouse and in-laws. After the women rebuff his request for a tax on the dairy goods, Krishna shifts his approach and flirtatiously levies taxes on Radha's physical attributes. For example, in one version of the līlā he tells her that she owes two hundred thousand cowries (units of shell-money) for the luster of her black, glossy hair. The early textual accounts of the Dān Līlā feature different conclusions; some indicate that Radha agrees to meet Krishna later that evening (*Dāna-keli-kaumudī*) while other versions conclude with Radha complaining bitterly about the audacity of Krishna to adopt the taxman role and harass her and her friends.

The narrative structure in these early textual sources clearly informs contemporary retellings of the Dān Līlā. However, these early templates of the story are not treated as strict templates for musicians. Rather, the general narrative outline found in these early sources plays a seed-like role, serving as a narrative base for musicians to expand on in various ways. One example of such a flexible approach to the Dān Līlā narrative structure is the way that musicians incorporate features of Gauḍīya Vaiṣṇava theology. In Dyuti Chakraborty's version of the Dān Līlā, for example, the image of Chaitanya is found in the Gaura-candrikā song that prefaces the entire Radha-Krishna story. By singing this piece of repertoire, Dyuti Chakraborty describes how Chaitanya, in a state of emotional absorption, has adopted the role of the road-tax collector in his native Bengal, thus mimicking the activities of Krishna. Another point of emphasis from the Gauḍīya Vaiṣṇava

perspective is the didactic interpolations that emerge between songs, presenting moments of devotional instruction to the audience. As mentioned, one example of this in Dyuti Chakraborty's performance is a reflection on the meaning of dān as not simply "tax" but as a "ritual gift" that the devotee offers to Krishna or Chaitanya. This is one of many examples that use the narrative of the līlā to expand a series of didactic messages that mark this version of the Dān Līlā.

Though firmly anchored in the mythical time-space of Radha and Krishna's divine play, the narrative outline of the Dān Līlā illustrates the perils and possibilities found in the act of travel and the uncertainties of pathways. For musicians to tell such stories through song and speech entails a similar entrance into the liminal spaces of West Bengal, as they travel across sweeping rural geographies and relatively uninhabited stretches of road to the villages where they have been hired to perform. For musicians living in the Kolkata metro area, traveling throughout West Bengal is a required aspect of being a professional musician, as they visit rural areas to depict the līlās of Radha and Krishna through song and speech.

ARRIVING/DEPARTING

Our rented Tata SUV pulled into an empty urban lot near the center of the small city of Kanthi in the East Midnapore district of West Bengal. Several members of the līlā kīrtan group headed out to find the organizers for the night's event while the rest of the group remained near the SUV and the group's instruments. The vacant lot where the vehicle sat was in a state of disrepair; plastic refuse lined the outer rim, and stray dogs roamed in search of food. I looked out at the scene, glancing past the promotional placard that Rahul Das had attached to the inside of the vehicle's windshield before we left Dyuti Chakraborty's house in Rishra (fig. 7.1). In the small laminated poster, Dyuti Chakraborty looked

Figure 7.1 Promotional placard for Dyuti Chakraborty. Photos taken by the author, 2012.

straight ahead; her hands were folded in front of her, and Gauḍīya Vaiṣṇava tilak marked her forehead. The poster contained details intended to promote her kīrtan group, including several phone numbers and many of her professional accomplishments and honorific titles. The top of the placard introduced her as "one who is knowledgeable in kīrtan music: Gītaśrī Dyuti Chakrabarty"[3] and mentioned her performance experience on radio and television and education at Rabindra Bharati University.

The power of foresight during that moment in the abandoned lot would have revealed not only the windshield's links to professional possibilities but also the role it would play in the perils that traveling musicians encounter. While driving through an uninhabited stretch of road on our return journey later that evening, a singular small crack in the glass would appear when a rock struck the windshield, rousing us from early morning exhaustion. Instead of slowing down and stopping, our driver would accelerate to a breakneck speed, insisting that the rock was thrown by thieves hoping to rob us when we stopped to assess the damage. The crack would then grow and branch across the windshield, reaching the far corners of the glass. Not listening to our protests, the driver would continue to accelerate until the glass collapsed inward upon us. Luckily escaping with minor cuts, we would then be waylaid at a highway rest stop, negotiating with local

police who questioned our story and wondered why a foreigner (me) was traveling with a kīrtan group. The final chapter of our evening would conclude with a cold, slow, and windy multi-hour drive back to the Kolkata area in a vehicle without a windshield. The professional possibilities that inspire kīrtan musicians to travel throughout the rural and liminal spaces of West Bengal also pull them into an uncertain sphere marked with the challenges of professional musicianship.

But this would all come to pass later. After waiting briefly in the vehicle, we were led to an impromptu green room that had been arranged for the group. We entered a building and followed a narrow hallway to an open room that would temporarily serve as a space for instrument storage and changing. The building abutted the central Kanthi Bazar, where that evening's līlā kīrtan would take place. A local events organization named the Young Star Club oversaw the first floor of this building, and they had hired Dyuti Chakraborty and Rahul Das to perform here after hearing their līlā kīrtan at the Jaydeb Melā the previous year. The musicians in the group deposited their instruments and began to change from their travel clothes into their performance outfits. The men put on their dhotis and panjabi shirts while the women in the ensemble left to find another room to put on their saris. Members of Young Star Club brought hot chai for the entire group.

The space where the līlā kīrtan performance would occur was only steps away from the green room. As is common in līlā kīrtan performances throughout West Bengal, the event would take place in an outside location that would allow for many attendees. In fact, the Young Star Club had arranged for the performance to take place in the middle of the city's central shopping district. What was normally a road had been closed for the evening, and a small tent that was open on all sides had been placed in the middle of this common space. Four long, cylinder-shaped fluorescent bulbs had been attached to the legs of the tent,

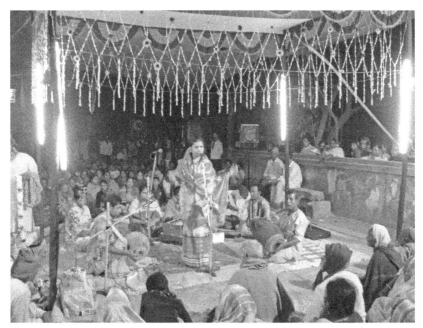

Figure 7.2 Dyuti Chakraborty and the kīrtan ensemble in the Kanthi
Bazaar. Photo taken by the author, 2012.

and small garlands of white jasmine flowers encircled the entire
stage area. Expecting a large turnout, the stage area was open on
all sides, and padded cotton sheets had been put on the ground
surrounding the tent. The sound engineers had also placed two
microphones for the lead singer facing opposite directions so she
could move back and forth between them and address the audi-
ence on both sides of the tent (see fig. 7.2). With the beginning of
the līlā kīrtan imminent, attendees began to assemble. Though
not an absolute division, one side of the performance space was
populated by men while most women and children settled in on
the other side of the tent. A group of senior men quickly took seats
near the front; younger men, women, and children soon found
seats around the tent. After the spaces with the cotton sheets were
filled, several rows of standing audience members congregated

behind those who were seated and next to a concrete wall that ran alongside the performance space.

RITUAL INVOCATIONS AND THE
TIME-SPACE OF THE KATHAK

A series of ritual acts signaled the beginning of the līlā kīrtan and further worked to mark the ritual authority of the kīrtan musicians. As they made their way to the stage with their instruments, an event organizer blew into a conch shell, and the sound pierced the evening air and the audience's chatter. The sound of the conch signaled the initiation of the ritual frame, mirroring how it precedes image worship in Gauḍīya Vaiṣṇava temple settings. Upon reaching the tent, the musicians entered a cloud of incense that was wafting throughout the space. The smoldering incense sticks were then placed in a corner of the tent next to an auspicious tulsi plant, a perennial whose leaves are used in temple rituals and that is commonly placed near the stage for līlā kīrtan performances. All the musicians apart from the main singer, Dyuti Chakraborty, took their places on the stage, and after completing a quick sound check they began an introductory nām kīrtan that focused on the names of Radha (hare) and Krishna (krishna, rāma) (audio example 7.1):

> hare krishna hare krishna krishna krishna hare hare
> hare rāma hare rāma rāma rāma hare hare

I would later learn that Dyuti Chakraborty had been in the green room calling her guru Nimai Mitra to ask for his blessings before the commencement of the līlā kīrtan. During this call, he had also told her which līlā of Radha and Krishna she should perform that evening, meaning that the musicians onstage would have to be able to immediately follow her lead once the performance began. After she received this key instruction from her guru, Dyuti Chakraborty went into the tent, where she sat on

the ground in the middle of the ensemble with her eyes closed, listening to the nām kīrtan that resonated throughout the space.

Her solemn countenance was one indicator of the ritual authority she commanded in the time-space of the performance. Another instance of this authority emerged in the relationship between the musicians and the patrons of the līlā kīrtan. In the beginning of the performance, a member of the Young Star Club came forward from the audience with his arms overflowing with flower garlands to offer the kīrtan musicians. He then placed a flower garland around the neck of each musician and a small dot of sandalwood paste on each person's forehead. Acts such as this ritually marked the space and singer and announced her authority for the audience, who would sit attentively for the upcoming four-hour combination of songs and storytelling. The patron further offered garlands to several senior audience members, noting the pious work of attending a līlā kīrtan, in which, as in similar forms of devotional performance in Bengal, "participation or non-participation . . . results in incurring sin or acquiring merit" (Bhadra 1994, 248). Indeed, because attending a līlā kīrtan is considered an act of piety that will bring auspiciousness to one's family and village, reasons for attending go beyond an attraction to the stories and songs. The ability to synchronize performances with devotional temporality in these time-spaces further hinges on relationships of ritual authority and power bestowed to the kathak through the invocatory rites that precede the līlā.

SONIC SYNCHRONIES OF SEQUENCE IN THE DĀN LĪLĀ

The Dān Līlā performance analyzed in this chapter progressed through a preset order of genres over the course of its four-hour duration, and the temporal location of each section related to aspects of ritual order in Gauḍīya Vaiṣṇava thought and practice. This temporal sequence illustrates an approach to ordering musical sound that is found across a wide sample of līlā kīrtan

performances; when comparing one performance to another, the differences one finds are generally thematic. The central role of sequence in structuring musical time is seen when considering the large-scale form of a līlā kīrtan performance. Before a kīrtan musician enacts the līlās of Radha and Krishna, such as the Dān Līlā story summarized above, she must progress through a prescribed order of eight genres of song, instrumental performance, and verse recitation that occur over a four-hour time frame. These eight sections can be further subdivided into three groupings that demonstrate the ritual and political intricacies of temporal order and sequence in a līlā kīrtan (fig. 7.3). The first group of genres plays an invocatory role in the context of a līlā kīrtan; the second group turn the focus to Chaitanya; and the final section arrives at the līlā of Radha and Krishna, considered the summum bonum of the performance. Performing each of these preceding genres fulfills either a ritually or theologically significant purpose in the performance, yet the fact that they preface the līlā of Radha and Krishna illustrates a key point of Gauḍīya Vaiṣṇava thought. The amorous divine play of Radha and Krishna is considered an intimate topic that must be approached with care and only after invoking the image of Chaitanya, a meditation that functions as a sonic gateway required to approach this subject.

GENRES OF INVOCATION

The ritual frame of a līlā kīrtan performance opens with an invocation of "sound," the translation of the name of the first section of a līlā kīrtan called *dhvani*, a cryptic descriptor that reflects the idea that sound is intimately tied to acts of ritual commencement in Hindu thought more broadly (Simms 1992). In this all-important thirty-second section, Dyuti Chakraborty invoked the performance frame with salutations to Chaitanya and his associates Nityānanda and Advaita, concluding with a

Figure 7.3 Sequence of genres in a līlā kīrtan.

request for the audience to call out the names of Krishna (video example 7.1):

> *"jaya jaya nitāi gaura sitānāth premānande*
> *nitāi gaur hari bol"*

"Salutations to Chaitanya, Nitāi, and Advaita, [the husband of Sītā]! In the bliss of divine love call out the names of Nityānanda, Chaitanya and Krishna [Hari]!"

Select phrases in this invocation were echoed by the dohār, and when the short invocation reached its conclusion, the singers were joined by rolling khols and clashing hand-cymbals. As the short phrase "nitāi gaur hari bol" was repeated several times, rising in pitch and volume, Dyuti Chakraborty raised her arms above her head and traced small circles in the air. This gesture cued seated audience members to raise their own arms or join their palms together in the air. The audience responded to these cues by enthusiastically repeating a short fragment of text: "nitāi gaur hari bol." The gesture of upraised arms was an iconic response that mirrored a gesture Chaitanya made during his own performance of kīrtan. This combination of chant and embodied response would occur dozens of times throughout the performance, often prompted by a repeat of Dyuti Chakraborty's circular gesture or often simply cued by the short phrase "nitāi

gaur hari bol." This enactment marked the audience's assent to a message in the līlā kīrtan and served as one way they participated in the devotional frame of the event.

This sonic invocation led to the second section of the performance, an instrumental performance that featured the khol and kartāls called the *hātuṭī*. The practice of opening a līlā kīrtan performance with instrumental khol compositions dates to the Kheturī Melā in the sixteenth century and since this early period has been considered a sonic appeal that "summons" Chaitanya to the kīrtan (Sanyal 1989, 201). In the hātuṭi section of the Kanthi performance, Rahul Das began with a short composition known as the khol pranām (see chap. 6) before cycling through several different compositions (audio example 7.2). A common rhythmic motif at the center of the hātuṭi compositions at this performance was an eight-mātrā pattern first played at a slow tempo and then at several different speeds. There are two sets of bols used for this pattern. The upper line is used at a slow tempo and the lower at a faster tempo (see tab. 7.1).

This basic pattern structured several of the hātuṭi compositions that followed, though various portions of the section included rapid drum rolls and the thrice-repeated rhythmic cadences known as *tehāis*. The rhythmic density of this section gradually increased over its four-minute duration and featured the accompaniment of hand-cymbals and an electronic keyboard, which underpinned the drum compositions with rapid melodic runs. Throughout the hātuṭi khol compositions, Dyuti Chakraborty sat calmly in front of the ensemble with her eyes closed, preparing for the next section of the līlā kīrtan.

In the middle of the hātuṭi section, the conspicuous melodic runs of the electronic keyboard suddenly went silent. The keyboard musician checked the cables around the instrument while signaling to the sound engineers that there was a problem. The malfunction continued throughout the remainder of the invocatory drumming section, requiring a break at its completion.

Table 7.1. Basic hātuṭi motive

1	2	3	4	5	6	7	8
♪ ♪ ♪	♪ ♪	♩	♪ ♪ ♪	♪ ♪	♩	♪ ♪	♩
ge teṭe	ge na	jhān	ge teṭe	ge na	jhān	ge na	jhān
guru	gur	da	guru	gur	da	gur	da

Because of this issue, the group decided to abandon the third step in the līlā kīrtan's sequential program: the lengthy ālāp section, typically a rāg-based vocal improvisation that features a short fragment of song text with the names of the deity Viṣṇu—"hari oṁ ānānta nārāyana"—a lyrical segment that demonstrates a relationship with the Dhrupad vocal genre (Sanyal and Widdess 2004, 151).[4]

After the keyboard issue was resolved, the section known as the maṅgalācaraṇ began. The Sanskrit name for this segment refers to a set of songs and prayers that invoke a ritual frame and is found in variety of devotional music contexts (see Schultz 2013, 141). In this section, Dyuti Chakraborty began by intoning a series of Sanskrit verses taken from Gauḍīya Vaiṣṇava practice (table 7.2 and audio example 7.3). The recitation of each verse followed a similar unmetered form and melodic template that roughly spanned an octave and determined the contour of the main singer and dohār's melodic repetition. Other instruments in the ensemble contributed rhythmic or melodic figures to underpin the recitation of the Sanskrit verses. The temporal sequence of the verses reinforced the ritual and theological order that governed the entire līlā kīrtan performance. The three verses that opened the maṅgalācaraṇ progressively offered salutations to (1) Chaitanya and Nityānanda, (2) Radha, and (3) Krishna. Each verse also depicted the embodied qualities and līlās of each deity. The sequence of these verses outlined Gauḍīya Vaiṣṇava theology as it emphasized that one must approach Chaitanya (and Nityānanda) before focusing on Radha and Krishna, and it thus served as a type of micro-temporal reflection of the larger

Table 7.2. Sanskrit verses from the maṅgalācaraṇ

ājānulambita-bhujau kanakāvadātau	Salutations to Chaitanya and
saṅkīrtanaikapitarau kamalāyatākṣau	Nityānanda, whose long arms hang to
viśvambharau dvija-varau	their knees, who resemble pure gold,
yugadharmapālau	who are the fathers of saṅkīrtan, who
vande jagatpriyakarau karunāvatārau	have eyes like lotus petals, who are the
	maintainers of the universe, who are
	the best of the twice-born, who are
	the protectors of the religion of the
	current age, and who are munificent
	abatārs, and thus dear to all.
tapta-kāñcana gaurāṅgi	I offer salutations to the goddess
rādhe vṛndāvaneśvari	Radha, who has a complexion like
vṛṣabhānu-sute devi	molten gold, who is the ruler of
praṇamāmi hari-priye	Brindaban, who is the daughter
	of Vṛṣabhānu, and who is dear to
	Krishna.
he kṛṣṇa karuṇā-sindho	Oh Krishna, ocean of compassion,
dīna-bandho jagat-pate	savior of the fallen and friend of all,
gopeśa gopikā-kānta	I offer salutations to you, the lover of
rādhā-kānta namo 'stu te	Radha and the gopīs, and the
	lord of the cowherds.

process of synchronization that animates the structure of a līlā kīrtan.

TURNING TO CHAITANYA

As the maṅgalācaraṇ section ended, the performance moved squarely into a new segment where the primary devotional focus turned to Chaitanya. The mix of song and storytelling in this portion of the līlā kīrtan invited the audience to focus on the form, qualities, and activities of Chaitanya. To mark the movement into this new segment, Dyuti Chakraborty stood for the first time during the performance, a posture she would adopt for the remainder of the līlā kīrtan performance. However, before progressing to the all-important Gaura-candrikā song that synchronized the identities of Chaitanya and Krishna, she performed a

Table 7.3. Gaura-bandanā song

bhaja gaur pada paṅkaja yugalām/	Worship Chaitanya's lotus-like feet.
bhaja nitāi pada paṅkaja yugalām//	Worship Nitāi's lotus-like feet.
yuge yuge abatār āsile he bārabār/ *pracarite hari-nām bilāiye abirām//*	In age after age, [Chaitanya] incarnates again and again. To spread the chanting of the name of Krishna (*hari-nām*), he distributes [that name] continuously.
nāśite bhava bhaya vipada-vāram/ *jīve karunā karoho hṛde karunā nidhana//*	To destroy the fear of material existence and curtail misfortune, he compassionately bestows mercy in the hearts of all.
yuge yuge avatārī karunā bitari/ *kaliyuge kalmaṣa nāśana//*	In every age, he is the incarnation that offers mercy. In the age of Kali, he destroys vice.

Sanskrit song from a genre known as Gaura-bandanā, which is part of a larger group of kīrtan praise songs (i.e., *bandanā*) directed at various gurus and deities and referred to as "bandanā kīrtan" (Chakraborty 1995, 15) (audio example 7.4). Two defining characteristics of the Gaura bandanā genre include a (1) descriptions of certain qualities of Chaitanya and (2) expression of the devotee's act of surrender.[5]

These four couplets of the Gaura bandanā song became source material in the performance as Dyuti Chakraborty inserted several didactic messages in between the various verses. The song's first couplet implored the audience to worship Chaitanya and Nityānanda; the following couplets elaborated on Chaitanya's identity, suggesting he was an abatāra of Krishna who had returned to the earthly realm to encourage the chanting of Krishna's name as a devotional practice. In an interjection following the first couplet, which was accompanied by a timekeeping vamp featuring the two khols, the harmonium, and the electronic keyboard, Dyuti Chakraborty spoke directly to the audience by adopting the voice of Chaitanya. In this interlude, she anticipated

the song's second couplet as she implored the audience to recite
the names of Krishna, a devotional practice that Chaitanya em-
phasized for the current age of Hindu cosmology, known as Kali
Yuga:

> There is only one way, and that way is not difficult. Of course,
> if we can adopt that method—adopt that method correctly—
> then we can attain the mercy of Krishna (bhagabān). What is
> that method? The only way is the congregational chanting of
> Krishna's names. [Dyuti Chakraborty calls out: nitāi gaura
> premānande; and the audience responds: hari bol!]. . . . This
> name [of Krishna] existed before the creation [of this universe].
> It is thus called tārak brahmaṇ nām. It means the name that de-
> livers, liberates, and uplifts all living beings. . . . And the one who
> delivered this name to the doors of every living being afflicted by
> the current age of Kali, without being asked, he is our Chaitanya
> [Gaura-hari]. . . . Listen, he showed this through his own conduct.
> He said, "Pay attention to this: You, living beings afflicted by the
> age of Kali, if you can chant the name of Krishna with love, and if
> only once you can cry, 'Oh Krishna!' then you will be delivered;
> then you will be liberated; then you can attain the supreme
> destination!

The climactic theme of this message led into a performance
of the song's second couplet, which spoke of Chaitanya's work
to spread the chanting of Krishna's name (*pracarite hari-nām
bilāiye abirām*). The modes of vocal and gestural work that a
kathak such as Dyuti Chakraborty navigates in the section above
are manifold, as the entire kathā section unfolds and the khol,
harmonium, and kartāl continued to vamp over the Keharvā
Tāl structure of the song. This sonic platform allowed a rela-
tively open format for Dyuti Chakraborty to deliver her message
as she switched to a mode of speaking marked by rapid tempo
shifts in her delivery. These shifts became most evident when
she paused for maximal effect, such as when she spoke about the
"method" (*upāya*) of hari-nām, or chanting the name of Krishna,
which is mentioned in the Gaura-bandanā song. After quickly

delivering the message about what the most potent method of devotional practice in the current age might be, she asked, "What is that method?" and then paused. Then, raising both arms above her head, she slowly answered her own question: *"Hari-nām saṅkīrtan!"* (collective chanting the name of Krishna). Without stopping, she then spun both of her arms above her head and called out loudly, "Nitāi gaura premānande!" (In the bliss of divine love, [chant] the names of Nitāi and Chaitanya.) The audience enthusiastically responded by calling out, "Hari-bol" (chant the name of Krishna [Hari]) as they joined their palms above their heads or raised both arms in the air. Throughout the entire span of the līlā kirtan, Dyuti Chakraborty used these types of vocal and gestural modes to engage the audience in the religious and social meanings of the kathā sections; of course, these interludes also further elongated song performances throughout the evening and were thus illustrative of the expansive mode of a līlā kīrtan performance.

THE WORD-PICTURES OF GAURA-CANDRIKĀ

Performing the Gaura-bandanā song fulfilled a sequential step required before one could approach the image of Chaitanya presented in the next segment of the līlā kīrtan: the Gaura-candrikā song. In this key part of the performance, Dyuti Chakraborty began to map the aesthetic and narrative direction that would guide the rest of the līlā kīrtan. It was only when Dyuti Chakraborty reached the Gaura-candrikā song that the Dān Līlā theme that would guide the rest of the līlā kīrtan was revealed. In this Gaura-candrikā song, discussed briefly in chapter 5, Chaitanya was imagined in the dress of a Dānī (tax collector) as he blocked the road in front of a group of young women in the village of Nabadwip. The temporal position of a Gaura-candrikā song thus articulated a theological idea about Chaitanya based on its temporal location in the līlā kīrtan. As it preceded the divine play

Table 7.4. Dān Līlā Gaura-candrikā song

gaurāṅga cāndera mane ki bhāba uṭhila/ [**Som Tāl**]	What feeling arose in the mind of the moon-like Chaitanya?/
nadīyāra mājhe gorā dāna sirajila// [**Birām Daśkośī Tāl**]	In Nadia, Chaitanya began the Dān (tax episode).
āre moro āre moro āmār gorā dvijamaṇi/	Oh, my, our Chaitanya [Gorā], the gem of the twice born.
betra diyā āguliyā rākhaye taruṇī//	With sticks he kept the young women from proceeding.
dān deho dān deho bali gorā ḍāke/	"Give me the tax, give me the tax," shouted Chaitanya.
nadiyā nāgarī saba paṛila bipāke//	All the young girls of Nadiya fell into distress.
kṛṣṇa abatāre āmi sādhiyāchi dān/	As Krishna I played this tax-collector role before.
se bhāba paṛila mane [āmār] bāsughoṣe gān//	My mind fell into that feeling, sings Basu Ghosa.

of Radha and Krishna in performance, it sonically embodied a theological assertion made through sequence.

The Gaura-candrikā song opened with a question about Chaitanya's state originally presented by the song's composer, Basu Ghosa: "What feeling arose in the mind of the moon-like Chaitanya?" (table 7.4 and video example 7.2). The image of this opening question, however, slowly unfolded over the course of several minutes, as the song's text was accompanied by the slow tempo of the large-meter musical style. As mentioned in the previous chapter, the sonic synchrony of duration that is constructed in the first two lines of the Gaura-candrikā song is linked with the section known as the song's face (gāner mukh). Dyuti Chakraborty's performance of the opening line of the song thus featured the twenty-eight-mātrā Som Tāl with its accompanying melodic structure used for the ṭhekā section (audio example 7.5).[6] Combining this large meter with its accompanying slow tempo (about

twenty beats per minute) required the performance of a melis-matic vocal part that elongated single syllables of the song over the course of several mātrās, as the relatively short half-couplet of the song was spread out over several minutes in one iteration of Som Tāl (table 7.5). The realization of this song text further included several short textual interjections—for example, the inclusion of "*āja*" (today) in mātrā nineteen communicated a sense of immediacy as it connected the contemplative state of Chaitanya to the performance in the present. Other textual ad-ditions in the first half-couplet were vocatives such as "*āhā*" (oh) and descriptions of Chaitanya that designated him as the "abode of emotion" (*bhāba nidhi*). After she completed one iteration of this slow-moving song rendition, the dohār and another accom-panying singer performed a second iteration of the song's first half-couplet.

The addition of interstitial lines of song text were featured as the Gaura-candrikā song continued (table 7.6). In the kāṭān section, the work of synchronizing Chaitanya's identity with Krishna became intensified as the added song text elaborated on the first part of the song by offering a reply to the question in the first half-couplet: what emotion arose in Chaitanya's mind? It was the experience of his emotional state from his previous incarna-tion as Krishna. The arrival of the kāṭān section further required the khol musicians to perform patterns from the similarly named kāṭān repertoire, which increased the rhythmic density of the section and further led to a gradual increase in the song's tempo. Indeed, the beginning of the kāṭān section witnessed the emer-gence of a perceptible groove-like feel as the tempo gradually increased and the musicians began to dance. The slow-tempo style and performance of the song before the introduction of the kāṭān section was somewhat amorphous, and discerning a regu-lar pulse was difficult; but with the introduction of the kāṭān, a slow groove emerged from the musical texture and further in-spired Dyuti Chakraborty and Rahul Das to dance in recognition

Table 7.5. Relationship between text and tāl in the Som Tāl ṭhekā

				25 (kol) gaurāṅga-cā-	26 (kāl) -ā-	27 (phānk) -ān-	28 (kāl) -der-
1 (tāl) -a-	2 (kāl) -a-	3 (phānk) -a-cānder-	4 (kāl) -a-	5 (kol) -a-	6 (kāl) -a-	7 (phānk) -a-	8 (kāl) -a-
9 (tāl) -a cānd-	10 (kāl) -era	11 (phānk) ma-	12 (kāl) -a-	13 (kol) -ne	14 (kāl) -e-	15 (phānk) -e-	16 (kāl) -e-
17 (tāl) -e	18 (kāl)	19 (phānk) āja ki bhāba u-	20 (kāl) -u-				
21 (tāl) -ṭhila āhā mari mari	22 (kāl) bhāba nidhi āmār	23 (phānk) gaura-	24 (kāl) hari	25 (kol) āhā gaura	26 (kāl) gaura	27 (phānk) gaurāṅga-cā-	28 (kāl) -āndera

of the increased tempo.[7] The kāṭān section then lasted for several minutes, as the tempo gradually increased and the khol musicians cycled through a number of instrumental compositions (video example 7.3).

With the kāṭān section completed, Dyuti Chakraborty inserted the section known as the jāmālī, which was set to the seven-mātrā Choṭa Daśkośī Tāl. This short interjection featured several vocative phrases before she performed the second half-couplet and the kāṭān section to fourteen-mātrā Birām Daśkośī Tāl. The lyrics of this half-couplet described how Chaitanya began to enact the Dān Līlā through his demand for a road tax. Combining features of the large-meter style, numerous different tāls, various features of khol repertoire, and examples of interstitial song text meant that the somewhat meager lyrical material from the song's first couplet required an eight-minute time frame for completion in the līlā kīrtan.

The completion of the first couplet of the Gaura-candrikā song set the stage for the use of storytelling and didactic lec-

Table 7.6. Interstitial lines for the first couplet of the Gaura-candrikā song

1. First half-couplet:
gaurāṅga cāndera mane ki bhāba uṭhila/ [Som Tāl]
What feeling arose in the mind of the moon-like Chaitanya?/

2. kāṭān:
āj pūraber bhābe bibhor hoy; āhā mari gaurāṅga-cānder [Som Tāl kāṭān]
Today my moon-like Gaurāṅga [Chaitanya] is absorbed in a previous emotional state.

3. jāmālī:
āhā re āhā mori mori [Choṭa Daśkośī Tāl]
Various vocatives: "oh" (*āhā re*) and "my" (*mori*)

4. Second half-couplet:
nadīyāra mājhe gorā dāna sirajila//
In Nadia Chaitanya (Gorā) began the Dān [Līlā].

5. kāṭān:
bhāba nidhi gaura-hari pūrab līlā śaran kori [Birām Daśkośī Tāl kāṭān]
I take shelter of Gaura-hari [Chaitanya], the abode of emotion, who contemplates his previous līlās.

tures that would be inserted between lyrical couplets. Throughout the entire performance, Dyuti Chakraborty would interject stories and devotional messages that might either reflect on thematic material from a song text or foreshadow what would emerge in subsequent lyrics. One example of the latter occurred as Dyuti Chakraborty began to unfold a story after the song's first couplet:

> What feeling arose in the mind of the moon-like Chaitanya?/
> In Nadia, Chaitanya began the Dān [Līlā]//.

Switching to the storytelling mode, she presented an image of Chaitanya, describing how he was dressed in the guise of a road-tax collector in Nabadwip, equipped with a turban on his head and a cane in his hand. This image, of course, inserted Chaitanya into Krishna's role, and, more specifically, foreshadowed the next couplet of the Gaura-candrikā song. The presence of the cane launched a short narrative that began with Dyuti Chakraborty's

question, "Why was he standing with a stick in his hand?" In re-
sponse to this, she recounted a Gauḍīya Vaiṣṇava story that told
how Krishna, as he was preparing to come to earth as Chaitanya,
vowed not to bring along any weapons, as he had in previous incar-
nations. Her story then described how the main weapon Krishna
left behind was his mythical and personified disc weapon (*cakra*),
known as Sudarśan. This decision was then dramatized through
a back-and-forth dialogue as she enacted the voices of Krishna
and the Sudarśan. Krishna told Sudarśan that the weapon would
remain behind and not return to earth; the weapon responded
with tears and begged to be taken along. After more dialogue, the
episode concluded when Dyuti Chakraborty adopted the voice
of Chaitanya and declared that he would bring Sudarśan in his
descent as Chaitanya, but not in the form of a weapon. Rather, he
would mystically insert the potency of the Sudarśan disc into the
name of Krishna. Those who thus chanted this name would be
imbued with a potency that would make them "eternal, pure, and
liberated."

This short interlude eventually ended, and the original image
of Chaitanya holding a cane and dressed as the tax collector re-
turned. Dyuti Chakraborty then sang the second couplet in the
Gaura-candrikā song, which specifically brought the image of
Chaitanya's cane into view and described how he would lower his
cane across the road as a type of tax-collecting prop:

āre moro āre moro āmār gorā dvijamaṇi/
betra diyā āguliyā rākhaye taruṇī//

Oh, my, our Chaitanya [Gorā], the gem of the twice born
[brahmans].
With a stick he kept the young women from proceeding.

The storytelling mode interrupted the progress of songs
throughout the līlā kīrtan, as thematic or narrative ideas in
the songs served to launch longer periods of spoken narration.

Indeed, one example of this appeared after the third couplet of the Gaura-candrikā song:

dān deho dān deho bali gorā ḍāke/
nadiyā nāgarī saba paṛila bipāke//

"Give me the tax, give me the tax," shouts Chaitanya.
All the young girls of Nadiyā fell into distress.

After singing this couplet, Dyuti Chakraborty briefly sang the first fragment of the ākhar line that follows this couplet: *dān deho deho dān.* Though the text of the ākhar appeared to simply re-organize the word order from the previous couplet (*dān deho dān deho*), in the context of performance it signaled the exposition of a new didactic theme. As mentioned previously, another set of meanings associated with the term dān connects with acts of offering ritual gifts. In this context, dān referred to the process of exchange where the devotee offers something of value to a deity, one of many such instances of semantic interchange. One of the most focused explorations of this idea was Dyuti Chakraborty's presentation of a lengthy story that momentarily departed from the image of Chaitanya dressed as the tax collector and instead depicted a group of humans visiting the Hindu deity Brahmā to seek advice on proper action (*upadeśa*).

The episode began after the ākhar lyrics "dān deho deho dān" (give me the tax) with the story of two groups asking for the advice of Brahmā, the "grandfather" of the gods (*pitāmaha*). The first group was the supernatural demigods (*debatās*), who, upon asking Brahmā for advice, received only the cryptic syllable da in response. Hearing this, the demigods were satisfied and began to leave. In her narration, Dyuti Chakraborty presented Brahmā's reply: "Wait, wait! Where are you going? I have only said da. After hearing only this, you are leaving? Aren't you going to tell me what you understood?" She then explained how the demigods interpreted this mysterious syllable based on its phonetic features, regarding it as an instruction for them to restrain (*daman*

korte) their desires for sensual enjoyment. The second group to come before Brahmā with a request for advice was the so-called demons (*asura*), another supernatural category of beings who are known for being disruptive and challenging the demigods in Puranic stories. The demons also received only the enigmatic syllable *da* in response to their inquiry. Like the demigods, they began to leave. However, before they could go, Brahma asked what they had understood. "Dear Brahmā," Dyuti Chakraborty narrated, adopting the position of the asuras, "we are demons by birth, and we inflict torture wherever we find a weaker person. By speaking the letter *da* you have advised us to show kindness to the weak." The demons made a phonetic correlation between the syllable *da* and the Bangla word *dayā* (kindness, mercy), which they interpreted as an instruction that they should show compassion to others.

In Dyuti Chakraborty's storytelling, the final group to approach Brahmā was the humans, who, having received the same puzzling instruction—*da*—took this syllable as an instruction meant to inspire them in acts of ritual giving (*dān*):

> They came before Brahmā offering salutations and seeking advice. Brahmā offered them advice, too. However, the only thing he said was "da." Having received this instruction, the humans were leaving, but Brahmā blocked their way and asked [what they had understood]. The humans replied, "Oh Brahmā, we are humans, and we have the tendency to constantly place demands before Chaitanya to fulfill our sensual demands. Give us this (*seṭā dao*); give us that; give us wealth; give us knowledge; give us fame. Give, give, give—give us everything. But we never say, Chaitanya, you take!" Brahmā said, "You are humans. What do you possess that you can give?"

Brahmā's question allowed Dyuti Chakraborty to neatly exit this narrative and return to the theme of the Gaura-candrikā song: "Listen: today, Chaitanya is giving instruction to the humans. What is he saying? What does he want? He said:"

What was simultaneously the answer to Brahmā's question and an instruction from Chaitanya was expressed in the song's tripartite ākhar section:

ākhar:
1) [*āmār*] *dān deho deho dān* Give an offering, give an offering.
2) *yākicchu āche karo tomāy* Whatever you have, give that to me.
3) *tomāder jībana joubana kulaśīlamāna* Your life, your youth, your familial prestige [*mātan*].

The answer to the question posed in the storytelling interlude— what do humans have to offer?—was thus answered as Dyuti Chakraborty wrapped up the storytelling interlude in the final line of the ākhar: offer "your life, your youth, and your familial prestige" (see video example 7.4). However, if one meaning of the phrase *dān deho* was a directive to make a ritual gift (*dān* = ritual give; offering / *deho* = give), a second way to interpret this short ākhar line is with *deho*'s other meaning: "body." Reading the interstitial line of *dān deho* as "offer your body" in service to Chaitanya is another way of interpreting much of the lyrical material that follows.

The didactic conclusion offered in the third ākhar line was further supported through features of musical accompaniment. As mentioned, the third line of the ākhar section is known as the mātan, a designation that simultaneously refers to a state of emotional absorption, the fragment of song text, and the accompanying khol pattern. Therefore, working in tandem with the musical and semantic progression toward the mātan were an increase in tempo, a rising melodic contour, and an increased rhythmic density in the accompanying khol patterns (video example 7.4). Like the manner in which tāls influence the melodic structures used in performance, ākhar song texts are also linked with a variety of melodic patterns. In this ākhar, the direction of

the melodic structure moved from a lower to a higher melodic register while the khol pattern also moved through three pieces of repertoire and increased in rhythmic density. The musical and semantic logic here, as it were, was to move the audience toward a convergent state of absorption in the singer's message through the rising melodic range and increased density of the rhythmic patterns. And they responded in kind. When Dyuti Chakrabarty traced a circle above her head upon reaching the mātan, audience members raised their arms in the air and shouted, "Gaur hari-bol," repeating the short fragment of text found throughout the performance and affirming the singer's message with enthusiastic participation.

The interstitial lines and storytelling episodes mentioned here were but a few that Dyuti Chakraborty and her group used over the course of the Gaura-candrikā song. All told, the combination of features of the expansive aesthetic stretched a relatively short amount of song text into a rendition that lasted nearly forty-five minutes. If we think of the song's text as a word-picture, it was seed-like in how it served as the source material for several musical transformations, didactic speeches, and storytelling episodes that presented the devotional message of Chaitanya and worked to transport the audience to the sacred time-space of Nabadwip. The time spent on the Gaura-candrikā song was not its only relevant temporal feature; its location was also a key aspect of the performance's temporal sequence, as this song was a theological and ritual prerequisite for the story of Radha and Krishna that was the centerpiece of the evening's performance.

THE DIVINE PLAY OF THE
TAX COLLECTOR IN BRINDABAN

Despite the lengthy series of invocatory songs and verses that came before, there was one final genre that required completion

before the līlā of Radha and Krishna could begin: a song of saluta-
tion known as the Radha-Krishna bandanā (table 7.7 and audio
example 7.6). The aim of this song was to shift the līlā kīrtan's
focus to the sacred time-space of Braj, the narrative site for the
remainder of the evening's song and storytelling. The Radha-
Krishna bandanā was a short Sanskrit song that presented several
images of Krishna in Braj, thus acting as a presentation of the
sacred space of Braj and Krishna's līlās. Before singing the song,
Dyuti Chakraborty noted this shift by commenting, "Come, we
are entering the sacred abode of Brindaban shouting aloud, 'Sal-
utations to Radha and Govinda!' We enter [while] worshiping
(bandanā) the feet of Radha and Govinda!"

After the prefatory Radha-Krishna bandanā song, Dyuti
Chakraborty opened the Dān Līlā narrative by describing how
Krishna and his friends were on the way to pasture their cows in
the morning. During this short introduction to the story, Dyuti
Chakraborty described how Krishna and his friends engaged in
competitive games in the pasture grounds. One short episode
she narrated described how Krishna lost a competition and was
required to carry his friend Śrīdāma on his shoulders. After sev-
eral of these short līlās, and with the arrival of late morning, she
narrated how Krishna's elder brother, Balarāma, brought Krishna
to rest and have their lunch in the shade. Following the meal,
Balarāma fell asleep; seeing the chance to slip out from the su-
pervision of his elder brother, Krishna then escaped with his
friend Subāla to find Radha and her friends and enact the līlā
of the tax collector. Interestingly, the temporal progression that
Dyuti Chakraborty outlined in this short segment moved chron-
ologically through the time periods (muhūrtas) that make up
the forenoon when Krishna typically takes the cows to the pas-
ture. In the time map discussed in chapter 2, this time of day di-
rectly precedes the midday period when Radha and Krishna will
meet in the forest of Brindaban, far away from the superinten-
dence of their families. The focus on presenting Krishna's līlā in a

Table 7.7. Radha-Krishna bandanā song

jaya rādhā-mādhava (jaya) *kuñja-vihārī* (*jaya*) *gopī-jana-vallabha* *giri-vara-dhari*	Salutations to Krishna, the lover of Radha, who enjoys in the forest bowers [of Braj], who is the lover of the gopīs, and the lifter of the mountain [of Govardhan].
muralī-manohara karuṇā-sāgara *jaya govardhana-dhari*	[Salutations to the one] who captivates the mind with [his] flute; who is an ocean of mercy; and who lifted [the mountain] of Govardhan.
yaśodā-nandana vraja-jana-rañjana *yāmuna-tīra-vana-cārī*	[Salutations to] the son of Yaśodā [Krishna], who gives pleasure to the inhabitants of Braj, and wanders by the banks of the Yāmuna river.

chronological order (i.e., from morning until midday) illustrated the continued influence of temporality found in the repertoire of meditative poetry and its corresponding eight periods of the day discussed in chapter 2.

If Dyuti Chakraborty's storytelling about Krishna presented one side of the narrative, the other part concerned Radha and how she would come to leave her house. In the next section, then, Dyuti Chakraborty continued to depict how Krishna and his friend Subāla encountered Vṛndādevī, a female elder central to the mythical time-space of Braj. Her role in a līlā kīrtan is often an agent who works to bring Radha and Krishna together, and Dyuti Chakraborty noted this role by referring to her with the epithet "the Artisan of Rasa in Vrindavan" (*brindāvabaner raser kārigar*). From Vṛndādevī, Krishna received a flower garland of marigolds that had been sent by Radha; this exchange then inspired Krishna and Subāla to devise a plan for Krishna to come into closer proximity and union with Radha: Krishna would adopt the dress and role of the road-tax collector. In the meantime, Vṛndādevī fulfilled her narrative role by departing for the house of Radha's in-laws to convince her mother- and sister-in-law to allow Radha to go to the market with her dairy goods.

LARGE-METER SONGS OF *DĀGĪ GĀN*

A culminating moment in the narrative that Dyuti Chakraborty had been unspooling arrived when Radha and Krishna first met. This moment of storytelling and aesthetic union happened with the performance of the song *"lalitā biśākhā sāthe,"* which presented a series of detailed images meant to assist envisioning a specific moment in the līlā (table 7.8). Indeed, the song text is replete with images of Radha as she moves forward on the path to meet with Krishna and includes descriptions of her scarf that has fallen to the ground, the perspiration gliding down her face, and the gleam of her jewelry, among other details. These word-pictures emerge during moments of prolonged reflection in song performances during a līlā kīrtan. If the storytelling mode can move the narrative along quickly, song texts might focus on a particular image or emotion, thus pausing the flow of the narrative. These moments of reflection or meditation are often elongated through the features of musical sound, as these periods of contemplation correspond with songs in the large-meter style. The links between visualization and musical style are thus emphasized during a līlā kīrtan performance through the manner in which songs manifest features of temporal duration.

The affective potency of large-meter songs is often referenced through a name attributed to this repertoire: *dāgi gān* (impactful song). The moniker refers to the effect that the song text and its accompanying musical style might have on the listener, and during the Dān Līlā performance, Dyuti Chakraborty connected the repertoire of dāgi gān with the large-meter musical style: "In our līlā kīrtan there are some important aspects—for example, dāgi gān or boṛo gān [long-song, or large-meter song]. What is dāgi gān? The song that leaves an impact (*dāg*) in our mind, that song is dāgi gān. . . . [Now] we are tasting the līlā of Krishna—will you listen to a dāgi gān or a large-meter song? . . . Because without [listening to] this, one cannot appreciate līlā kīrtan correctly.

Table 7.8. Dān Līlā, Dāgī Gān song

lalitā biśākhā sāthe caliyā jāite pathe, kata sādhe bāṭāiche pā/	While going on the path with Lalita and Bisakha,[Radha] has a hope in her steps/
uthalilā bhābosāra elāiyā keśabhāra, dharane nā jāya āji gā//	Her emotion overflowing, her hair falling on her back, she cannot control her body//
[tomrā dekho āmāder] uḍani pareche bhuinye ghām cunyāiche muiye, cānd mukha kareche jhalamala/	Look, Radha's scarf has fallen to the ground, [and] perspiration was dripping down her face. Her moon-like face glitters/
hiyāya prabāla māla hema kāṭhi śobhe bhālo, ānkhi duṭi kareche chalachala//	A coral necklace hangs across her breast, and a golden tiara rests on her forehead; her eyes were full of tears.
saṅginī ratana mālā sabe naba naba bālā, raser pāthāre śaśī sari/	Like moons in an ocean of ras, the young girls with her appeared like a garland of jewels.
dānīra cakora ānkhi tiyāsita tāhā dekhi, majiyā āpanā pāśari//	Seeing that, the Cakora-like eyes of the Dānī [Krishna] felt thirsty and he swooned.
raho raho bali dheye patha āgulilā jeye, dān dāo bali pāte hāt/	Saying "stop, stop," he ran toward them barring their path; saying "give the tax," he put out his hand/
e dvija mādhaber bānī ke tomāy karila dānī, lalitā dhūlāya nija mātha//	These are the words of Dvija Mādhaba: "who has made you the Dānī?" Lalita put dust on her head.//

The rasa is within [this style of song]." The affective links that she mentions here in reference to the large-meter style are illustrated in a song fragment that begins with the second couplet, perhaps most obvious in the references to visualization found in the lyrics. The original song text presented an image of disheveled Radha arriving at the scene where Krishna is dressed as the taxman. She has lost her scarf and is beginning to perspire in expectation as she approaches Krishna's location. The original song lyrics were prefaced by the short phrase "tomrā dekho" (look), an ākhar-like interjection. This directive demonstrated the link and concrete

temporal variable that animated the connection between musi-cal time and meditation and further encouraged the audience to imagine this scene, as it was performed in the large-meter style with the fourteen-mātrā Teoṭ Tāl (video example 7.5):

pad: *[tomrā dekho āmāder] uḍani pareche bhuinye ghām cunyāiche muiye*
Look, our [Radha's] scarf fell to the ground [and] perspiration was dripping down her face.

In the interstitial ākhar line that followed this portion of the half-couplet, Dyuti Chakraborty reflected on the superlative nature of Radha's devotion to Krishna, suggesting that her dis-ordered physical state was due to her single-minded focus on Krishna. A central point in this line was the relationship be-tween vision and devotion, as the text focused on how Radha's devotion led to her imminent meeting, a link reinforced by the continued use of the large-meter style with Teoṭ Tāl (also video example 7.5):

ākhar: *eki anurāga re emana anurāga nayane ki gobinda darśan pāoyā jār*
What kind of devotion is this? Only one who pos-sess such devotion can attain the vision of Gobinda [Krishna].

The connection between devotion and vision emphasized in the ākhar section continued in following verses of the song. In-deed, the images of Radha and her friends had such a profound effect on Krishna that he momentarily forgot he had adopted the role of the road-tax collector, and he became transfixed by the scene in front of him. This situation, Dyuti Chakraborty ex-plained, was rectified in the last couplet of the song, when Krishna suddenly attempted to assert his role as the taxman:

*raho raho bali dheye patha āgulilā giye, dān dāo bali pāte hāt/
e dvija mādhaber bānī ke tomāy karila dānī, lalitā dhūlāya nija mātha//*

Saying, "Stop, stop!" he ran toward them barring their path, offer-
ing his hand he asked for the tax.
These are the words of Dvija Mādhaba: "Who has made you the
Dānī?" Lalitā put dust on her head.//

CONFRONTING COLORISM IN THE DĀN LĪLĀ

As soon as she completed the final couplet of the song above, depict-
ing Krishna's request for the road tax, Dyuti Chakraborty quickly
began a new song that articulated the voice and perspective of Lalitā,
one of Radha's chief friends. The short text initiated a sequence of
song and storytelling where Radha's friends criticized Krishna for
his audacity in adopting the identity of the road-tax collector:

> eki mādhaber bānī ke tomāy karila dāni
> lalitā balila jāni nā māni nā

> "These are only Krishna's words. Who made you the taxman?
> I don't know, I don't care," says Lalitā.

Radha's friends then pose a number of questions to Krishna, cir-
culating around one general idea: how dare you approach Radha?!
Krishna responds to these protests by affirming that he is the dānī,
and these young women cannot pass this spot without offering
him the required duty. During this back-and-forth quarreling,
Dyuti Chakraborty sings one song voiced by Radha's friend that
criticizes Krishna by comparing him to a black bee (bhramarā):

> tumi rupete bhramarā gune nanīcorā/
> tomār ki lāja nāi kānāi//

> You appear like a black bee, and your attribute is a stealer of cream
> [i.e., Radha].
> Do you not feel shame, Krishna?

The imagery here described Krishna as the black bee who was
intent on stealing the white cream—a metaphoric image that
was meant to indicate that Krishna had a dark complexion like

the bee, while Radha had a fair complexion like cream. Though Krishna's blackish complexion has often been cited as a positive aesthetic quality in devotional poetry (Jayadeva 1997), at this moment of the story it was refigured as indicative of a low social status. Indeed, Dyuti Chakraborty's narrative described how Radha's friends treated Krishna's black complexion as indexical of a range of negative attributes, as they accused him of being a thief and a penniless cowherd. In response to these insults, Dyuti Chakraborty performed the song *"ki balile sudhāmukhi"* ("Oh, moon-faced one [Radha], what did you say?"), discussed in chapter 5, where Krishna offered a number of rebuttals meant to counter the distance that the gopīs are trying to create between him and Radha. Though this song did not directly identify Krishna as the black bee, this specific accusation was addressed after this song, as Dyuti Chakraborty voiced Krishna's rebuttal to this specific insult: "You have said too much about me being black, black, black; Lalitā and Viśākhā, think about it, the fact that my body's complexion is black, is that my fault?" Turning to the audience, Dyuti Chakraborty then exited the narrative by asking, "What do you say? There are many among us here who have a black skin color. Also, some have a skin color that is dark brown (*cāpā*). And some have a complexion that is pink.... Krishna says, 'See, whichever [color] we are born with is no fault of our own.' [To the audience] What do you say? We are born in whichever form that Krishna has sent us."

After this short message, Dyuti Chakraborty redirected the performance's focus to the Dān Līlā narrative, again adopting the voice of Krishna: "So, today Krishna said, 'Look here, Lalitā and Viśākhā, my black skin color is no fault of mine.... I have been born in the way that destiny has sent me!'" Dyuti Chakraborty then began a song where Krishna's refrain stated, "Destiny has made me black. What can I do?"

The practice of shifting the focus from the ritual and narrative frame of the līlā kīrtan to discussions of present-day social issues

in this case was one example of many that happened through-
out the evening's performance. In the short interlude discussed
here, Dyuti Chakraborty's message drew from the mythical
time-space of Krishna to create a didactic message to criticize a
social valuation of skin color that is widespread in contemporary
India and that, she believed, runs contrary to the focus on the
egalitarian message found in Chaitanya's social stance. Though
her message did not directly address differences of caste, it did
function as a commentary on the preference for lighter skin tones
in South Asia, a socially constructed hierarchy that rests on ide-
ologies of "colorism," or the "preference for and privileging of
lighter skin and discrimination against those with darker skin"
(Glenn 2008, 281). Indeed, a perusal of television and other media
during my time in India revealed a plethora of advertisements
selling skin-lightening products, a market fueled by both local
logics of colorism and the global marketing of skin-bleaching
cosmetic products (Glenn 2008). Dyuti Chakraborty's rhetoric
that downplayed difference of skin color among that audience
and further connected dark skin tones with Krishna worked
against the social hierarchy of colorism found in South Asia. It
was in moments such as these that the narrative frame of the līlā
kīrtan overlapped with social issues of contemporary import, an
example of how a "perspective from within ritual is one that spills
out into the realm of the sociopolitical landscape" (Jankowsky
2010, 26).

THE INFLUENCE OF EROTICISM FROM EARLIER TEXTS

Echoing the textual sources mentioned earlier, Dyuti Chakraborty's
narrative proceeded to depict how Krishna's request for a tax be-
came focused on Radha's jewelry and physical form. The role of
Radha's friends in this new part of the narrative was no longer
aimed at keeping Krishna away from Radha; rather, in this part of
the līlā kīrtan, Dyuti Chakraborty described how Radha's friends

presented a path for Krishna and Radha's amorous union. However, before this union could occur, they informed him that he would have to perform several austerities and acts of penance that were outlined in a short song:

oi giriyā jadi gaurī ārādhiyā
pān karo kanaka dhūme

You must perform worship in a golden mountain cave
and consume gold smoke.

Dyuti Chakraborty elaborated on these cryptic requests with details that she added between song verses. When discussing the act of mountain-cave worship, she offered the details that Krishna would have to "perform austerity" in a "cave situated between two mountain peaks." Then, in reference to the instruction that he must consume golden smoke, she noted that the term *kanaka dhūm* refers to "a blackish smoke that arises when gold is melted," a noxious blend of fumes that "cannot be inhaled."

With these difficult and potentially hazardous austerities presented, Dyuti Chakraborty vocalized Krishna's short response to the first request, which was then followed by a song: "You said that I will have to perform austerity seated in a mountain cave that is located between two mountain peaks, right? Fine."

tomāri hṛdaya beṇī badarikāśrama
unnata kucagiri joḍa

A braid lies in your heart, a place of austerity.
A pair of raised breasts, like mountaintops, are there.

In this short couplet, Krishna evoked a location in the Himalayan region (*beṇī badarikā*) as a reference to the mountainous cave that Radha's friends had presented. The riverine confluence (*beṇī*) in the mountainous region known as Badarikā carries an association with the performance of religious austerity, as the Puranic literature commonly describes sages living in this desolate region for religious practice and meditation. In the song, however, this

mountainous place of austerity is compared with Radha's body. Indeed, through a short song Krishna compares the space between Radha's breasts to a mountainous cave. This is the place where he chooses to perform austerity, as Dyuti Chakraborty explained by adopting Krishna's voice: "Hey, Lalitā and Viśakha, look carefully at Radha's breasts. There is a mountain cave situated between those breasts, namely the heart of your Radha. That is the only place of austerity for me. Look, Radha's heart is my place of austerity (*beṇī badarikā*). That is the only place where I can perform austerity."

Another task assigned to Krishna was the directive that he must consume gold smoke if he wanted to unite with Radha. As mentioned, this austerity involved consuming a toxic black smoke emitted from the melting of gold. In the līlā's narrative, however, Dyuti Chakraborty explained how Krishna redirected this command to suggest that his austerity could again be performed in relation to Radha's body: "Lalitā and Viśakhā, what is the complexion (*kāntiṭi*) of Radha's body? [To the audience:] Gathering of devotees, please recall the salutation to Radha." Then Dyuti Chakraborty recited the invocatory verse from earlier in the performance, which described the color of Radha's bodily complexion:

> *tapta-kāñcana gaurāṅgi*
> *rādhe vṛndāvaneśvari*
> *vṛṣabhānu-sute devī*
> *praṇamāmi hari-priye*

> I offer salutations to the goddess Radha, who has a complexion like molten gold, who is the ruler of Brindaban, who is the daughter of Vṛṣabhānu, and who is dear to Krishna.

She continued, "What is the bodily complexion of Radha? Kāñcana means gold. Radha's body exhibits a radiance that emerges when gold is melted." She then switched to voice Krishna's speech: "Hey Lalitā and Viśakhā, who else but I can consume

this complexion of molten gold, this abundance of beauty, purity, love, and potency? . . . I have consumed this abundance of beauty . . . and I will continue to do so for all time."

Krishna thus redefines the original request, stating that the consumption of gold smoke did not refer only to the fume produced from melting gold; rather, he suggests that the golden radiance emitted by Radha's golden body is an equivalently subtle substance that can be ingested and thus fulfill the demands of Radha's friends. The way Krishna shifted the focus from the consumption of smoke to the consumption of a subtle radiance emanating from Radha's form depended on the indeterminacy found in the verb *pān kora* (drink or consume), which could denote the act of drinking or a more general consumption. This indeterminacy thus allowed the shift from the practice of the rather impersonal austerities first outlined—cave dwelling and smoke consumption—to the more explicitly erotic sphere where Krishna sought an amorous union with Radha. The twist that Krishna introduced, and how it relied on wordplay, reflects a history of disguising sexual innuendo through double meanings in Gauḍīya Vaiṣṇava dramaturgy (Wulff 1984).[8] Furthermore, it demonstrates the longstanding use of eroticism found in the early depictions of the tax episode such as Baḍu Caṇḍīdās's fourteenth-century *Śrī-kṛṣṇa-kīrttana*. Although the explicit eroticism of these texts may no longer be front and center in līlā kīrtan performances, these undertones surface in performance and the fabric of Gauḍīya Vaiṣṇava stories in the present.

The requests from Radha's friends, and Krishna's creative method of fulfilling them, were precursors to the final section of a līlā kīrtan known as the "union" (*milan*). The milan section fulfills the closing ritual progression of a līlā kīrtan, as musicians consider it inauspicious to conclude a performance without completing this final step of bringing Radha and Krishna together in song. In the Dān Līlā narrative, after Krishna appeased Radha's friends through his fulfillment of their request, the entire group

began to feast on the milk products that Radha and her friends were bringing to market: "See, today Radha and Krishna had an unprecedented union. Today, at the place of the Dān Līlā, Radha and Krishna were united. Therefore, come, together we will chant and glorify this union with the names of Krishna!"

Before beginning the final song of the evening, one that would fulfill the final temporal stage of the milan, Dyuti Chakraborty had one more directive for the audience: "Come, let us all raise our two arms above our heads, chanting in glorification the names of Radha and Krishna! Now, as we end, we should visualize [smaraṇa kari] the united couple of Radha and Krishna!" The final statement of the līlā kīrtan thus emphasized how the interconnected spheres of musical sound and visualization are at the center of the expansive musical aesthetic, and this directive again illustrated the enduring connections between meditation and musical sound that have endured throughout the genre's history.

CONCLUSION AND MILAN

Dyuti Chakraborty's multi-hour līlā kīrtan exhibited both an adherence to the temporal order prescribed by the genre and a degree of autonomy that allowed her to inject sociopolitical and devotional messages within the performance. The order of genres that she progressed through during a līlā kīrtan performance articulated a synchrony of temporal sequence that has remained central to the genre's aesthetic aims. After performing a series of invocatory genres—which included chants, song, and instrumental sections—the aesthetic and narrative direction for the performance emerged through the focus on Chaitanya. This was particularly evident in the Gaura-candrikā song, where Chaitanya was imagined as adopting the role of the dānī, an image that synchronized his identity with Krishna through song. The temporal location of the Gaura-candrikā song further served as

part of a larger ritual progression, as voicing this song was a pre-requisite for hearing the amorous līlā of Radha and Krishna.

The significance of the synchrony of duration was also illustrated throughout the performance, as features of the large-meter musical style were linked with the genre's history of devotional visualization. Long-duration songs, thought to have an impactful effect on the audience, connected the domains of vision and devotion as they described images of Radha approaching Krishna on the path to the market. The music's ritual roles demonstrated the synchronies of sequence and duration. Throughout the entire līlā, Dyuti Chakraborty, as the ritually skilled kathak, embodied this position by including songs, stories, and messages that she added within the larger temporal frame of the performance. The durational variables that adhere to the ritual frame were given time to unfold as instances of musical sound through the social role of the kathak and her insertion of messages with both devotional and social import.

When the final song of the milan section ended, Rahul Das remained in the stage area as the other kīrtan musicians departed for the green room. And while most of the audience similarly left for the post-kīrtan meal that that the sponsoring committee would provide, a group approached Rahul Das to purchase līlā kīrtan VCDs of his ensemble that he began to remove from his side bag. In addition to providing cash for the return trip that evening, the handful of VCDs he sold would likely serve a valuable promotional role, connecting his ensemble with future parties who might hire them for exclusive līlā kīrtan events such as the one just completed. Of course, each of the VCDs that audience members brought home that evening would feature līlā kīrtan performances that had been transformed on account of the temporal limitations of the medium. Indeed, when compared to the multi-hour Dān Līlā performance from that evening in Kanthi, the līlā kīrtan VCDs featured significantly truncated versions of song and storytelling. In the mediated context, the focus on se-

quence and duration in features of musical time had been modified, transformed, and at times omitted. This trend of musical transformation could also be found in the settings of promotional music festivals, which are also significant in the professional cultural economy of kīrtan musicians. The next section of the book turns to these contexts of promotional music festivals and media production to study the links and disjunctures that animate the politics of musical time in the professional economy of contemporary kīrtan performance.

NOTES

1. Sen goes further in his characterization of the *Śrī-kṛṣṇa-kīrttana*, describing it as presenting "secular" versions of Krishna's līlās that lean toward "crudeness and vulgarity" (1992, 66).

2. See Rūpagosvāmī (1976).

3. The honorific prefix Gītaśrī, which can be loosely defined as "beautiful singer," is most famously associated with the twentieth-century kīrtan singer Chabi Bandopadhyay.

4. Kīrtan musicians make another connection with Dhrupad as it is often sung in the Dhrupad-*aṅg*, or Dhrupad "style" (Personal Communication, Dyuti Chakraborty, October 15, 2012, Rishra).

5. Personal communication, Kankana Mitra, September 15, 2012, Kolkata.

6. The basic outline of the melodic structure used for this song closely resembles the one described for Som Tāl in chapter 6.

7. The perception of meter here is like the concept of entrainment in theories of musical meter. See London (2004).

8. The use of double meaning in Gauḍīya Vaiṣṇava literature might go back further in time to the genres of *caryā gīti*, or "Mystic Play-part Songs" (Sen 1992, 24), that were composed in Old Bengali. These songs were also known for using double meanings as a type of "code language" (*sandhā vacana*) (28).

PART III

THE SHRINKING MARKETS FOR
EXPANDING SONGS

—ɯ—

THE MARKETPLACE OF MUSIC FESTIVALS: MODERN SOCIAL TIME AND MUSICAL LABOR

A FRIEND AND I FINALLY arrived at the assembly of tents where the musician Rahul Das was lodging at the annual Jaydeb Melā. Our walk across the bridge from the other side of the Ajay River had taken nearly an hour, even though we had walked only a single kilometer. Our hired car had gone as far as it could among a morass of buses, motorcycles, and pedestrians before our exasperated driver could inch no closer to the festival grounds. We then disembarked and moved at a snail's pace through the congested crowds. Today, hundreds of thousands of people were converging on the small village of Joydeb Kenduli to hear kīrtan performances, bathe in the river, shop, and enjoy festival-style food. The call of the lunar calendar had brought festivalgoers to this village deep in rural West Bengal for the Hindu holiday of Makar Sankranti. According to local folklore, one who bathed in the Ajay River on this day gained an extra dose of religious merit. Another attraction was thousands of padābalī kīrtan musicians performing on temporary stages throughout the festival grounds. Beginning in the evening of the first day and continuing until the late afternoon of the third day, a twenty-four-hour rotation of

musicians would take the stages, using song and storytelling to enact the divine plays of Radha, Krishna, and Chaitanya.

After arriving at the heart of the festival grounds, we entered one of the tents that kīrtan musicians used for lodging during the event. A narrow passageway led straight ahead; on either side were small, enclosed spaces where kīrtan groups slept and relaxed between performances. We eventually found Rahul Das's space in the tent, where he was unwinding with the other musicians in his group. It was a simple arrangement—fresh straw was strewn about on the floor, and the space was filled with musical instruments and baggage. Hanging prominently across the front of their small enclosure was a large poster of Dyuti Chakraborty, Rahul Das's wife and the lead singer of the group. The location of the poster was significant, as it signaled where interested parties could find her kīrtan group. She and Rahul Das were at this festival not only to perform. They would also reunite with old contacts and search for new clients who might hire them to come to their homes, temples, or other cultural institutions to perform during the upcoming year. Rahul Das organized the majority of his paid performance opportunities each year on the strength of the līlā kīrtan performances he and his ensemble would offer at the festival.

Rahul Das was pleased to see us, and we accompanied him outside to talk. Conversing in his tent space was nearly impossible on account of the ear-splitting volume levels emanating from the other side of the wall that separated the backstage rooms from the performance space. We were eager to hear his group and asked when and where he and Dyuti Chakraborty would perform. Today was the busiest day of the festival, and they had several consecutive performances occurring in various locations. After considering for a moment, Rahul Das told us the best location would be the Pāncha Tattva Sebā-Āśram's stage, the same location where he was lodging for the festival. He looked at us squarely and told us he would perform at 7:00 p.m. This was a

prime-time slot at one of the largest and most centrally located stages at the festival. We shared words of excitement about the excellent booking, yet at the same time my friend and I looked at each other doubtfully. Musical performances in India in general, and in the case of padābalī kīrtan in particular, are known to rarely begin according to schedule. Indeed, it is common for musical concerts to begin significantly later than their advertised start time. Rahul Das immediately registered our glance and vehemently stated that at the Jaydeb Melā, "Seven o'clock *means* seven o'clock." We soon learned that the laxity of temporal regulation that governs much musical scheduling in West Bengal had been replaced by another set of strict time practices at the Jaydeb Melā. The confluence of large audiences, numerous musicians, and limited stages had led to both shrinking time spans for performance and informal modes of enforcing the temporal boundaries of one's allotted stage time. Because of these factors, it was not uncommon for musicians to end songs in midphrase or omit renditions of the large-meter style when adapting to the limited time spans of what had become a live-music market. Here, the value of stage time was multiplied exponentially, and musicians guarded their time onstage because each minute of performance might lead to an opportunity to meet new clients and promote their musical careers.

This chapter describes the politics that surround the musical and promotional strategies that padābalī kīrtan musicians encounter at the annual Jaydeb Melā. Returning to the focus on modern social time, I analyze the various layers of temporal influence that affect the performances and promotional work of kīrtan musicians at the festival. The conflicts of modern social time are demonstrated when representations of sacred time expressed through songs and musical style meet with the exigencies of festival administration and the growing number of professional musicians who seek stage time at the event. The musical and promotional acts at this festival not only represent

ways of acting within time; they further underscore how musicians seek to make the maximum use of the limited time of this three-day festival to secure new performance bookings. In the case of promotional techniques, acting within time means that musicians use the short-term length of the festival to find ways to creatively advertise their group. In terms of musical adaptations, kīrtan musicians feature shortened versions of the expansive musical aesthetic as they adapt to the independent temporal variables that govern the shrinking time slots at the festival.

Acting within time at the festival is a response to the intense competition for exposure, which is exacerbated by this event's status as a "periodic market": a finite time-space where a confluence of consumers aggregate in one area for a fixed time span (Plattner 1989, 186). The potential number of new contacts a kīrtan musician can make at this three-day event far outstrips any other music festival during the year, and musicians implement a variety of creative methods to act within the fixed and shortened temporal parameters of the festival. Through performances and promotional materials, musicians seek to make professional connections for the upcoming year, turning this event into a labor market where attempts to spend time well underscore anxieties about the politics of musical time in contemporary kīrtan performance.

In considering the Jaydeb Melā as a periodic market, I extend the concept in significant ways from its more common use in economic anthropology. The periodic market has often been associated with rural geographies and non-cosmopolitan populations. For example, Stuart Plattner describes "periodic marketplaces [as central to] the commercial life of agrarian or peasant societies" (Plattner 1989, 186) where one of their key features—indeed, their periodicity—is that they are set up and dispersed according to agricultural crops or rural events. Market-based exchange of agricultural goods is combined with the solidification of social ties in this model of the periodic market, as "economic, political, and

religious activities [are performed] at one time and place" (186). The orientation in this perspective views the periodic market as a site of rurality that depends on the labor of non-cosmopolitan subjects. In analyzing the Jaydeb Melā as a period market, I attempt to widen the lens of analysis in two ways. While scholarly orientation on the periodic market has focused on the exchange of material goods (Wanmali 1980; Riddell 1974), the potential for these events to function as marketplaces for labor is understudied. Though there is a vigorous market for material goods at the Jaydeb Melā, the aim of musicians is not to sell material musical commodities. Rather, they seek to arrange future performances by attracting potential clients and signing contracts for later dates. These promotional techniques and performances, then, are as much about determining the future as they are about the present or the past, and thus represent the subjectivities of kīrtan musicians as deeply enmeshed in variety of social temporalities. Second, the overarching analysis of the periodic market in anthropology and geography has emphasized its function in a rural economy and downplayed its connection to larger political and economic shifts (e.g., Plattner 1989). However, the Jaydeb Melā has not been immune to the influences of neoliberal policy, which have restructured the temporal fabric of modern life and led to new subject positions that stress entrepreneurial values and techniques of economic risk taking. Another temporal effect of the festival, then, is the way in which a new neoliberal time phase has increased the numbers of professional musicians who have adopted new entrepreneurial roles as they further their careers. In response to this, the task of determining which musicians get stage time, and for how long, has fallen to festival administrators whose decisions represent features of institutional time. Crucially, the time allowances they determine do not allow for full renditions of the expansive musical aesthetic, thus underscoring contradictions between the representations of ritual time in musical style and the practices of institutional time that play out at the Jaydeb Melā.

The periodic nature of the festival, and the intense competition for stage time and visibility, emphasize a key concept from economic anthropology's analysis of the periodic market: a defining characteristic of these periodic markets is the *accumulation of demand* (Plattner 1989, 186). A basic organizational principle of a periodic market is that "goods are *not* available in a place for most of the time, causing the demand to be accumulated" (186). Spurred on by this accumulation of demand, the growing numbers of kīrtan musicians who attend this event represent an increasing *supply* of musical performers. Audience demand and musical supply are linked and thus share a symbiotic relationship at this festival, as the two are causal elements in the growing number of festival attendees each year. The limited three-day time span of the Jaydeb Melā and the increasing musical supply of musicians continue to shrink the time durations at this event and necessitate several strategies used to act within time.

However, the promotional activities and musical transformations that kīrtan musicians use at the festival do not easily escape criticism. These negative opinions about the rise in professionalization at the event highlight the debates about commodification that are entwined with a politics of musical style. In recent years, this event has been marked as emblematic of the divisions that more widely separate the economies of instruction and professionalization. Therefore, in addition to being a time-space defined by intense professional activity, the work of musicians at the Jaydeb Melā has been increasingly associated with the corrosion of social values. Before focusing on the ways that musicians act within the shrinking time durations of the festival, this chapter presents the pejorative assessments of musical professionalization at the Jaydeb Melā that circulate in a variety of discursive spheres in urban Kolkata. These negative opinions are centered on the work musicians perform at the festival yet also apply to a variety of other performance contexts in present-day West Bengal. One critique of musicians working in the professional

sphere is that they downplay the genre's association with social values with the intent of increasing performance's relationship with economic value, a focus that I discuss here as a discourse of commodification.

MUSIC FESTIVALS AND THE DISCOURSE OF COMMODIFICATION

Several recent critiques voice anxieties about the growing centrality of economic exchange at the Jaydeb Melā. One example of this is found in media reports suggesting that the rising numbers of kīrtan musicians at the festival have forced out Baul mendicant singers, a group considered the main performers at this event until the mid-1980s (Capwell 1986). A provocative recent article in the Kolkata-based newspaper *The Statesman*, titled "Bauls Battle Kirtan Surge," claims that Baul performers have become overrun and "cornered" by the more recent rise in the number of kīrtan musicians at the festival.[1] This development has alarmed festival organizers, who have suggested that the Jaydeb Melā is "gradually losing its character" on account of the more than two thousand kīrtan musicians who perform at the event each year.[2] The promotional work of musicians at the festival has further been duly noted. In another newspaper article, for example, Gautam Ganguly, the Birbhum district information and cultural officer, comments that "most of the kirtanias perform in the mela to gain popularity. For this, they even perform free of cost to make themselves known."[3] The Jaydeb Melā organizational committee estimates kīrtan musicians and their clients annually agree to "contracts worth Rs. 2 Crore" (equivalent to roughly $330,000) at the Jaydeb Melā.[4]

Negative perspectives of promotional activities at the festival draw from a more widespread discourse in West Bengal that views economic exchange as having a deleterious influence on kīrtan performance. As mentioned, the history, song texts, and

musical style of padābalī kīrtan have been associated with a range of social values from the sphere of Gauḍīya Vaiṣṇava thought and the regional politics of Bengali cultural nationalism. In the case of the latter, two key markers in this discourse are the genre's connections with themes of egalitarian social structure and mass education. While the anti-caste public kīrtan performances of Chaitanya were seen as promoting an egalitarian social structure, the genre's use of vernacular Bangla to present details of Sanskrit rasa theory was considered a form of mass education. In contemporary discourse, however, processes of economic exchange are thought to undermine these social values that have remained central in defining kīrtan's social location. One example of this is found in a recent documentary film, *Songs in Oblivion* (2012), directed by Samrat Chakraborty, which could be the first English-language documentary about kīrtan in Bengal. In the concluding scene of the film, we hear the narrator over an image of a kīrtan musician riding a motor scooter with a khol over his shoulder: "Above all it can be said, the most important characteristic of . . . [Chaitanya's] kīrtan was the creation of a type of mass communication and communion. But today this kīrtan . . . is slowly and gradually becoming a matter of crass consumerism, and the reason behind this is globalization."[5]

The terms *mass communication* and *communion* in the narration signal spheres of social value found in the earlier bhadralok discourse: mass communication suggests a similarity to the educational promise of kīrtan while communion hints at features of cultural exchange in an egalitarian social structure. These social values are described as being presumably erased by "crass consumerism" in the current phase of padābalī kīrtan performance. The release and success of the documentary discussed above led to several interviews with the director published in Kolkata-area media. In one pointed critique, he noted how the fact that "kīrtan singers today earn their livelihood by singing these devotional songs . . . has somehow diluted the importance and the impact of

kirtans."[6] Padābalī kīrtan's social values are thus placed at odds with processes of economic exchange in media pronouncements. But why is there such disapproval of padābalī kīrtan musicians seeking out a livelihood in contemporary West Bengal?

A key idea in Ash Amin and Nigel Thrift's study of the cultural economy is their identification of the moral impact of Marxist "socialist economic thought" (2004, xvi). This perspective, they argue, posits a "clear distinction . . . drawn between the moral worthiness of labor for social utility . . . and the degenerative effects of labor based solely on production for profit" (xvi). The influence of this idea of socialist economic thought is evident in the opinion expressed above. Moreover, in West Bengal its emergence can be traced to a long-standing communist polit-ical alliance that was in the majority for nearly thirty-four years (1977–2011) and formed around the Communist Party of India (Marxist). Indeed, terms such as *globalization* and *neoliberalism* often carry a negative connotation in West Bengal because of the long-standing communist influence on policy, propaganda, and the intellectual milieu of the region's primary urban cen-ter, Kolkata.[7] In the case of globalization, for example, Bhaskar Mukhopadhyay's research in West Bengal and the Left-leaning center of Kolkata has noted how "a major leitmotif of disquietude about globalization in India has been its supposed inculcation of 'western' consumerism to the gullible Indian masses" (2012, 35). Similarly, neoliberal economic policies meet with resistance in West Bengal, documented by the widespread public protests against the government's recent neoliberal policy shifts (Band-hopadhyay and Dinda 2013).

The discourse of commodification is one element in a politics that fuels debates about musical change and economic exchange. At the center of these negative opinions about musical and pro-motional activity are anxieties about disturbing the devotional and regional meanings found in the genre's frame of musical time. Implicit in these critiques is the idea that the rise of economic

exchange and professionalization results in the erasure of the social values associated with kīrtan's musical style and history. The discourse of commodification thus presents the specious idea that either social or economic values are produced in forms of expressive culture, but not both.[8] The negative critiques that musicians thus face in promotional music festivals resort to a binary mode of analysis suggesting that either they engage in promoting social values or they are merely emphasizing the genre's economic value. The binary mode of this discourse is part of a longer intellectual history that defined the exchange-value of the commodity as fundamentally different from the use-value of the gift (Mukhopadhyay 2012, 57). Another example of how this argument is directed at professional kīrtan musicians can be found in a Kolkata-area newspaper article where the documentary filmmaker mentioned earlier underlines the binary between economic and social values by questioning how professional kīrtan musicians can assign a "price" to a music that is credited with being a "weapon for rebellion against social evils."[9] The mention of price—a discrete monetary value—suggests that the familiar Marxist categories of use-value and exchange-value underpin criticisms of professional musicians in West Bengal. Negative critiques of professional padābalī kīrtan performance gain traction insofar as they use a rhetoric that reflects this familiar binary of value that is central to the discourse of commodification. What is lacking in these pejorative perspectives on professional kīrtan performance is the recognition that musicians face intense competition for promotion and performance at the annual Jaydeb Melā.

LUNAR TIME AND THE JAYDEB MELĀ

In mid-January every year, the annual Jaydeb Melā overruns the small village of Joydeb Kenduli. This village lies on the Birbhum district side of the Ajay River, a waterway that meanders through

the Indian states of Bihar and Jharkhand before forming the bor-
der between the districts of Birbhum and Bardhaman in West
Bengal. The village's and festival's names reflect the local belief
that this was the birthplace of the twelfth-century poet-composer
Jayadeva. The Jaydeb Melā takes place during the astrological
event of Makar Sankranti, a three-day period formed as a de-
pendent time variable as it aligns with the sun's movement into
the zodiac sign of Makar, widely celebrated across India. In West
Bengal, this festival also goes by the name Poush Sankranti
(named after the Bengali month Poush) and further marks the
harvest period for rice and date sugar crops in West Bengal. The
mixed themes of Indian astrological significance and agricultural
bounty thus lend to this event a mixture of sacred and secular
meanings. Though many pilgrims come to the festival seeking
the accrual of religious merit by bathing in the Ajay River and
listening to devotional music, others come for the carnival-style
rides and deep-fried foods that are sold throughout the event. The
Jaydeb Melā, then, follows a template that defines many religious
events in Bengal, as it is at once a sacred event and a secular fair
where attendees mix devotional aims with acts of everyday rev-
elry (McDermott 2011). It is estimated that nearly half a million
people attend this rural festival, and an entire city of temporary
structures is built for the event. The village grounds include large
tents with performance stages, temporary lodging structures,
and impromptu food and merchandise shops.

At the center of the festival grounds in Joydeb Kenduli is a
seventeenth-century terra-cotta temple that marks the birthplace
of Jayadeva (fig. 8.1). The Radha-Binoda Mandir, as it is known,
houses images of Radha and Krishna visited by festival attendees.
The connection between the twelfth-century poet and the time
when the festival occurs is another factor in attracting thousands
of festivalgoers. Local folklore describes that when Jayadeva was
elderly, he could no longer make the journey from his home to
bathe in the Ganges River, a trek of nearly two hundred kilometers.

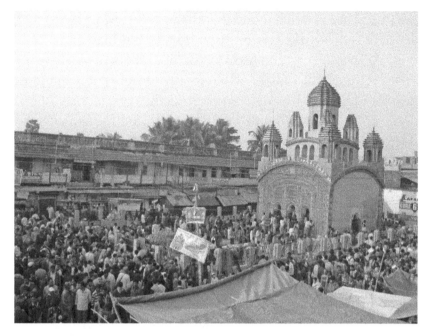

Figure 8.1 The Rādhā-Binoda Mandir in Joydeb Kenduli. Photo taken by the author, 2012.

An image of the personified Ganges River then appeared to Jayadeva in a dream, informing him that she would manifest herself in the Ajay River during Makar Sankranti every year. During this time, pilgrims attest, bathing in the local Ajay River will confer the spiritual merit that one would attain by bathing in the Ganges (Das 1406 BS [1999], 34–37). Historically, then, the time-space of the Jaydeb Melā features a range of sacred and secular attractions that have led to an ever-growing number of attendees, merchants, and musicians over the course of its history.

PROMOTIONAL TECHNIQUES AND INSTITUTIONAL TIME

The central administrative units at the festival function as both religious institutions and nongovernmental aid organizations called *sebā-āśrams*. Arriving at the festival from throughout

West Bengal, these sebā-āśrams offer lodging for kīrtan groups that attend while also managing the scheduling of performance time. Each of these organizations erects a variety of temporary structures for lodging and food service that are clustered around performance stages and viewing areas. Kīrtan musicians will not only perform on the stages provided by these organizations but also the use their lodging spaces for impromptu meetings to discuss future performances and sign contracts with clients at the festival. The mission of the sebā-āśrams combines a focus on devotional religion and a commitment to philanthropy in their institutional aims, a range of projects and values communicated by combining the terms for a monastic hermitage (*āśram*) and religious and philanthropic service (*sebā*). The administrators of these organizations control access to the stages, and each sebā-āśram has a kīrtan committee (*samiti*) that determines the schedule for performers. In addition to determining stage time, the sebā-āśram charges a fee for room and board to musicians, which has a direct bearing on a kīrtan ensemble's chance of getting stage time. The arrangement is like pay-to-play situations in competitive music markets, as kīrtan musicians need to be affiliated with a particular sebā-āśram to obtain the most visible time slots.

The fact that kīrtan musicians will invest a significant amount of money to promote their groups at the festival represents the impact of recent entrepreneurial shifts in India. While one set of inquiries into the influence of neoliberalism on music in India has focused on the impact of technology in the sphere of popular and film music (Booth and Shope 2014), another set of questions examines how musicians operating in smaller musical markets have embraced processes of professional flexibility, risk-taking, and self-marketing (Weidman 2014). This latter development is key to the way that kīrtan musicians view the periodic market of the Jaydeb Melā as an unparalleled opportunity to advertise their group. In the entrepreneurial mode of risk-taking, musicians spend a significant amount of money to promote their

Figure 8.2 Promotional poster at Jaydeb Melā. Photo taken by the author, 2012.

group at the festival with funds that will not immediately be re-covered. For example, Rahul Das informed me that his kīrtan troupe would spend between Rs. 18,000 and 20,000 ($276–307) to cover the costs of travel, room and board, hired musicians, and promotional materials for the entire festival in 2012. However, this investment can be quickly rewarded when it leads to exclusive live performances that will each pay between Rs. 8,000 and 10,000 ($123–154).

The intense competition for exposure at the festival has led musicians to adopt various promotional techniques over the three-day event. Kīrtan musicians produce a variety of visual media for display and distribution at the festival, including vinyl posters, paper flyers, and business cards to advertise their group. These promotional materials display devotional iconography, cell phone numbers, and email addresses for interested parties who

Figure 8.3 Promotional posters at Jaydeb Melā. Photos taken by the author, 2012.

might hire them for exclusive līlā kīrtan performances (fig. 8.2). These advertisements begin to go up the day before the festival and gradually fill nearly every space available by the end of the event. Kīrtan musicians thus advertise their services on the walls of buildings and tents, on trees, and across pathways in a competition for physical space that matches attempts to obtain stage time (fig. 8.3).

The limited time-space of the Jaydeb Melā leads to several ways that musicians act within time. Because posting visual promotional materials is meant to bring about a face-to-face meeting during the three-day event, finding a space for advertising is of critical importance. At the Jaydeb Melā in 2012, one event highlighted the intense competition for exposure at this short event. I had arrived in the late morning on the first day, but because kīrtan performances would not begin until later in the evening, the crowds were still relatively small. A friend and I were casually making our way through the festival grounds when we noticed

a man posting simple black-and-white flyers advertising Rahul Das and Dyuti Chakraborty's kīrtan group on a concrete wall by the side of the road (fig. 8.4). Though I knew Rahul Das, Dyuti Chakraborty, and the members of their kīrtan group, I did not recognize the man posting the flyers. Upon questioning, he told us that Rahul Das and Dyuti Chakraborty had hired him to come to the festival early to begin advertising their group, even though they had not yet arrived. The fear of missing out on prime spaces for visual media underscored one technique of acting within the temporal confines of the periodic market.

Although the handmade flyers that were being posted lacked the production quality found in the full-color posters mentioned above, they nevertheless contained the requisite information. Positioned prominently at the top of the flyer was an introduction to the singer: "One who is knowledgeable in kīrtan music: Gītaśrī Dyuti Chakraborty." Further mention of her various professional and educational achievements was also included, noting her performances on radio and television and her master's degree in performance from Rabindra Bharati University. Of critical importance for the promotional purposes of the flyer were the cell and home phone numbers positioned in the upper right-hand corner. A final message was written in red ink on the bottom of the flyer, seemingly forgotten during the initial printing. This hastily added piece of information told potential clients that Dyuti Chakraborty could be found at the Pāñcha-Tattva Sebā-Āśram at the Jaydeb Melā. This important notice was not meant to direct festival attendees to a performance event; rather, mentioning a specific sebā-āśram in promotional posters was intended to guide interested parties to the backstage spaces where musicians were lodging. The backstage rooms at each sebā-āśram were busy locations where kīrtan musicians would meet with potential clients, discuss scheduling, and, hopefully, sign contracts for future performances. As mentioned, many kīrtan musicians, such as Dyuti Chakraborty, displayed large posters at the entrance to

Figure 8.4 Poster for Dyuti Chakraborty at Jaydeb Melā. Photo taken by the author, 2012.

Figure 8.5 Promotional poster found backstage at the Jaydeb Melā. Photo taken by the author, 2012.

their room (fig. 8.5). Visual media at the festival thus worked to increase the exposure of each kīrtan group over the duration of the event. The importance of meeting potential clients at the Jaydeb Melā is further found in the fact that the festival arrives at a critical part of the year, directly preceding the busiest season for professional performers (January to June).

As mentioned, the promotional activities of kīrtan musicians have caused consternation among cultural activists and festival administrators. These negative opinions are part of discourse that sees professional activity at the festival as part of a larger process of degenerating various social values. One example of this is found in the writings of Ajit Kumar Das, a historian of the Jaydeb Melā who offers a negative appraisal of musicians' promotional activities in his book *Jaydeb-Melā: Sekāler o Ekāler* (*Jaydeb-Melā: Then and Now*): "The kīrtanīyās only come here

for the purpose of preaching their own glory. They think that this Jaydeb Melā is only a big platform for [displaying] kīrtan propaganda and for procuring contracts for other programs. They do not come here to show respect to Jaydeb who is the original guru of padābalī kīrtan. So, in front of the āśrams and *ākhṛas* [performance spaces], big posters with the names of the kīrtanīyā can be seen. It is a marketing thing" (1406 BS [1999], 263). The visual advertisements and promotional techniques of professional kīrtan musicians are thus seen as being at odds with the social values linked with the festival.

MUSICAL STYLE IN THE PERIODIC MARKET

Negative opinions about musicians' promotional activities are only part of a larger story. Another point of criticism notes how musical performances at the Jaydeb Melā omit the large-meter style and include songs from outside of the padābalī kīrtan repertoire. Because the increasing number of musicians at the festival has led to shrinking time spans for performance, renditions of the large-meter musical style prove difficult to complete. The shorter time durations at the festival result from at least two levels of modern social time. One overarching influence is from the recent influx of capital into middle-class society in India, which has led to more paying clients and thus performance opportunities for professional kīrtan musicians. Simply put, promotional music festivals such as the Jaydeb Melā attract thousands of musicians because they are successful in arranging future live performance opportunities. A second and more localized influence is the scheduling work of the kīrtan committees at each sebā-āśram. As an instance of institutional time management, the one-hour slots offered to musicians at the festival do not offer the temporal parameters that allow musicians to fully complete aspects of the large-meter style. The multilayered temporal influences that converge at events such as the Jaydeb Melā illustrate a key facet

of modern social time, and the temporal conflicts that mark it as a time-space are "thick . . . with ethical problems, impossible dilemmas, and difficult orchestrations" (Bear 2014a, 6.).

There is an inherent conflict between the average time slot for a līlā kīrtan performance at the Jaydeb Melā and renditions of the Gaura-candrikā song repertoire. Because time durations for performers vary between one and one and a half hours, performing a large-meter style song, which can last from forty-five minutes to an hour, is nearly impossible. Completing all the requirements of the large-meter form described previously would leave little time for the kīrtan musician to tell the story of Radha and Krishna that is the centerpiece of the performance. The importance of the Radha-Krishna story for audience members in the professional cultural economy presents an alternative social value to the large-meter style, as enacting the līlās of Radha and Krishna through song and storytelling proves to be popular with audience members. The other negative critique of Jaydeb Melā performances is that musicians include songs from outside of the padābalī kīrtan repertoire. A common example of this is the inclusion of Hindi-language devotional songs that have gained popularity in India's commercial recording industry. The combination of omitting the large-meter style and the addition of Hindi devotional songs has led to negative opinions that define kīrtan performances at the Jaydeb Melā as "popular."[10]

The rush to obtain physical space for posters mentioned above is matched by techniques where kīrtan groups intensely guard the stage time allotted by the sebā-āśrams. A common technique kīrtan musicians use to secure their allotted time segment is the *crowd out*. As one kīrtan ensemble begins to reach the end of its one-hour time slot, the next group climbs onto the stage and surrounds the performers (fig. 8.6). If the kīrtan musicians do not stop their performance, it is not uncommon for the next group to point to their watches or complain, causing the group onstage to abruptly end their performance, often in the middle

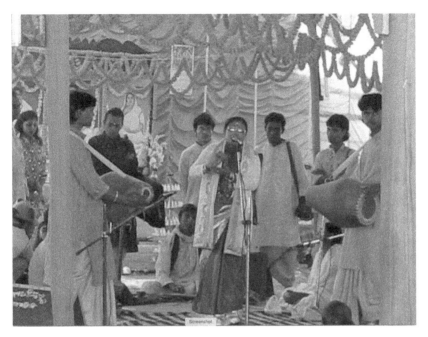

Figure 8.6 Kīrtan crowd out at the Jaydeb Melā. Photo taken by the author, 2012.

of a song. The conflicts of this nature often end without serious disagreement; nevertheless, there is a certain mode of aggressiveness that leads kīrtan ensembles to surround one another during a performance. Because of the intense competition for time slots, organizers schedule performances on a rolling twenty-four-hour schedule for the busiest days of the Jaydeb Melā, and kīrtan groups thus rotate between different performing stages throughout the day and night. Temporal techniques of securing one's allotted stage time occur in response to abstract time allowances that are a function of institutional time. Indeed, one principle that guides the scheduling priorities of sebā-āśrams is to offer shortened time slots to allow as many groups as possible a chance to perform. While this may seem practical for festival administrators, it nevertheless forces musicians to make a variety of decisions about omitting aspects of the large-meter form. The

process of adapting musical style in these shortened time frames is part and parcel of the process of temporal abstraction that defines present-day professional performance.

Musicians at the festival have developed novel ways of adapting the large-meter style to the shortened time durations. One example is found in Dyuti Chakraborty's performance at the Jaydeb Melā in 2012. However, before analyzing how she adapted aspects of musical form at the festival, I briefly pause to recall the basic parameters of the large-meter style discussed in chapter 6. As noted there, Gaura-candrikā songs about Chaitanya comprise the repertoire commonly associated with the large-meter style. The specific structural principle that underpins each song is a progression from larger to smaller tāls through the course of the song. In a typical form (see table 4.5), the first line of a Gaura-candrikā song text is set to the twenty-eight-mātrā Som Tāl, and the second line features a fourteen-mātrā tāl. After the first couplet, Gaura-candrikā songs use the seven-mātrā Jhānti Tāl, which can be used to accompany the remainder of the song, though sometimes the final couplets use the six-mātrā Lophā Tāl. In between each line of song text, this form further includes the additional lines of interstitial lyrics (kāṭān and ākhar) discussed in chapter 5.

Dyuti Chakraborty's līlā kīrtan performance at the Jaydeb Melā focused on the Radha-Krishna story known as Naukā-bilās, or the Boat Pastime. The setting for this story was the time-space of Brindaban, and the narrative depicted a trip on a riverboat where Radha and her friends had the surprising revelation that the boatman was Krishna in disguise. This theme was foreshadowed in the Gaura-candrikā song used to preface this story, titled "*āre mora āre mora gaurāṅga-rāya*" (see table 8.1), a song that describes the images of Chaitanya playing in the river with his companions.

Her performance of this song at the festival both fulfilled and transformed features of the large-meter musical style men-

Table 8.1. Gaura-candrikā song for Naukā-bilās

āre mora āre mora gaurāṅga rāya/	Oh, my Gaurāṅga Rāya.
suradhunī majhe jāñā nabīna nābika hoiñā sahacara miliyā khelāya//	Going in the Suradhunī [Ganga], and becoming the new helmsman, Chaitanya began to play with his companions.
priya gadādhara saṅge pūruba rabhasa raṅge naukāya basiyā kare keli/	Thinking of the happiness of his previous episodes, Chaitanya performed those same episodes on the boat with his dear Gadādhara.
ḍubu ḍubu kare lā bahaye biṣama bā dekhi hāse gorā banamālī//	Seeing that the wind was blowing fiercely, and the boat was about to be sink, Gorā Banamālī [Chaitanya] smiled.
keha kare utarola ghana ghana haribol dukule nadīyār loka dekhe/	Creating a commotion, some people began to call the name of Hari [Krishna]. The people of Nadīyā [Nabadwip] were watching from both banks.
bhubanamohana nāiyā dekhiyā bibaśa hoiyā yubatī bhulila lākhe lākhe//	Seeing the world-charming beauty of the boatman Chaitanya, thousands of young women forgot everything else.
jagajana-citacora gaurasundara mora je kare tāhāi parateka/	Look at what my Gaura-sundara [Chaitanya], the one who steals the minds of the entire world, was doing.
kahe dāsa rāmānande ehena ānanda kande bañcita rahinu mui eka	Rāmānanda Dāsa says, "Only I am deprived of seeing such a blissful event."

tioned above. In the first line of the song, she used the twenty-eight-mātrā Som Tāl. The pairing of the song's text with the slow-moving tempo (\quarternote= 25) created a sparse rhythmic texture, where syllables of song text were melismatically stretched out over several mātrās (table 8.2). For example, the melismatic performance of the word *āre* (oh) expanded over mātrās five

Table 8.2. Relationship between text and tāl in the Som Tāl ṭhekā

				25 (kol)	26	27 (phānk)	28 (kāl)
				āre	(kāl)	-a-	-a
				mora-	-a-		
1 (sam/ tāl)	2 (kāl)	3 (phānk)	4 (kāl)	5 (kol)	6 (kāl)	7 (phānk)	8 (kāl)
āre-	-e-	-e	ā-	re-	-e-	-e-	-e-
9 (tāl)	10 (kāl)	11 (phānk)	12 (kāl)	13 (kol)	14 (kāl)	15 (phānk)	16 (kāl)
-e	āre	mo-	-o-	-ra-	-a-	-a-	-a-
17 (tāl)	18 (kāl)	19 (phānk)	20 (kāl)				
-a-	-a	āmār śrī gauranga-	-a				
21 (tāl)	22 (kāl)	23 (phānk)	24 (kāl)	25 (kol)	26 (kāl)	27 (phānk)	28 (kāl)
rāya āhā mori mori	bhāba nidhi āmār	gaura	hari	āre mora	āre	mora-	-a

to nine, accompanied by a sparse khol and hand-cymbal accompaniment. Following this first line of the couplet, Dyuti Chakraborty performed the kāṭān section in Som Tāl, thus maintaining the first two formal features of the Gaura-candrikā form (audio example 8.1).

At this point in the song performance, Dyuti Chakraborty introduced variations. In the second line of the song, the performance conventions of this Gaura-candrikā song form call for a series of five transformations of the song's text. However, to adapt to the shortened time allowance of the festival, she omitted three of the five features of the expansive musical style. The first omission was the interlude that typically occurs between the first and second lines of the couplet called the *jāmālī*. As mentioned in the previous chapter, the text for this section—*āhā re āhā mari*—is a fragment of interstitial text not directly from the song, featuring a collection of vocative expressions such as "oh" (*āhā re*) and "my" (*mari*) and is set to the seven-mātrā Choṭo Daśkośī Tāl. The second and third omissions in the Gaura-candrikā form involved the

Table 8.3. Relationship between text and tāl in the omitted sections of the Gaura-candrikā form

Jāmālī in Choṭa Daśkośi Tāl						
1 (sam/ tāl) re-	**2** (phāṅk) -e-	**3** (tāl) -e	**4** (phāṅk) āhā	**5** (tāl) mori	**6** (tāl) mori	**7** (phāṅk) āhā

↓

Birām Daśkośi Tāl, ṭhekā			
1 (sam/tāl) sura-	**2** (phāṅk) -dhunī	**3** (kol) majhe	**4** (phāṅk)
5 (tāl) sura	**6** (phāṅk) -dhunī	**7** (kol) majhe	**8** (phāṅk) suradhunī
9 (tāl) majhe	**10** (phāṅk) jāñā		
11 (tāl) na-	**12** (phāṅk) -bīna nā-	**13** (kol) -bika	**14** (phāṅk) hoiñā

↓

Birām Daśkośī Tāl, kāṭān			
1 (sam/tāl) gau-	**2** (phāṅk) -aur	**3** (kol) ha-	**4** (phāṅk) -ri
5 (tāl)	**6** (phāṅk) pūrab	**7** (kol) līlā-	**8** (phāṅk) -ā-
9 (tāl) -ā	**10** (phāṅk) śaran		
11 (tāl) ka-	**12** (phāṅk) -ri	**13** (kol) bhāba	**14** (phāṅk) nidhi

removal of two key parts of the song's form. Dyuti Chakraborty skipped both the timekeeping ṭhekā and embellished kāṭān patterns that were set to the fourteen-mātrā tāl (table 8.3). The song text from these two sections was reset to the shorter six-mātrā Lophā Tāl, which was further performed at a quick tempo (audio example 8.2).

Table 8.4. Comparison of musical expansions and omissions for the second half-couplet of *"āre mora āre mora gaurāṅga rāya"*

"āre moro āre moro gaurāṅga rāya" (Second half-couplet)	*"āre moro āre moro gaurāṅga rāya"* (Second half-couplet)
Go-puchha form, Nimai Mitra	Jaydeb Melā performance, Dyuti Chakrabarty and Rahul Das
1. Choṭo Daśkośī Tāl (jāmālī)	
2. Birām Daśkośī Tāl, ṭhekā	
3. Birām Daśkośī Tāl, kāṭān	
4. Repeat performance of the text, Lophā Tāl, ṭhekā	4. Repeat performance of the text, Lophā Tāl, ṭhekā
5. Lopha Tāl, ākhar	5. Lopha Tāl, ākhar

The omission of these three sections—jāmālī, Birām Daśkośī ṭhekā, and kāṭān—significantly shortened the Gaura-candrikā form and thus allowed her to quickly reach the story of Radha and Krishna that would be the center of her performance. A comparison of Dyuti Chakraborty's performance at the Jaydeb Melā with the original musical form that she had learned from Nimai Mitra reveals an omission of three of the five rhythmic and melodic transformations of the text (table 8.4). Instead of exemplifying the concept of expansion that is key to the musical value of padābalī kīrtan, it could be said that this section of Dyuti Chakraborty and Rahul Das's Jaydeb Melā performance was a form of temporal *contraction*, albeit one that is influenced by the accumulation of demand and temporal influences found at the Jaydeb Melā.

HINDI DEVOTIONAL SONGS IN THE PROFESSIONAL ECONOMY

In addition to transforming the Gaura-candrikā song form, Dyuti Chakraborty's performance also used song texts from outside of the padābalī kīrtan repertoire. One example of this in her Jaydeb

Melā līlā kīrtan was her inclusion of the popular Hindi devotional song (*bhajan*) "*prabhu kā nām japo mana mere*" ("Oh Mind, Chant the Name of God") (table 8.5), a song made famous by Mukesh, a prominent singer in the Mumbai film-music industry from the mid-1940s until the mid-1970s (Booth 2008, 44). Though best known for his Hindi film songs, "*prabhu kā nām japo mana mere*" is an example of how Mukesh's popularity spread beyond the sphere of film recordings into commercial forms of devotional music, a category of song that became a mainstay in the popular music industry of India in the late twentieth century (Manuel 1993).[11] Though using a Hindi song represents a significant departure from how padābalī kīrtan is taught in the instructional context, drawing from the value it holds in the domain of popular devotional song makes it central to the way musicians attract new audiences.

Because this song is not from the padābalī kīrtan repertoire, Dyuti Chakraborty's inclusion of this song's message in her līlā kīrtan performance required skillfully intertwining it within the narrative structure of her storytelling mode. As is common in the Gaura-candrikā repertoire, this occurred as part of the way she was interjecting storytelling sections between couplets to extrapolate on the themes found in the song text. After singing the first couplet of the Gaura-candrikā song discussed above, which concluded with the image of Chaitanya playing in the river, Dyuti Chakraborty extended the song's boat theme into her didactic message. Instead of discussing the activities described in the song, she offered a metaphorical definition of the boat theme that evoked a common image in Gauḍīya Vaiṣṇava soteriology. Comparing the mortal realm to an ocean, she described Chaitanya as a ferryman who could carry one across the ocean of earthly existence. In so doing, she posed a question to the audience: what do we have to give to Chaitanya, the ferryman, to be brought across the ocean of suffering that is this material realm? "Not very much. But what does he [Chaitanya] say? 'Just once

Table 8.5. Hindi devotional song

prabhu kā nām japo mana mere/ *dūra kare vohī saṃkaṭa tere//*	Oh mind, chant the name of God. Make your troubles go far away.
hare krishna hare krishna *krishna krishna hare hare* *hare rām hare rām* *rām rām hare hare*	nām-kīrtan
jīvan raina baserā hai *kyā terā kyā merā hai* *kyūṅg isa kā aphasosa kare*	This life is but a night's stop. What is yours? What is mine? Why regret this?
piṃjarā jaba khula jātā hai *paṃchi kaba ruka pātā hai* *kyūṅg isa kā aphasosa kare*	When the cage opens, how can the bird be stopped? Why regret this?

give [me] an offering of tears.' This means that one must cry out loud with love, wailing, 'Where are you, Gaura?' Only then will he ferry you across [the ocean of the material realm]. One must only once cry, 'Oh Gaura' with devotion. . . . See, we advise that one should always chant the name of Hari [Krishna]. Why? What will happen if one chants the name of Hari? Just listen to what the poet says." The answer to this rhetorical question came in the form of the Hindi devotional song "*prabhu kā nām japo man mere*," which presented the message that by chanting Krishna's name, one's troubles will disappear. The connection between Dyuti Chakraborty's didactic speech and the song was clear: just as Chaitanya says that one must offer tears through the chanting of Krishna's name, so the Hindi devotional song suggests that one should chant the name of Krishna. In their performance of this song, Dyuti Chakraborty and Rahul Das featured the melody and tāl pattern used by Mukesh in the well-known recorded version.[12] Like the song text, the four-mātrā Keharva Tāl used to accompany the song is not from the padābalī kīrtan repertoire but is a meter commonly found in popular devotional music or Hindustani semiclassical genres (audio example 8.3).

Nested between lines of the Gaura-candrikā song, the inclusion of the Hindi *bhajan* represents the expansive and seed-like aesthetic of padābalī kīrtan discusseds previously. This process continued when Dyuti Chakraborty offered a commentary on the message found in the song's text. After singing the second line of the song—*dūra kare vohī saṃkaṭa tere* (make your troubles go far away)—she paused to expand on this idea while the kīrtan group vamped in Keharva Tāl: "If you chant the name, what will happen? Listen, the [song's] author has given an explanation. . . . "*Dūra kare vohī saṃkaṭa tere*" [Make your troubles go far away]. There is a saying, right? In adversity we remember him [God], in prosperity we forget [him]. Therefore, it is said that we should constantly chant the name of Krishna . . . [and] he will give us unsolicited mercy." The inclusion of a Hindi bhajan represents one way that professional kīrtan musicians respond to the shortened time durations at promotional festivals, as they work to capture the attention and interest of festival attendees. However, at the same time, the manner in which these songs are positioned, nested in between songs from the padābalī kīrtan repertoire, demonstrates the continued importance of the expansive musical aesthetic.

MUSICAL TRANSFORMATIONS AND THE DISCOURSE OF COMMODIFICATION

These two musical methods of acting within time at the annual Jaydeb Melā festival represented significant departures from aspects of padābalī kīrtan's musical style and song repertoire. Consequently, hearing negative opinions about these transformations from kīrtan musicians who did not perform at the festival was common. These musical adaptations were defined as representing a "light" musical style, one that is first and foremost structured to be "popular."[13] These critiques about musical style are not so different from the discourse of commodification discussed

earlier in this chapter. A common point of agreement is that the rise of economic value in relation to padābalī kīrtan performance leads to a concomitant decrease in social and musical values.

It would be an exaggeration, however, to claim that professional kīrtan musicians at the festival were not aware of the interrelationships between musical style and social value. When I asked Rahul Das and Dyuti Chakraborty about the transformations they made to the large-meter form at the festival, their response expressed a degree of resignation. When I met with them several months after the festival, Rahul Das matter-of-factly stated that the omission of the fourteen-mātrā Birām Daśkośī Tāl was due to the shortened time slots at the festival and was not a decision that was taken lightly.[14] In terms of the Hindi bhajan, Rahul Das again acknowledged that including this song was a deviation from the norms of performance that they had learned in the instructional economy, yet he explained that the addition of this song was aimed at increasing "public enjoyment."[15]

Nevertheless, it is difficult to ignore how musicians foreground the priorities of economic exchange over and above decisions about maintaining musical form at the Jaydeb Melā. Preserving the stylistic imperatives that link the large-meter form to a range of social values is likely not the main priority at the festival. The idea that Hindi bhajans are included for public enjoyment would also seem to represent how professional musicians give precedence to audience reception and its relationship to economic concerns. While the claim of the discourse of commodification—that social values are diluted when economic value is prioritized—does not hold true as an absolute distinction, Dyuti Chakraborty and Rahul Das's performance at the festival can be connected with processes of commodification and the heightened importance of exchange-value. One way to think about how musicians approach the time-space of the festival is to consider their mode of performance through what Arjun Appadurai refers to as the "commodity situation" (1986, 13). This

represents a temporal phase "in which [something's] exchange-ability (past, present, future) for some other thing is its socially relevant feature" (13). The future exchangeability of the Jaydeb Melā mode of performance, as it were, is found in the possibility that future acts of musical labor will earn a discrete monetary price. Padābalī kīrtan performances such as Dyuti Chakraborty's at the Jaydeb Melā seem to represent a heightened moment of commodification in the larger orbits of these musicians, or a "commodity phase" to borrow Appadurai's term (13). Different modes of musical performance, according to this perspective, might be seen as having different relationships to processes of commodification. We might, then, compare this performance to the sale of a CD in a retail music outlet (Beaster-Jones 2014). The mode of performance that musicians emphasize at the festival is like the "moment" a CD is for sale and thus represents the "height of its commodity status" (336). At the Jaydeb Melā, the social and musical values of the genre emphasized in the instructional econ-omy (use-value) are temporarily overshadowed by a commodity phase (exchange-value), as musicians seek to turn their shortened musical performances into future contracts.

It is worth pausing to reflect on the temporal dimensions of Appadurai's formulation of the commodity phase. If the mode of performance at the Jaydeb Melā does focus on priorities of economic exchange, it is also profoundly future oriented, as its primary purpose is to serve as a promotional performance that can help connect musicians to future clients. On the one hand, the mode of performance that alters the large-meter style and includes Hindi songs seems to disregard the range of historically situated values that define the genre's performative and discur-sive spheres, discussed previously. However, on the other hand, a caveat to this conclusion is found in the fact that performances at the Jaydeb Melā cannot be so easily disconnected from full-length līlā kīrtan renditions such as the one described previously. In fact, the performance by Dyuti Chakraborty and Rahul Das

analyzed in chapter 7 was arranged on the strength of their per-
formance at the Jaydeb Melā. It would thus seem that the values
that kīrtan musicians such as Dyuti Chakraborty and Rahul Das
learned in the instructional economy are only temporarily over-
whelmed in performance settings such as the Jaydeb Melā. When
given a longer interval of time, they include the large tāls, slow
tempos, and textual additions of the large-meter style.

CONCLUSION

Tellingly, one of the most common objections made about the
musical transformations at promotional festivals is that they
omit features of the large-meter style. Historian Hitesh Sanyal
expressed one way that this point is quickly inflated to wide-
spread denigrations: "Recently, some professional singers have
tried to shorten and simplify . . . kīrtan songs as much as possible.
The result of this is that kīrtan music has been significantly dam-
aged" (1989, 222–23). However, perspectives such as this seem to
ignore how intense competition for time allowances influences
the ability of kīrtan musicians to complete features of the expan-
sive musical aesthetic.

These negative opinions of musical transformation often
fail to contextualize the various temporal influences that com-
bine to construct the time-spaces at the Jaydeb Melā. As I have
argued in this chapter, several layers of temporal influence are
central to the constitution of modern social time at the festival.
One layer of time organization involves how this the festival
is positioned as a periodic market in relationship with annual
patterns of religious practice and agriculture. The Jaydeb Melā's
connection with astrological patterns, folkloric depictions of
Jayadeva, and a proximity to agricultural harvests underscore
how the festival is brought into synchronization with features
of natural and nonhuman time. These time-related links un-
derscore how features of time organization at the festival often

rest on dependent temporal variables that influence when the festival occurs each year. However, the fact that musicians have translated this all-important event into a periodic market for musical labor has led to increasing numbers of musicians who perform and an increase in features of temporal abstraction. Over the course of the past decade, derivative influences from India's reforms of economic liberalization have influenced the shifting subjectivities that boost interest in risk-taking and entrepreneurial zeal, while also contributing to large-scale structural shifts that have led to a growing middle class that has taken an interest in hiring professional kīrtan musicians. A third form of temporal governance is the mode of institutional time, where organizational committees determine the scheduling for kīrtan musicians. Each of these temporal influences requires musicians to consider the ways they might achieve both promotional and musical aims, and these decisions often need to balance how the imperatives of musical style interacts with the shortened and abstract durations offered at the festival. These three temporal frames are not the only ones influencing the shifting and shrinking time durations at the Jaydeb Melā, yet they do reveal the variety of discursive and material issues that make up the contested domain of musical time in professional kīrtan performance.

The modes of performance featured at promotional music festivals do not represent the only ways that musicians learn to act within time. Another form of musical work in the professional cultural economy is media production. More recently, musicians have begun their own music production companies to operate within the live-music markets of performance in present-day West Bengal. The next chapter examines the limitations and possibilities found in the sphere of media production as musicians weigh the economic potential that these media offer despite the shrinking time spans that are found in production and consumption.

NOTES

1. Statesman News Service, "Bauls Battle Kirtan Surge," *The Statesman*, January 10, 2004.

2. Statesman News Service, "Bauls Battle Kirtan Surge."

3. Statesman News Service, "Lost Tunes of the Bauls," *The Statesman*, January 18, 2008.

4. Statesman News Service, "Lost Tunes of the Bauls." The value of $330,000 is based on 2012 exchange rates.

5. *Songs in Oblivion*. 2012. Directed by Samrat Chakrobarty. KF Films. DVD.

6. Mukherjee, Shreya, "Raising a Question," *Hindustan Times (Kolkata)*, June 7, 2013.

7. For more on the relationship between kīrtan, communism, and political protest, see Graves (2019).

8. See Beaster-Jones (2016, 13).

9. Ghosh, Chandreyee. 2013. "Rebellion Song," *The Telegraph* (Calcutta Edition), 7 July.

10. Anonymous, personal communication, January 17, 2012, Kolkata.

11. For details on the career of Mukesh, see Ranade (2006, 374–79).

12. See Mukesh. 2009. *"prabhu kanaam jopo man mere."* YouTube. Accessed November 23, 2019. https://www.youtube.com/watch?v=8cHRoCu1ydo.

13. Anonymous, personal communication, January 17, 2012, Kolkata.

14. Personal communication, December 2, 2012, Konnagar, India.

15. Personal communication, December 2, 2012, Konnagar, India.

NINE

—⚉—

MEDIA MARKETS: VISUALIZATION AND THE ABSTRACTION OF MUSICAL TIME

IF YOU UNWRAP A LĪLĀ KĪRTAN VCD from its sleeve, insert it in a media player, and press play, several conventions of sound and image emerge. What might be immediately apparent are the ways the technological capacities of the VCD represent various historical and mythical time frames. The video material on the VCD intermingles three types of images: shots of the main kīrtan singer and ensemble, video of a group of actors portraying the līlās of Radha and Krishna, and a final collection of stock images of Gauḍīya Vaiṣṇava pilgrimage locales in West Bengal. A fifty-minute līlā kīrtan studio recording that features song and storytelling works as a type of sonic glue to stitch the images together. Through the combination of sound and image, then, VCD production constructs a type of temporal convergence through the overlapping time frames that are presented in song and storytelling. One example is found when the recorded speech of the singer is paired with images of the actors playing Radha and Krishna to effect a type of mediated convergence to bridge aspects of temporal disjuncture. The technological work of linking the images of the kīrtan ensemble with the mythic time-space of

Radha and Krishna in Braj creates a chronotope where mythical and contemporary time are fused (Eisenlohr 2015), as it further emphasizes the long-standing links between the genre and practices of visualization.

Despite overt techniques that work toward creating a sense of convergence, the VCD medium is also marked by several temporal disjunctures. Features of duration and sequence found in musical time that are central to the genre's ritual and aesthetic aims are transformed, transfigured, and, at times, omitted during VCD production. With a maximum running time of approximately fifty minutes, the ability to include long-duration songs of the large-meter style is limited on account of the digital MPEG format that encodes the audio and video material on a VCD. Similarly, individual genres from the sequence that guide the ritual and theological direction of a līlā kīrtan are often shortened or removed, a process that alters the usual movement from the invocatory opening to the amorous divine play of Radha and Krishna in a multihour performance. These temporal disjunctures on a VCD are not limited to the level of sound, though. Another set of uncouplings is found in the video images, where actors seek to mime the sounds from the audio track in production, which often fall short of the production standards that define forms of pan-regional or pan-Indian media production. While this phenomenon is often defined as representing a lack of technical ability, analyzing these production techniques from an ethnographic perspective demonstrates how these disjunctures derive from the social and natural temporalities that musicians and producers navigate during the production process. The final VCD product, then, can be read as a representation of modern social time, as it illustrates the temporal conflicts that inevitably arise when the effects of disparate methods of temporal thought or practice converge.

This chapter examines the possibilities and limitations that media production offers in the contemporary markets of professional kīrtan performance. The analysis turns to the temporal

limits that VCD production introduces, which require musicians to omit features of the expansive musical aesthetic. Despite these limitations, however, the ability to combine synchronized audio and video material in this medium presents possibilities for the storytelling mode of performance and the genre's connections with theater and visualization, as musicians hire actors to enact the devotional stories told in song. Focusing on features of temporal abstraction, I analyze the influences that impinge on media production that are simultaneously inherent to the VCD medium and affected by the sphere of production more generally. Drawing on ethnographic approaches to the study of media (Ginsburg, Abu-Lughod, and Larkin 2002; Dornfeld 1998), I seek to complicate the idea that VCD production simply results from a lack of technological acumen, a perspective that often reflects the idea that these media express a subaltern aesthetic. This claim, as presented later in this chapter, suggests that because VCDs circulate in rural areas they represent a form of low-class media consumption that rests on a simultaneous amalgamation of conceptions of genre, media form, and community. By combining an analysis of the final VCD product with ethnographic analysis, the study analyzes the larger economic and temporal layers of influence that are part of the construction of a līlā kīrtan VCD. This part of the study specifically focuses on the methods used to produce the singer Shampa Mishra's līlā kīrtan VCD titled *Muralī Bṛṣṭi* (*The Rain of the Flute*), produced by Rahul Das's SM Music in 2012.

Though this chapter focuses on the present-day use of the VCD, the adoption of this particular media form is part of a longer history of padābalī kīrtan's encounter with media production. Since the early twentieth century, two factors have been relevant to the ways that kīrtan musicians have interacted with various media forms, from wax cylinders to LP records. The first involves the manner in which musicians have adapted to the shortened time durations dictated by media forms; a second has been the manner that media use has entailed a shift from a multisensory mode

of presentation to a medium that has allowed for only sound. As described previously, the techniques of gesture and dance in live līlā kīrtan performances are but some of the ways that visual and tactile modes have remained central to the narrative and affective work of performance. However, because these methods have exceeded the possibilities available on the audio-only formats of records and cassettes in the soundscape of twentieth-century India, the ability of VCDs to include images presented kīrtan musicians with a new technoscape in the present. This turned out to be a crucial reason for the enthusiastic use of this medium among professional kīrtan musicians over the past decade, a transformation that happened in tandem with the decentralization of the music industry in the late twentieth century (Manuel 1993). Moreover, audiences who attend līlā kīrtan performances eagerly purchase and view these VCDs on their own devices as well as listen to them on car and portable audio devices across West Bengal. The opening section of this chapter offers a brief history of padābalī kīrtan and media production in India to illustrate how musicians have interfaced with the abstract time frames of media over the course of the past century, a period that precedes the enthusiastic embrace of the VCD format in the present.

HISTORIES OF TEMPORAL ABSTRACTION

Recording technologies were available in colonial India at roughly the same time as other locations in the world, and early media forms, such as wax cylinders and shellac discs, were brought to South Asia for experimental recording projects in the early twentieth century. The first recordings made by the Gramophone & Typewriter Ltd. in India took place in the Bengal region, and in Kolkata in particular, where, in 1902, British and American recording engineers first recorded dozens of indigenous musicians on seven- and ten-inch discs (Kinnear 2000, 5). This early experimental recording tour was a way of testing the market for the

eventual establishment of a record factory opened in the central Kolkata neighborhood of Sealdah in 1908. The recording studio in this factory was the site of the earliest recordings of Bengali kīrtan, and the early catalogue of the Gramophone Company, Ltd., as it came to be known, reveals that the company was recording a mixture of song and instrumental forms that encompassed regional and pan-Indian styles. Two cases demonstrate how kīrtan performances during the early years of media use in South Asia engaged with the abstract time frames available at the time.

The Sealdah factory was using state-of-the-art technology on par with manufacturing facilities found in Europe; nevertheless, there was a certain amount of inflexibility that defined the recording process. The lack of fit between the abstract time durations of early media and the expansive musical style of Bengali kīrtan is often most evident at a song's end. One example of this is found in a 1909 recording by the kīrtan musician Punna Moyee Dassi (Roma Bai), a singer mentioned in chapter 3, and her rendition of "*kanu kahe rāi kahite ḍarāi*" ("Krishna says, 'Rāi [Radha], I am afraid to tell you'") (table 9.1).[1] The song's text, which is eight couplets in length, offers a dialogue between Krishna and Radha. The song often appears in the Kalahāntaritā līlā, when Krishna approaches Radha in a mood of repentance, praising the superlative nature of her devotion and seeking forgiveness for his infidelity.[2] What is interesting about Punna Moyee Dassi's recording is how she included the interstitial ākhar lines for several of the verses of the original song. One example of this is the personal interjection where Krishna admits that he knows nothing of Radha's love (*āmi tomār premer kibā jāni*). Several similar ākhar lines feature in this early recording, and each, of course, features a number of melodic and rhythmic additions to the song, as discussed previously. However, it seems that before Punna Moyee Dassi could reach the end of the song, and during the ākhar line following the fifth couplet, the recording abruptly ended in the

Table 9.1. *"kanu kahe rāi kahite ḍarāi"* as sung by Punna Moyee Dassi

1. *kānu kahe rāi kahite ḍarāi* *dhabalī carāi muñi* **ākhar**: *āmi tomār premer kibā jāni* *āmi rādhār bai to nai*	Krishna says, "Oh Rāi [Radha], I am afraid to tell you that I graze cattle. What do I know about your love? Without Radha, I am nothing.
2. *rākhāliyā mati ki jāni pirīti* *premera pasarā tui* **ākhar**: *āmi goṭhe māṭhe dhāi dhabali carāi*	With the mind of a cowherd boy, what do I know about love? You [oversee] the shop of love. I bring the white nursing cow to roam in the fields.
premamayī āmi tomār premer kibā jāni	Oh, Radha, what do I know about your love?
3. *premadhana more diyācha kiśorī* *tāre śodha dite nāri* (**omitted**)	The wealth of love that you, Radha, have given me, that I cannot repay.
4. *tumi mahājana je kara bhartsana* *śudhā sama mohe lāge*	You are the merchant [of love] that can rebuke me, and that seems like nectar to me.
ākhar: *rādhe tumi āmār premer guru* *O he Radha, tumi āmār premer guru*	Radha, you are my guru of love. Oh, Radha! You are my guru of love.
5. *mora nāgarāli bāṛāilā kiśorī* *piriti-rabhasa āge*	You have increased my courage; the force of affection is at its peak.
6. *tomāra ṛṇa je śodhite nārilāma* *prema anurāga bine*	The debt I owe to you cannot be repaid without love and devotion.
7. *kānta kahe kānu gaurāṅga haile* *khālāsa haibe ṛṇe* (**omitted**)	Kānta says, "Oh Krishna [Kānu], if you become Chaitanya, you can release that debt."
8. *jagate kāhāra nā hai adhīna* *jagate kāra nā dhāri* (**omitted**)	I am not dependent on the world. I owe no debts to anyone.

middle of a sung phrase. The addition of these interstitial lyr-
ics and the manner in which they exceeded the abstract time of
the recording is the most plausible reason for this, but a variety
of other factors might account for the sudden conclusion to the
song. One might have been the novelty of recording technology
in Bengal during the first decade of the twentieth century for the
singer; another might have been a lack of direction offered by
the recording engineers, a group who were most likely working

with the genre of kīrtan for the first time. Whatever the cause, this recording represents one way that features of the expansive musical aesthetic met with the fixed and abstract time durations of media production in the early twentieth century.

Another early case that illustrates the way kīrtan musicians interfaced with the time frames of short-play records is Krishnachandra De (1894–1962). Though rural male kīrtan musicians at the center of the musical recovery in colonial Bengal never fully entered the sphere of the commercial recording industry, De, as a student of the kīrtan musician Nabadwipchandra Brajabashi, represents one link to the sphere of the commercial media industry. De was a singer-actor who transitioned from Bengali theater to film, and his training in padābalī kīrtan offered him a point of entry into the production of devotional films in the early twentieth century.[3] More specifically, De was an actor and singer in the film *Chandidas* (1932), produced by the Kolkata-based New Theatres Ltd. The movie told a version of the life story of the pre-Chaitanya padakartā and was the first in a lengthy run of Gaudīya Vaiṣṇava–themed films that featured in Bengali cinema over several decades.[4]

Despite the success of these Vaiṣṇava-themed media, transferring devotional songs to the sphere of film production required musicians to conform to new temporal limitations. A key parameter of film songs in the early twentieth century was determined by the relationship between the cinema and forms of commercial distribution. Though songs were a key part of the narrative and affective work of cinema, popular films songs were further produced and distributed as short-play records purchased by an emergent class of music consumers in South Asia. The relationship between the song's role in the film and its transformation to a recorded commodity represented the song's "double life" (Morcom 2007). To adjust to this commercial and physical reality, De omitted the interstitial song lines central to the repertoire. One example is De's performance of *"chunyo nā chunyo*

nā bandhu" ("Oh Friend, do not touch me!") (table 9.2) from *Chandidas*, where De was both an actor and a singer on the film's soundtrack. The song is spoken from Radha's perspective and organized around her directive to Krishna: "Do not touch me! Keep away!" Radha has waited the entire evening for a prearranged tryst with Krishna, but when he finally arrives, she can see marks on his body from another lover. De recorded at least two different versions of this song, one for the film's soundtrack in 1932 and a second commissioned by HMV Records in 1933 to be released as a seven-inch commercial record.[5] In each version, De focused on completing only Chaṇḍīdās's original song text and, crucially, omitted the performance of the interstitial lines of song text that are an established convention of the genre. On the version of the song De recorded for HMV, he progresses through each couplet, finishing the last line seconds before the song fades to silence. The song truncations found in these two examples sketch out part of the larger historical arc that has defined kīrtan's relationship with mediation throughout the past century, as connections between temporal features of devotional practice and the expansive musical aesthetic were unrealized within the abstract time frames of new media. The move toward temporal abstraction found in these recordings, then, illustrates the link between media production, abstract time, and forms of capitalist expansion during this period (Postone 1993, 213), a point that emphasizes how media forms have been an essential link in the chain of the commodification of music under capitalism.[6]

But what happened as media forms could accommodate longer durations? As it turns out, later developments in media technology did not lead to drastically different results than the examples just discussed. Indeed, despite the significant temporal gains that were introduced with long-play records, cassettes, and CDs in the second half of the twentieth century, media use was still marked by significant transformations to the expansive musical aesthetic. To

Table 9.2. *"chunyo nā chunyo nā bandhu"* as sung by Krishnachandra De

chunyo nā chunyo nā bandhu oikhāne thāka/	Oh friend, do not touch me! Keep away!
mukura laiyā cānda mukha khāni dekha	Look at your moon-like face in the mirror.
nayanera kājara bayāne legeche kālara upare kāla/	The collyrium of your eyes has stained your face; it appears as black on black.
prabhāte uṭhiyā o mukha dekhinu dina jābe āja bhāla//	Rising in the morning and seeing that face, [I thought] this day will be good.
adharera tāmbula bayāne legeche ghume dhulu dhulu ānkhi/	Chewed betel leaf from your mouth has stuck to your face, and your eyes are half closed with drowsiness.
āmā pāne cāo phiriyā dāṇḍāo	Look at me! Stand in front of me!
nayana bhariyā dekhi//	Let me see you with my open eyes.
cāncara keśera cikana cūḍā se kena bukera mājhe/	Why is the glossy, curly hair of your topknot now on your chest?
sindurera dāga āche sarbagāye morā hale mari lāje//	Your whole body is stained with the marks of vermillion. If this happened to me, I might die in shame.
nīla kamala jhāmaru hayeche malina hayeche deha/	The blue lotus [Krishna] has become faded; his body has lost its glow.
kon rasabatī pāya sudhānidhi niṇḍi layeche seha//	Which Rasabatī [gopī] has squeezed all the nectar from that ocean?
kuṭila nayane kahiche sundarī adhika kariyā toṛā /	The beautiful one [Radha] offers an excessive rebuke with a wink.
kahe caṇḍīdāsa āpana svabhāba chāḍite nā pāre corā//	Caṇḍīdāsa says that thief [Krishna] cannot change his nature.

offer one example, in the 1970s a select group of kīrtan musicians in India used the LP format, which offered a significantly expanded duration of roughly forty-five minutes spread across both sides of its twelve-inch vinyl form. Because the means for recording and producing this media form were still controlled by the major labels in India, relatively few kīrtan musicians recorded in the LP format. Two singers who did record several līlā kīrtan

LP records were Chabi Bandopadhyay and Rathin Ghosh, two musicians with access to the commercial music industry on account of their ties to the film industry: Chabi Bandopadhyay sang in midcentury Bengali films, and Rathin Ghosh was a music director for several films. These musicians introduced two new production techniques for the LP medium, borrowed from the sphere of live performance. The first was the inclusion of storytelling segments that were used in between songs to advance the līlā's narrative. The second was the manner in which these LP recordings were focused on a specific līlā, which now could be done because of the longer forty-five-minute time span. The titles of various LP recordings during the 1970–1980 period demonstrates how musicians and producers conceived of the LP's possibilities along these lines. Rathin Ghosh recorded several LPs with a thematic focus on one divine play, including *Bājikar-Milan: Mānabhanjan* (*Meeting the Magician: Dispelling [Radha's] Pique*) (1977) and *Krishna Kālī—Pālā Kīrtan* (*The Story of Krishna as Dūrgā [Kālī]*) (1978). In the 1980s, Chabi Bandopadhyay became one of the most popular kīrtan singers in Bengal through LP recordings that were organized according to specific līlās, such as *Śrī Gaurānga Mahāprabhu Līlā Kīrtan*, recorded in 1986. These developments continued with the production of cassettes in the 1980s and 1990s, though kīrtan musicians never fully embraced the possibilities of cassette production in a similar fashion as other devotional musicians (Manuel 1993).

However, despite the inclusion of the storytelling mode, the LP and cassette formats did not include many features of the expansive musical aesthetic. Perhaps the most glaring omission was the near total lack of songs that featured the large-meter musical style with its slow tempos and large tāl structures. Therefore, even though LP and cassette forms offered longer time spans, they still never allowed for durations that would permit full realizations of the expansive musical aesthetic. One result of this is that relatively few kīrtan musicians are found in the archive of short-play,

long-play, and cassette media throughout the twentieth century. For example, despite having a long career in performance, Nimai Mitra made only one media recording, a cassette titled *Āmāder Gaurāṅga*, released in 1988. In fact, his reticence to engage with these media was once relayed in a discussion with a student during a lesson I was attending. He reported that one could not find large-meter song performances in these earlier media forms, as the production method was responsible for "cutting" features of the expansive musical aesthetic,[7] a perspective that several musicians and historians of the genre shared with me. What did introduce a sea change in the use of media in the early twenty-first century was kīrtan musicians' adoption of the VCD medium and its ability to combine image and sound to depict the līlās at the center of the genre's repertoire.

THE AFFECTIVE IMAGES AND TEMPORAL
LIMITATIONS OF VCD PRODUCTION

The twentieth-century media forms used by musicians such as Punna Moyee Dassi, Krishnachandra De, and others represent one way that musicians attempted to forge careers in Bengal's regional entertainment industries. To greater and lesser degrees, these musicians saw these settings as opportunities to apply their knowledge of devotional song to new contexts and enter the sphere of the regional music industry in Bengal. The situation for kīrtan musicians in present-day West Bengal, however, proves significantly different as VCD production does not lead to careers in the regional media industry. Moreover, musicians rarely make significant profits from the production and sale of VCDs. As mentioned previously, the most common way that musicians engage with media production is to advertise their group to secure opportunities for exclusive live līlā kīrtan performances. While VCD production is a process that fuels forms of self-promotion, it also ties into the long-standing focus on

visualization as VCD images materialize the time-spaces of the līlās of Radha and Krishna found in song texts. These visual capabilities of the VCD medium, when coupled with the establishment of local studios with the technological capacity for production, were key to its widespread adoption among professional kīrtan musicians. During my fieldwork, it was extremely rare to meet a professional kīrtan musician who did not produce VCDs for distribution. Indeed, in initial meetings with musicians, I would often be presented with VCDs as gifts. Compared to cassettes and audio CDs, then, there was a clear increase in media use with the arrival of the VCD medium.

VCD production begins when kīrtan musicians record a roughly fifty-minute audio track. In the single- or multi-day sessions I attended in 2012, a kīrtan ensemble would enter the studio to record the audio track for the VCD as the first step in the process. Like a live performance, the central figure in the studio recording was the main singer (mūl gāyen), who directed the mix of song and storytelling to depict a specific līlā. The instrumentation of the kīrtan ensemble in the studio was also similar to live performances, though lower-volume instruments that would usually not be used in live contexts, such as the sitar, were often included in studio recordings. Kīrtan ensembles also employed producers to offer suggestions about performance and production during the sessions. In some cases, the producer would be a media industry professional who specialized in kīrtan and other nonclassical genres; in other cases, it might be the guru of one of the kīrtan musicians. The kīrtan ensemble recorded the audio track live with the main instruments of the group, including the khol and kartāls; the quieter accompanying instruments and additional vocal parts were recorded later. Across the dozens of VCDs I have listened to, one point that becomes clear is that the overall sonic texture of the audio track is thinner than in a live performance. One reason for this is that usually only a single khol is used for the recording, with two microphones placed directly

near the drumheads; another is that the singer can voice her song and storytelling parts in a quieter setting with a microphone, as opposed to the louder context of a live līlā kīrtan event.

The studio engineer is also an active voice during the creation of the audio track, as he suggests moments in the recording when he might insert various stock sound effects or audio production techniques. The most audible instance of this is usually the heavy reverb added to kīrtan recordings in the studio, which is similar to other types of devotional song in South Asia. In another example, SM Music artist Shampa Mishra's *Muralī Bṛṣṭi* VCD included stock bird sounds that were added to portions of the recorded storytelling depicting pastoral scenes. At the conclusion of the recording session, the kīrtan ensemble will leave the studio with the final audio track, which is then used for the second stage in VCD production: it will be played at the video shoot where the kīrtan musicians and hired actors will mime the song and storytelling during filming. The third and final stage of VCD production involves synchronizing the recorded audio and video in a studio and adding stock images that the producer will add of pilgrimage locations in West Bengal.

The length of the final audio track is based on the coding norms and the data capacity used for VCD production. The abstract time frame of the CD and MPEG format determines the duration of the audio track, a calculation based on the fact that the audio will be combined with the large video data files that will be added later. Indeed, adding another temporal layer to the analysis, we should note that the MPEG format uses a form of temporal compression to erase redundancies in the production of an audio-video data file. Despite the ability of this format to compress the file size, the final product is still limited to an abstract time frame, thus adhering to other ways that technological formats conform to a "set of rules according to which a technology can operate" (Sterne 2012, 7). The maximum amount of data storage allowed on the CD medium used in VCD production is seven

hundred megabytes, which will accommodate fifty minutes of audio-video material when encoded in the digital MPEG format. With the longer durations of short- and long-play records earlier in the twentieth century, kīrtan musicians were using the most cutting-edge forms of recording technology; with the VCD medium, they are adopting a less sophisticated technology. As mentioned, the distribution of the VCD in (South) Asia marked another aspect of global influence, as this media form and its abstract time frames arrived in the global south only after achieving irrelevance in the global north.[8] In North America, the VCD was supplanted by the DVD format, which allowed for a significantly larger data capacity than the VCD and much higher audio-video quality on account of its 4.7 gigabyte data capacity. Offering nearly seven times the data capacity, the invention of the DVD medium signaled the end of the VCD medium's relevance in American and European markets, and the creators of the VCD format with its shorter time allowances searched for emerging markets where it could gain a foothold. Although the DVD medium was present in Indian markets beginning in the 2000s, used primarily for popular and classical music, the VCD ultimately became the main media format in local and regional music markets. One reason for this was because of the wide availability of playback machines in rural areas and the general low costs associated with VCD production. Adapting to the VCD medium thus represents the way musicians encounter independent temporal variables that have arrived in the global south during media production.

The musical transformations that define the recording of the VCD audio track involve adjustments to the sonic synchronies of sequence and duration. An example of modifications of sequence is found in Dyuti Chakraborty's Naukā-bilās līlā kīrtan VCD, released on the Raga Music label in 2012. The VCD is a mediated version of the full, multi-hour līlā kīrtan structure that she learned from Nimai Mitra in private lessons. Indeed, because she also performs this specific līlā kīrtan in live contexts, it proved

to be a useful point of comparison. To create the audio track that would serve as the foundation for the VCD, Dyuti Chakraborty and Rahul Das adapted the sequence of genres that typically synchronize features of musical time with ritual and theological order. Studying the audio track for Dyuti Chakraborty's Naukā-bilās VCD thus reveals a series of transformations and omissions to features of temporal sequence (fig. 9.1). As discussed, an overarching organizational principle of a līlā kīrtan is the value placed upon the temporal order of genres that organize features of ritual time in performance. The sequential movement through a performance follows a prescribed series of songs and genres that precede the exposition of the divine play of Radha and Krishna, a topic that can be presented only at the end of this temporal order. Though the *Naukā-bilāsa* VCD recording begins with the short dhvani invocation that typically initiates a live līlā kīrtan, the second prescribed section, the percussive *hāṭutī*, has been altogether omitted. Dyuti Chakraborty's audio track also skips over the Gaura-bandanā and Gaura-candrikā genres. Both song repertoires hold significant roles in the order of a līlā kīrtan, and the latter, as mentioned previously, is a key repertoire in establishing features of ritual and theological order in premodern Bengal. The decisions to transform and omit sections of a performance rests with issues of duration. The omission of the percussive hātuṭī section, which can last as long as ten minutes, and the Gaura-candrikā song, which can require forty-five minutes in performance, is one way of quickly gaining more time for the other genres and sections of the līlā kīrtan. Including these two genres would have occupied the entire abstract time frame of the VCD format. Omitting the Gaura-candrikā song and other genres from the sequential order of a līlā kīrtan is one way to circumvent the shortened durations of VCD production. However, other examples demonstrate how kīrtan musicians adjust the durational features of the large-meter style used in the Gaura-candrikā repertoire.

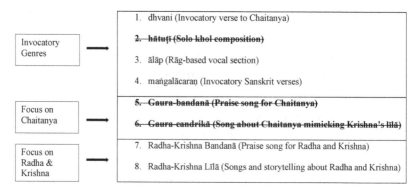

Figure 9.1 Genres omitted in the Naukā-bilās VCD.

Modifications to the song *"māna-biraha-jvare pahun bhela bhora"* ("Many months passed in the fever of separation and pique") in a recent recording by the singer Suman Bhattacharya illustrate how the durational features of a Gaura-candrikā song are transformed in VCD production.[9] This song is used to open both live and mediated performances of a līlā kīrtan titled *Śrī Rādhār Mānabhanjan* (*Dispelling Radha's Pique*), a divine play that describes Krishna's attempt to make amends with Radha after his infidelity. The Gaura-candrikā song, discussed briefly in chapter 4, presents an image of Chaitanya adopting Radha's emotions of separation from Krishna in the mood of pique (*māna*). In a live-performance version of the song, Suman Bhattacharya set the song text to a sequence of tāls that are commonly used with the Gaura-candrikā repertoire.[10] The first half-couplet of the song featured the sparse texture of the large-meter musical style set to the twenty-eight-mātrā Som Tāl. To match the short text within this long-duration style, Suman Bhattacharya repeats words, adds short vocative phrases, and features a melismatic singing style. The combination of the large meter, slow tempo, and additions of interstitial lyrics requires a time span of four minutes to complete the first half-couplet of the song. And, as mentioned, the time needed to complete an entire song using similar styles of musical expansion often requires forty minutes.

Table 9.3. Comparison of live and recorded Gaura-candrikā song

Suman Bhattacharya's Live Version	Suman Bhattacharya's VCD Version
"māna-biraha-jvare pahun bhela bhora"	"māna-biraha-jvare pahun bhela bhora"
Many months passed in the fever of separation and pique.	Many months passed in the fever of separation and pique.
Text used:	Text used:
māna-biraha [o he] biraha [bhābe] māna-biraha [bhābe āmār] pahun bhela bhora [āhā mari re] (o, he, āhā, re = Oh!) (bhābe = in the emotion [of]) (āmār, mari = my)	māna-biraha-jvare pahun bhela bhora
Tāl used: Som Tāl (28 mātrās)	Tāl used: Jhānti Tāl (7 mātrās)
Duration: c. 4 minutes	Duration: c. 40 seconds

The shorter time allowances of the VCD medium complicate the inclusion of these features of the expansive musical aesthetic. For example, when recording the same song for the audio track for the VCD version of *Śrī Rādhār Mānbhanjan*, one way that Suman Bhattacharya addressed the relatively shorter time span was through altering the musical setting of tāl and tempo for the song text. This transformation kept the ritually significant song within the larger sequence of the performance while still reducing the song's duration. The VCD version includes three transformations of the large-meter style: (1) the use of a shorter tāl and quicker tempo; (2) little to no repetition of individual words from the first half-couplet; and (3) no inclusion of additional words not found in the original song (see table 9.3). The overall result of these transformations is that the half-couplet of the song, which previously required close to four minutes to complete, was finished in forty seconds. Such moments of musical compression pass quickly during a recorded performance and underscore how musicians interface with the abstract time frames of media forms and their durational parameters.

FURTHER LAYERS OF TEMPORAL CONVERGENCE
AND DISJUNCTURE IN PRODUCTION

The final fifty-minute audio track that musicians record in the studio acts as the template for the next stage of VCD production. With the audio portion in hand, musicians and producers initiate a process to film the video images that will be synchronized with the songs and storytelling of the līlā kīrtan. As mentioned, three image types structure the visual portion of a līlā kīrtan VCD. The first consists of a series of scenes where hired actors play the roles of the mythical and historical characters described through song and storytelling. In these shots, actors adopt the dress and personas of Radha, Krishna, and other figures in the divine play, often trying to memorize and mime the dialogue that had been prerecorded on the audio track. The second image type in VCD production features the main singer and her kīrtan ensemble miming the vocal, instrumental, and storytelling performances from the prerecorded audio track. A third and final type consists of stock images of various pilgrimage sites from across West Bengal and north India more generally. These pictures and videos are stored on the in-house computer of the studio engineer who assists with production and are added to the VCD in the final stage of mixing.

The final combination of the prerecorded audio with these various image types can be seen in a short song from Dyuti Chakraborty's *Naukā-bilās* līlā kīrtan VCD. The song "*rāi kānu jamunāra mājhe*" (table 9.4) occurs in the middle of the līlā that centers on a river boat meeting between Radha and Krishna. In the first two couplets of the song, the text depicts several scenes where Krishna, as the boatman, has finally convinced Radha and her friends to embark and cross the Yamuna River on his boat. The song's text focuses on how Radha and Krishna's river journey helped the two lovers escape the opprobrium of their families by floating through the waters of the river. In the second couplet,

Table 9.4. "*rāi kānu jamunāra mājhe*" from the Naukā-bilās VCD

rāi kānu jamunāra mājhe/	Radha and Krishna were in the midst of the Yamuna River.
phiraye taraṇī jaler ghuraṇī *dure gela kula lāhe//*	In the whirling waters, they sailed far away from the criticism of their families.
kumbhīra makara mīna uṭhata *saghane badana tuli//*	The crocodiles and fish lifted their heads out of the water.
hariṣe jamunā uthale dviguṇā rāi *kānu rupe bhuli//*	The delighted Yamuna River greatly overflowed her banks, swept away by the beauty of Radha and Krishna.

we hear about the various beings in the water, and the composer depicts the river as a personified form overflowing her banks with joy as Radha and Krishna sail in her waters.

During the video shoot, the musicians and producers depict the images described in the song's first two lines.[11] One of the first scenes features the image of an actor whose visage is superimposed over rippling waters, meant to represent the personification of the Yamuna River (fig. 9.2). In the audio accompanying this image, Dyuti Chakraborty explains how "the Yamuna cannot control her joy, as she holds Radha and Krishna in her heart, and she sees their unparalleled beauty." Another series of images in this short example features Dyuti Chakraborty miming her previously recorded song and storytelling audio while standing before the images of Radha and Krishna. These shots are often interspersed with other video images that show the entire kīrtan ensemble and include the instrumentalists who are accompanying the song. The images of the singer gradually give way to the shots of the actors performing the roles of Krishna, Radha, and her friends. When the first couplet of the song begins, the camera scans the length of a riverboat scene where Radha and Krishna are seated with their companions. A coterie of Radha's friends (*sākhis*), dressed in matching yellow, red, and green outfits, surrounds the actors playing Radha and Krishna on the riverboat.

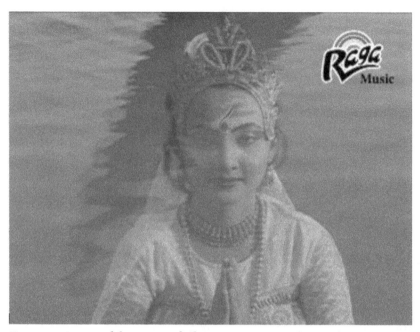

Figure 9.2 Image of the personified Yamunā River in the Naukā-bilās
VCD.

Each of the actors holds a decorated earthen pot in her hands as a
prop that reminds us of their trip to the market. The camera shot
eventually reveals Radha and Krishna seated in the center of the
boat; the actor playing Krishna is paddling with Radha seated
next to him, holding her veil over her face. The outsized crowns
on their heads signal their central role in the līlā and further refer-
ence similar types of headdresses used in the worship of temple
images of Radha and Krishna. The shot of Radha, Krishna, and
their company on the boat serves as a visual focus for this section
of the VCD, but it is regularly interrupted by images of the main
singer and the kīrtan ensemble. The return to these shots of the
singer and ensemble continue to reference the messages found
in the song text. In one example, Dyuti Chakraborty uses iconic
hand gestures that reference the river creatures, such as fish and
crocodiles, that are described in the song.

Despite the visual opportunities that VCDs offer, objections to their production aesthetic often underscore borders of class discourse indexically linked to urban and rural locales in West Bengal. For urban and middle-class media sensibilities, the production techniques of these media are commonly defined as lacking aesthetic value. I heard this perspective in Kolkata in 2012, during an interview with the director of Raga Music, the label that released Dyuti Chakraborty's Naukā-bilās VCD. While discussing the catalogue of Raga Music and the label's lack of a rural distribution network, the director, Sweta, proffered her opinion of VCD consumers: "they are basically from [the] interior. These people are not . . . Kolkata-based. They are not city-based. . . . In the interior, the people today are just a little bit down to earth or something, you can say. They are not very technologically savvy."[12] Sweta somewhat pejoratively pointed to the ways that computer-generated effects are used to depict "spirits" and "mythological" scenes in VCD production, which one might conflate with the image of the personified visage of the Yamuna River in the previous example.[13] To draw a contrast, she also mentioned the types of media that, in her estimation, urban Kolkata-based consumers prefer, such as the 2010 Indian blockbuster film *Robot*, which was famous for its use of high-quality CGI graphics. Putting a period on our conversation, she again referenced the use of VCD media to create the impression of supernatural phenomena: "So in the interior, people believe all these kinds of presentation. But in Kolkata there is *nobody*."[14] Her claim that rural subaltern audiences consume technology differently from urban consumers is reminiscent of colonial-era ideologies that framed subaltern subjects as having a fundamentally different perspective on media use (Larkin 2008).

These comments allude to a hierarchy of media production in India that might be roughly divided into three categories. At the top are pan-Indian and global forms of media, such as Bollywood, that use a high level of audio and video production techniques.

Below this, representing something of a middle tier, are forms of regional-language media. In West Bengal, Raga Music would be in this category as a production company that focuses on the creation and distribution of Bangla-language products that are consumed by a regional and often middle-class audience. A third level of media production is populated by low-budget forms such as VCD products that are considered to have a lower level of production and, crucially, are rarely seen in commercial media stores. Though Dyuti Chakraborty's Naukā-bilās VCD was produced by Raga Music and thus might seem to be in the second tier of regional language media, it was not featured in online catalogs or in retail stores that feature Raga Music media. Though Raga Music does produce līlā kīrtan VCDs, this genre represents an extremely small portion of its entire catalogue of regional music; indeed, it has released only a handful of līlā kīrtan media out of a total catalog that numbers more than two thousand audio and video products.[15] In fact, Rahul Das and Dyuti Chakraborty were required to make a substantial upfront payment to the Raga Music label before production on their VCD began as a way of conferring the cultural capital of this regional media company to their product. Despite this, however, their VCD was not central to Raga Music's catalog and marketing thrust, and *Naukā-bilāsa* was not distributed to retail outlets in West Bengal. Moreover, when I visited Raga Music's main retail location in Kolkata, the retail store M. Biswas & Symphony, during periods of fieldwork research in 2011 and 2012, Dyuti Chakraborty's *Naukā-bilāsa* VCD and other līlā kīrtan products occupied an inconspicuous location. In fact, the entirety of the līlā kīrtan VCD collection was lumped together in a hidden bin in the back of the store, a low-profile location that stood in stark contrast to much other media for sale.

Returning to the *Naukā-bilāsa* VCD, several features of production might illustrate how urban and middle-class audiences perceive a lack of aesthetic value in VCD production, and thus

categorize it as a form of low-class media production in India. For example, though the riverboat was anchored in place, the use of the camera pan was one technique meant to suggest it was in motion. Another case is the lack of verisimilitude in the miming of the prerecorded audio track; studying the images of singers and instrumentalists reveals that their video images only marginally match the prerecorded audio track. A final example is that the actors' eyes often follow the movement and placement of the camera, a feature of production absent in the pan-Indian and regional media products found in other spheres of the media market in present-day India.

It is not unusual, of course, that practices of media production outside of the dominant media industries in the West are often defined by their lack of aesthetic value relative to Western media forms (Hilder 2017). Yet this tendency can also be applied to relationships between national and regional media industries in India, and the three-tiered framework mentioned above might be one example of this. Scholars doing ethnographic work at the juncture of media production, distribution, and consumption outside of the dominant spheres of Hollywood (and Bollywood) can thus offer a corrective lens that considers variations in production techniques as resulting from more than a purported lack in aesthetic value relative to dominant norms. This perspective can instead reflect on the often delicately balanced social, political, and economic contexts where media are produced. In the case of VCD production, Henry Stobart has noted a "lo-tech aesthetic" in indigenous communities in highland Bolivia, where his fieldwork demonstrates that the lack of aesthetic value in production can be linked to the low-income markets where these media circulate (2017). Another example is found in Brian Larkin's identification of an "extravagant aesthetics" that defines features of Nigerian film, a genre that emerged with the rise of personal digital technologies in Nigeria. The critical and ethnographic intervention that Larkin makes in this analysis works to

define non-Western media not as representations of a negative aesthetic ontology but as cultural products formed in the diverse networks of social life and insecurity found in contemporary Nigeria. The melodramatic mode of media production that he studies, often captured in production techniques such as lip-synching and exaggerated camera close-ups, thus represent a "fantastic response to the insecurity and vulnerability of everyday life" in urban Nigeria (2008, 172), and further represent an aesthetic form that encapsulates a larger shift from state-based to privatized media production. In the sounds and images of Nigerian film and the lo-tech production of Bolivian VCDs, these researchers present one way that the ethnographic study of media production can work to link the final product with its larger social background.

TEMPORALITY, VCD PRODUCTION, AND THE LO-TECH AESTHETIC

A final example in this chapter similarly explores the context surrounding VCD production from the perspective of ethnography to complicate the negative valuation aimed at these media. I focus on a VCD produced by Rahul Das's media company in 2012 to further introduce a consideration of temporality into the equation of modern social time and its role in the construction of the final VCD medium. If the abstract time limits of VCDs present a temporal baseline for these media, a study of production underscores other layers of social and natural temporality that affect media production. It was the interaction of the two temporal strata of wage labor and natural time in SM Music's production of the VCD *Muralī Bṛṣṭi* that created the most fraught conflict (fig. 9.3). Filming in a rural location meant that the hired actors who had traveled there needed to complete the shoot before the sun set, thus underscoring the interaction between the temporal constraints of wage labor and the duration of sunlight. The challenges of VCD production thus illustrate that the time-spaces

defined through acts of musical labor are ways that musicians and producers mediate the "conflicting rhythms, representations, and technologies of time" (Bear 2014b, 72).

The temporal complications involved in organizing the wage labor necessary to produce VCDs are part of a larger system of production. To film the visual portion of the *Muralī Bṛṣṭi* VCD, Rahul Das had hired a fifteen-person production crew that commuted more than two hours from the urban center of Kolkata by train for a film shoot in rural West Bengal. Because VCD images work to evoke the mythical-cum-ancient time-spaces of Gauḍīya Vaiṣṇava līlās, they are often filmed in remote and pastoral locales that are situated far from the city and its industrial sprawl. The small town of Bansberia in the Hooghly district was carefully chosen as the site for filming this VCD, as it is famous for an eighteenth-century Kali temple and nearby ruins, two settings that were used as backdrops for several scenes in the filming. The monetary commitment needed to mobilize the party of actors and filming crew to facilitate the video shots in rural West Bengal linked production with a series of temporal limits. Perhaps most pressing was the fact that the daily rate of wage labor offered to actors and other production crew members was intensified by the location of the shoot. Because the film crew and hired actors had traveled to Bansberia and had to return to Kolkata at the end of the day, there was a heightened focus on the passage of time relative to the progress of filming the līlā.

The time constraints of wage labor at this shoot were in direct competition with the arching movement of the sun across the late autumn sky. The incongruous nature of these two rhythms was made evident as I stood in a recently mowed hay field that sat behind the Kali Temple at the site of the shoot (fig. 9.4). While the actors playing Radha and Krishna paused to adjust their makeup, Tapash Debnath, a member of the production crew directing the actors, gave instructions for the next scene. A temporary silence had descended over the

Figure 9.3 *Muralī Bṛṣṭi* (*The Rain of Flutes*) VCD by Shampa Mishra.

Figure 9.4 Preparing for the video shoot in Bansberia.
Photo taken by the author, 2012.

field; the car battery–powered CD player had been momentarily
turned off as the crew prepared to film the next scene. The quiet
of this moment only slightly masked a simmering anxiety of the
production crew that was steadily increasing as the sun moved
across the November sky. It was already two o'clock in the after-
noon, and there were several shots that had to be completed be-
fore the sun set at 5:00 p.m. If the sun set before the final outdoor
shots were completed, Rahul Das's budget would not allow for
another day of hiring the crew and actors needed for filming. Part
of the budgetary constraints of VCD production, then, is found
in the lack of compensation that musicians can expect from dir-
ect sales for these media, as the forms are primarily used to book
exclusive līlā kīrtan performances.

One moment of video capture that illustrated the fraught
situation on this day was a scene from the līlā when Radha

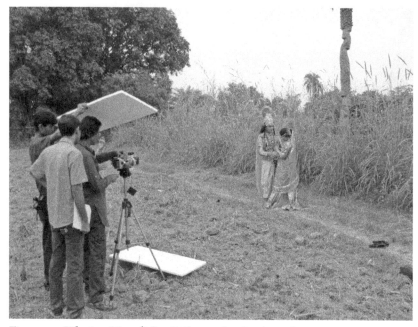

Figure 9.5 Filming *Muralī Bṛṣṭī*. Photo taken by the author, 2012.

and Krishna awoke from a night spent together. This scene represented a key moment in the larger episode, as it was meant to film the moment when Radha mistakenly brings Krishna's flute to her home after their night together. In the larger narrative of the līlā, Radha's mother-in-law then discovers Krishna's flute in her bed, and she accuses Radha of sneaking off to meet Krishna during the night. To assist her, one of Radha and Krishna's allies tells Radha's mother-in-law that there was a magical rainstorm of flutes during the evening (thus the title of the līlā, *The Rain of Flutes*), which deposited these instruments throughout Braj. The residents of Braj then are surprised to see that every home in Brindaban has been miraculously inundated with flutes that have apparently fallen from the sky, a revelation that exonerates Radha and conceals her amorous tryst with Krishna.

As the actors prepared to shoot the scene where we find Radha mistakenly carrying home Krishna's flute, the action signal was given, and the audio track began resounding from the impromptu

stereo system. It became immediately obvious that the two actors had not memorized the lines of dialogue from the prerecorded audio track. Tapash Debnath, who was directing this scene, noticed this problem and began shouting out the lines that the two actors were supposed to be miming. The difficulty of this was that it required him to anticipate upcoming lines of dialogue and call them out to the actors a few seconds before they occurred in the audio track playing in the background. If performed well, the actors would hear Tapash Debnath yell out their lines seconds before the same ones would be heard in the prerecorded audio track. They would then be able to synchronize their miming with the audio track as the camera filmed.

Perhaps not surprisingly, this method created several disjunctures between sound and image found in the final VCD product. A transcription for this scene uses three levels of representation to underscore the tenuous relationship between image and sound in this shot: (1) normal text conveys a successful miming of the audio by the actor who plays Radha in the scene; (2) words in *italics* represent a case where there is only a marginal connection between sound and image; and finally, (3) **bold** text represents a video performance that completely omits the miming of a phrase:

> Radha: āmāder . . . āmāder e gupta līlā, *jena oi kṛṣṇa-bādinīrā jānte nā pāre. Calo.* **Calo!** *Ekhani, niśi thākte āmrā gṛhe jāi.* Tabe jābār *āge tumi āmārke pūrbe sāje sāje dāo.*
>
> *The antagonists of Krishna cannot know about* our secret līlā [pastime].
> *Let's go.* **Let's go!** *After spending the night together, we will go to our homes.*
> But before leaving, *you will help me decorate myself.*

One example of omission was found in the missing utterance of "*calo*" or "let's go" in the miming session, though studying the transcription above reveals a general lack of verisimilitude that marked the production process. The video clip of this scene

is bookended by two scenes of the main kīrtan singer, Shampa Mishra, who narrates the story before moving into a song performance (video example 9.1).

Despite the imperfections that defined the work of linking the pre-recorded VCD audio during the video shoot, the audio track continued to play in the background as the production crew quickly segued to the next scene, a performance of the song "hari nija āñcare rāi mukha mucchāye" ("Krishna, with his own cloth, cleaned Radha's face") (see table 9.5), which gives a detailed description of how Krishna helped Radha get dressed (video example 9.2).[16] Synchronized with this song performance are two types of video: the first features the singer Shampa Mishra miming her own vocal part, and the second is a scene that shows Krishna assisting Radha as she adjusts her makeup and dress to return home. Radha and Krishna are in the same pastoral setting as the previous scene, but now they rise so that Krishna can assist Radha; he pretends to fix her makeup and hair before adjusting her dress, only to pause to gaze at her beauty when finished. Radha then pulls her sari over her face and turns to go, and Krishna's gaze follows her as she leaves the camera frame. The video material from this short scene, which lasts roughly two and a half minutes, is repeated six times, using a variety of different production techniques: in color, black and white, and then in a split-frame image, which shows Shampa Mishra side by side with the episode of Radha and Krishna that she is narrating (fig. 9.6). These images that become part of the final VCD production mirror the expansive logic that is at the center of the genre, as musicians and producers work to elaborate on the devotional theme of the song through digital means.

While this repeated scene appears in the finalized VCD, the process of directing the actors emerged from a fluid series of directions and disagreements that occurred behind the camera. Like the case above, the directors of the VCD filming decided there was not enough time to rehearse this scene, and

Table 9.5. Portion of *"hari nija āñcare rāi mukha mucchāye"* as performed by Shampa Mishra on the *Muralī Br̥ṣṭī* VCD

hari nija āncare rāi-mukha muchaye/	Krishna cleaned Radha's face with his own cloth.
kuṅkume tanu puna sāje//	He placed kunkum on her body again.
ākhar:	
sājāi re kaṭa jaṭana kare	Oh, the attention he paid to dressing her.
(āre) alaka tilaka dei sīthi banāyi/	He painted tilak on her forehead and wove her hair/
cikure kabari puna sāje sāje//	He made braids in her hair//
ākhar:	
āj sājāi kaṭa jaṭan kare	the attention he paid to dressing her today,
ucchal rasa maṇike	the jewel of overflowing rasa,
prema sahāge nike	the embodiment of love.

the direction for Radha and Krishna's action occurred as the film was rolling. Indeed, much like the spontaneous method of miming the audio in the previously discussed scene, the stage direction here was influenced by a general lack of rehearsal determined by the temporal limitations of the remaining daylight. The following analysis uses text in italics to represent the action of Radha and Krishna during the filming of the scene, while the nonitalicized text presents a transcription of what was said by Tapash Debnath (TD) and Rahul Das (RD) as the filming was happening:

> Radha finishes her mimed speech of the audio track sitting next to Krishna on the ground ("But, before that, you will help me dress.")
> The sound system begins playing Shampa Mishra's narration ("Today, our Govinda [Krishna] helped Radha dress").
> TD: "Get up."
> Radha and Krishna then quickly stand up for the next scene; the camera continues shooting and the sound system begins to play the song "hari nija āñcare rāi mukha mucchāye."
> TD (to Krishna): Help her dress. Go! And give her the flute to hold.

Figure 9.6 Expanding on the video material in *Muralī Bṛṣṭi*.

Krishna hands his flute to Radha and adjusts her shawl by pull-
ing it over her shoulders. He then touches her face and hair, as if he
was adjusting her make up.
TD (to Krishna): "Look at her face."
Krishna steps back from Radha, and, holding her chin in his
hand, smiles as he looks at her face. He then returns to his task of
adjusting her hair. Rahul Das then interjects.
RD: Smile!
TD: No, don't smile! (To Radha): Go! Take the flute, and don't
smile. Enough! Go!
Radha backs away from Krishna, and slowly turns her back to
him while leaving. She pulls her shawl up to cover her face as she
walks away. Krishna stares at her with his mouth agape. The film-
ing of this scene then ends as Radha leaves the frame of the video
camera.

The short amount of video material that was produced through
this hastily directed scene was expanded through various post-
production techniques to match the duration of the prerecorded
song. And after this scene was done, the entire crew rushed off
to film one more set of images for the day, a task that was only
just completed before the sun set. As these two examples have
demonstrated, several features of VCD production—such as
marginally successful miming and attempts to extend hastily
directed scenes with image modification—result from various
intersecting temporal influences. Indeed, though these are fea-
tures of VCD production that are often taken to represent a lack
of technological ability, defining these moments as illustrative of

features of a lo-tech aesthetic is more complicated when we con-
sider the other layers of temporal influence that were present at
this particular filming session. Instead of seeing the final VCD
product as representing a low-class and subaltern aesthetic, we
might consider how its sounds and images represent moments of
temporal disjuncture that surround the production and consump-
tion of līlā kīrtan VCDs in the media markets of West Bengal.

CONCLUSION

Studying how kīrtan musicians act within the abstract time-spaces
of media production uncovers a series of temporal disjunctures in-
herent to a politics of musical time in media production. Through-
out the forms of short- and long-play records to cassettes and,
finally, in the digital media forms and formats in the present, the
time-spaces offered in media production have required musicians
to adapt to a range of independently determined time frames. The
time spans found in these media markets are the result of both the
materialities of technology, and, importantly, forms of capitalist
exchange that have seen the arrival and entrenchment of various
media forms in South Asia. The establishment of early recording
technologies, such as the short-play record, was made possible
because of the value that sound recordings produced as music
commodities. This link between media production and capitalist
exchange further highlights the fact that kīrtan musicians from
the theater and film industries in urban Kolkata became the voices
captured in this early period of sound recording. Because of this
fact, kīrtan musicians from rural Bengal focusing on the large-
meter style were mostly absent from this project. Of course, the
recordings of these urban musicians were still marked by several
musical transformations, such as the inability to include the ren-
ditions of interstitial lyrics in these early media. Though the shift
to long-play records and cassettes offered lengthier time allow-
ances, these developments witnessed the continued absence of the

large-meter style in media production. Moreover, the rise in LP recordings made sure that media production remained entrenched in the sphere of large musical corporations in India and unavailable to the majority of kīrtan musicians.

The arrival of the VCD medium and other digital technologies has offered several new visual possibilities that have allowed kīrtan musicians to enact features of theater, dance, and gesture that were absent in previous media forms. These developments might be seen as forms of temporal convergence, where musicians and producers seek to lessen the distance between the present and the mythical time-space of Radha and Krishna through depicting their līlās during VCD production. At the same time, however, the time-space of the VCD medium is marked by several temporal disjunctures that can be gleaned by reading the various layers of temporal influence that mark the sounds, images, and modes of production of VCDs. Though working within the confines of the abstract time allowance of the media, musicians and producers encounter other aspects of temporal influence through the intersecting social and natural patterns of time that impinge on the process of production. Perhaps because of this, kīrtan musicians working primarily in the instructional economy often refer negatively to VCD production. Nimai Mitra pejoratively referred to the process as related to "business" in one of our meetings.[17] In so doing, he aligned with musicians working primarily in the instructional economy who link the practice of media production with a process of negative social valuation that is found in the transformation of features of musical style. These voices are similar to the discourse found in the regional media industry, where VCD production techniques are seen as indexing a rural and subaltern preference for media use. This perspective often fails to account for the various ways that media production fuels the professional economy, as kīrtan musicians creatively use VCD production to align with the genre's history with visualization and theater, while also using these media to keep

professional careers afloat. These negative opinions also seem to ignore the ways that production occurs within contexts where numerous streams of time-related influence converge, from the exigencies of wage labor to the natural rhythms that impinge on filming the līlās of hired actors.

However, we might also be attentive to the unexpected trajectories of media use that animate the musical economies of kīrtan. As Brian Larkin notes in the case of urban Nigeria, "technologies are unstable things," and their meanings and social uses are "vulnerable to changing political orders and subject to the contingencies of objects' physical life" (2008, 3). The uses and practices of VCD media point to the shifting ways that a media form interacts with a performance genre that has depended on live contexts for most of its history. On the one hand, the abstract time-space of media use challenges the features of sonic synchronization that have been central to the genre's links with devotional performance; on the other hand, this media work has expanded the possibilities of the storytelling mode through its inclusion of the images and scenes that afford līlā kīrtan performance a large audience in contemporary West Bengal. The politics of media use in the present, then, reflect not only transformations of musical form and style; they further illustrate how musicians act within the margins of larger temporal flows defined by forms of local and global modern social time.

NOTES

1. The date the recording was made is unknown. It was first released in March 1909. See Kinnear (2000, 77).

2. The song is often included in performances of the Kalahāntaritā līlā kīrtan, an episode focusing on Radha's dejection after a quarrel with Krishna. The Kalahantarita nāyikā is the fourth out of the eight traditional depictions of the heroine. See chapter 4.

3. For more information on Krishnachandra De, see *Krishnachandra*, edited by Bandopadhyay (2012). The popularity of his performances in

Bengali theater inspired recording companies of the time to hire him to record his songs as short-play record releases. For example, De recorded two songs in 1926—"*jaya sītāpati sundara tanu*" and "*andhakārer antarete*"—that were originally featured in the drama "Sītā." See the discography of De's recordings in Bandopadhyay (2012).

4. Notable films in this genre include *Vidyapati* (1937), *Nimāi Sanyas* (1940), *Bhagaban Shrikrishna Chaitanya* (1953), *Nilācale Mahāprabhu* (1957), *Nader Nimāi* (1960), and *Radha-krishna* (1964).

5. See the discography in Bandopadhyay (2012).

6. See Taylor (2007).

7. Personal communication, November 16, 2012, Kolkata.

8. A number of recent works studying VCD production and reception in the global South (e.g., Stobart 2010; Morcom 2008; Manuel 2012; Fiol 2011) underscore the fact that the VCD medium remains associated with musicians working outside of the orbit of large-scale international and regional media industries.

9. Suman Bhattacharya has established a successful career as a live kīrtan musician in addition to having recorded many VCDs. As a sought-after performer of kīrtan and someone knowledgeable in its history and theory, he further teaches kīrtan at Visva-Bharati University in Santiniketan, West Bengal.

10. See Suman Bhattacharya. 2018. Kirtan (Bengali devotional song). "*Sri Radhar Manbhanjan.*" Kaahon Music. YouTube channel. Accessed October 21, 2021. https://www.youtube.com/watch?v=T7bCSfpqyMI &t=643s.

11. See Dyuti Chakraborty. 2016. "Krishna Lila (full CD)." Rahul Bharadwaj. YouTube Channel. Accessed October 29, 2020. https://www.youtube.com/watch?v=A3YEUC1DyPk. (Song begins at 43:10).

12. Personal communication, November 12, 2012, Kolkata.

13. Personal communication, November 12, 2012, Kolkata.

14. Personal communication, November 12, 2012, Kolkata.

15. For an overview of the Raga Music catalog, see http://ragamusic.co.in.

16. This song is by the padakartā Govinda Dāsa.

17. Personal communication, October 8, 2012, Kolkata.

TEN

—⁂—

CONCLUSION: KĪRTAN ONLINE

IN THE YEARS FOLLOWING MY period of extended fieldwork research in West Bengal in 2011–12, the internet has increasingly become more central to the promotional plans of kīrtan musicians. Indeed, the then-common digital form of the VCD, prominent throughout the 2000s and early 2010s, has migrated online as musicians and producers have begun to upload their media to YouTube. This increase in online activity does reflect a shift that has overtaken the sphere of padābalī kīrtan since the early 2010s, a time frame when it was uncommon to see kīrtan musicians making use of the internet for promotional or production purposes. Indeed, during the early 2010s, it was rare to find musicians creating their own websites, posting on social media, or uploading videos to YouTube. If the example of producing līlā kīrtan VCDs represented one way that digital technologies were front and center in early 2010s, there were other ways that the digital sphere of the internet proved to be conspicuously absent. The manner in which līlā kīrtan VCDs circulated throughout West Bengal during the early 2010s, then, relied on forms of movement that might be considered more properly analog in nature. If we consider that forms of analog media are defined by physical characteristics, such as the grooves in a record or wax cylinder, then we might note how the physicality of kīrtan media distribution

during this time moved throughout analogic and embodied networks. During this period, we might say that VCD media were, in a sense, appendices to forms of live līlā kīrtan performance, as they circulated along with traveling musicians due to the lack of robust networks of distribution. Sold and distributed at the completion of a multihour līlā kīrtan performance, these media were not completely divorced from the features of musical time that have defined features of the genre throughout its history.

In this book's previous chapters, thinking about features of musical time has been presented as one way to connect moments of historical, ethnographic, and performance analysis to demonstrate the bidirectional exchange that animates the frames of social and musical time. Focusing on the forms of representation and production found in a single media form has been one way to note this interchange, but the analysis of the history, theology, and political implications in live features of the Gaura-candrikā song repertoire, to take one example, presents another sonic space where aspects of modern social time become synchronized. From the earliest records that document the process of devotional visualization and līlā-smaraṇa in Braj, to the ways this repertoire came to represent a political theology as it relocated to Bengal, the sequential and durational features of performance came to represent ways that musicians have acted on time. Throughout this period the influence of various patrons— from the zamindār class to the bhadralok—remained central to the continued performance, transmission, and redefining of the expansive musical aesthetic. Indeed, it was during this time that padābalī kīrtan joined a range of other literary and performative Gaudīya Vaiṣṇava forms that became redefined as expressions of a regional Bengali nationalism. This discourse worked to link the image of the sādhaka kīrtanīyā and the large-meter style to a so-called golden age of the genre that coincided with the era of musicians such as Narottama Dāsa. The rise of the VCD form might be seen as linked with the gradual decline of patronage

from these sources and the concomitant rise of new neoliberal subjectivities and practices; of course, it also illustrates the reality that there are minimal opportunities for performance in urban Kolkata today.

However, despite the ways that VCD media engaged the story-telling mode and underscored the genre's links with visualization, there also seemed to be a surprising way that it failed to capitalize on the temporal possibilities of digital technology. Throughout my study of live and mediated performances of padābalī kīrtan, there was one question that repeatedly surfaced in my own thoughts: why do kīrtan musicians not employ the long durations made available by new digital media forms to present full rendi-tions of the expansive musical aesthetic? This observation was based on the fact that kīrtan musicians rarely used digital media and the internet to record and distribute full-length renditions of the expansive musical aesthetic in the forms of full-length līlā kīrtans or even individual large-meter song renditions. Why did kīrtan musicians engaging with the transformations of features of the expansive musical style not take advantage of the abundant time-spaces of digital media? What was behind the seeming lack of interest in the use of digital formats and the internet to record and distribute songs that featured the large-meter musical style?

In 2018, the sudden creation of three YouTube channels featur-ing līlā kīrtan performances hinted at a new direction for the use of digital media. Though some kīrtan musicians, such as Rahul Das, had begun using YouTube in the mid-2010s to upload the contents of their līlā kīrtan VCDs, this more recent develop-ment featured several central organizing platforms that took the form of YouTube channels and were not the work of singular musicians. The largest and perhaps earliest channel was called Jago Hindu (Awake, Hindu), which promoted itself as a channel whose "open and central purpose is to promote *sanātan dharma* (eternal religion)" through the distribution of līlā kīrtan video re-cordings.[1] Two more YouTube channels with a similar focus were

created in 2018: RK Kīrtan Jagat (The World of Radha-Krishna Kīrtan) and Bangla Kīrtan Jagat (The World of Bangla Kīrtan). The Jago Hindu channel is based in Bangladesh while RK Kīrtan Jagat and Bangla Kīrtan Jagat are based in India.

The method used to produce the hundreds of videos listed on these channels is unlike the techniques used for līlā kīrtan VCDs. Indeed, the most striking difference is the fact that they lack any video of actors playing out the līlās of Radha and Krishna. These YouTube channels instead present videos that feature a single camera shot of a live līlā kīrtan performance. More recently, Bangla Kīrtan Jagat has begun to livestream līlā kīrtan events on YouTube, which also features a single camera directed at the kīrtan ensemble. The hundreds of video clips on these three channels are excerpts from longer, live līlā kīrtan performances. While the shortest videos are only three minutes in duration, some of the longest examples feature more than one hour of a performance, though the typical length is somewhere around the twenty- to forty-minute range. The length of the excerpt often corresponds to a particular episode or didactic message that occurs during the longer līlā kīrtan. Many of the video excerpts are titled as forms of *tattba kathā* (discourse on religious truth) and present a specific elaboration on a song or storytelling episode in a līlā kīrtan. As discussed in chapter 7, these didactic interludes often correspond to a particular devotional or ethical message that the singer links to the līlā's main theme. However, in the format of these YouTube channels, the short excerpts are often presented as stand-alone moments and not explicitly connected with the theme of the līlā. In one example, the kīrtan singer Somasree Roy's excerpt tells the story of a young female devotee who is married to the son of an atheistic zamindār, an anecdote that appears to be historical.[2] When the young bride moves into his house and begins her usual practice of chanting and singing Krishna's name (nām kīrtan), the zamindār is furious. However, the young devotee's arguments to the zamindār outline why he should also engage in this specific

form of devotional practice. In the end of the narrative that Roy presents, the zamindār regrets his actions and begins to take up the practice of nām kīrtan. The power of Somasree Roy's story-telling is in full display in this short excerpt; however, despite the engaging nature of this video clip, the YouTube viewer has little sense of how this story is linked to the larger līlā kīrtan that was obviously unfolding.

Despite the fragmentary nature of these videos, the popularity of these YouTube channels demonstrates a growing interest in these singers and the genre. Indeed, some of the most watched clips on these channels garner millions of views in a relatively short time period. For example, one of the most watched videos on the channel Jago Hindu by the singer Papiya Das was watched 5.8 million times in an eight-month period;[3] another popular video by Beauty Mondal received 5.2 million views in a seven-month period.[4] Attention for these videos seems to be growing exponentially, and videos posted more recently are gathering views quickly—as I write this, the video clip about the atheistic zamindār by Somasree Roy has been watched over six hundred thousand times in one week.[5] Though these numbers might not approach those garnered by the most popular videos on You-Tube, they surely demonstrate how digital media and the internet are contributing to an eagerness for līlā kīrtan videos in greater Bengal and beyond. More recently, kīrtan musicians are reaping some of the synergistic benefits of the internet, as they are further linking to their YouTube videos on their Facebook profiles to create more traffic to these channels. In the final months of writing this book, I have noticed how kīrtan musicians have begun to livestream performances over Facebook and, as the COVID-19 pandemic was at its height, offer solo song performances online as well.

These new forms of distribution surely represent novel ways that features of musical sound and storytelling in padābalī kīrtan are become deterritorialized and absorbed within larger

technoscapes of distribution (Appadurai 1996, 33). Though most obvious, the spatial considerations of this are not only global in the sense that they bridge the global North and South. Indeed, the location of the most popular YouTube channel in Bangladesh can also be seen as a way of linking to the longer history of performance in greater Bengal that was interrupted with the partition of India and Bangladesh into separate nation-states. Often, the videos on these YouTube channels include cell phone numbers (tellingly, both Indian and Bangladeshi) for professional musicians. YouTube channels that feature padābalī kīrtan, then, are akin to older itinerant musicians who used to traverse the riverine pathways of greater Bengal in search of instruction and support—a process that now plays out over the exchange of a digital medium.

Of course, while these new internet channels create convergences across spatial dimensions, their production and consumption are further linked to shifts in temporality. Though the promise of instantaneity and simultaneity in the discourse of neoliberal "real time" might represent more of an ideal than a reality (Hope 2016), these new YouTube platforms hint at this promise of temporality. Indeed, the near-immediate dispersal of kīrtan videos and livestreams as they are posted and consumed illustrates how forms of digital media are approaching the aim of instantaneity. The decrease in the time it takes for kīrtan media to reach new audiences in the present is significant. For example, as recently as the early 2010s, when I was beginning fieldwork, it would take months for me to receive līlā kīrtan VCDs that musicians or colleagues would mail to me or bring back to the United States, a time frame that has been significantly shortened today through the proliferation of these channels. As for simultaneity, the recent adoption of livestreaming to distribute video of līlā kīrtan performances on YouTube presents another way that forms of digital media are linked with new temporal flows. The ability to stream a live kīrtan performance occurring in India as it happens and view

it in North America, as I am suddenly and surprisingly able to do, presents a fundamentally different way that kīrtan musicians are beginning to act on time.

Nevertheless, despite these convergences resulting from new forms of digital media, features of temporal disjuncture seem to linger around these new forms. As mentioned, though digital media forms would seem to present a robust platform for the capture and distribution of features of the expansive musical aesthetic, the videos on these new YouTube channels present only fragments of these long-duration forms. After reviewing hundreds of video clips on the channels dedicated to kīrtan, I have yet to see a single example of the large-meter style and its slow tempos and long forms. Similarly, though the seemingly popular sections of tattba kathā that expound on devotional and ethical themes do represent a key practice of the expansive musical aesthetic, the manner in which they are presented on YouTube illustrates how they are disconnected from the larger affective and narrative frame of the līlā kīrtan. Perhaps most jarringly, while watching līlā kīrtan videos on these channels, one is regularly interrupted by video commercials that break the temporal progress of a song or storytelling section. While watching kīrtan excerpts, I am regularly presented with fifteen- to thirty-second advertisements that interrupt the kathā section and present material based on my own personal internet search history. A viewing of the story of the atheistic zamindār's conversion was thus suddenly interrupted by an advertisement for project-management computer software at one moment and a promotion for a food-delivery service the next. These temporal disjunctures, of course, are not unique to the sphere of kīrtan videos but are ways of acting within time that are part and parcel of how cultural production proceeds alongside the practices of global capitalism in the twenty-first century.

These newer and internet-based aspects of temporal convergence and disjuncture underscore the longer dynamics of musical

time that have animated features of the genre's history. Through focusing on the ways that kīrtan musicians and others have acted on and within time across the early modern and present-day periods, I have focused on how musical time both constructs and reacts to features of social time that are linked with devotional practice, regional nationalism, and economic exchange. These new contexts of internet distribution may simply call attention to the dynamic interplay that has been at the center of the construction and destabilization of the genre's sonic synchronies over its history. They further demonstrate how the temporal negotiations that occur through features of musical sound will continue to influence a politics of musical time that involves padābalī kīrtan and devotional performance in Bengal for decades to come.

NOTES

1. Jago Hindu. YouTube channel. n.d. "Description." Accessed December 1, 2019. https://www.youtube.com/channel /UCXUAk9gNCyYtMpWWkroGt2g/about.

2. See Somasree Roy. 2019. "*bhagabān bolte kichu nei?*" Jago Hindu. YouTube channel. Accessed December 3, 2019. https://www.youtube.com /watch?v=zHmJoL2ZC1A.

3. See Papiya Das. 2019. "*jīban dhanya hobei pāpiyā didir emana miṣṭi kaṇṭhe kīrtan śune.*" Jago Hindu. YouTube channel. Accessed November 24, 2019. https://www.youtube.com/watch?v=NM_Od-Uzy-o.

4. See Beauty Mondal. 2019. "*niuṭi didir kaṇṭhe nay mane hay bānśīr sur.*" Jago Hindu. YouTube channel. Accessed November 24, 2019. https://www .youtube.com/watch?v=jUdvDKpHg-Y.

5. See Somasree Roy. 2019. "*bhagabān bolte kichu nei?*" Jago Hindu. YouTube channel. Accessed December 3, 2019. https://www.youtube.com /watch?v=zHmJoL2ZC1A.

GLOSSARY

ABATĀRA: incarnation of a deity.

ĀKHAR: interstitial line of song used with shorter tāls.

BHAKTI-RATNĀKARA: hagiographical text that describes the events of the Kheturī Melā.

BISHNUPRIYĀ PATRIKĀ: colonial-era periodical published in Kolkata and dedicated to recovering features of Gauḍīya Vaiṣṇava thought, practice, and materiality.

BHADRALOK: Bengali middle class. In the colonial era, the bhadralok were key actors in government and critiques of cultural production.

BHAKTI: devotional religion.

BISTĀR: process of expansion central the musical and ideational spheres of padābalī kīrtan.

BORO-TĀL KĪRTAN: large-meter kīrtan and a reference to the slow-moving musical style of Bengali kīrtan that also uses slow tempos in performance.

BRAJ: region in north India considered Krishna's birthplace and the area where he performed his līlās. Brindaban is within Braj.

BRAJ GOSVĀMĪS: group of male renunciates and scholars who developed key treatises in the early modern period.

BRINDABAN: city in the region of Braj known for its associations with Krishna pilgrimage, worship, and padābalī kīrtan.

CHAITANYA: fifteenth-century mystic who established the thought and practice of Gaudīya Vaiṣṇavism.

DĀN LĪLĀ: the divine play that features Krishna playing the role of the road-tax collector.

DHĀMA: divine abode of Krishna.

ḌHAP KĪRTAN: style of "light" devotional song popular in the commercial recording industry in the early twentieth century.

DOHĀR: second or accompanying singer in a kīrtan ensemble.

GAḌANHĀṬĪ: school of padābalī kīrtan debuted by Narottama Dāsa at the Kheturī Melā but rarely found in the present.

GAUDĪYA VAIṢṆAVISM: devotional religion in Bengal associated with Chaitanya.

GAURĀṄGA: epithet for Chaitanya as the Golden-Limbed One.

GAURA-CANDRIKĀ: invocatory song that describes Chaitanya's connection with Radha and Krishna. The most common repertoire associated with the large-meter musical style in Manoharasāhī kīrtan.

GHARĀNĀ: term often defined as "family" and borrowed from Hindustani music to describe kīrtan schools, such as Manoharasāhī gharānā.

JAYDEB MELĀ: annual religious festival in rural Bengal where kīrtan musicians perform for large audiences, often to find new audiences for the genre.

JOYDEB KENDULI: location of the annual Jaydeb Melā, thought by some to be the birthplace of the poet Jayadeva.

KARTĀL: pair of brass hand-cymbals used in a kīrtan ensemble.

KĀṬĀN: type of interstitial lyric used with songs in the large-meter musical style.

KATHĀ: sections of storytelling featured in a līlā kīrtan performance.

KHAGENDRANATH MITRA: key collaborator with the musician Nabadwipchandra Brajabashi and author and promoter of padābalī kīrtan in colonial Bengal.

KHETURĪ MELĀ: religious festival in the late sixteenth century in present-day Bangladesh where Narottama Dāsa is thought to have debuted a new style of kīrtan.

KHOL: double-headed clay drum used in kīrtan.

KĪRTAN: devotional song, used as a term to cover the spheres of padābalī and līlā kīrtan in this book.

KĪRTANĪYĀ: performer of kīrtan, translated as *kīrtan musician* throughout this book.

KRISHNA: primary deity and object of devotion in Gauḍīya Vaiṣṇavism.

LALITĀ: close friend of Radha in the mythical time-space of Braj.

LĪLĀ: divine play of Radha, Krishna, or Chaitanya in Gauḍīya Vaiṣṇavism.

LĪLĀ KĪRTAN: performance of devotional song and storytelling that depicts a divine play of Radha and Krishna or Chaitanya.

LĪLĀ-SMARAṆA: practice of visualizing or remembering the līlās of Radha and Krishna.

MAHĀJANA PADAKARTĀS: composers of the repertoire of Vaiṣṇava padābalī.

MANOHARASĀHĪ: main school or style of padābalī kīrtan described in this book.

MĀTRĀ: time unit in the theoretical sphere of tāl. Also referred to as "beat" or "pulse" in descriptions of music.

MELĀ: typically, in this book, a festival with religious associations.

MUHŪRTA: time span of forty-eight minutes in the practice of līlā-smaraṇa.

NABADWIP: the birthplace of Chaitanya and an important Gauḍīya Vaiṣṇava pilgrimage location.

NABADWIPCHANDRA BRAJABASHI: kīrtan musician and author from Braj who relocated to Kolkata in the late nineteenth century and was a central guru for bhadralok musicians during the first half of the twentieth century.

NĀM KĪRTAN: devotional song that repeats the names of deities.

NAROTTAMA-BILĀSA: hagiographical text that describes the events of the Kheturī Melā.

NAROTTAMA DĀSA: disciple of the Braj Gosvāmīs and considered the originator of līlā kīrtan.

NĀṬYAŚĀSTRA: early first-millennium treatise on drama.

NAUKĀ-BILĀS: the boat pastime that features episodes with Radha and Krishna in the Yamuna River.

PAD: verse or song.

PADĀBALĪ KĪRTAN: devotional sung poetry that sets the repertoire of Vaiṣṇava padābalī to music.

PŪRVA-RĀGA: first attraction or infatuation, one of the eight forms of the amorous mood in Gauḍīya Vaiṣṇava aesthetics.

RADHA: Krishna's paramour and a worshiped deity in Gauḍīya Vaiṣṇavism.

RĀG: melody type.

RASA: mood; in the case of padābalī kīrtan, usually refers to one of the eight amorous forms or general affect of kīrtan performance.

RŪPA GOSVĀMĪ: disciple of Chaitanya from Bengal who relocated to Braj and wrote key theoretical Gauḍīya Vaiṣṇava treaties. Credited with theorizing the practice of līlā-smaraṇa.

SĀDHAKA: one who practices sādhana with reference to ritual and musical skill in the case of padābalī kīrtan.

SĀDHAKA KĪRTANĪYĀ: a cultural template that came to define the identity and role of the devout and skilled musician.

SĀDHANA: multivalent term that refers to both ritual practice and musical skill.

SAṄGIT VIJÑĀN PRAVEŚIKĀ: colonial-era Bengal music journal.

ŚRĪ-PADĀMṚTA-MĀDHURĪ: the Sweet Elixir of Verse, a multivolume anthology of Vaiṣṇava padābalī edited by Nabadwipchandra Brajabashi and Khagendranath Mitra.

ŚRĪ-ŚRĪ-PADA-KALPATARU: the Wish-fulfilling Tree of Lyrics, the largest anthology of Vaiṣṇava padābalī, edited by Satishchandra Ray.

SVĀMĪ HARIDĀS: musician from the Braj region thought to be a guru of Narottama Dāsa in the early modern period.

TĀL: metric forms in many South Asian musics that structure instrumental and vocal performance.

UCCĀṄGA KĪRTAN: classical or high-art kīrtan.

UJJVALANĪLAMAṆI: theoretical treatise of Rūpa Gosvāmī, influential on the aesthetic theory of padābalī kīrtan.

VAIṢṆAVA PADĀBALĪ: the textual repertoire of verse used in padābalī kīrtan.

VIŚAKHĀ: close friend of Radha in the mythical time-space of Braj.

VIṢṆU: one of the three main deities in Hinduism. Gauḍīya Vaiṣnava theology posits that Krishna is an incarnation of Viṣṇu.

ZAMINDĀR: landed aristocrat in north India.

BIBLIOGRAPHY

Adam, Barbara. 2004. *Time*. Malden, MA: Polity.

Alaghband-Zadeh, Chloë. 2015. "Sonic Performativity: Analysing Gender in North Indian Classical Vocal Music." *Ethnomusicology Forum* 24, no. 3: 349–79.

Amin, Ash, and Nigel Thrift, eds. 2004. *The Blackwell Cultural Economy Reader*. Oxford: Blackwell.

Appadurai, Arjun, ed. 1986. *The Social Life of Things: Commodities in Cultural Perspective*. New York: Cambridge University Press.

———. 1996. *Modernity at Large: Cultural Dimensions of Globalization*. Minneapolis: University of Minnesota Press.

Armstrong, Robert Plant. 1971. *The Affecting Presence: An Essay in Humanistic Anthropology*. Urbana: University of Illinois Press.

Ayyagari, Shalini. 2014. "At Home in the Studio: The Sound of Manganiyar Music Going Popular." In *More than Bollywood: Studies in Indian Popular Music*, edited by Gregory D. Booth and Bradley Shope, 256–75. New York: Oxford University Press.

Bakhle, Janaki. 2005. *Two Men and Music: Nationalism in the Making of an Indian Classical Tradition*. New York: Oxford University Press.

Bakhtin, M. M. 1981. *The Dialogic Imagination: Four Essays*. Austin: University of Texas Press.

Bandopadhyay, Debajit, ed. 2012. *Krishnachandra*. Kolkata: Sutradhar.

Bandhyopadhyay, Tirthankar, and Soumyananda Dinda. 2013. "Neo-Liberalism and Protest in West Bengal: An Analysis through the Media Lens." MPRA Paper. May 8, 2013. http://mpra.ub.uni-muenchen.de/50741.

Banerjee, Prathama. 2006. *Politics of Time: "Primitives" and History-Writing in a Colonial Society.* New York: Oxford University Press.

Banerjee, Sumanta. 1989. *The Parlour and the Streets: Elite and Popular Culture in Nineteenth Century Calcutta.* Calcutta: Seagull Books.

———. 1990. "Marginalization of Women's Popular Culture in Nine-teenth-Century Bengal." In *Recasting Women: Essays in Indian Colonial History.* New Brunswick: Rutgers University Press.

———. 1998. *Dangerous Outcast: The Prostitute in Nineteenth Century Bengal.* Calcutta: Seagull Books.

Baṛu Caṇḍīdāsa. 1984. *Singing the Glory of Lord Krishna: The Śrīkṛṣṇakīrtana.* Edited by M. H. Klaiman. Chico, CA: Scholars Press.

Basu, Priyanka. 2017. "Becoming 'Folk': Religion, Protest and Cultural Communism in the Kabigāna of Ramesh Sil and Gumani Dewan." *South Asian History and Culture* 8, no. 3: 317–37.

Bear, Laura. 2014a. "Doubt, Conflict, Mediation: The Anthropology of Modern Time." *Journal of the Royal Anthropological Institute* 20: 3–30.

———. 2014b. "For Labour: Ajeet's Accident and the Ethics of Techno-logical Fixes in Time." *Journal of the Royal Anthropological Institute* 20: 71–88.

———. 2015. *Navigating Austerity: Currents of Debt along a South Asian River.* Stanford, CA: Stanford University Press.

Beaster-Jones, Jayson. 2014. "Beyond Musical Exceptionalism: Music, Value, and Ethnomusicology." *Ethnomusicology* 58, no. 2: 334–40.

———. 2016. *Music Commodities, Markets, and Values: Music as Merchan-dise.* New York: Routledge.

Beck, Guy L. 2011. "Haridasi Sampradaya." In *Brill's Encyclopedia of Hindu-ism,* edited by Knut A. Jacobsen, 329–38. Vol. III. Boston: Brill.

Becker, A. L. 1980. "Text-Building, Epistemology, and Aesthetics in Java-nese Shadow Theatre." *Dispositio* 5, no. 13/14: 137–68.

Becker, Judith. 1979. "Time and Tune in Java." In *The Imagination of Real-ity: Essays in Southeast Asian Coherence Systems,* edited by A. L. Becker and Aram A. Yengoyan, 197–211. Norwood, NJ: ABLEX Publishing Corporation.

———. 1981. "Hindu-Buddhist Time in Javanese Gamelan Music." In *The Study of Time IV,* edited by J. T. Fraser, Nathaniel Lawrence, and David Park, 161–72. New York: Springer-Verlag.

Berger, Harris M. 2009. *Stance: Ideas about Emotion, Style, and Meaning for the Study of Expressive Culture.* Middletown: Wesleyan University Press.

Bhadra, Gautam. 1994. "The Performer and the Listener: Kathakatā in Modern Bengal." *Studies in History* 10, no. 2: 243–54.

Bhakti-ratnākara of Narahari Cakravartī [Ghanasyāna Dāsa]. 2004. Kolkata: Sri Gauriya Math.

Bharata Muni. 1950. *The Nātyásāstra: A Treatise on Hindu Dramaturgy and Histrionics, Ascribed to Bharata-Muni*. Edited by Manomohan Ghosh. Bibliotheca Indica 272. Calcutta: Asiatic Society.

Bhatia, Varuni. 2009. "Devotional Traditions and National Culture: Recovering Gaudiya Vaishnavism in Colonial Bengal." PhD diss., Columbia University.

———. 2017. *Unforgetting Chaitanya: Vaishnavism and Cultures of Devotion in Colonial Bengal*. New York: Oxford University Press.

Bhattacharya, Manoranjan. 1317 BS. *Śrī-khol Śikṣā*. Self-published.

Bhattacharya, Rimli. 1998. "Introduction." In *Binodini Dasi: My Story and My Life as an Actress*, 3–46. New Delhi: Raj Press.

Bhattacharya, Tithi. 2005. *The Sentinels of Culture: Class, Education, and the Colonial Intellectual in Bengal (1848–85)*. New York: Oxford University Press.

Bisht, Krishna. 1986. *The Sacred Symphony: A Study of Buddhistic and Vaishnav Music of Bengal in Relation to Hindustani Classical Music*. Ghaziabad: Bhagirath Sewa Sansthan.

Blake, Andrew. 2004. "To the Millennium: Music as Twentieth-Century Commodity." In *The Cambridge History of Twentieth-Century Music*, edited by Nicholas Cook and Anthony Pople, 478–505. Cambridge: Cambridge University Press.

Booth, Gregory D. 2008. *Behind the Curtain: Making Music in Mumbai's Film Studios*. New York: Oxford University Press.

Booth, Gregory D., and Bradley Shope, eds. 2014. *More than Bollywood: Studies in Indian Popular Music*. New York: Oxford University Press.

Born, Georgina. 2010. "For a Relational Musicology: Music and Interdisciplinarity, Beyond the Practice Turn." *Journal of the Royal Musical Association* 135, no. 2: 205–43.

———. 2015. "Making Time: Temporality, History, and the Cultural Object." *New Literary History* 46, no. 3: 361–86.

Brajabashi, Nabadwipchandra. 1338 BS. "Śrī-Bhābāḍhya Gauracandrasya: Dhānasī Madhyam Daśkusī." *Saṅgit Vijñān Praveśikā* 8, no. 8: 494–95.

———. 1933. "Khol Bādya." In *Śrī-Padāmṛta-Mādhurī*. Vol. 2. Kolkata: Shri Nagendra-Kumar Lodha M.A. B.L.

Brajabashi, Nabadwipchandra, and Khagendranatha Mitra, eds. 1317 BS (1910). *Śrī-Padāmṛta-Mādhurī*. Vol 1. n.p.

———. 1948. *Śrī-Padāmṛta-Mādhurī*. Vol. 1, 2nd ed. 24 Pargana: Shri Nagendra-Kumar Lodha M.A. B.L.

Brown, Rebecca M. 2017. *Displaying Time: The Many Temporalities of the Festival of India*. Seattle: University of Washington Press.

Bryant, Edwin F. 2007. "Krishna in the Tenth Book of the Bhagavata Purana." In *Krishna: A Sourcebook*, edited by Edwin F. Bryant, 111–36. New York: Oxford University Press.

Buchta, David. 2017. "Evoking Rasa through Stotra: Rūpa Gosvāmin's Līlāmṛta, A List of Kṛṣṇa's Names." *International Journal of Hindu Studies* 20, no. 3: 355–71.

Burrows, David. 2007. *Time and the Warm Body: A Musical Perspective on the Construction of Time*. Boston: Brill.

Capwell, Charles. 1986. *The Music of the Bauls of Bengal*. Kent: Kent State University Press.

Cassio, Francesca. 2015. "Gurbani Sangit: Authenticity and Influences: A Study of the Sikh Musical Tradition in Relation to Medieval and Early Modern Indian Music." *Sikh Formations: Religion, Culture, Theory* 11: 1-2, 23-60. http://dx.doi.org/10.1080/17448727.2015.1023105.

Chakrabarty, Ramakanta. 1985. *Vaiṣṇavism in Bengal, 1486–1900*. Calcutta: Sanskrit Pustak Bhandar.

———. 1996. "Vaisnava Kirtan in Bengal." *Journal of Vaishnava Studies* 12, no. 2: 179–99.

Chakraborti, Bikas. 2014. "Mirabai and Indubala: Spiritual Empowerment Redefined." In *Boundaries of the Self: Gender, Culture and Spaces*, edited by Debalina Banerjee, 127–39. Newcastle upon Tyne: Cambridge Scholars Publishing.

Chakraborty, Mriganka Sekhar. 1992. *Indian Musicology: Melodic Structure*. Calcutta: Firma KLM.

———. 1995. *Bānglār Kīrtan Gān*. Kolkata: Nepalchandra Ghosh.

Chatterjee, Partha. 1993. *The Nation and Its Fragments: Colonial and Postcolonial Histories*. Princeton, NJ: Princeton University Press.

Chatterji, Roma. 2009. *Writing Identities: Folklore and Performative Arts of Purulia, Bengal*. New Delhi: Aryan Books International.

———. 2016. "Scripting the Folk: History, Folklore, and the Imagination of Place in Bengal." *Annual Review of Anthropology* 45, no. 1: 377–94.

Chaudhuri, Tapan. 1988. *Europe Reconsidered: Perceptions of the West in Nineteenth-Century Bengal*. New York: Oxford University Press.

Chowdhury, Indira. 1998. *The Frail Hero and Virile History: Gender and the Politics of Culture in Colonial Bengal*. New York: Oxford University Press.

Clayton, Martin. 2000. *Time in Indian Music: Rhythm, Metre, and Form in North Indian Rāg Performance*. New York: Oxford University Press.

———. 2011. "Metre and Tal in North Indian Music." *Durham Research Online*, 21. https://dro.dur.ac.uk/8756/1/8756.pdf?DDD23+dmuosm +dul4eg.

Comaroff, Jean, and John L. Comaroff, eds. 2001. *Millennial Capitalism and the Culture of Neoliberalism*. Durham: Duke University Press.

Das, Ajit Kumar. 1406 BS. *Jaydeb-Melā: Sekāler o Ekāler*. Joydeb Kenduli: Pushpabhaban.

Das Gupta, Hemendra Nath. 1934. *The Indian Stage*. Calcutta: Metropolitan Printing & Publishing House.

Das, Haridasa. 1955. *Śrī Śrī Gauḍīya Vaiṣṇava Jīban*. Vol. 2. Nabadwip, West Bengal: Haribol Kutir.

Das, Nrisimha Ramanujacharya. 1392 BS. "Sādhaka Kīrttanāchārya Nabadwipchandra Brajabashi." *Ujjīban* 32, no. 7: 269–75.

De, Sushil Kumar. 1960. *History of Sanskrit Poetics*. 2d rev. ed. Calcutta: Firma K. L. Mukhopadhyay.

Debi, Aparna. 1345. "Bhāratīya Saṅgīter Bibhinna Rupa." *Saṅgit Vijñān Praveśikā* 15, no. 2: 66–73.

Delmonico, Neal Gorton. 1990. "Sacred Rapture: A Study of the Religious Aesthetic of Rupa Gosvamin." PhD diss., University of Chicago.

DeNapoli, Antoinette E. 2014. *Real Sadhus Sing to God: Gender, Asceticism, and Vernacular Religion in Rajasthan*. New York: Oxford University Press.

Dennen, David. 2010. "The Third Stream: Oḍiśī Music, Regional Nationalism, and the Concept of 'Classical.'" *Asian Music* 41, no. 2: 149–79.

Dimock, Edward C. 1958. "The Place of Gauracandrikā in Bengali Vaiṣṇava Lyrics." *Journal of the American Oriental Society* 78, no. 3: 153–69.

———. 1966. *The Place of the Hidden Moon: Erotic Mysticism in the Vaiṣṇavasahajiyā Cult of Bengal*. Chicago: University of Chicago Press.

———. 1968. *In Praise of Krishna: Songs from the Bengali*. London: Cape.

Dimock, Edward C, and Tony K. Stewart. 1999. "Introduction: An Overview of the Text." In *Caitanya Caritāmṛta of Kṛṣṇadāsa Kavirāja*, edited by Tony K. Stewart, translated by Edward C. Dimock, 3–141. Cambridge, MA: Harvard University Press.

Dornfeld, Barry. 1998. *Producing Public Television, Producing Public Culture*. Princeton, NJ: Princeton University Press.

Du Perron, L. 2002. "Ṭhumrī: A Discussion of the Female Voice in Hindustani Music." *Modern Asian Studies* 36: 173–93.

Durkheim, Émile. 1915. *The Elementary Forms of the Religious Life, a Study in Religious Sociology*. New York: Macmillan.

Eisenlohr, Patrick. 2015. "Mediating Disjunctures of Time: Ancestral Chronotopes in Ritual and Media Practices." *Anthropological Quarterly* 88, no. 2: 281–304.

Engelhardt, Jeffers. 2009. "Right Singing in Estonian Orthodox Christianity: A Study of Music, Theology, and Religious Ideology." *Ethnomusicology* 53, no. 1: 32–57.

Erdman, Joan Landy, ed. 1992. *Arts Patronage in India: Methods, Motives, and Markets.* New Delhi: Manohar Publications.

Erlmann, Veit. 1996. *Nightsong: Performance, Power, and Practice in South Africa.* Chicago Studies in Ethnomusicology. Chicago: University of Chicago.

Fabian, Johannes. 2014. *Time and the Other: How Anthropology Makes Its Object.* New York: Columbia University Press.

Fahy, John. 2018. "The Constructive Ambiguity of Vedic Culture in ISKCON Mayapur." *The Journal of Hindu Studies* 11, no. 3: 234–59.

Fairfield, Benjamin. 2019. "Social Synchrony and Tuning Out: Karen Participation in Music, Tradition, and Ethnicity in Northern Thailand." *Ethnomusicology* 63, no. 3: 470–98.

Fiol, Stefan. 2011. "From Folk to Popular and Back: Musical Feedback between Studio Recordings and Festival Dance-Songs in Uttarakhand, North India." *Asian Music* 42, no. 1: 24–53.

———. 2017. *Recasting Folk in the Himalayas: Indian Music, Media, and Social Mobility.* Champaign: University of Illinois Press.

Friedson, Steven M. 2009. *Remains of Ritual: Northern Gods in a Southern Land.* Chicago: University of Chicago Press.

Ganti, Tejaswini. 2014. "Neoliberalism." *Annual Review of Anthropology* 43, no. 1: 89–104.

Geertz, Clifford. 1973. *The Interpretation of Cultures.* New York: Basic Books.

Gell, Alfred. 1992. *The Anthropology of Time: Cultural Constructions of Temporal Maps and Images.* Providence: Berg.

Ginsburg, Faye D., Lila Abu-Lughod, and Brian Larkin. 2002. *Media Worlds: Anthropology on New Terrain.* Berkeley: University of California Press.

Glenn, Evelyn Nakano. 2008. "Yearning for Lightness: Transnational Circuits in the Marketing and Consumption of Skin Lighteners." *Gender & Society* 22, no. 3: 281–302.

Goswami, Karunamaya. 1985. *Sangitkoś.* Dhaka: Bangla Academy.

Graeber, David. 2001. *Toward an Anthropological Theory of Value: The False Coin of Our Own Dreams.* New York: Palgrave.

Graves, Eben. 2009. "Chaitanya Vaishnava Perspectives on the Bengali Khol." *Journal of Vaishnava Studies* 17, no. 2: 103–26.

———. 2014. "Padavali-Kirtan: Music, Religious Aesthetics, and Nationalism in West Bengal's Cultural Economy." PhD diss., University of Texas at Austin.

———. 2017a. "'Kīrtan's Downfall': The Sādhaka Kīrtanīyā, Cultural Nationalism and Gender in Early Twentieth-Century Bengal." *The Journal of Hindu Studies* 10, no. 3: 328–57.

———. 2017b. "The Marketplace of Devotional Song: Cultural Economies of Exchange in Bengali Padāvalī-Kīrtan." *Ethnomusicology* 61, no. 1: 52–86.

———. 2019. "'Are You All Coming to the Esplanade?': Devotional Music and Contingent Politics in West Bengal." In *Bhakti & Power: Debating India's Religion of the Heart*, edited by John Stratton Hawley, Christian Lee Novetzke, and Swapna Sharma, 63–73. Seattle: University of Washington Press.

———. 2020. "Nabadwipchandra Brajabashi: A Resident of Krishna's Braj in the Colonial Capital." *Journal of Vaishnava Studies* 29, no. 1: 23–38.

Groesbeck, Rolf. 1999. "'Classical Music,' 'Folk Music,' and the Brahmanical Temple in Kerala, India." *Asian Music* 30, no. 2: 87–112.

Gupta, Ravi. 2007. *The Caitanya Vaiṣṇava Vedānta of Jīva Gosvāmī: When Knowledge Meets Devotion*. New York: Routledge.

———. 2013. "Gauḍīya Vaiṣṇavism - Hinduism - Oxford Bibliographies Online." 2013. https://www-oxfordbibliographies-com.yale.idm.oclc .org/view/document/obo-9780195399318/obo-9780195399318-0140 .xml?rskey=pQ7Nsm&result=65.

Haberman, David L. 1988. *Acting as a Way of Salvation: A Study of Rāgānugā Bhakti Sādhana*. New York: Oxford University Press.

———. 1994. *Journey through the Twelve Forests: An Encounter with Krishna*. New York: Oxford University Press.

Hansen, Kathryn. 1992. *Grounds for Play: The Nautanki Theatre of North India*. Berkeley: University of California Press.

Harvey, David. 1989. *The Condition of Postmodernity: An Enquiry into the Origins of Cultural Change*. New York: Blackwell.

———. 2005. *A Brief History of Neoliberalism*. New York: Oxford University Press.

Hawley, John Stratton. 2015. *A Storm of Songs: India and the Idea of the Bhakti Movement*. Cambridge, MA: Harvard University Press.

Hein, Norvin J. 1976. "Caitanya's Ecstasies and the Theology of the Name." In *Hinduism: New Essays in the History of Religions*, edited by Bardwell L. Smith, 16–32. Leiden: E. J. Brill.

Henry, Edward O. 1988. *Chant the Names of God: Musical Culture in Bhoj-puri-Speaking India*. San Diego, CA: San Diego State University Press.

Herrera, Eduardo. 2018. "Masculinity, Violence, and Deindividuation in Argentine Soccer Chants: The Sonic Potentials of Participatory Sounding-in-Synchrony." *Ethnomusicology* 62, no. 3: 470–99.

Hess, Linda. 2015. *Bodies of Song: Kabir Oral Traditions and Performative Worlds in North India*. New York: Oxford University Press.

Hilder, Thomas R. 2017. "Music, Indigeneity, Digital Media: An Introduction." In *Music, Indigeneity, Digital Media*, edited by Thomas R. Hilder, Henry Stobart, and Shzr Ee Tan, 1–27. Rochester: University of Rochester Press.

Ho, Meilu. 2006. "The Liturgical Music of the Pusti Marg of India: An Embryonic Form of the Classical Tradition." PhD diss., UCLA.

Holdrege, Barbara A. 2015. *Bhakti and Embodiment: Fashioning Divine Bodies and Devotional Bodies in Kṛṣṇa Bhakti*. New York: Routledge.

Hope, Wayne. 2006. "Global Capitalism and the Critique of Real Time." *Time & Society* 15, no. 2/3: 275–302.

———. 2016. *Time, Communication and Global Capitalism*. New York: Palgrave Macmillan.

Hubert, Thibaut d'. 2018. "Literary History of Bengal." Oxford Research Encyclopedia of Asian History. February 26, 2018. https://doi.org /10.1093/acrefore/9780190277727.013.39.

Hussain, Syed Ejaz. 2003. *The Bengal Sultanate: Politics, Economy and Coins, A.D. 1205–1576*. New Delhi: Manohar.

Husserl, Edmund. 2019. *The Phenomenology of Internal Time-Consciousness*. Bloomington: Indiana University Press.

Jankowsky, Richard C. 2010. *Stambeli: Music, Trance, and Alterity in Tunisia*. Chicago: University of Chicago Press.

Jayadeva. 1997. *Love Song of the Dark Lord: Jayadeva's Gītagovinda*. Translated by Barbara Stoler Miller. New York: Columbia University Press.

Kapchan, Deborah A. 2007. *Traveling Spirit Masters: Moroccan Gnawa Trance and Music in the Global Marketplace*. Middletown: Wesleyan University Press.

Kapferer, Bruce. 2004. "Ritual Dynamics and Virtual Practice: Beyond Representation and Meaning." *Social Analysis* 48, no. 2: 35–54.

Katz, Mark. 2010. *Capturing Sound: How Technology Has Changed Music*. Berkeley: University of California Press.

Kaviraj, Sudipta. 2003. "The Two Histories of Literary Culture in Bengal." In *Literary Cultures in History: Reconstructions from South Asia*, edited by Sheldon Pollock. Berkeley: University of California Press.

Kinnear, Michael S. 1994. *The Gramophone Company's First Indian Recordings, 1899–1908*. Bombay: Popular Prakashan.

———. 2000. *The Gramophone Company's Indian Recordings 1908 to 1910*. Heidelberg, Victoria, Australia: Bajakhana.

Kippen, James. 1988. *The Tabla of Lucknow: A Cultural Analysis of a Musical Tradition*. New York: Cambridge University Press.

———. 2006. *Gurudev's Drumming Legacy: Music, Theory and Nationalism in the Mṛdaṅg Aur Tabla Vādanpaddhati of Gurudev Patwardhan*. Burlington: Ashgate.

———. 2008. "Working with the Masters." In *Shadows in the Field: New Perspectives for Fieldwork in Ethnomusicology*, edited by Gregory Barz and Timothy J. Cooley. New York: Oxford University Press.

Klaiman, M. H. 1984. "Dānakhaṇḍa." In *Singing the Glory of Lord Krishna: The Śrīkṛṣṇakīrtana*, edited by M. H. Klaiman, 47–118. Chico, CA: Scholars Press.

Knutson, Jesse. 2014. *Into the Twilight of Sanskrit Court Poetry: The Sena Salon of Bengal and Beyond*. Berkeley: University of California Press.

Kramer, Jonathan D. 1988. *The Time of Music: New Meanings, New Temporalities, New Listening Strategies*. New York: Schirmer Books.

Kṛṣṇadāsa Kavirāja Gosvāmi. 1999. *Caitanya Caritāmṛta of Kṛṣṇadāsa Kavirāja: A Translation and Commentary*. Translated by Edward C. Dimock and Tony K. Stewart. Cambridge, MA: Harvard University Press.

La Trobe, Jyoshna. 2010. "Red Earth Song: *Marāī* Kīrtan of Rāṛh: Devotional Singing and the Performance of Ecstasy in the Purulia District of Bengal, India." PhD diss., University of London.

Lahiri, Durgadas, ed. 1312 BS (1905). *Vaiṣṇava-Padalahirī*. Kolkata: 38/2, Bahvanicaran Datta Street.

Laing, D. 2003. "Music and the Market: The Economics of Music in the Modern World." In *The Cultural Study of Music: A Critical Introduction*, edited by Martin Clayton, Trevor Herbert, and Richard Middleton. New York: Routledge.

Larkin, Brian. 2008. *Signal and Noise: Media, Infrastructure, and Urban Culture in Nigeria*. Durham: Duke University Press.

Linden, Bob van der. 2019. *Arnold Bake: A Life with South Asian Music*. New York: Routledge.

London, Justin. 2004. *Hearing in Time: Psychological Aspects of Musical Meter*. New York: Oxford University Press.

Lorea, Carola Erika. 2016. *Folklore, Religion and the Songs of a Bengali Madman: A Journey between Performance and the Politics of Cultural Representation*. Boston: Brill.

Maciszewski, Amelia. 2007. "Nayika Ki Yadgar: North Indian Women Musicians and Their Words." In *Music and Modernity: North Indian Classical Music in an Age of Mechanical Reproduction*, edited by Amlan Das Gupta, 156–219. Kolkata: Thema.

Mahmood, Saba. 2005. *Politics of Piety: The Islamic Revival and the Feminist Subject*. Princeton, NJ: Princeton University Press.

Mains, Daniel. 2007. "Neoliberal Times: Progress, Boredom, and Shame among Young Men in Urban Ethiopia." *American Ethnologist* 34, 4: 659–73.

Manuel, Peter. 1989. *Thumrī in Historical and Stylistic Perspectives*. Delhi: Motilal Banarasidass.

———. 1993. *Cassette Culture: Popular Music and Technology in North India*. Chicago: University of Chicago Press.

———. 2012. "Popular Music as Popular Expression in North India and the Bhojpuri Region, from Cassette Culture to VCD Culture." *South Asian Popular Culture* 10, 3: 223–36.

Marcus, Scott L. 2007. *Music in Egypt: Experiencing Music, Expressing Culture*. New York: Oxford University Press.

Marian-Bălaşa, Marin. 2005. "Who Actually Needs Transcription? Notes on the Modern Rise of a Method and the Postmodern Fall of an Ideology." *The World of Music* 47, 2: 5–29.

Mason, Kaley. 2013. "Musicians and the Politics of Dignity in South India." In *The Cambridge History of World Music*, edited by Philip V. Bohlman, 441–72. New York: Cambridge University Press.

Massey, Heath. 2015. *The Origin of Time: Heidegger and Bergson*. Albany: State University of New York Press.

May, Jon, and N. J Thrift. 2003. *TimeSpace: Geographies of Temporality*. New York: Routledge.

McDermott, Rachel Fell. 2011. *Revelry, Rivalry, and Longing for the Goddesses of Bengal: The Fortunes of Hindu Festivals*. New York: Columbia University Press.

McGraw, Andrew Clay. 2008. "Different Temporalities: The Time of Balinese Gamelan." *Yearbook for Traditional Music* 40: 136–62.

McNeil, Adrian. 2017. "Seed Ideas and Creativity in Hindustani Raga Music: Beyond the Composition–Improvisation Dialectic." *Ethnomusicology Forum* 26, no. 1: 116–32.

McTaggart, J. Ellis. 1908. "The Unreality of Time." *Mind* 17 (68): 457–74.

Mitra, Khagendranath. 1948. "Foreword." In *Śrī-Padāmṛta-mādhurī*, Vol. 1, 2nd ed. 24 Pargana: Shri Nagendra-Kumar Lodha M.A. B.L.

———. 1333 BS. "Rasa-Kīrtan." *Bharatabarsha* 14, pt. 1, 2: 377–82.

———. 1352 BS. *Kīrtan*. Kolkata: Bishbabharati Granthalay.

Morcom, Anna. 2007. *Hindi Film Songs and the Cinema*. Burlington: Ashgate.

———. 2008. "Getting Heard in Tibet: Music, Media and Markets." *Consumption Markets & Culture* 11, no. 4: 259–85.

———. 2013. *Illicit Worlds of Indian Dance: Cultures of Exclusion*. New York: Oxford University Press.

———. 2015. "Terrains of Bollywood Dance: (Neoliberal) Capitalism and the Transformation of Cultural Economies." *Ethnomusicology* 59, no. 2: 288–314.

Mukhopadhyay, Bhaskara. 2012. *The Rumor of Globalization: Desecrating the Global from Vernacular Margins*. New York: Columbia University Press.

Mukhopadhyay, Harekrishna. 1971. *Bāṅgālāra Kīrtana o Kīrtanīyā*. Kolkata: Sāhitya Saṃsad.

———, ed. 2010. *Vaiṣṇava Padābalī*. Kolkata: Sahitya Sangsad.

———. 2011. *Bāṅgālāra Kīrtana o Kīrtanīyā*. 2nd ed. Kolkata: Pashchimbanga Rajua Pustak Parshad.

Munn, Nancy. 1992. "The Cultural Anthropology of Time: A Critical Essay." *Annual Review of Anthropology* 21: 93–123.

Murphy, Anne. 2011. "Introductory Essay." In *Time, History and the Religious Imaginary in South Asia*, edited by Anne Murphy, 1–11. New York: Routledge.

Myers, Helen, ed. 1993. *Ethnomusicology: Historical and Regional Studies*. New York: W. W. Norton.

Narottama Dāsa. 1975. "Smaraṇa Mangala." In *Narottama Dāsa o Tāṁhāra Racanābalī*, edited by Niradaprasad Nath. Kolkata: Kalikata Bishabidyalaya.

Nelson, David P. 2008. *Solkattu Manual: An Introduction to the Rhythmic Language of South Indian Music*. Middletown: Wesleyan University Press.

Neuman, Daniel M. 1990. *The Life of Music in North India: The Organization of an Artistic Tradition*. Chicago: University of Chicago Press.

Nijman, Jan, and Michael Shin. 2014. "The Megacity." In *Atlas of Cities*, edited by Paul Knox. Princeton, NJ: Princeton University Press.

Novetzke, Christian Lee. 2008a. "Bhakti and Its Public." *International Journal of Hindu Studies* 11, no. 3: 255–72.

———. 2008b. *Religion and Public Memory: A Cultural History of Saint Namdev in India*. New York: Columbia University Press.

———. 2015. "Note to Self: What Marathi Kirtankars' Notebooks Suggest about Literacy, Performance, and the Travelling Performer in Pre-

Colonial Maharashtra." In *Tellings and Texts: Music, Literature and Performance in North India*, edited by Francesca Orsini and Katherine Butler Schofield, 169–84. Cambridge: Open Book Publisher.

———. 2017. *The Quotidian Revolution: Vernacularization, Religion, and the Premodern Public Sphere in India*. New York: Columbia University Press.

O'Connell, Joseph T. 1990. "Do Bhakti Movements Change Hindu Social Structures? The Case of Caitanya's Vaiṣṇavas in Bengal." In *Boeings and Bullcock-Carts: Studies in Change and Continuity in Indian Civilization*, edited by Bardwell L. Smith, 4 :39–63. Delhi: Chanakya.

Okita, Kiyokazu. 2014. *Hindu Theology in Early Modern South Asia: The Rise of Devotionalism and the Politics of Genealogy*. New York: Oxford University Press.

———. 2016. "The Influence of Śiṅgabhūpāla II on Bengali Vaiṣṇava Aesthetics." *Journal of Indian and Buddhist Studies* 64, no. 3: 1081–87.

———. 2017. "From Rasa to Bhaktirasa: The Development of a Devotional Aesthetic Theory in Early Modern South Asia." *Journal of Indian and Buddhist Studies* 65, no. 3: 1066–72.

Oza, Rupal. 2006. *The Making of Neoliberal India: Nationalism, Gender, and the Paradoxes of Globalization*. New York: Routledge.

Pechilis, Karen. 1999. *The Embodiment of Bhakti*. New York: Oxford University Press.

Plattner, Stuart, ed. 1989. *Economic Anthropology*. Stanford, CA: Stanford University Press.

Pollock, Sheldon I. 2016. *A Rasa Reader: Classical Indian Aesthetics*. New York: Columbia University Press.

Postone, Moishe. 1993. *Time, Labor, and Social Domination: A Reinterpretation of Marx's Critical Theory*. New York: Cambridge University Press.

Prajnanananda, Swami. 1956. "Introduction." In *Sangitasara-Samgraha of Sri Ghanasyamadāsa*, edited by Swami Prajnanananda, 1–41. Calcutta: Ramakrishna Vedanta Math.

———. 1970. *Padābalī Kīrtan Itihās*. Kolkata: Shri Ramakrishna Vedanta Math.

Qureshi, Regula. 1986. *Sufi Music of India and Pakistan: Sound, Context, and Meaning in Qawwali*. New York: Cambridge University Press.

———. 2002. "Mode of Production and Musical Production: Is Hindustani Music Feudal?" In *Music and Marx: Ideas, Practice, Politics*, edited by Regula Qureshi, 81–105. New York: Routledge.

Rahaim, Matthew. 2012. *Musicking Bodies: Gesture and Voice in Hindustani Music*. Middletown, CT: Wesleyan University Press.

Ranade, Ashok D. 2006. *Hindi Film Song: Music beyond Boundaries*. New Delhi: Promilla & Co.

Riddell, J. Barry. 1974. "Periodic Markets in Sierra Leone." *Annals of the Association of American Geographers* 64, no. 4: 541–48.

Roeder, John Barlow. 2011. "Introduction." In *Analytical and Cross-Cultural Studies in World Music*, edited by John Barlow Roeder and Michael Tenzer. New York: Oxford University Press.

Rosen, Steven. 1991. *The Lives of the Vaishnava Saints: Shrinivas Acharya, Narottam Das Thakur, Shyamananda Pandit*. New York: Folks Books.

Rosenstein, Ludmila L. 1997. *The Devotional Poetry of Svāmī Haridās: A Study of Early Braja Bhāṣā Verse*. Groningen: Egbert Forsten.

Rosse, Michael. 1995. "The Movement for the Revitalization of 'Hindu' Music in Northern India, 1860–1930: The Role of Associations and Institutions." PhD diss., University of Pennsylvania.

Rowell, Lewis. 1978. "Time in the Musical Consciousness of Old High Civilizations—East and West." In *The Study of Time III*, edited by J. T. Fraser, N. Lawrence, and D. Park. New York: Springer-Verlag.

———. 1992. *Music and Musical Thought in Early India*. Chicago: University of Chicago Press.

Ruckert, George. 2004. *Music in North India: Experiencing Music, Expressing Culture*. New York: Oxford University Press.

Rūpagosvāmī. 1341 BS. *Ujjvalanīlamaṇi*. Baraharamapura: Śrī Brajanāthamiśreṇāsya asya catūrthasaṃskaraṇaṃ prakāśitaṃ.

———. 1976. *Dāna-Keli-Kaumudī*. Indore: Bharati Publications for & on behalf of Bharati Research Institute.

Sanford, A. Whitney. 2008. *Singing Krishna: Sound Becomes Sight in Paramanand's Poetry*. Ithaca: State University of New York Press.

Sangari, Kumkum, and Sudesh Vaid, eds. 1990. *Recasting Women: Essays in Indian Colonial History*. New Brunswick: Rutgers University Press.

Sanyal, Hiteshranjan. 1985. "Transformation of the Regional Bhakti Movement (Sixteenth and Seventeenth Centuries)." In *Bengali Vaisnavism, Orientalism, Society and the Arts*, edited by Joseph T. O'Connell, 59–70. East Lansing: Asian Studies Center, Michigan State University.

———. 1989. *Bangla Kīrtaner Itihās*. Calcutta: K. P. Bagchi & Company.

———. 2019. *Trends of Change in Bhakti Movement in Bengal*. New York: Oxford University Press.

Sanyal, Ritwik, and Richard Widdess. 2004. *Dhrupad: Tradition and Performance in Indian Music*. Burlington: Ashgate.

Sarbadhikary, Sukanya. 2015. *The Place of Devotion: Siting and Experiencing Divinity in Bengal-Vaishnavism*. Oakland: University of California Press.

Sarkar, Sumit. 1992. "'Kaliyuga', 'Chakri' and 'Bhakti': Ramakrishna and His Times." *Economic and Political Weekly* 27, no. 29: 1543–66.

———. 2002. *Beyond Nationalist Frames: Postmodernism, Hindu Fundamentalism, History.* Bloomington: Indiana University Press.

Sax, William. 1995. "Introduction." In *The Gods at Play: Līlā in South Asia,* edited by William Sax, 3–10. New York: Oxford University Press.

Schofield, Katherine Butler. 2010. "Reviving the Golden Age Again: 'Classicization,' Hindustani Music, and the Mughals." *Ethnomusicology* 54, no. 3: 484–517.

Schultz, Anna C. 2013. *Singing a Hindu Nation: Marathi Devotional Performance and Nationalism.* New York: Oxford University Press.

Schwartz, Susan L. 2004. *Rasa: Performing the Divine in India.* New York: Columbia University Press.

Schweig, Graham, and David Buchta. 2018. "Rasa Theory." *Brill's Encyclopedia of Hinduism Online,* last modified 2018. https://referenceworks .brillonline.com/entries/brill-s-encyclopedia-of-hinduism/rasa-theory -COM_2040070?s.num=18.

Schweig, Graham M. 2005. *Dance of Divine Love: The Rāsa Līlā of Krishna from the Bhāgavata Purāṇa, India's Classic Sacred Love Story.* Princeton, NJ: Princeton University Press.

Sen, Dineshchandra, and Khagendranath Mitra, eds. 1943. *Vaiṣṇava Padābalī.* 2nd ed. Kolkata: Kalikata Bishabidyalaya.

Sen, Sanhita. 2009. *Tradition and Modernity of the Elite: A Saga of the Acharyyas of Muktagachha and the Paikpara Raj, 1857–1947.* Kolkata: Readers Service.

Sen, Sukumar. 1992. *History of Bengali Literature.* New Delhi: Sahitya Akademi.

Shipley, Jesse Weaver, and Marina Peterson. 2012. "Introduction: Audio Work: Labor, Value, and the Making of Musical Aesthetics." *Journal of Popular Music Studies* 24, no. 4: 399–410.

Simms, Robert. 1992. "Aspects of Cosmological Symbolism in Hindusthani Musical Forms." *Asian Music* 24, no. 1: 67–89.

Singha, Rina, and Reginald Massey. 1967. *Indian Dances: Their History and Growth.* New York: G. Braziller.

Slawek, Stephen. 1987. *Sitār Technique in Nibaddh Forms.* Delhi: Motilal Banarsidass.

Smith, Anthony. 1994 "The Crisis of Dual Legitimation." In *Nationalism,* edited by John Hutchinson and Anthony Smith, 113–21. New York: Oxford University Press.

Smith, William. 2000. "Inventing Brajabuli." *Archiv Orientální, Journal of Asian and African Studies* 68: 387–98.

Srinivasan, Doris. 2006. "Royalty's Courtesans and God's Mortal Wives." In *The Courtesan's Arts: Cross-Cultural Perspectives*, edited by Martha Feldman and Bonnie Gordon, 161–81. New York: Oxford University Press.

Sterne, Jonathan. 2012. *MP3: The Meaning of a Format.* Durham: Duke University Press.

Stewart, Tony K. 2005. "Reading for Krishna's Pleasure: Gauḍīya Vaishnava Meditation, Literary Interiority, and the Phenomenology of Repetition." *Journal of Vaishnava Studies* 14, no. 1: 243–80.

———. 2010. *The Final Word: The Caitanya Caritāmṛta and the Grammar of Religious Tradition.* New York: Oxford University Press.

Stobart, Henry. 2010. "Rampant Reproduction and Digital Democracy: Shifting Landscapes of Music Production and 'Piracy' in Bolivia." *Ethnomusicology Forum* 19, no. 1: 27–56.

———. 2017. "Creative Pragmatism: Competency and Aesthetics in Bolivian Indigenous Music Video (VCD) Production." In *Music, Indigeneity, Digital Media*, edited by Thomas R. Hilder, Henry Stobart, and Shzr Ee Tan. Rochester, NY: University of Rochester Press.

Stokes, Martin. 1992. "Islam, the Turkish State and Arabesk." *Popular Music* 11, no. 2: 213–27.

———. 2002. "Marx, Money, and Musicians." In *Music and Marx: Ideas, Practice, Politics*, edited by Regula Qureshi, 139–66. New York: Routledge.

Subramanian, Lakshmi. 2006. *From the Tanjore Court to the Madras Music Academy: A Social History of Music in South India.* New York: Oxford University Press.

Sykes, Jim. 2018a. *The Musical Gift: Sonic Generosity in Post-War Sri Lanka.* New York: Oxford University Press.

———. 2018b. "South Asian Drumming beyond Tala: The Problem with 'Meter' in Buddhist Sri Lanka." *Analytical Approaches to World Music* 6 (2): 1–49.

Talbot, Cynthia. 2016. *The Last Hindu Emperor : Prithviraj Chauhan and the Indian Past, 1200–2000.* Cambridge: Cambridge University Press.

Taylor, Timothy D. 2007. "The Commodification of Music at the Dawn of the Era of 'Mechanical Music.'" *Ethnomusicology* 51, no. 2: 281–305.

Tenzer, Michael, ed. 2006. *Analytical Studies in World Music.* Oxford; New York: Oxford University Press.

———. 2011. "Generalized Representations of Musical Time and Periodic Structures." *Ethnomusicology* 55, no. 3: 369–86.

Tenzer, Michael, and John Barlow Roeder, eds. 2011. *Analytical and Cross-Cultural Studies in World Music.* New York: Oxford University Press.

Thompson, E. P. 1967. "Time, Work-Discipline, and Industrial Capitalism." *Past & Present* no. 38: 56–97.

Thompson, Hanne-Ruth. 2012. *Bengali.* Philadelphia: John Benjamins Publishing Company.

Turino, Thomas. 2008. *Music as Social Life: The Politics of Participation.* Chicago Studies in Ethnomusicology. Chicago: University of Chicago Press.

Urban, Hugh B. 2001. *The Economics of Ecstasy: Tantra, Secrecy, and Power in Colonial Bengal.* New York: Oxford University Press.

Vaishnava Das, and Satishchandra Ray, eds. 1322–1338 BS. *Śrī-Śrī-Pada-Kalpataru.* 5 vols. Kolkata: Ramakamala Simha for the Bangiya Sahitya Parishad.

Valpey, Kenneth. 2006. *Attending Krishna's Image.* New York: Routledge.

Wade, Bonnie C. 1984. *Khyāl: Creativity within North India's Classical Music Tradition.* New York: Cambridge University Press.

———. 1992. "Patronage in India's Musical Culture." In *Arts Patronage in India: Methods, Motives and Markets,* edited by Joan L. Erdman, 181–93. New Delhi: Manohar.

Walsh, John Henry Tull. 1902. *A History of Murshidabad District (Bengal) with Biographies of Some of Its Noted Families.* London: Jarrold & Sons.

Wang, Shujen. 2003. *Framing Piracy: Globalization and Film Distribution in Greater China.* Rowman & Littlefield.

Wanmali, Sudhir. 1980. "The Regulated and Periodic Markets and Rural Development in India." *Transactions of the Institute of British Geographers* 5, no. 4: 466–86.

Waterman, Christopher. 1993. "Africa." In *Ethnomusicology: Historical and Regional Studies,* edited by Helen Myers, 240–59. New York: W. W. Norton.

Weidman, Amanda. 2006. *Singing the Classical, Voicing the Modern: The Postcolonial Politics of Music in South India.* Durham: Duke University Press.

———. 2014. "Neoliberal Logics of Voice: Playback Singing and Public Femaleness in South India." *Culture, Theory and Critique* 55, no. 2: 175–93.

Widdess, Richard. 1981. "Tāla and Melody in Early Indian Music: A Study of Nānyadeva's Pāṇkikā Songs with Musical Notation." *Bulletin of the*

School of Oriental and African Studies, University of London 44, no. 3: 481–508.

———. 1994. "Festivals of Dhrupad in Northern India: New Contexts for an Ancient Art." *British Journal of Ethnomusicology* 3: 89–109.

———. 2013. *Dāphā: Sacred Singing in a South Asian City*. Burlington: Ashgate.

Williams, Richard. 2014. "Hindustani Music Between Awadh and Bengal, c.1758–1905." PhD diss., King's College London.

Wolf, Richard K. 2005. *The Black Cow's Footprint: Time, Space, and Music in the Lives of the Kotas of South India*. Urbana: University of Illinois Press.

———. 2014. *The Voice in the Drum: Music, Language, and Emotion in Islamicate South Asia*. Urbana: University of Illinois Press.

Wong, Lucian. 2015. "Gauḍīya Vaiṣṇava Studies: Mapping the Field." *Religions of South Asia* 9: 305–31.

Wulff, Donna. 1984. *Drama as a Mode of Religious Realization: The Vidagdhamādhava of Rūpa Gosvāmī*. Chico, CA: Scholars Press.

———. 1985. "Images and Roles of Women in Bengali Vaiṣṇava Padāvalī Kīrtan." In *Bengali Vaisnavism, Orientalism, Society and the Arts*, edited by Joseph T. O'Connell. East Lansing: Asian Studies Center, Michigan State University.

———. 1996. "Internal Interpretation: The Ākhar Lines in Performances of Padāvalī Kīrtan." *Journal of Vaishnava Studies* 4, no. 4: 75–86.

———. 1997. "Rādhā's Audacity in Kīrtan Performances and Women's Status in Greater Bengal." In *Women and Goddess Traditions in Antiquity and Today*, 64–84. Minneapolis: Fortress Press.

———. 2009. "The Debate over Improvisation's Legitimacy in Bengali Devotional Performance." *Journal of Vaishnava Studies* 17, no. 2: 95–102.

Yang, Mayfair Mei-hui. 2000. "Putting Global Capitalism in Its Place: Economic Hybridity, Bataille, and Ritual Expenditure." *Current Anthropology* 41, no. 4: 477–509.

Zarrilli, Phillip B. 1992. "A Tradition of Change: The Role of Patrons and Patronage in the Kathakali Dance-Drama." In *Arts Patronage in India: Methods, Motives and Markets*, edited by Joan L. Erdman, 91–142. New Delhi: Manohar.

DISCOGRAPHY

Bandopadhyay, Chabi, Gitaśrī. 1984. *Kīrtana-Sudhā*. EMI ECSD.41551. LP.

———. 1986. *Śrī Gaurāṅga Mahāprabhur Līlā-Kīrtan*. His Master's Voice PSLP 1606. LP.

De, Krishnachandra. 1926. *Jaya Sītāpati Sundar Tanu* & *Andhakārer Antar-ete*. Vol. P 7404. HMV/Twin. SP.

Ghosh, Rathin. 1977. *Bājikar-Milan: Mānabhanjan*. Gathani. S/GRL 1003.

———. 1978. *Krishna Kālī - Pālā Kīrtan*. Gathani. S/GRL 1006.

Mitra, Nimai. 1988. *Āmāder Gaurāṅga*. M/S Calcutta Record & Cassettes. Cassette.

FILMOGRAPHY

Bhagaban Shrikrishna Chaitanya. 1953. Directed by Debaki Bose. Debaki Bose Productions.

Chandidas. 1932. Directed by Debaki Bose. New Theaters. DVD.

Muralī-Bṛṣṭi. 2012. Performed by Shampa Mishra. SM Music. VCD.

Nader Nimāi. 1960. Directed by Bimal Ray Jr. Progressive Enterprises. VCD.

Naukā-bilās. 2012. Performed by Dyuti Chakrabarty. Raga Music. VCD.

Nilācale Mahāprabhu. 1955. Directed by Kartik Chatterjee. Uday Chitra. VCD.

Nimai Sanyasi. 1940. Directed by Phani Burma.

Radha-Krishna. 1964. Directed by Ardhendu Mukhopadhyay. Angel Digital. VCD.

Songs in Oblivion. 2012. Directed by Samrat Chakrobarty. KF Films. DVD.

Vidyapati. 1937. Directed by Debaki Bose. New Theatres.

INDEX

Locators in italic refer to figures, maps, and tables.

EBEN GRAVES is Assistant Director at
the Yale Institute of Sacred Music.